**The
Shirley
Sherwood
Collection**
Modern Masterpieces
of Botanical Art

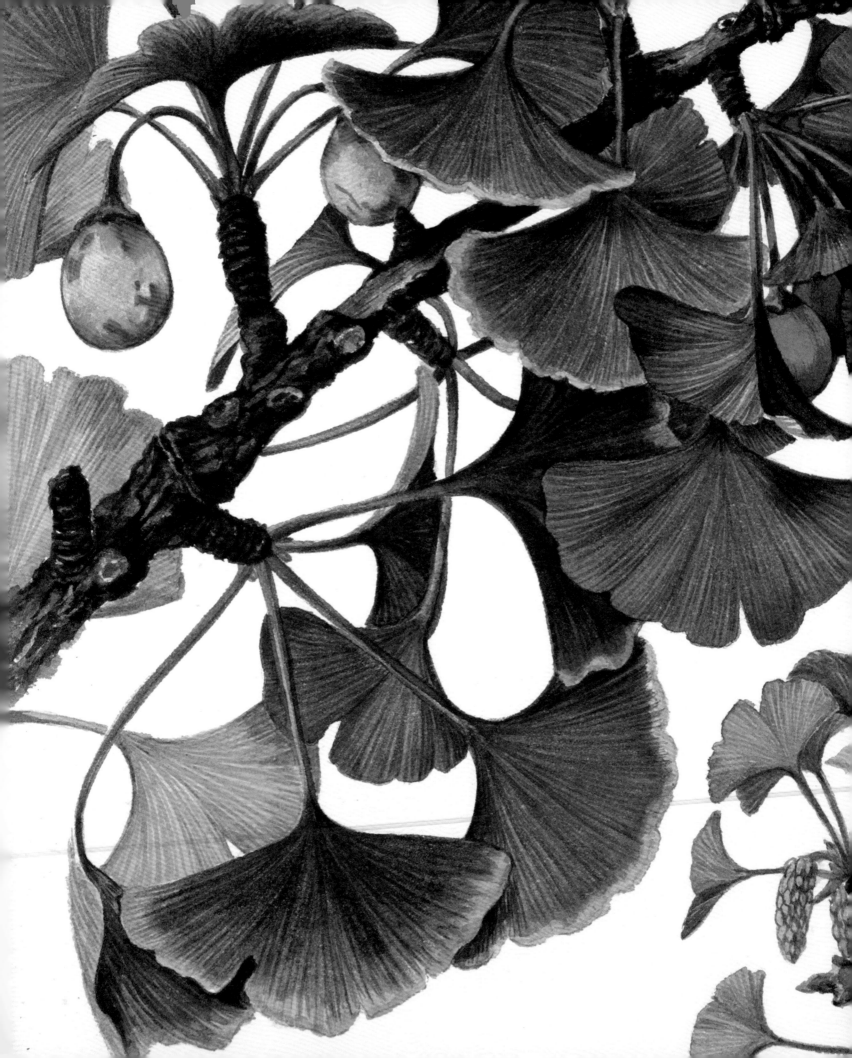

The Shirley Sherwood Collection

Modern Masterpieces of Botanical Art

Shirley Sherwood

Kew Publishing
Royal Botanic Gardens, Kew

© The Board of Trustees of the Royal Botanic Gardens, Kew 2020
Text © Shirley Sherwood
Illustrations © the artists, as stated in the captions
Photographs © Shirley Sherwood

The authors have asserted their rights as authors of this work in accordance with the Copyright, Designs and Patents Act 1988

All rights reserved. No part of this publication may be reproduced, stored in a retrieval system, or transmitted, in any form, or by any means, electronic, mechanical, photocopying, recording or otherwise, without written permission of the publisher unless in accordance with the provisions of the Copyright Designs and Patents Act 1988.

Great care has been taken to maintain the accuracy of the information contained in this work. However, neither the publisher, the editors nor authors can be held responsible for any consequences arising from use of the information contained herein. The views expressed in this work are those of the authors and do not necessarily reflect those of the publisher or of the Board of Trustees of the Royal Botanic Gardens, Kew.

First published in 2019, reprinted in 2020
Royal Botanic Gardens, Kew, Richmond, Surrey, TW9 3AB, UK
www.kew.org

ISBN 978 1 84246 693 3

Distributed on behalf of the Royal Botanic Gardens, Kew in North America by the University of Chicago Press, 1427 East 60th Street, Chicago, IL 60637, USA.

British Library Cataloguing in Publication Data
A catalogue record for this book is available from the British Library

Copy-editing: Michelle Payne
Design and page layout: Ocky Murray, Christine Beard
Production management: Georgina Hills

Frontispiece
Detail from *Ginkgo biloba* 1971, by Manabu Saito

Printed and bound in the UK by Gomer Press Limited

For information or to purchase all Kew titles please visit
shop.kew.org/kewbooksonline or email publishing@kew.org

Kew's mission is to be the global resource in plant and fungal knowledge and the world's leading botanic garden.

Kew receives approximately one third of its funding from Government through the Department for Environment, Food and Rural Affairs (Defra). All other funding needed to support Kew's vital work comes from members, foundations, donors and commercial activities, including book sales.

Contents

Foreword — Sir Peter Crane vii

Introduction — Shirley Sherwood 1

British Isles 3

Europe 69

North America 101

Latin America 139

South Africa 169

Australasia 205

Asia 237

Painting the dove tree 281

Artist biographies 286

Artists in the Shirley Sherwood Collection 307

The Shirley Sherwood Collection exhibitions and venues 309

Selected bibliography 310

Acknowledgements 310

Index 311

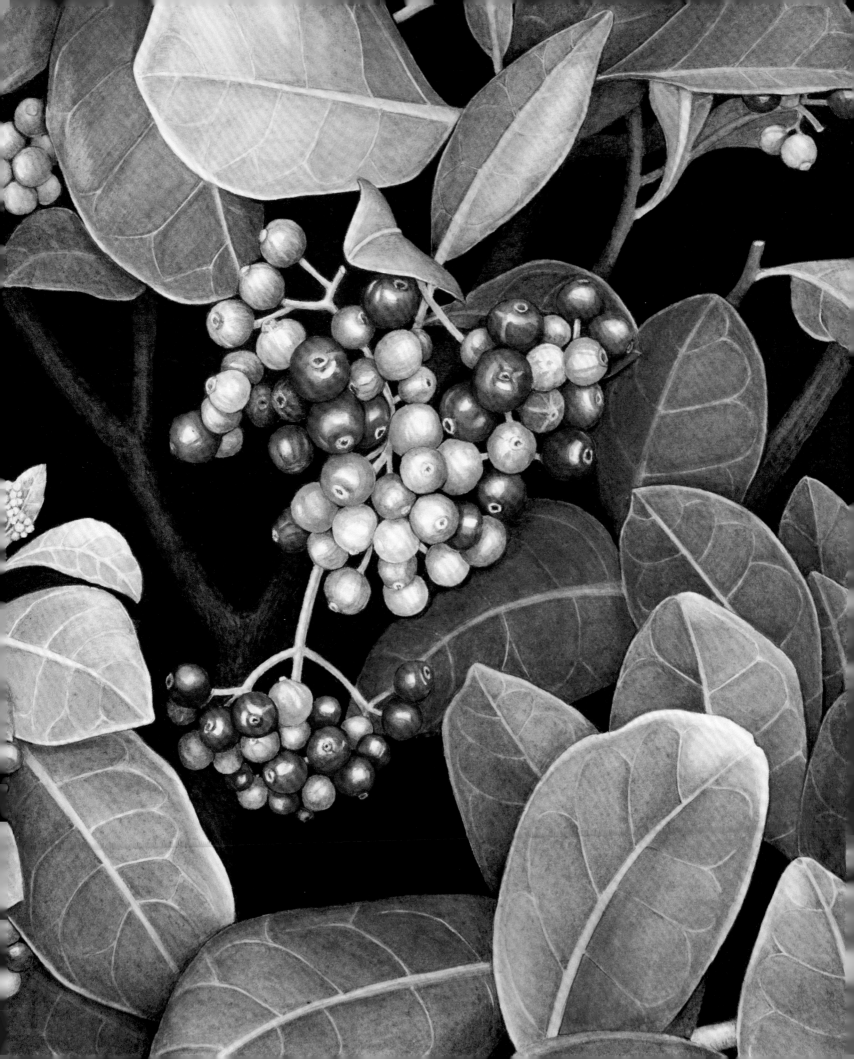

Foreword

REFLECTING ON Wilfrid Blunt's classic book *The Art of Botanical Illustration*, or reveling in the exquisite artistry of Ehret, Redouté, or Robert, the aspiring botanical artist could be forgiven for thinking that the best days of this exacting genre are in the past. This is most certainly not the case. The spectacular works in this book, all exemplars from Dr Shirley Sherwood's incomparable collection of contemporary botanical art, highlight an artistic practice that infuses accuracy with artistry, and deep love of plants, to create new works that rank with the greatest of the eighteenth and nineteenth century: works that will stand the test of time. In the twenty-first century, contemporary botanical art is bursting with creativity, flourishing globally, and imbued with exciting possibilities for the future.

The astonishing renaissance in the practice of botanical art is only a few decades old. There was no sign of it when Blunt surveyed the field in the 1950s. Through her collecting and through the many exhibits that she has curated, Dr Shirley Sherwood has played a pivotal role in triggering, energising and influencing this remarkable transition. She has been the greatest patron of contemporary botanical art and she has been unfailing in her support and encouragement of countless artists. In 1990, when Dr Sherwood began to develop her pre-eminent collection, the number of really good botanical artists was less than a hundred, and those artists were mainly concentrated in Europe and North America. Today that number is perhaps several thousand, and, as is clear from the different sections of this magnificent book, those artists live and work all over the world. Their passion for plants is also purposeful. Botanical Art Worldwide, a recent global collaboration, synchronised juried exhibits of contemporary botanical art in 25 countries. Each exhibit featured 40 works on native plants, enhancing awareness of plant life and its importance for the future.

The vast range of works in this book show how far the practice of botanical art has come. The diversity of styles and subjects, the range of techniques, and the exuberance of expression reveal a genre that continues to mature, and in which practitioners are comfortable with exploring the blurred line between formal botanical art and the long tradition of flower painting, without ever sacrificing accuracy. Botanical art is alive and well. This book brings together some of the very best.

Sir Peter Crane FRS

Detail from Black-Bird-Berry: *Psychotria capensis* 2016, by Carol Reddick
(see page 190)

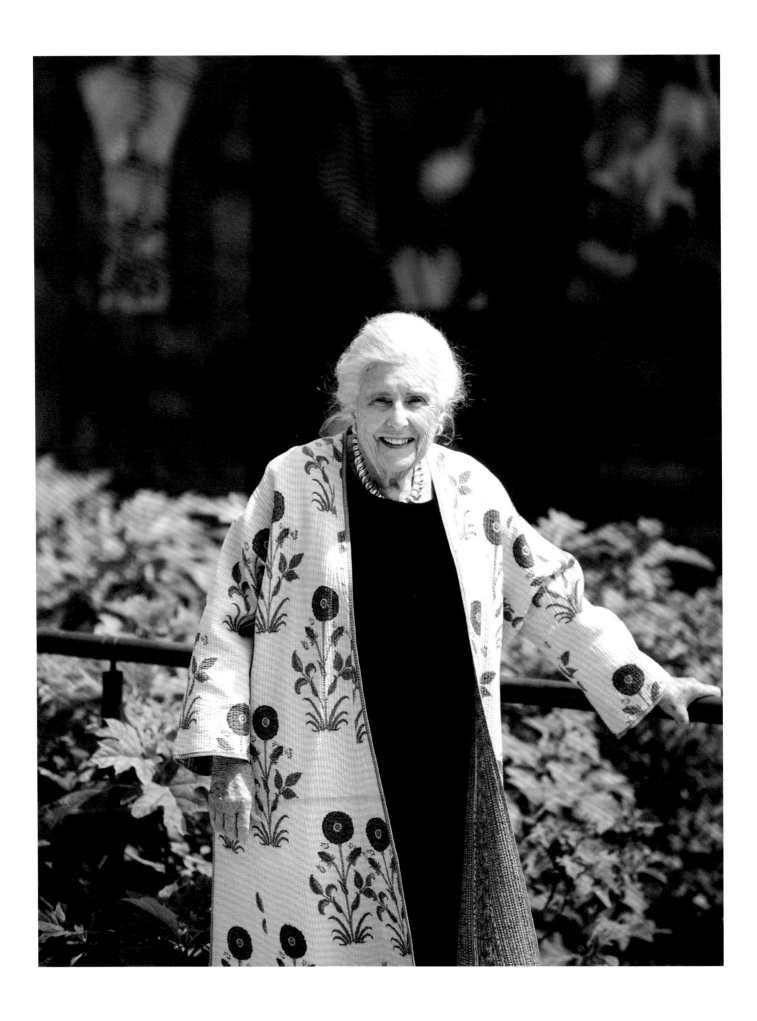

Introduction

Shirley Sherwood

FOR AS LONG as I can remember I have been passionate about the natural world. As a child I was always outside exploring, looking for plants, bird watching or climbing trees. On holidays I was obsessed by flowers glimpsed from the moving car – perhaps it was something new? My mother loved plants too and painted them beautifully (one of her botanical paintings is included here).

Eventually I read botany at Oxford and revelled in the superb collection of historical botanical drawings held in the botany department. Much later I curated an exhibition in the Ashmolean Museum showing a thousand years of botanical art treasures from Oxford alongside contemporary paintings from my collection.

I started collecting at Kew, buying my first painting by Pandora Sellars in 1990, and I became enthused by the excellent work being done there. Now my collection has reached over 1,000 works from 300 artists working in 36 countries. This book is a retrospective sampling from early acquisitions of contemporary botanical paintings starting in the 1990s to more recent works acquired almost up to the book's publication in 2019. I have had to be fiercely selective as it would have been too unwieldy to include all 1,000 plus paintings that now make up my collection, so I had to choose a hardcore of only a quarter of the works with only one or a few works from half of the artists.

In the early 1990s there was no doubt that the focus of botanical art was in the British Isles. There were galleries selling botanical art, some good classes like Anne-Marie Evans at the Chelsea Physic Garden and a ready audience of gardening enthusiasts and nature lovers. London was a hub, not only for British artists but for Australians like Paul Jones, Susannah Blaxill and Margaret Stones, ex-pats like Jessica Tcherepnine and Katherine Manisco, who both lived in the States, and Margaret Mee, who concentrated on the Amazon but showed in the Tryon Galleries in London.

My collection grew, as I added paintings from around the world. I travelled to a range of fascinating places and always looked for local artists. In 1996 I was asked to put on an exhibition at Kew, in Cambridge Cottage, and I wrote my first book on botanical art to act as a catalogue. It was a great success and I decided to arrange a 'World Tour' from the Hunt Institute in Pittsburg, US to Japan, Australia and South Africa. I also organised master classes for over ten years, run by some of the best botanical artists at the same time as the shows. At one stage I put on four exhibitions in one year – I must have been mad! But this new exposure to contemporary botanical art stirred interest, then enthusiasm, followed by societies being formed and exhibitions held in the most encouraging way. My collection has been shown in nine countries since 1996. I had many exhibitions in the States with perhaps the most prestigious being at the Smithsonian's iconic National Museum of Natural History, at the Denver Art Museum and at the Hunt Institute, Pittsburg.

Botanical Art Worldwide Day

This remarkable celebration of botanical art took place on 18th May 2018 as the day dawned in sequence in 25 participating countries around the world, starting with New Zealand and finishing with California. Initiated by the American Society of Botanical Artists (ASBA) several years ago, each participating country selected 40 paintings by local artists of their native plants. All these paintings were scanned and assembled as a digital slide show to be projected around the world in botanical gardens, museums and art galleries. This overwhelming response astonished both organisers and participants and showed that botanical art was flourishing in all sorts of surprising places. It was brilliantly organised by the ASBA. At Kew we had eight demonstrations in the Shirley Sherwood Gallery, several talks and the precious slides projected large in the galleries, appreciated by a thousand visitors who stayed all day.

Styles are changing and the internet is having a profound effect on concepts and techniques. Many artists are painting much larger, magnified works, using different backgrounds, concentrating on a particular tone or colour, widening their horizons in a variety of ways. Vellum is being used as a support by far more artists. Teaching has blossomed with a huge number of classes to choose from. Some have been taught by long-distance learning courses, seeing their tutor only a few times. In this approach the internet plays a big part and has brought new artists forward most successfully. Anxiety about climate change has encouraged artists to focus on native plants which may be challenged by change in water supply, temperature and destruction of their habitats.

www.shirleysherwood.com

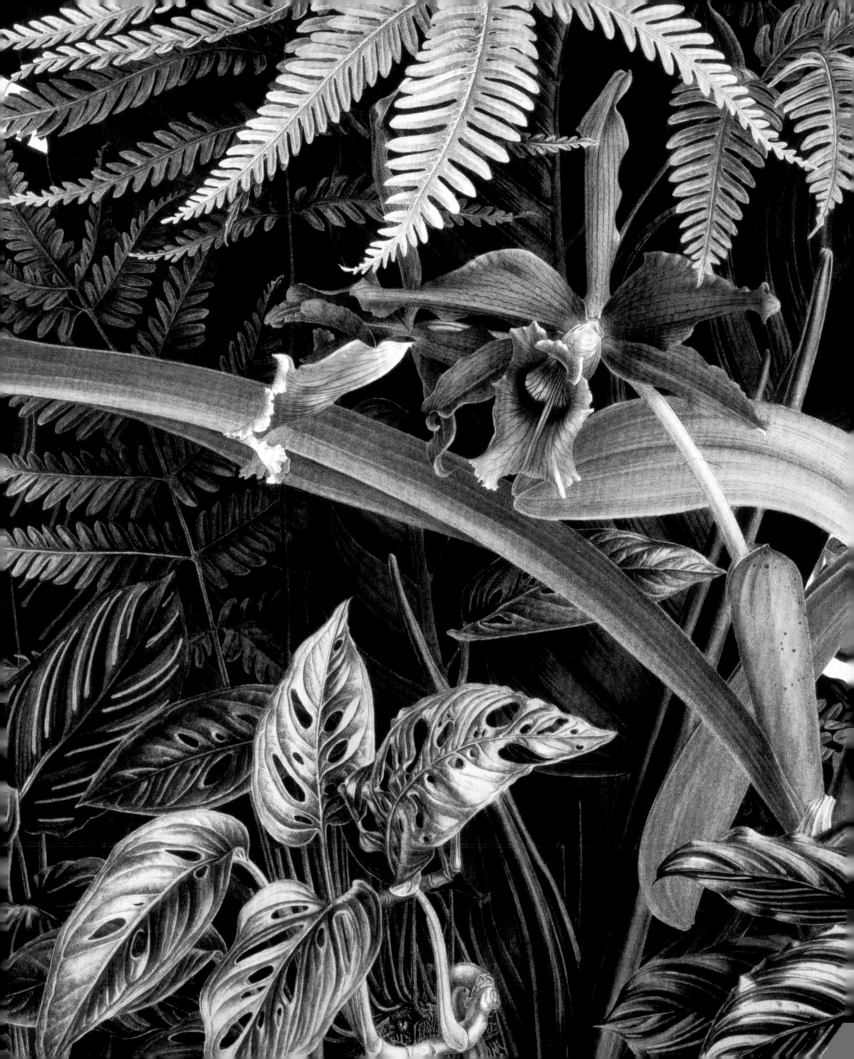

British Isles

British Isles

WHY ARE THERE so many artists from the British Isles in my collection of botanical art? The answer is that there were quite simply more botanical artists in Britain in the 1990s than anywhere else, as botanical art has been such a tradition in Britain. Secondly, although I have travelled widely, I still spend a lot of my time divided between London and Oxfordshire and so see more exhibitions and know more artists here than from anywhere else, especially recently through the Shirley Sherwood Gallery and the internet.

The British artists I collected early were Brigid Edwards, Mary Grierson, Margaret Mee and Rory McEwen. I commissioned Pandora Sellars, Annie Farrer, Sue Herbert, Josephine Hague and Coral Guest, usually to paint plants from my garden or seen on my travels. Many paintings were acquired from the Kew Gardens Gallery, often drawn by Kew's freelance artists.

In the 1990s Kew was putting on some excellent exhibitions by contemporary botanical artists and this is where I acquired a number of works from Brigid Edwards and Pandora Sellars. The shows were held in Cambridge Cottage, and were curated by Brinsley Burbidge and Laura Guiffrida. This was where I bought my first botanical painting by Pandora Sellars, not realising that it was going to trigger a collecting passion that has lasted for 30 years and taken me on 'missions' all over the world. At the time, botanical illustrators could be rather solitary figures at the back of the herbarium, not particularly regarded by the botanists who needed them to illustrate their scientific papers – but I was blown away by the quality of the work I found.

The Royal Horticultural Society (RHS) has been very important as it organised painting displays of eight works per artist which were held three or four times a year at meetings in the Horticultural Halls, Vincent Square, London. Now only six works are needed and sadly there are fewer shows each year. The paintings are evaluated for medals from bronze to silver, silver gilt and gold. They are usually judged in London and can be seen by the public for a couple of days. I have been on the judging committee for many years and I particularly encouraged artists from overseas to apply when I realised how many talented artists there were elsewhere in the world. It was valuable too for the judges to see the high standards being reached especially by Japanese, Brazilian, South African and Australasian artists. It has been very satisfying to see how improved the entries have been in recent years.

A next big step forward was the building of the Shirley Sherwood Gallery by my family. It opened in the Royal Botanic Gardens, Kew in 2008, and stands next to the Marianne North Gallery. Since then there have been over 50 exhibitions, always with some contributions from my collection and Kew's Archives. I had been commissioning and acquiring paintings since 1990 and by 2018 had more than a thousand works from artists working all over the world. Another milestone was that by 2018 we counted over one million visitors to the Shirley Sherwood Gallery. It has become the central focus of botanical art in the world today and the footfall has increased dramatically.

Gillian Barlow
Artichoke Seed Head: *Cynara cardunculus* 2001
Watercolour on vellum 230 x 152 mm
From Newhouse Galleries, New York 2002
[Shirley Sherwood Collection 468]

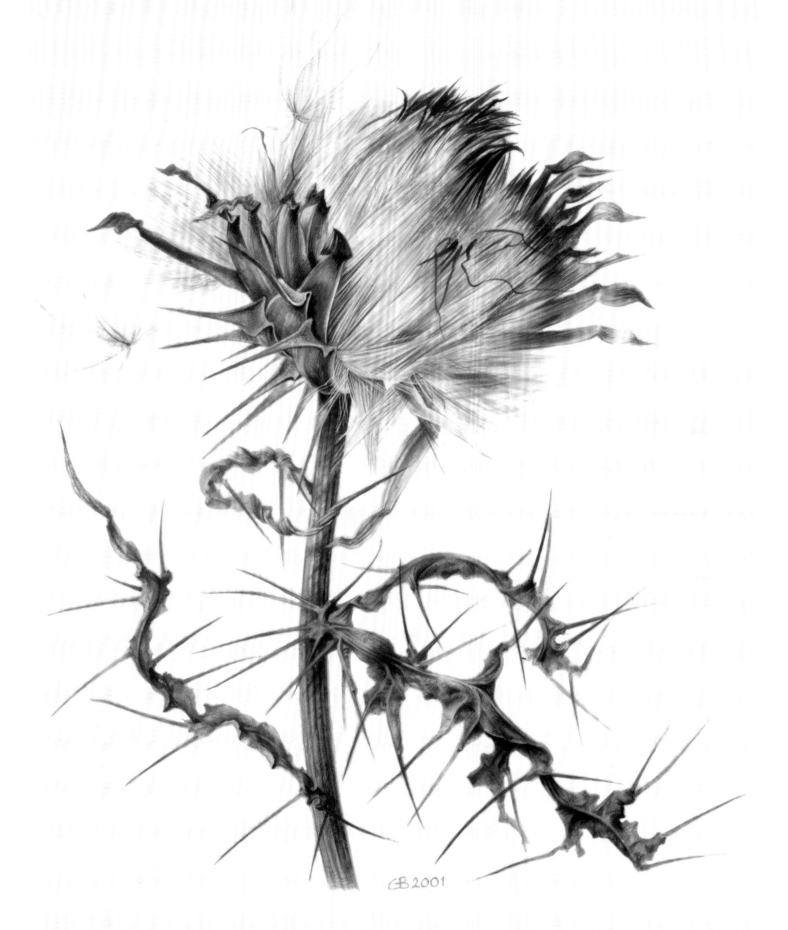

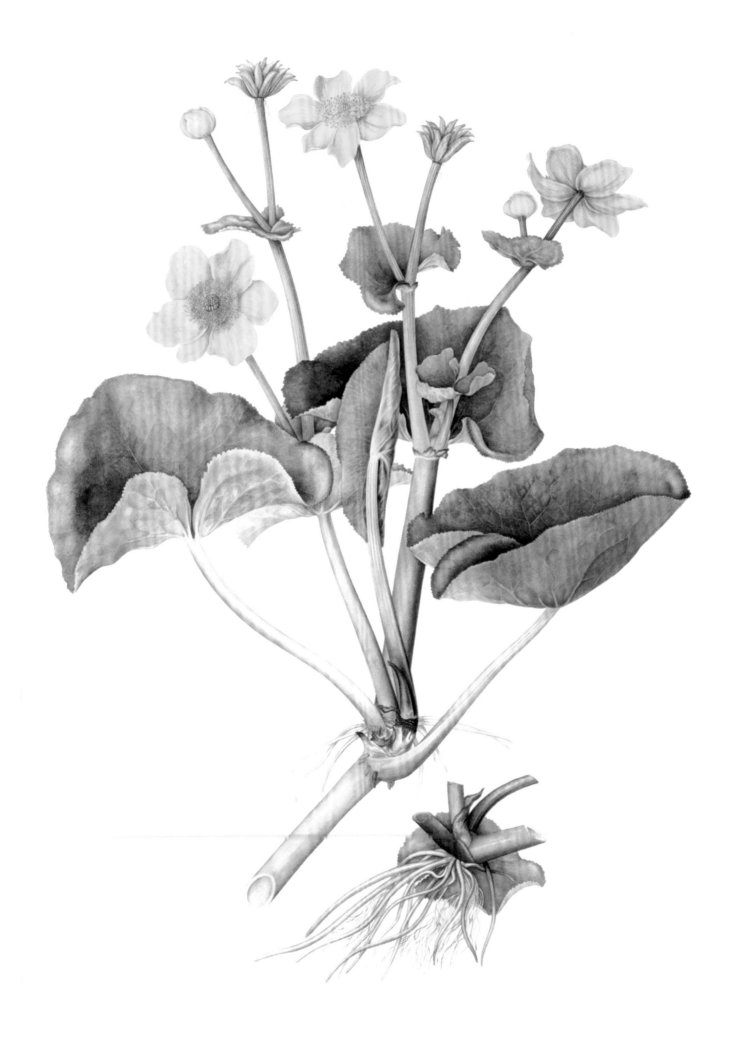

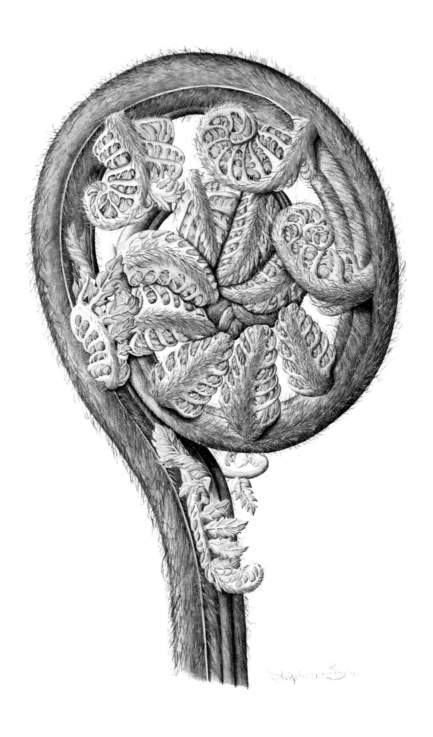

Gillian Barlow
Kingcup: *Caltha palustris* **1994**
Watercolour on paper 550 x 370 mm
From the SBA 1995, where she was awarded Best in Show.
[Shirley Sherwood Collection 217]
←

Stephanie Berni
Australian Tree Fern: *Balantium antarcticum* **2004**
Watercolour over pencil on paper 290 x 200 mm
From Ebury Galleries 2004
[Shirley Sherwood Collection 556]

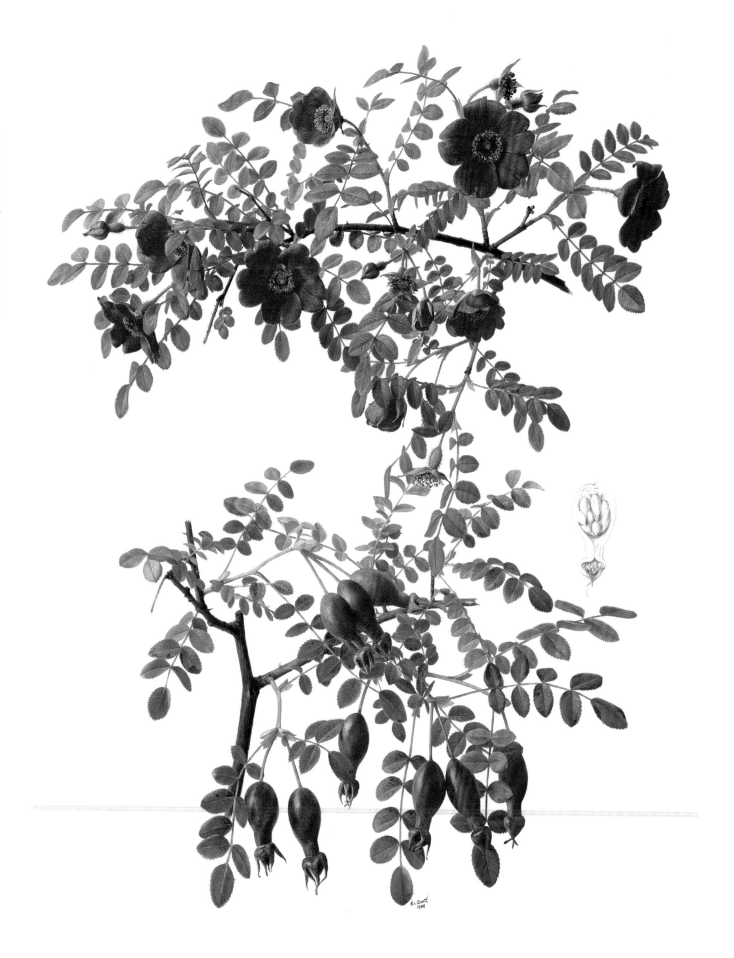

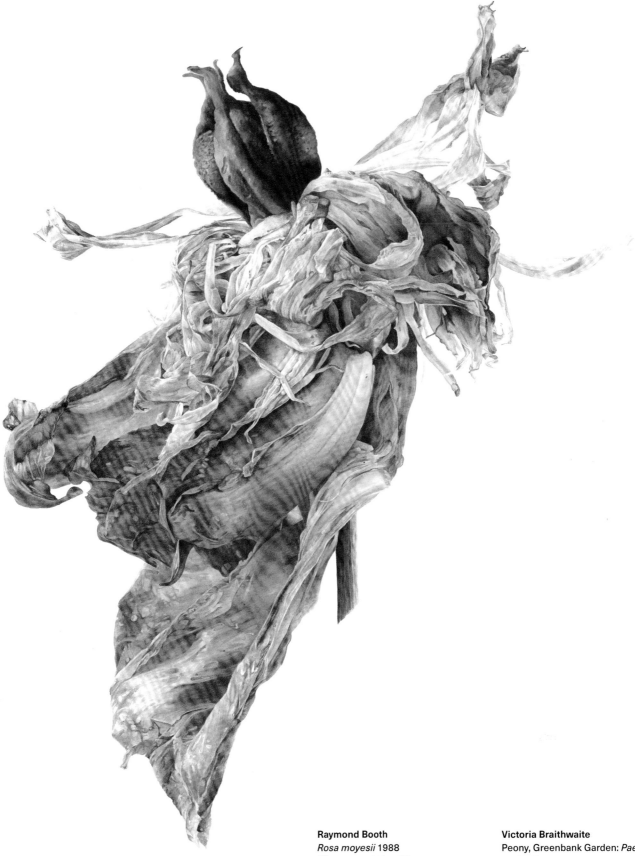

Raymond Booth
Rosa moyesii 1988
Oil on paper 610 x 430 mm
From Fine Art Society 1991
Booth was unusual in using oil paint on prepared paper.
[Shirley Sherwood Collection 016]
←

Victoria Braithwaite
Peony, Greenbank Garden: *Paeonia* sp. 2018
Watercolour on paper 850 x 760 mm
From the artist 2018
[Shirley Sherwood Collection 999]

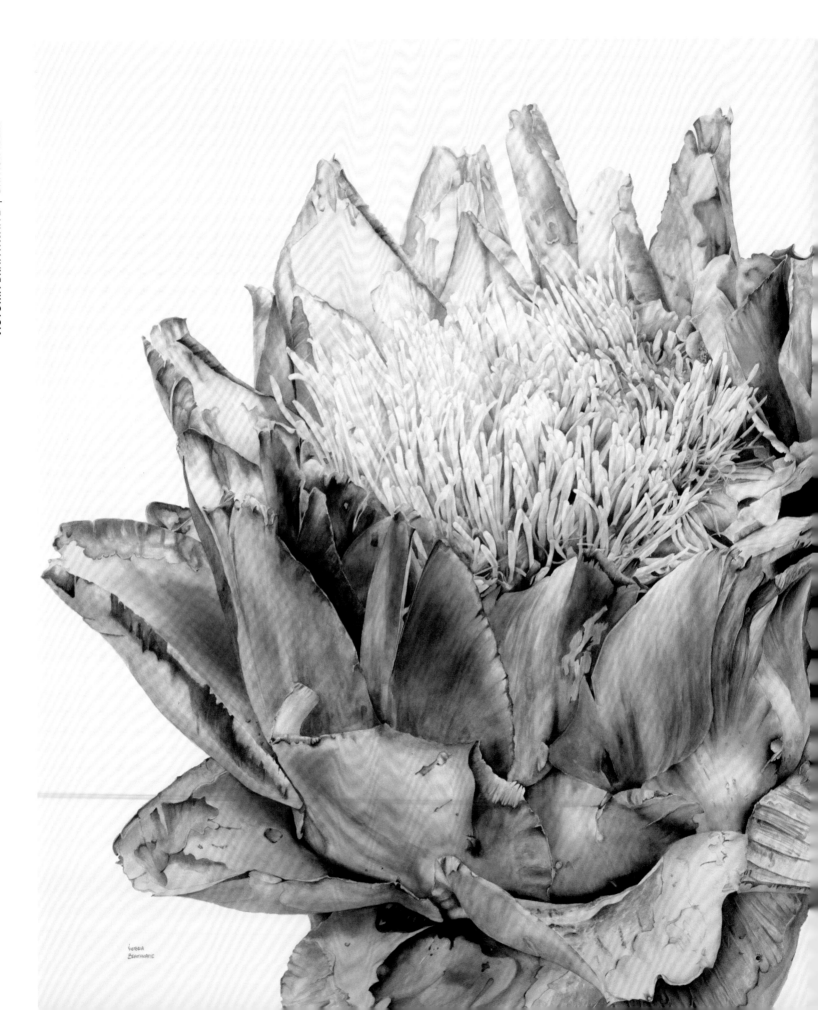

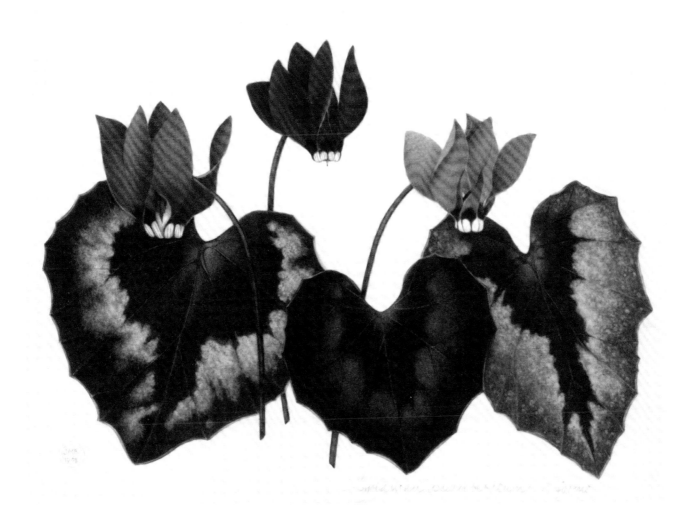

Victoria Braithwaite
Globe Artichoke 'Lindisfarne Castle':
Cynara cardunculus 2013
Watercolour on paper 640 x 530 mm
From the SBA Show 2014
[Shirley Sherwood Collection 874]
←

Jenny Brasier
Cyclamen pseudibericum 1993
Watercolour on McEwen's vellum 90 x 125 mm
From the artist 1994
The artist was given vellum that had belonged to Rory McEwen.
[Shirley Sherwood Collection 170]

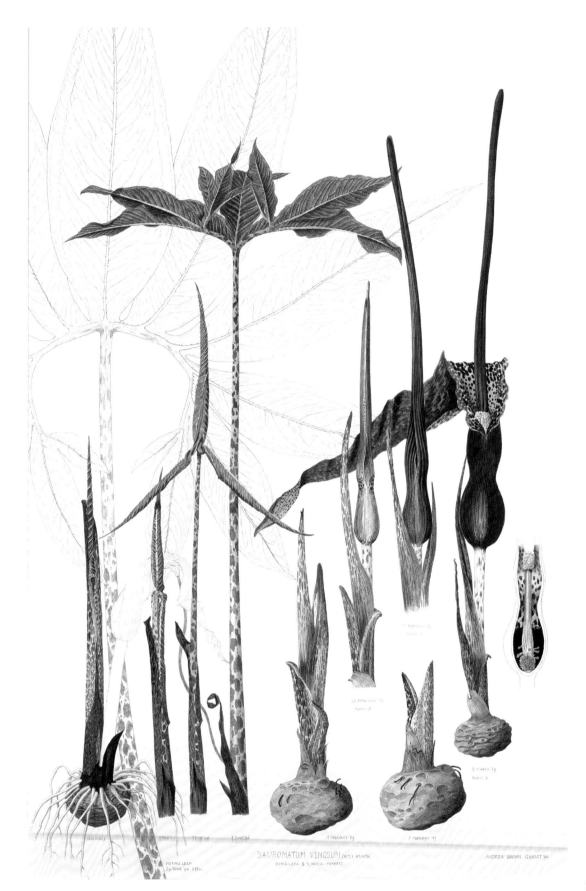

Andrew Brown
Voodoo Lily: *Sauromatum venosum*
1994
Pencil & watercolour on paper 680 x 450 mm
Showing the flowering sequence. This work took two years to complete as it was difficult to grow.
[Shirley Sherwood Collection 186]

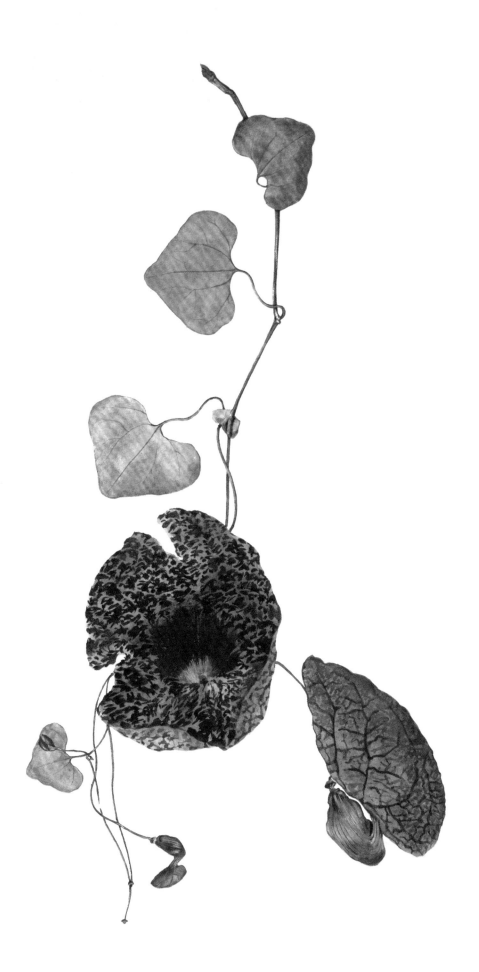

Norah Briggs
Aristolochia sp. 1949
Watercolour on paper 430 x 240 mm
Norah Briggs was Shirley Sherwood's mother. Painted from a dried specimen collected from the Himalaya, North West Frontier Province, Pakistan by Shirley Briggs in 1948.
[Shirley Sherwood Collection 914]

Susan Christopher-Coulson
The Winter Garden, Scented Sprigs
and Feisty Flowers 2014
Coloured pencil on paper 395 x 395 mm
From the SBA Show 2014
[Shirley Sherwood Collection 873]

Pauline Dean
Jade Vine: *Strongylodon macrobotrys*
2001
Watercolour on paper 680 x 465 mm
From the artist 2004
A wonderful climber from the Philippines.
[Shirley Sherwood Collection 574]
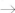

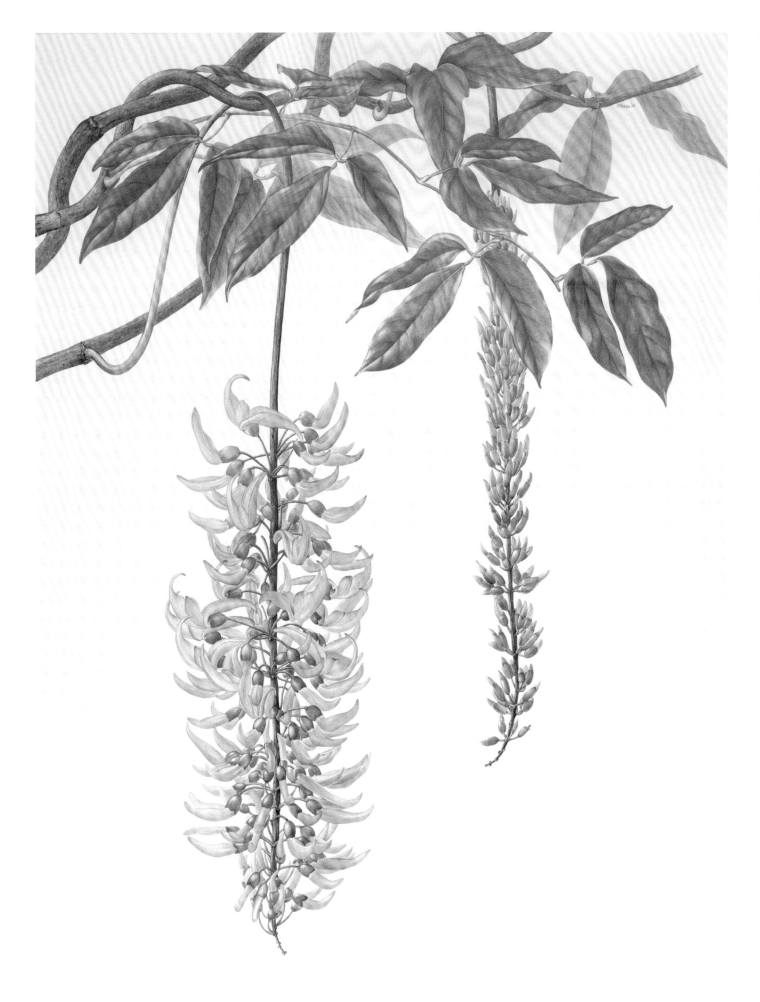

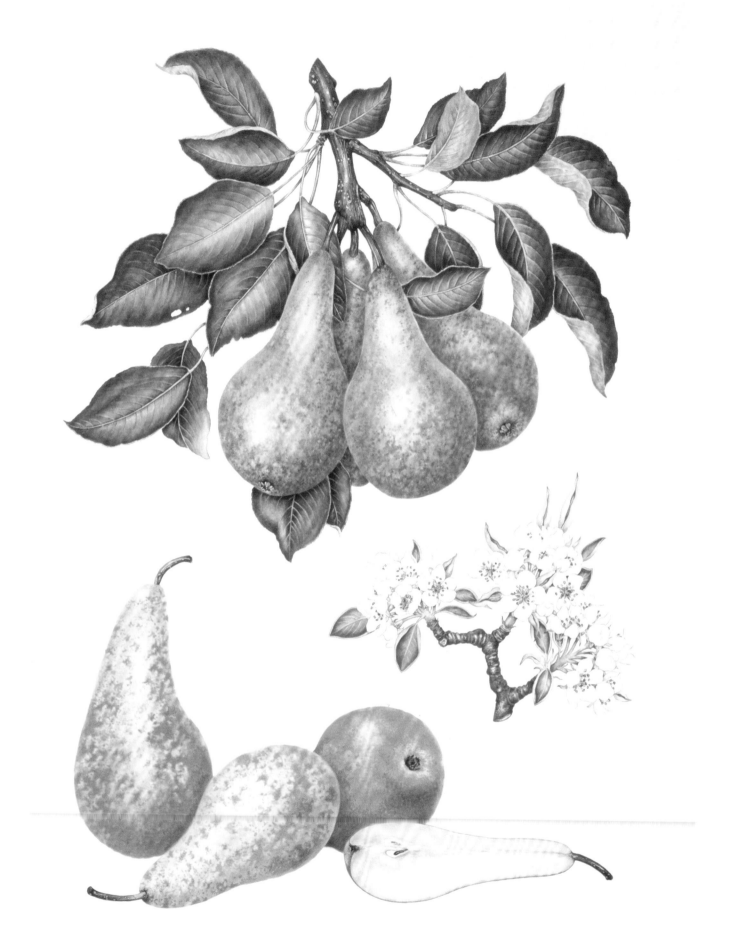

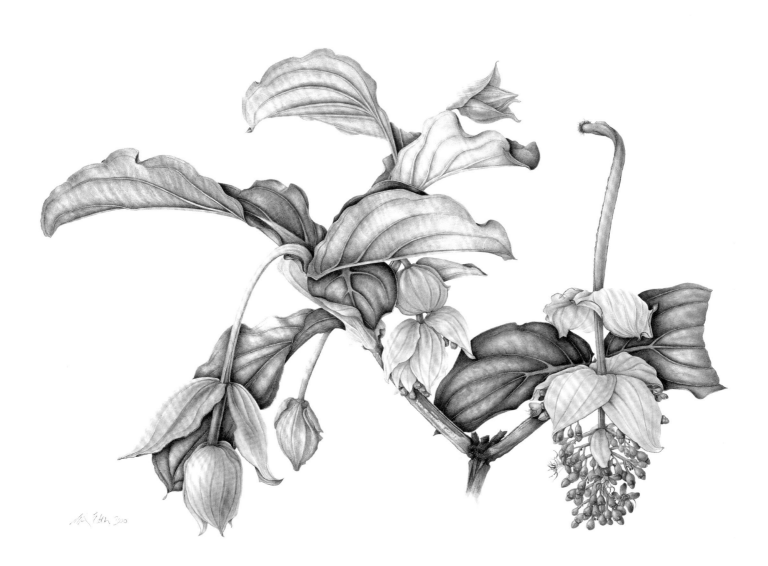

Elisabeth Dowle
Pear 'Conference' 1991
Watercolour on paper 435 x 320 mm
From the artist 1996
On the cover of *The Book of Pears* by Joan Morgan, illustrated by Elisabeth Dowle.
[Shirley Sherwood Collection 271]
←

Margaret Ann Eden
Medinilla magnifica **2000**
Watercolour on paper 560 x 750 mm
From Hortus Gallery 2000
[Shirley Sherwood Collection 412]

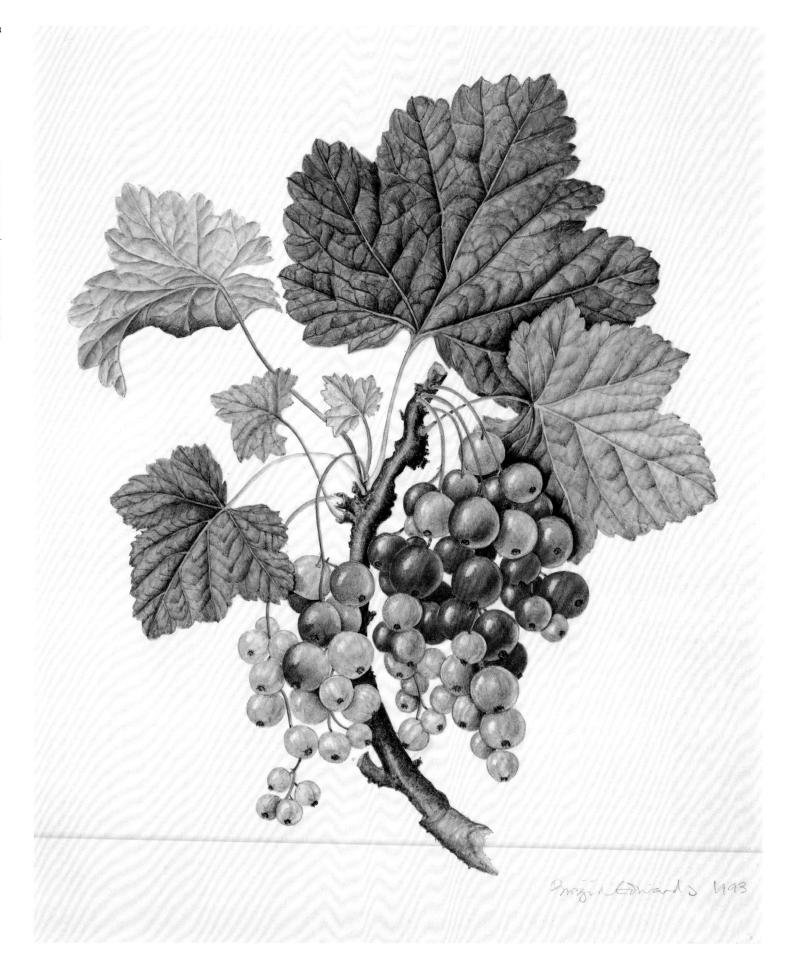

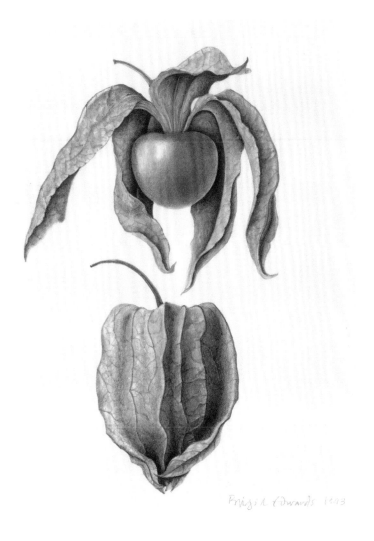

Brigid Edwards
Redcurrants: *Ribes rubrum* 1993
Watercolour over pencil on vellum
200 x 165 mm
From Kew Gardens Gallery 1994
[Shirley Sherwood Collection 138]
←

Brigid Edwards
Cape Gooseberry: *Physalis peruviana* 1993
Watercolour on vellum 190 x 125 mm
From Kew Gardens Gallery 1994
Originates in Peru and Chile.
[Shirley Sherwood Collection 139]

Brigid Edwards
Douglas Fir: *Pseudotsuga menziesii* 1993
Watercolour over pencil on vellum
250 x 180 mm
From Kew Gardens Gallery 1994
Native to western North America.
[Shirley Sherwood Collection 140]

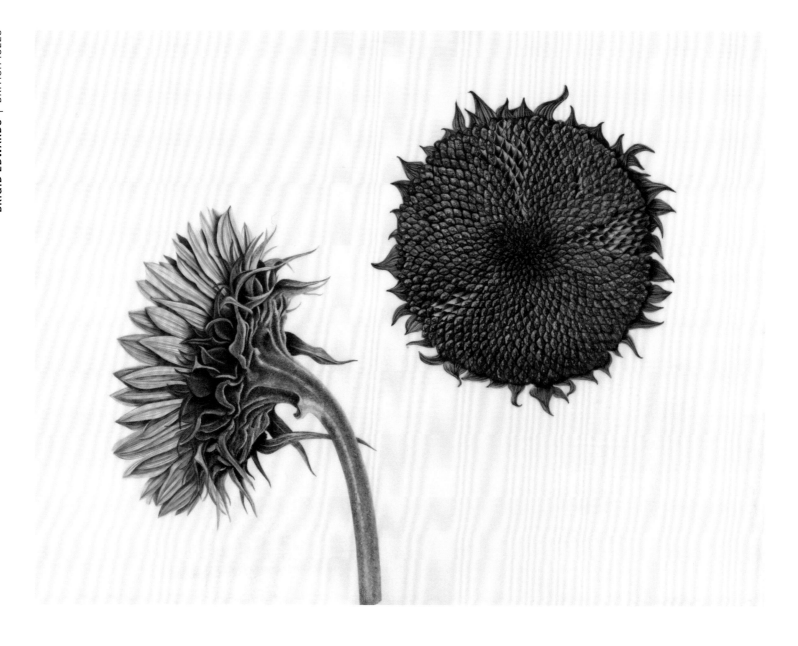

Brigid Edwards
Sunflower: *Helianthus annuus* 2015
Watercolour over pencil on vellum
406 x 533 mm
From Thomas Gibson Fine Art Ltd 2016
The heavy seed head falls to the ground, where it may be eaten by caching rodents and birds or dispersed by floating on surface water.
A recent painting, after a prolonged period away from botanical subjects.
[Shirley Sherwood Collection 961]

Annie Farrer
Cedar of Lebanon: *Cedrus libani*
1991/92
Watercolour on paper 550 x 680 mm
Commissioned 1991
A branch from a tree in the Sherwood garden.
[Shirley Sherwood Collection 044]
→

Annie Farrer
Courgette tendrils II: *Cucurbita pepo*
2002
Watercolour on paper 285 x 400 mm
From Hortus Gallery 2002
Reproduced in *Plant* published by
Phaidon, 2016.
[Shirley Sherwood Collection 463]
←

Annie Farrer
Grass and Moss Clump 2008
Watercolour on paper 440 x 660 mm
From the artist 2008
[Shirley Sherwood Collection 686]

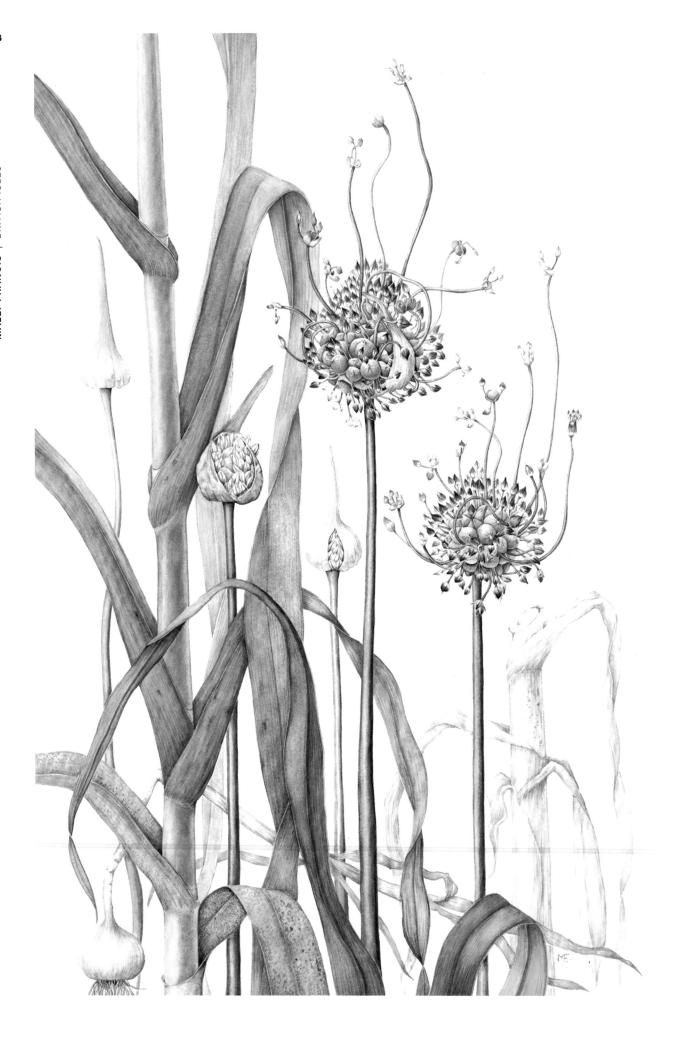

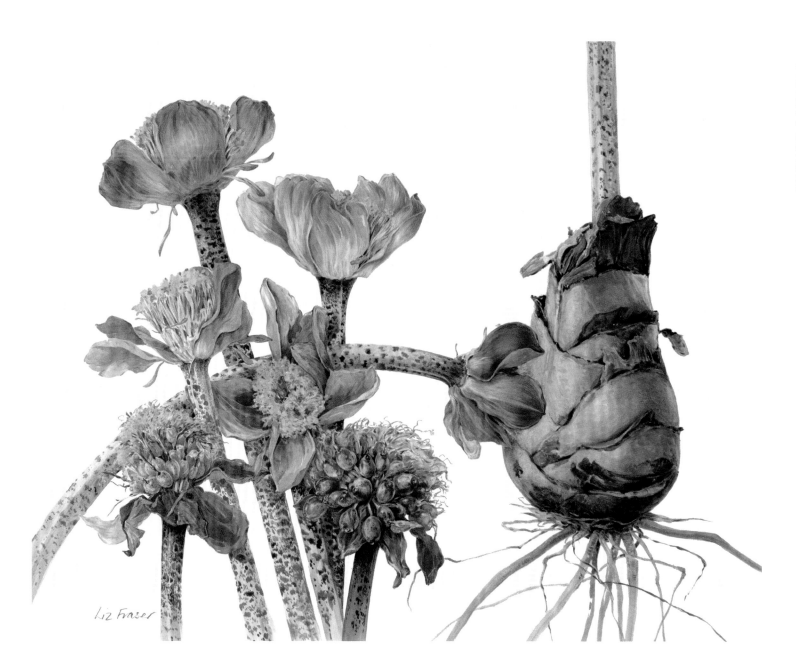

Mally Francis
The Babington's Leek: *Allium ampeloprasum* var. *babingtonii* **2017**
Watercolour on paper 450 x 300 mm
From the ABBA 2018
Front cover for the ABBA leaflet for Botanical Art Worldwide Day, 2018. Displayed at the RHS show 2018.
[Shirley Sherwood Collection 996]
←

Liz Fraser
Haemanthus coccineus **1996**
Acrylic on paper 360 x 458 mm
From the artist 2008
Used as an illustration for *The Smallest Kingdom: Plants and Plant Collectors at the Cape of Good Hope* by Mike Fraser and Liz Fraser, 2008.
[Shirley Sherwood Collection 800]

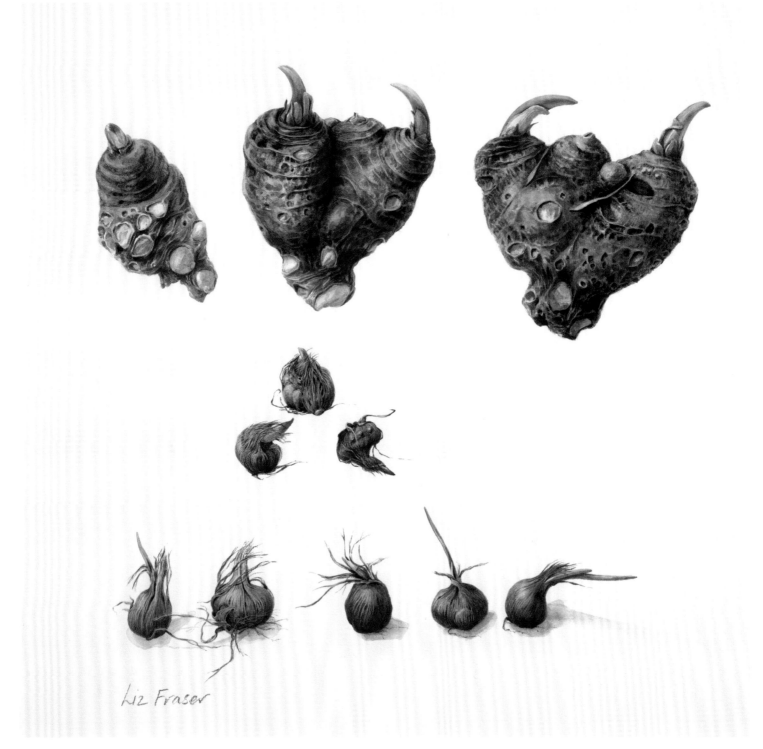

Liz Fraser
Baboon Flower: *Babiana stricta* 'Ixia'
Gold arum lily bulbs 2007
Acrylic on paper 350 x 365 mm
From the artist 2008
Used as an illustration for *The Smallest Kingdom: Plants and Plant Collectors at the Cape of Good Hope* by Mike Fraser and Liz Fraser, 2008.
[Shirley Sherwood Collection 802]

Sarah Graham
'Big Fir': Magnified cone of
Leucadendron strobilinum 2008
Pastel on paper 1430 x 1220 mm
From Sims Reed Gallery, London 2008
Sarah Graham collected this small cone (about 3 cm long) on the top of Table Mountain. The enlarged drawing was sufficiently well observed to be identified from herbarium specimens in Kirstenbosch Botanical Gardens, South Africa.
[Shirley Sherwood Collection 701]
→

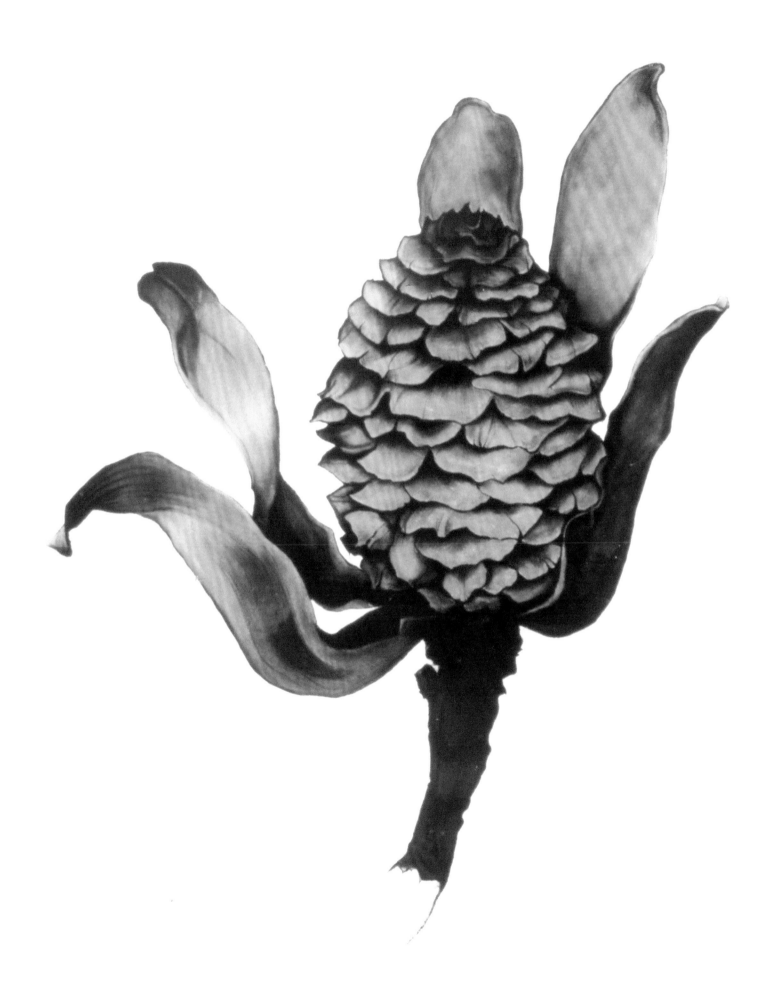

Mary Grierson
Yellow Water Lily
Watercolour on paper 260 x 340 mm
From Spink 1990
[Shirley Sherwood Collection 004]

Coral Guest
Lilium longiflorum 'Ice Queen' 1995
Watercolour on paper 760 x 570 mm
Commissioned in 1995
[Shirley Sherwood Collection 224]
→

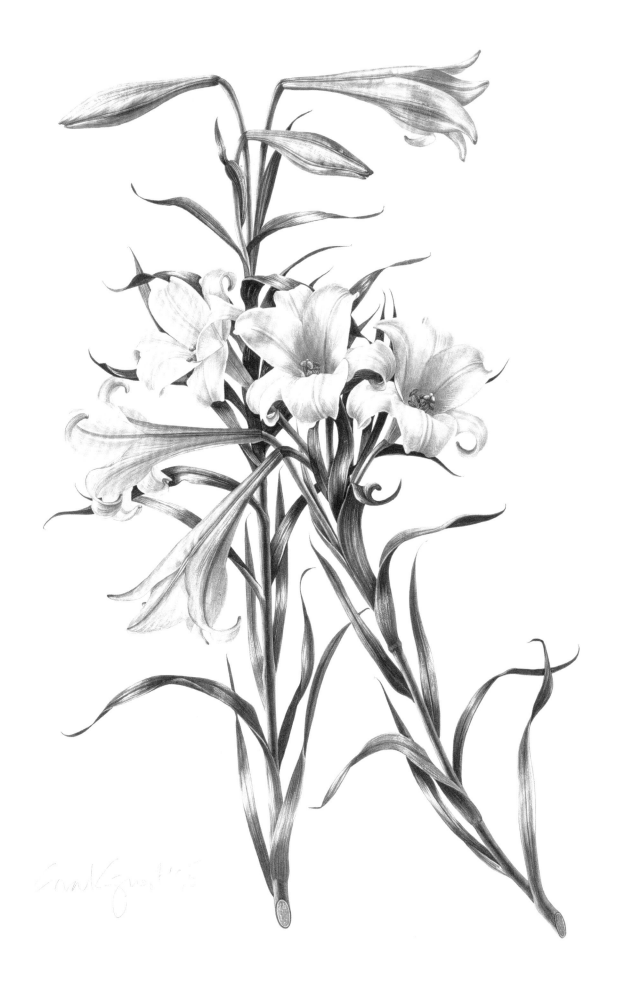

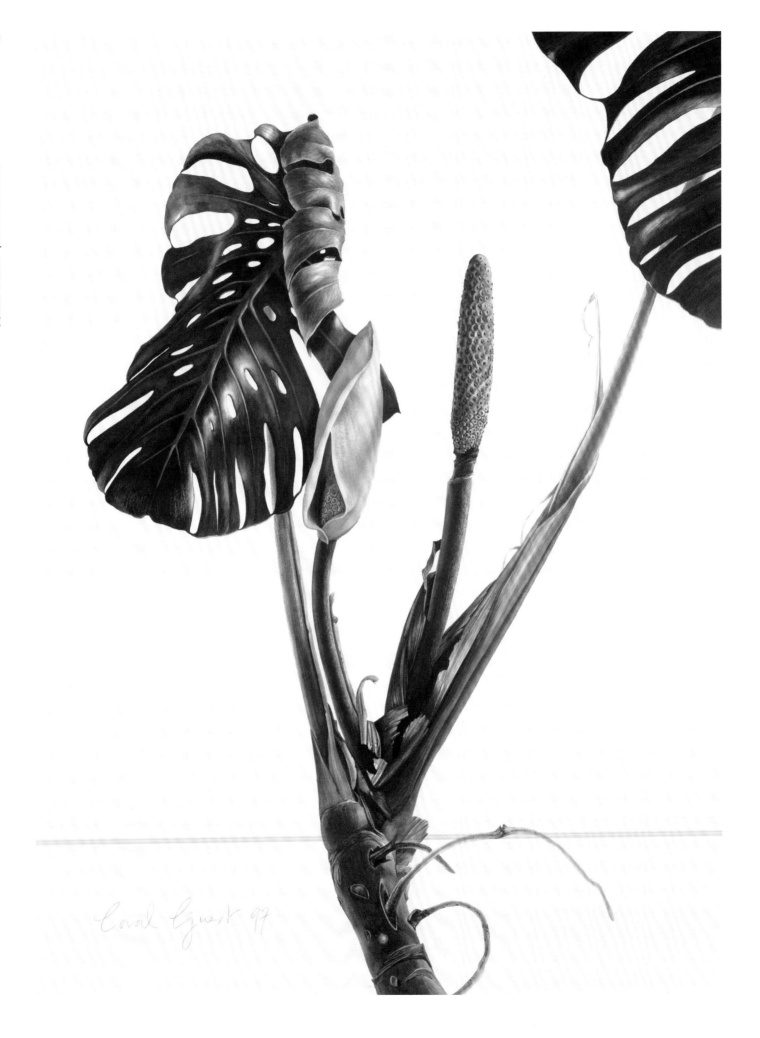

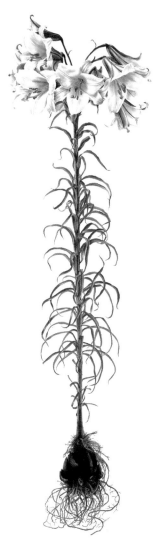
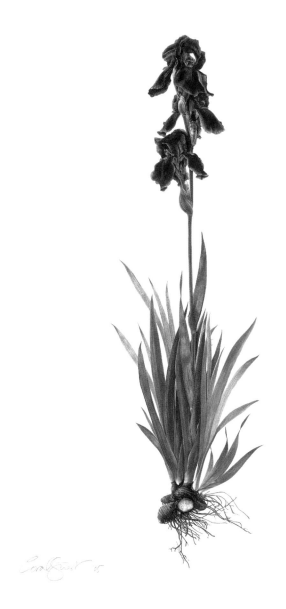

Coral Guest
Monstera deliciosa 1997
Watercolour on paper 750 x 550 mm
Commissioned 1997
Painted from *Monstera deliciosa* grown by Dr Sherwood.
[Shirley Sherwood Collection 313]
←

Coral Guest
Lilium regale 2007
Acrylic on traditional white cold-pressed paper 640 gsm 1510 x 1025 mm
Commissioned 2007
The heavy paper was burnished with an etching tool to smooth the surface on the areas intended for fine detail. In this way it was possible to paint the lily full size on a single thick sheet of 'rough' paper, yet still achieve detailed results.
[Shirley Sherwood Collection 683]

Coral Guest
Iris 'Superstition' 2005
Watercolour on paper 1525 x 1025 mm
Commissioned 2005 after being seen at Chelsea Flower Show and grown by the artist. Coral Guest was able to paint this life-sized study on paper from T.H. Saunders. The new Traditional White, cold-pressed paper of 640 gsm weight did not buckle when used as large as 1524 x 1016 mm.
She was inspired by Albrecht Dürer's painting of *Iris trojana* in 1503. His life-sized iris was on two pieces of paper 775 x 313 mm and it is now in the Kunsthalle, Bremen.
[Shirley Sherwood Collection 619]

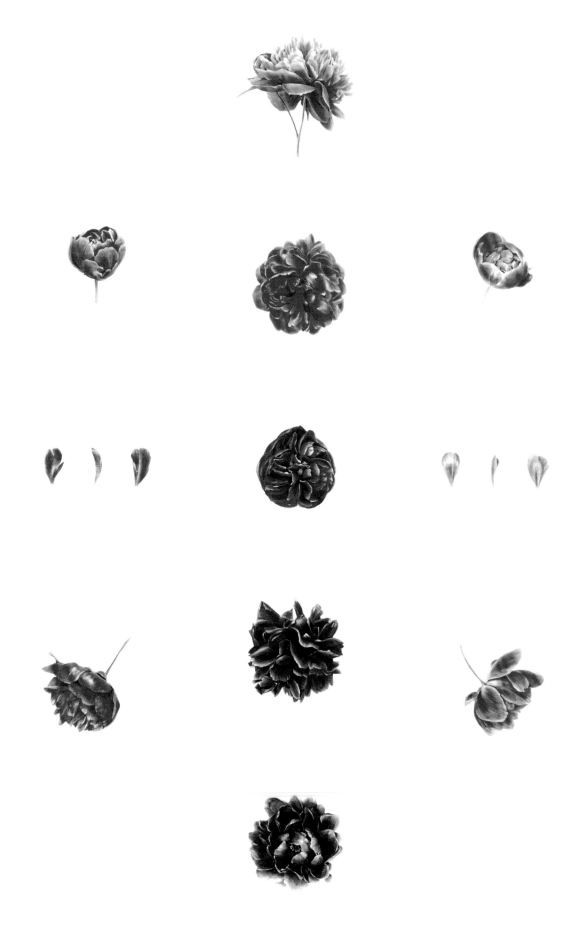

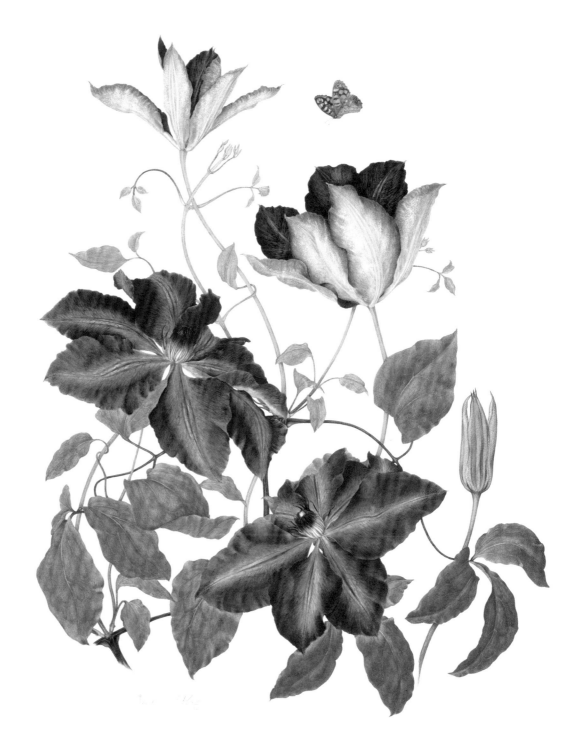

Coral Guest
The Phenology Cabinet of the Incandescent Petal
Magenta Cultivars Series I of *Paeonia lactiflora* **from 19th Century France**
2006–2014
Acrylic on canvas 1530 x 1020 mm
Gift from the artist after an exhibition at Jonathan Cooper Gallery 2014
Painted seasonally from observation, each June/July from 2006 to 2014, the work represents a total of eleven cultivars of *Paeonia lactiflora* that are all part of the magenta colour sphere. Magenta is a mixture of red and violet/blue light. The work is a visual chart of Coral Guest's own phenological data that has been accumulated over 9 years and is a chronicle of the yearly first flowering of the French heritage peonies in her personal collection. Each cultivar is painted at its point of perfection and optimum growth. Each bloom is a result of the specific year in which it was painted and the work includes the weathering effects of that year, such as the influence from frost, rain and hail, sun blanching and early petal fall.
[Shirley Sherwood Collection 915G]
←

Josephine Hague
Clematis 'Elsa Spath'
Watercolour on paper 480 x 380 mm
Commissioned 1991
Painted from a plant in the Sherwood garden.
[Shirley Sherwood Collection 036]

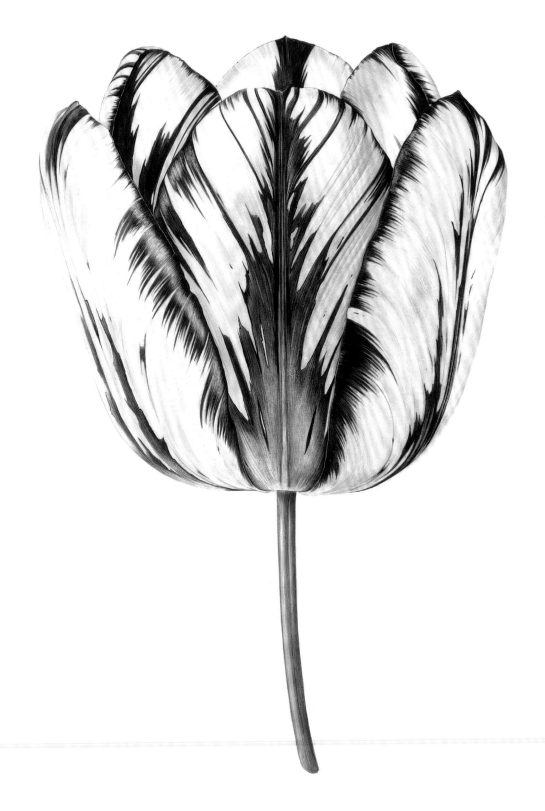

Celia Hegedüs
Tulipa 'Rory McEwen'
Watercolour on vellum 508 x 458 mm
From Offer Waterman 2006
[Shirley Sherwood Collection 638]

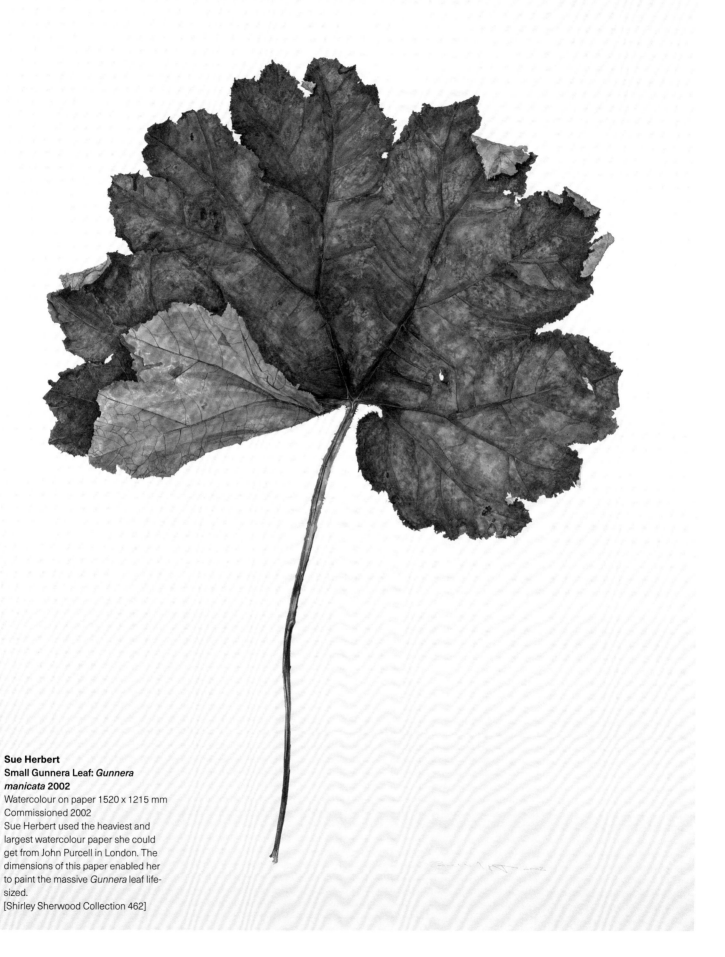

Sue Herbert
Small Gunnera Leaf: *Gunnera manicata* **2002**
Watercolour on paper 1520 x 1215 mm
Commissioned 2002
Sue Herbert used the heaviest and largest watercolour paper she could get from John Purcell in London. The dimensions of this paper enabled her to paint the massive *Gunnera* leaf life-sized.
[Shirley Sherwood Collection 462]

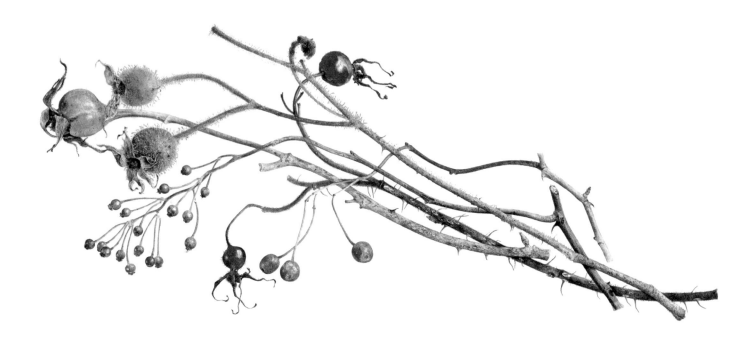

Helga Hislop
Rose Hips
Watercolour on vellum 250 x 340 mm
From the artist 1994
This is a quiet study on vellum, a substrate favoured by the artist.
[Shirley Sherwood Collection 202]

Rebecca John
Lichens on Rowan (magnified) 1998
Watercolour over pencil on paper
275 x 185 mm
From Lefevre Gallery 1999
[Shirley Sherwood Collection 360]
→

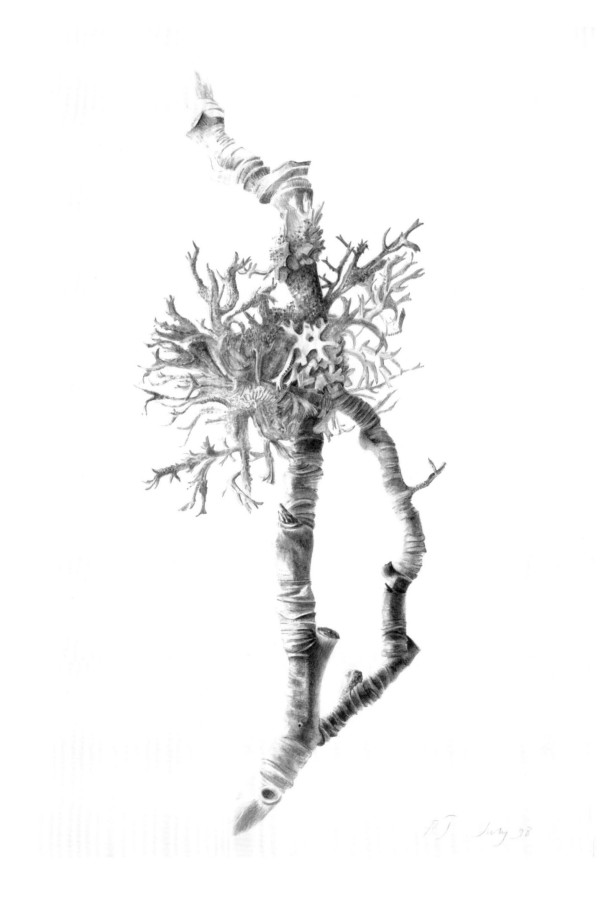

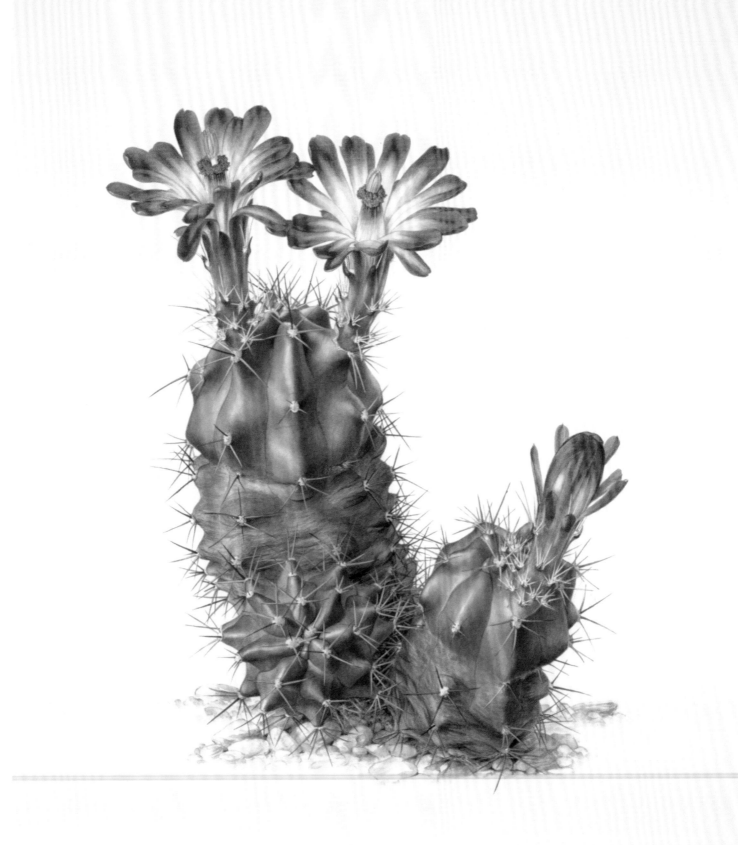

Christabel King
Echinocereus triglochidiatus var. *paucispinus* **1998**
Watercolour and gouache 290 x 225 mm
From Tryon & Swann Gallery 1998
Christabel King has worked at Kew for over 40 years. Many of her studies appear in *Curtis's Botanical Magazine* and have been hung in exhibitions at Kew. She has taught in the Margaret Mee Fellowship Programme at Kew.
[Shirley Sherwood Collection 343]

Rory McEwen
Upper Club, Eton 1979
Watercolour on vellum 340 x 295 mm
Acquired 2012
[Shirley Sherwood Collection 837]

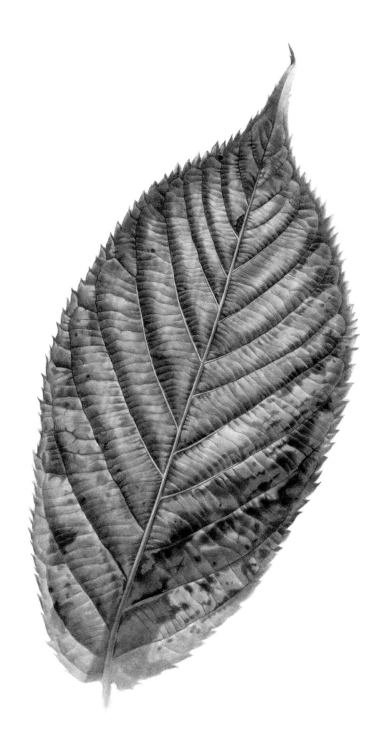

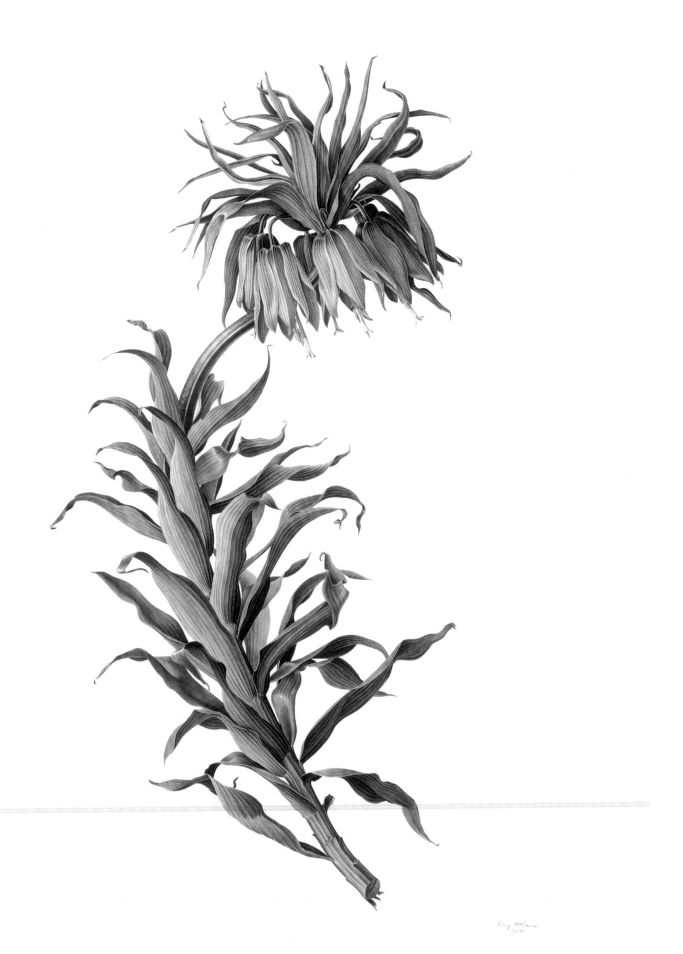

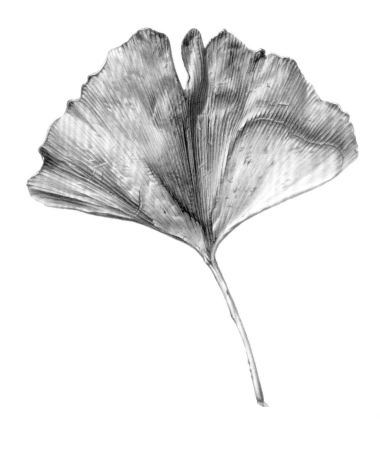

Rory McEwen
Crown Imperial: *Fritillaria imperialis*
1965
Watercolour on vellum 780 x 565 mm
Acquired 1995
[Shirley Sherwood Collection 242]
←

Rory McEwen
Ginkgo Leaf East 61 Street New York
1980
Watercolour on vellum 190 x 230 mm
From Offer Waterman 2000
McEwen did a series of leaves, magnified like this ginkgo, named from where he found them.
[Shirley Sherwood Collection 405]

Rory McEwen,
Old Fashioned Rose, Beech Mast and Clover 1974
Watercolour on vellum 545 x 695 mm
Acquired from the McEwen Estate 1995
Rory McEwen led the way, with an approach and technique which inspired many of today's artists, some of whom were encouraged to use vellum, his favourite substrate.
[Shirley Sherwood Collection 238]

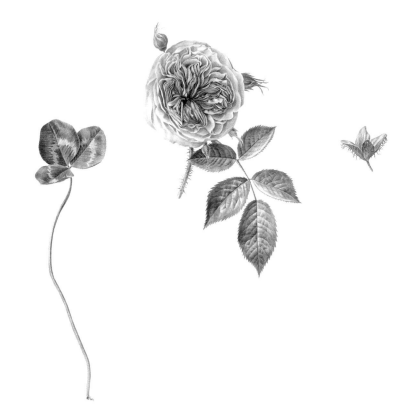

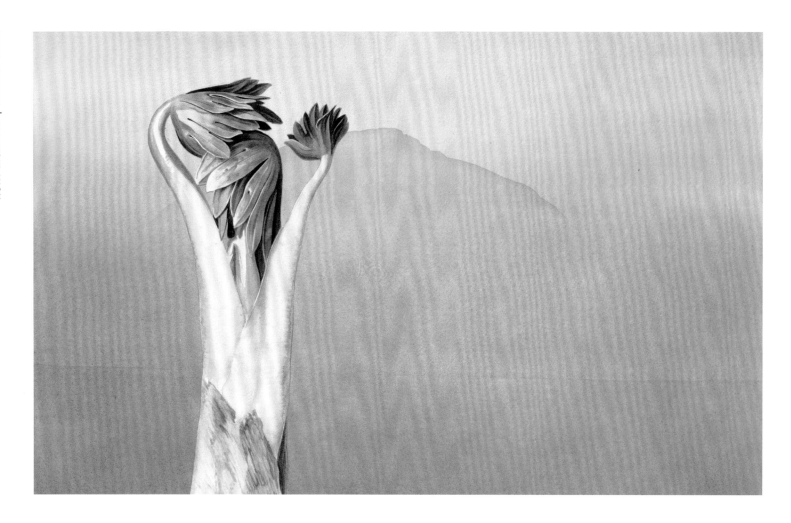

Rory McEwen
Aconitum, Monk's Hood with Ailsa Craig II; 'Homage to Karl Blossfeldt' no. 5 1977
Watercolour on paper 310 x 450 mm
Acquired 2003
McEwen did a series of paintings based on black and white photographs taken by Blossfeldt in the late 1920s, of plant subjects magnified for teaching.
[Shirley Sherwood Collection 489]

Robert McNeill
Seed Pod of Great Himalayan Lily: *Cardiocrinum giganteum* 2017
Watercolour on paper, magnified x 9
750 x 560 mm
From the artist 2017
Wind dispersal from a large toothed seed pod.
[Shirley Sherwood Collection 962]
→

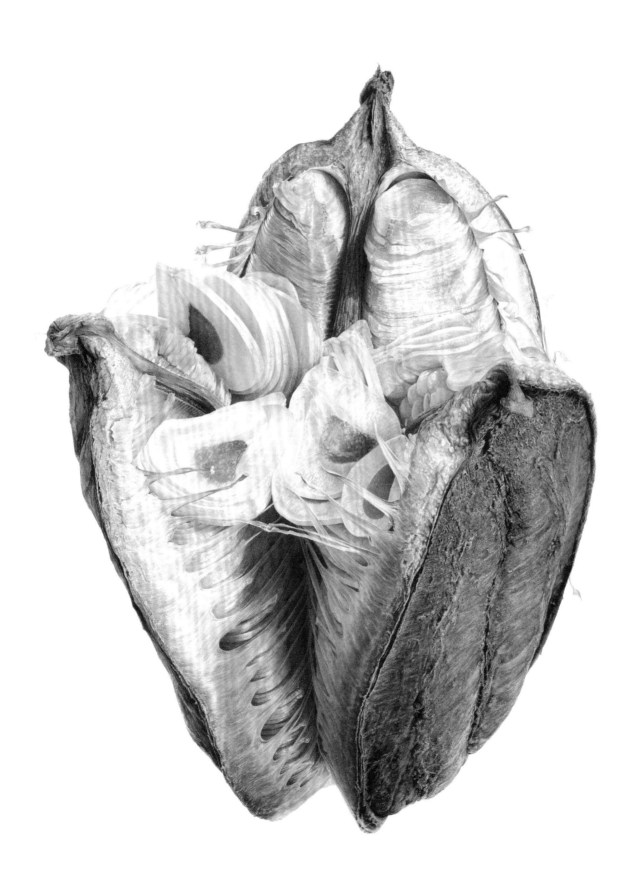

Catharine Nicholson
After the storm 2009
Giclee print pen and ink on paper 785 x 1230 mm
From the artist's estate 2012
Catharine Nicholson had an intensive commune with nature and a very special, detailed approach to the environment with every twig measured meticulously.
[Shirley Sherwood Collection 839]

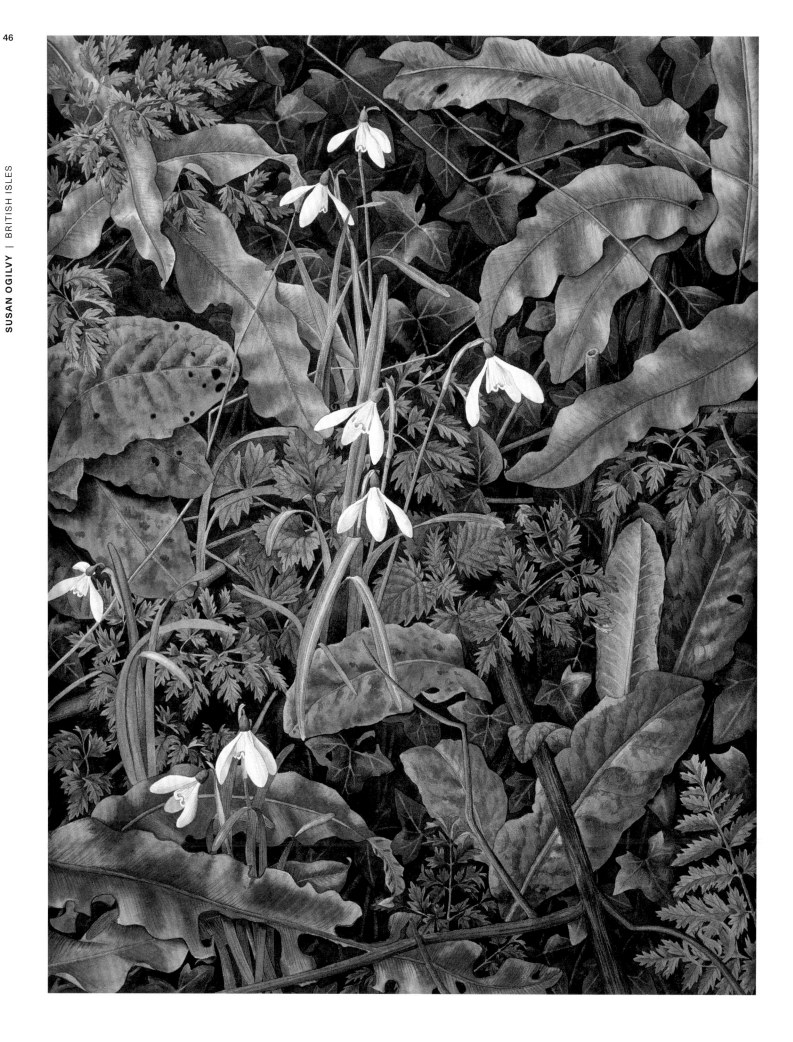

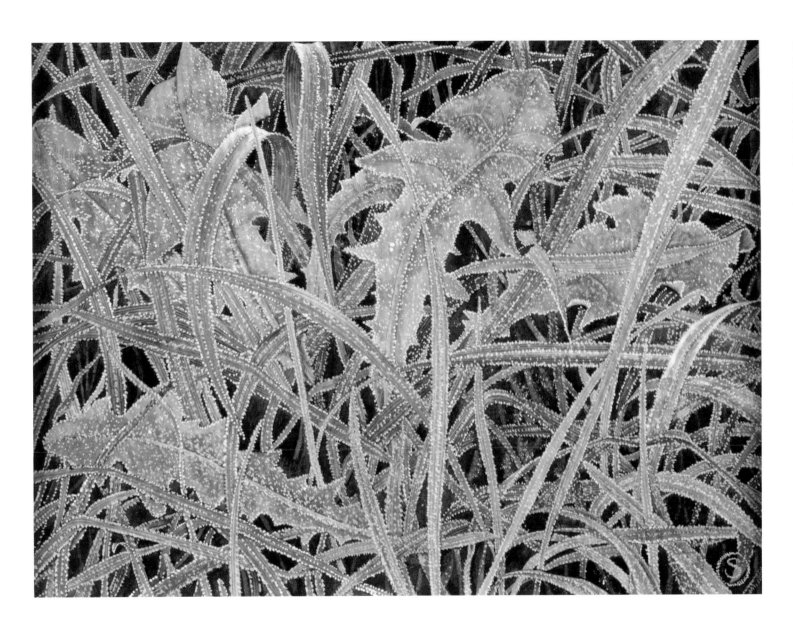

Susan Ogilvy
Snowdrops, Churchyard: *Galanthus nivalis* 2000
Watercolour on paper 457 x 350 mm
From Jonathan Cooper Gallery 2007
This 'birds-eye' view of snowdrops in the hedgerow is a remarkable habitat painting.
[Shirley Sherwood Collection 678]
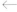

Susan Ogilvy
Frost, Orchard 2007
Watercolour on paper
196 x 260 mm
From Jonathan Cooper Gallery 2007
[Shirley Sherwood Collection 679]

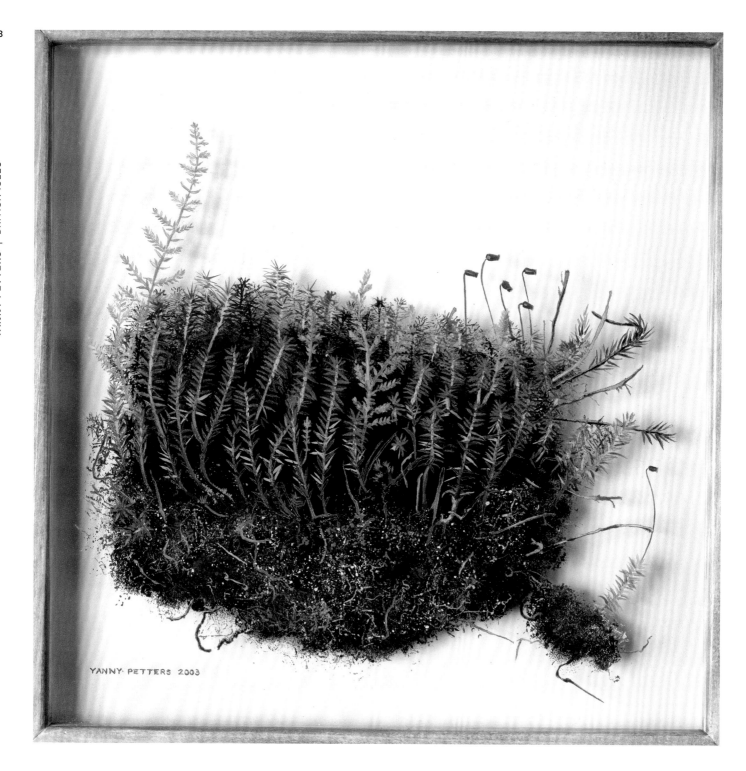

Yanny Petters
Moss: *Polytrichum commune* 2003
Oil painting on glass 440 x 440 mm
From the artist 2003
Yanny Petters works on the back surface of the glass, with a reverse painting technique, similar to that used in painting the inside of Chinese snuff bottles. Her subjects highlight the environment of Irish bogs.
[Shirley Sherwood Collection 505]

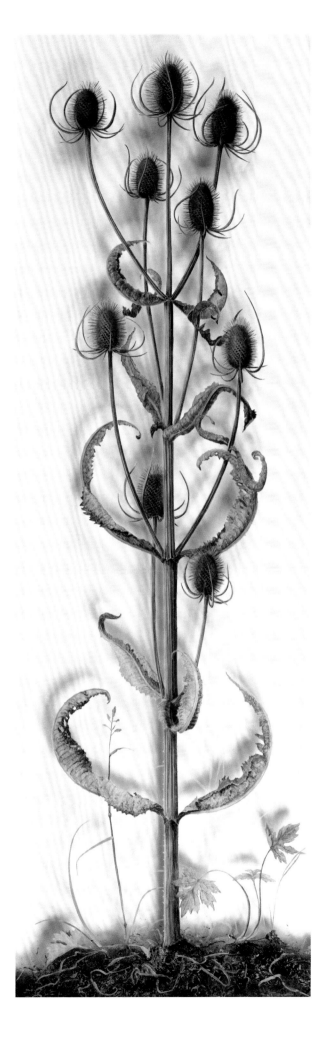

Yanny Petters
Teasel for Finches November
Dipsacus fullonum 2015
Oil painting on glass 1680 x 545 mm
From the Oliver Cornet Gallery, Dublin
2016
Teasel is sometimes planted to attract gold finches which eat and disperse the seeds.
[Shirley Sherwood Collection 960]

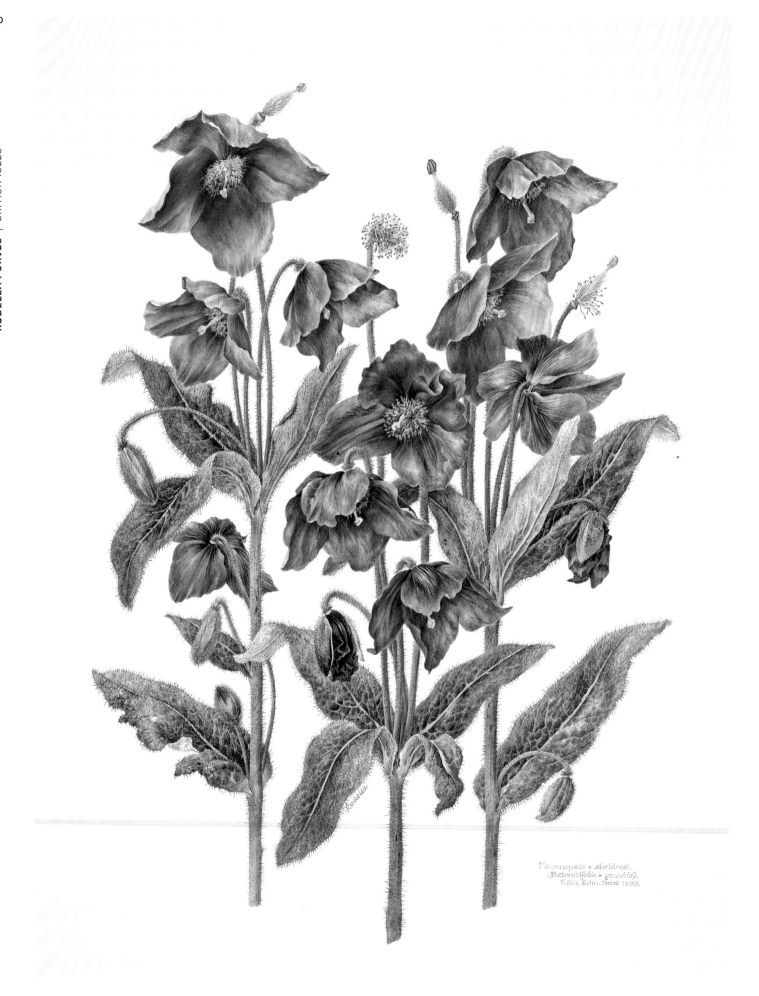

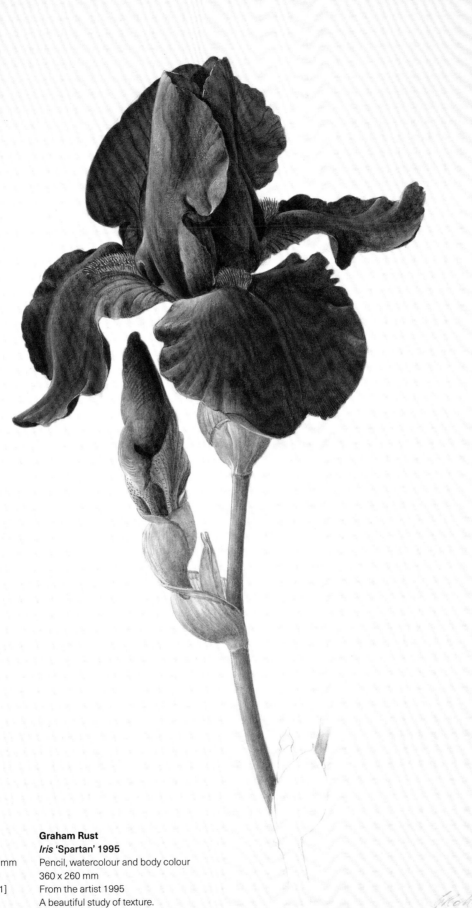

Rodella Purves
Meconopsis x *sheldonii* **1999**
Watercolour on paper 720 x 540 mm
Commissioned 1998
[Shirley Sherwood Collection 361]
←

Graham Rust
Iris 'Spartan' **1995**
Pencil, watercolour and body colour
360 x 260 mm
From the artist 1995
A beautiful study of texture.
[Shirley Sherwood Collection 225]

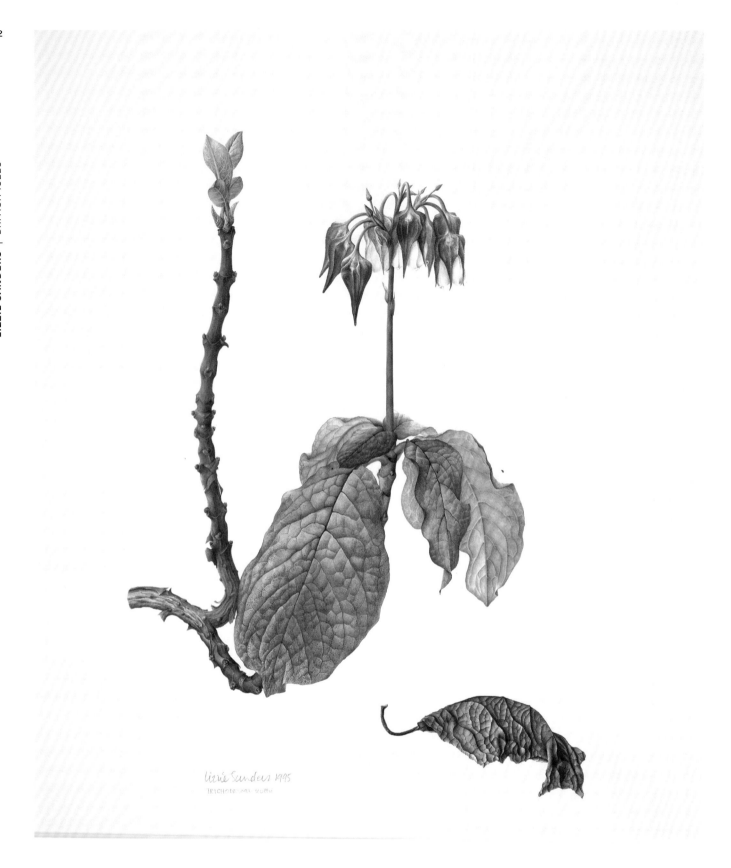

Lizzie Sanders
Trichodesma scottii 1995
Watercolour on paper 552 x 368 mm
From RHS show 2000
[Shirley Sherwood Collection 401]

Rosie Sanders
Dandelions and Other Flowers
Fern, Bluebell, Wild Garlic, Yellow
Archangel and Dandelion 2014
Watercolour on Arches 640 gsm paper
1020 x 770 mm
From Jonathan Cooper Gallery 2014
[Shirley Sherwood Collection 875]
→

ROSIE SANDERS | BRITISH ISLES

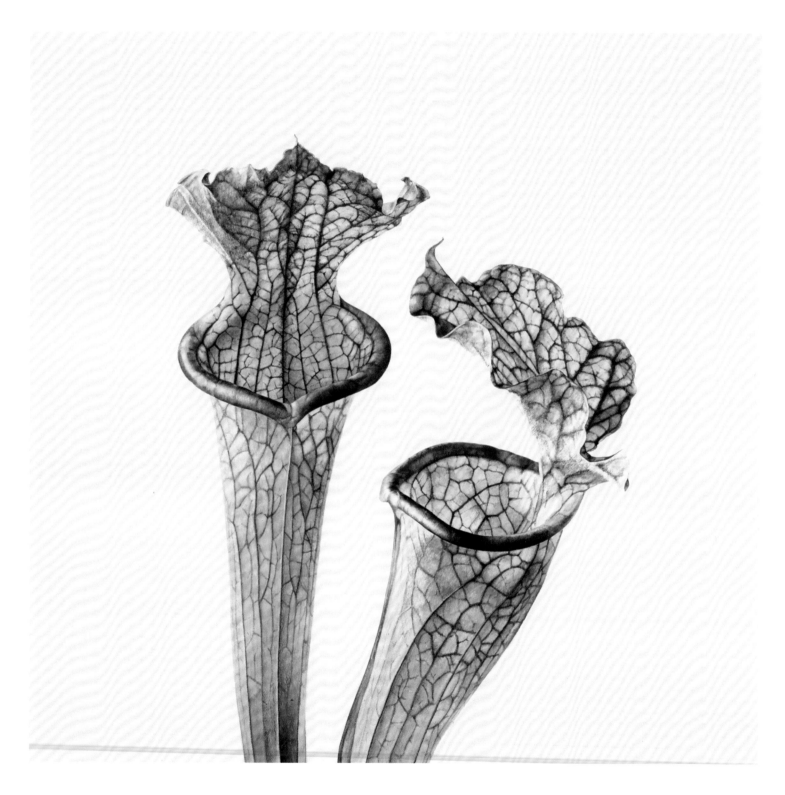

Rosie Sanders
Pitcher Plants: *Sarracenia* x *whittarii*
2004
Watercolour on paper 1020 x 1020 mm
From Jonathan Cooper Gallery 2004
[Shirley Sherwood Collection 566]

Rosie Sanders
Dandelion: Three o'clock 2014
Charcoal with watercolour on
Aquari 210 gsm paper 500 x 500 mm
From Jonathan Cooper Gallery,
commissioned 2014
[Shirley Sherwood Collection 899]
→

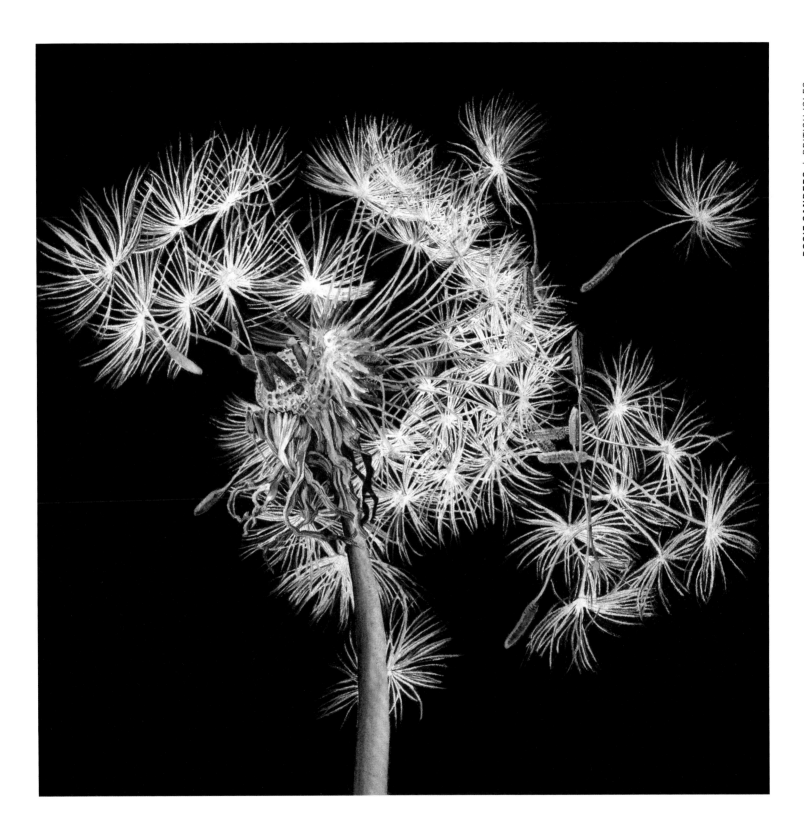

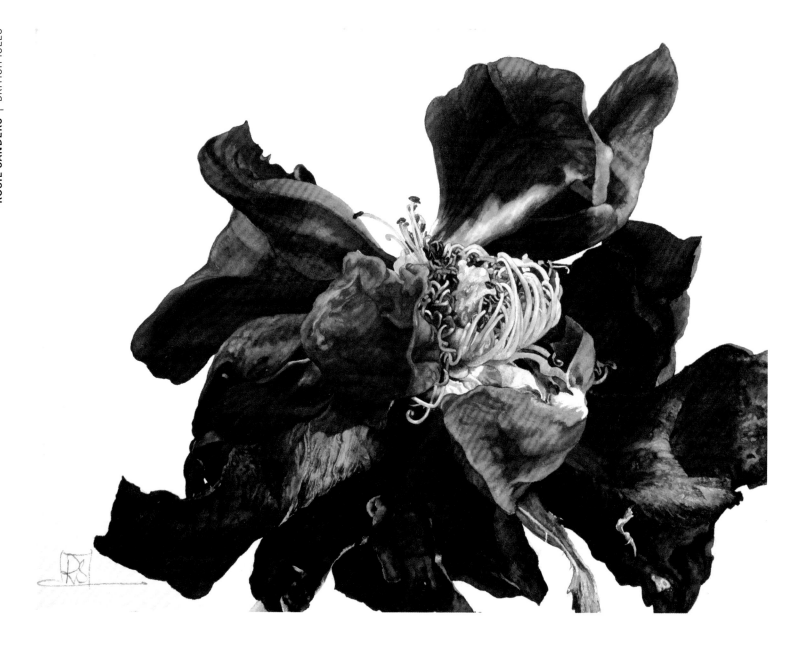

Rosie Sanders
Rose: Red Sensation 2016
Watercolour on paper 390 x 500 mm
From Jonathan Cooper Gallery 2017
[Shirley Sherwood Collection 973]

Pandora Sellars
Tulip hybrid (white): *Tulipa* sp.
Watercolour on paper 150 x 140 mm
Acquired 2007
[Shirley Sherwood Collection 667]
→

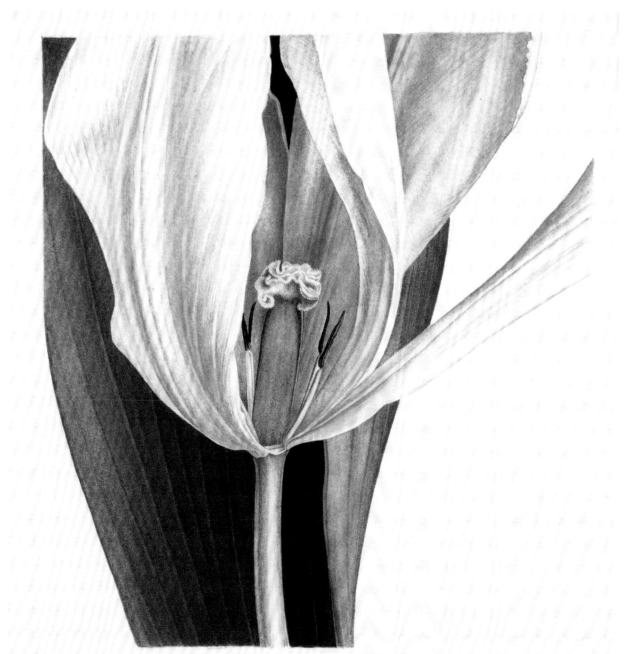

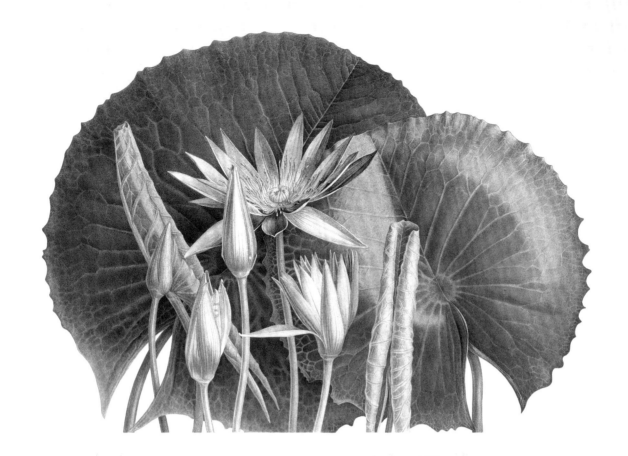
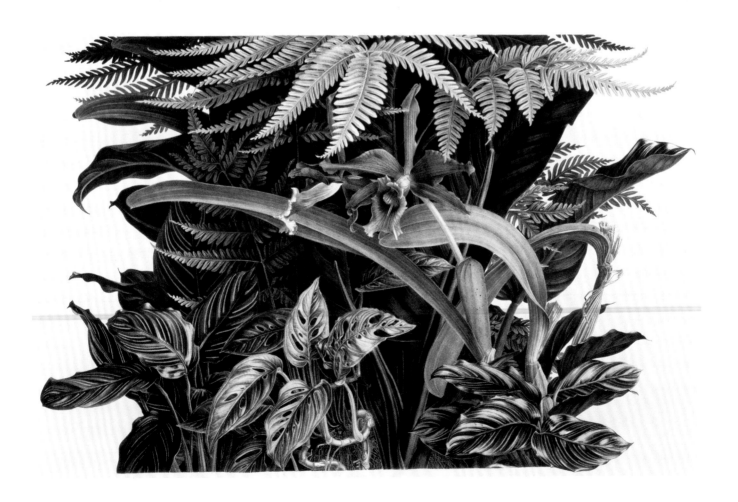

Pandora Sellars
Blue Water Lily: *Nymphaea nouchali* **var.** *caerulea* **1995**
Watercolour on paper 385 x 500 mm
Commissioned 1993
This took 2 years to complete, with the flowers worked first, then the leaves. Used on the cover of *Contemporary Botanical Artists*, 1996.
[Shirley Sherwood Collection 215]
←

Pandora Sellars
Laelia tenebrosa **1989**
Watercolour on paper 410 x 600 mm
From Kew Gardens Gallery 1990
The first painting in the Shirley Sherwood Collection, Pandora Sellars is particularly admired for her compositions of 'botanical theatre'.
[Shirley Sherwood Collection 001]
←

Pandora Sellars
Hippeastrum buds and seed capsule: *Hippeastrum* sp. 1999
Watercolour on paper 170 x 225 mm
From Gordon Craig Gallery 2000
[Shirley Sherwood Collection 414]

Pandora Sellars
Arum italicum, *Arum maculatum* and *Arisarum proboscideum* 1996
Watercolour on paper 350 x 470 mm
Commissioned 1995
One of her best composite paintings.
[Shirley Sherwood Collection 263]

Jess Shepherd
'041020151159' Giant Leaf – Poplar:
Populus x *canadensis* 2015/2016
Watercolour on paper 900 x 1260 mm
From the artist 2018
The artist identifies the leaf by recording the time she found it in Spain, on 4 October 2015 at 11.59.
[Shirley Sherwood Collection 984]

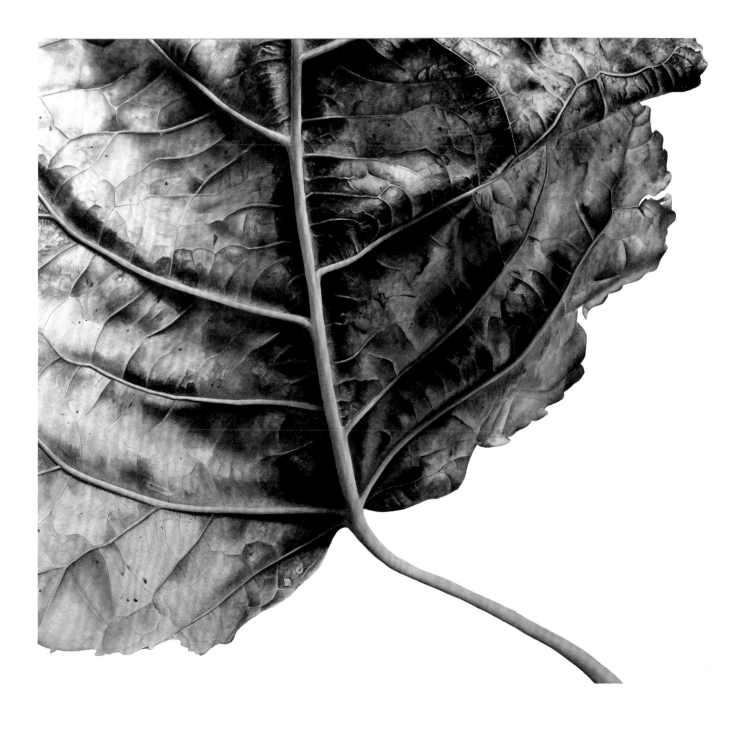

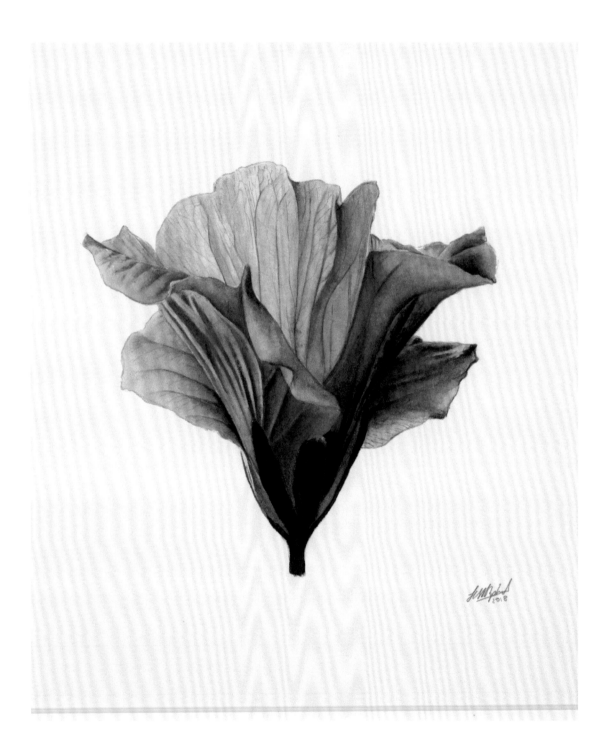

Jess Shepherd
'Blue Bird' Flower: *Hibiscus syriacus*
2018
Watercolour on paper 180 x 150 mm
From the artist 2018
A delightful small gift from her 'blue' period.
[Shirley Sherwood Collection 992]

Siriol Sherlock
Magnolia campbellii var. *mollicomata*
1991
Watercolour on paper 570 x 440 mm
From Kew Gardens Gallery 1992
[Shirley Sherwood Collection 067]
→

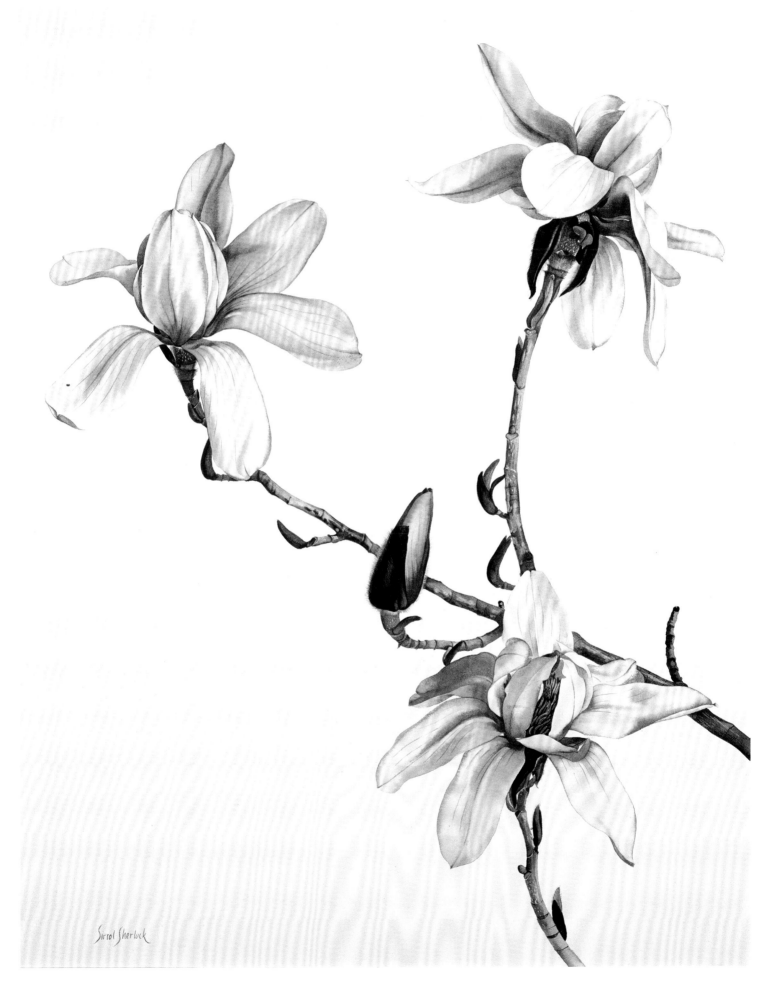

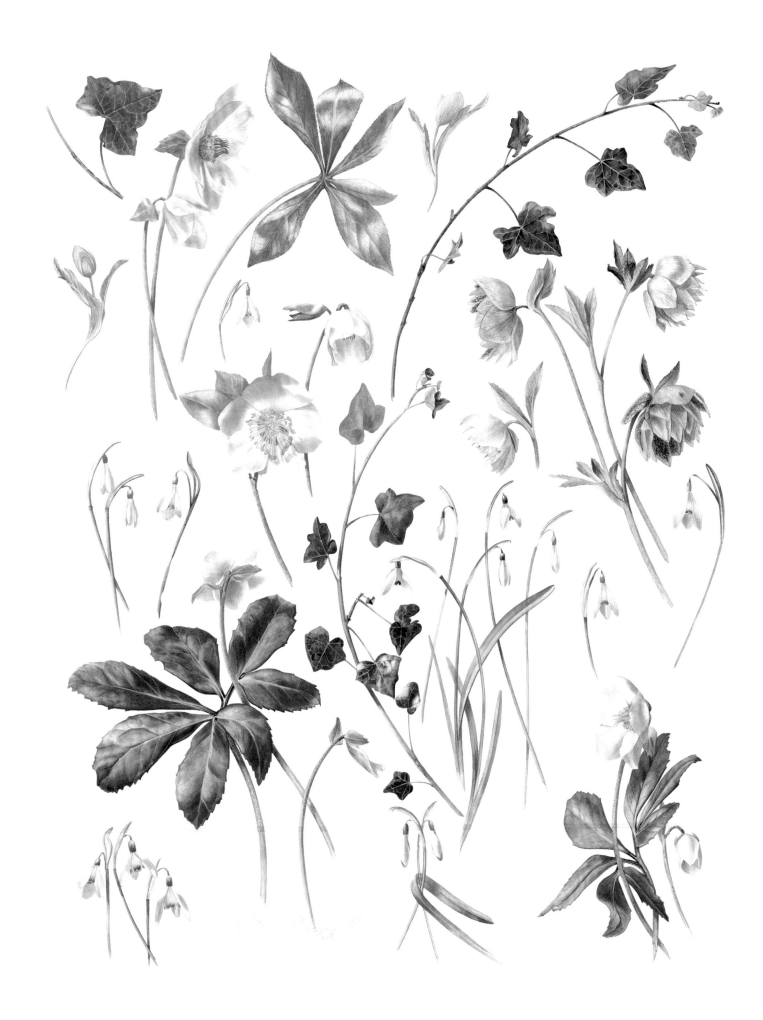

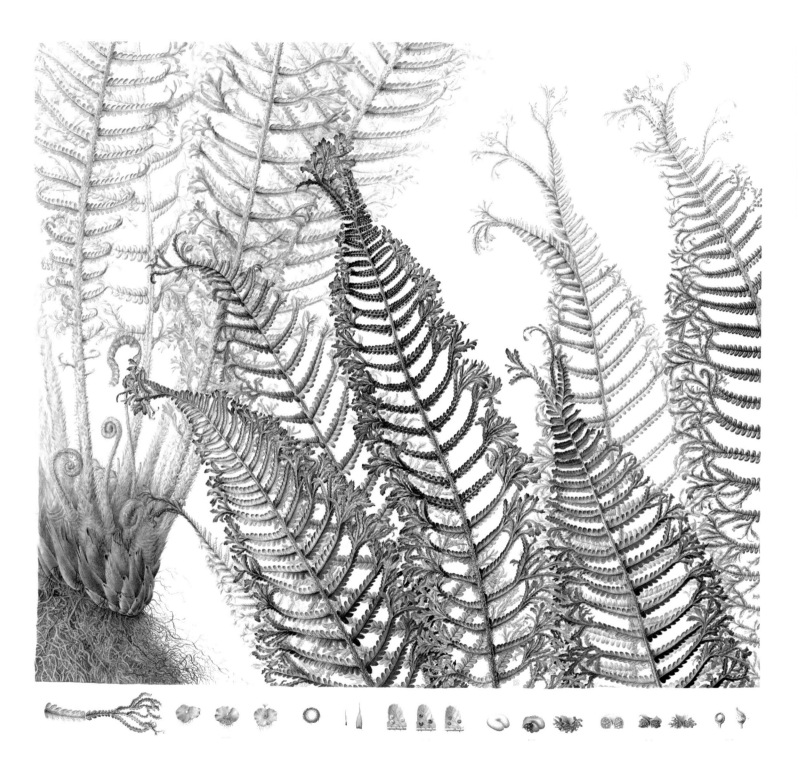

Billy Showell
Winter Pattern 2017
Watercolour on paper 660 x 540 mm
From the SBA Show 2017
[Shirley Sherwood Collection 974]
←

Laura Silburn
Dryopteris affinis 'Cristata' 2018
Watercolour on paper 580 x 550 mm
From the RHS Show 2018 when she was awarded a gold medal.
[Shirley Sherwood Collection 993]

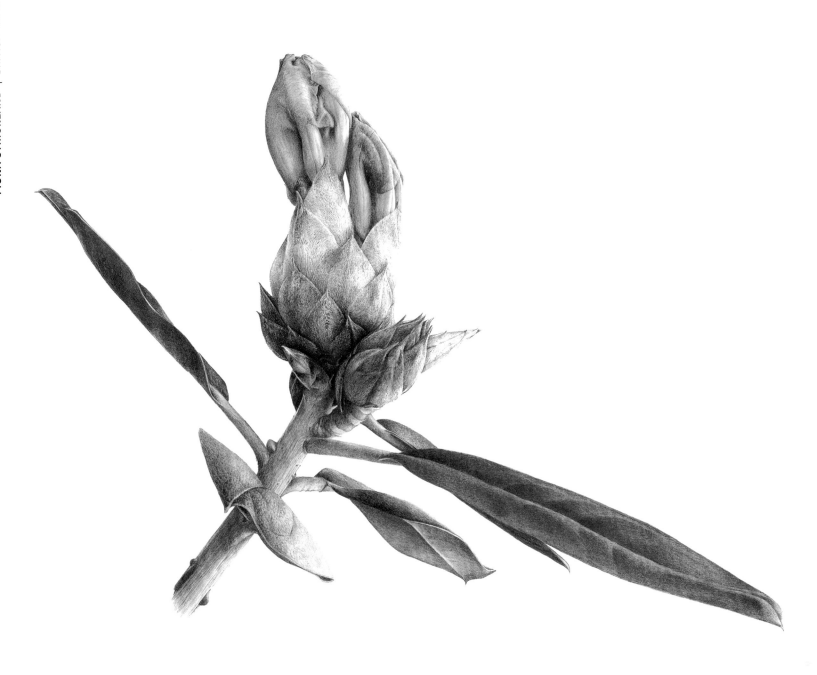

Fiona Strickland
Rhododendron 'Horizon Monarch'
2013
Watercolour on paper 476 x 616 mm
From Jonathan Cooper Gallery 2016
Reproduced in *Plant* published by
Phaidon, 2016
[Shirley Sherwood Collection 959]

Julia Trickey
Tulipa 'Orange Favourite' 2014
Tulip in watercolour on a gouache
background 330 x 240 mm
From the artist 2014
[Shirley Sherwood Collection 891]
→

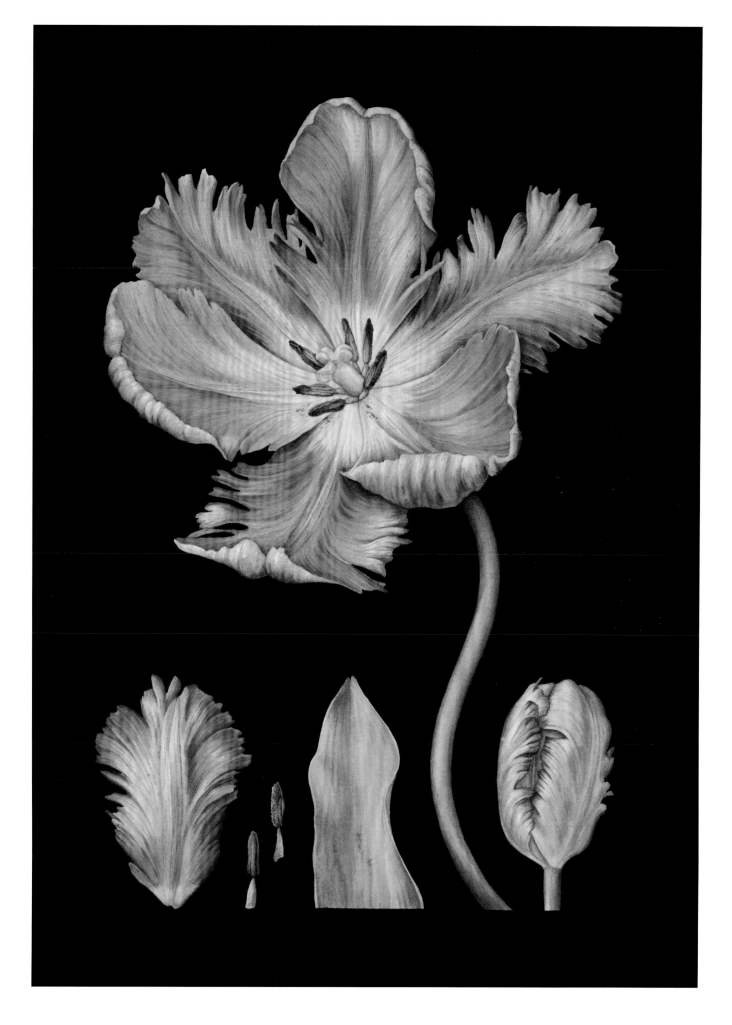

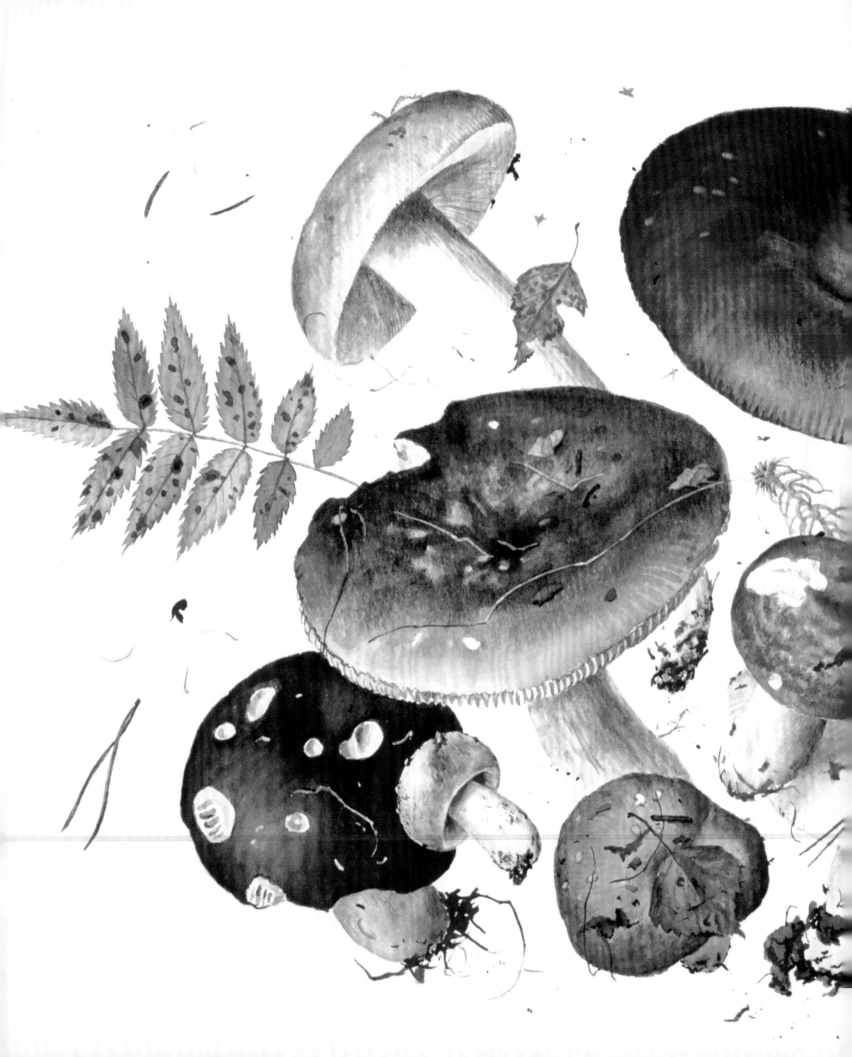

Europe

Europe

WHEN I STARTED collecting botanical art in 1990, I quickly discovered that work by historical masters was far more respected and valued than contemporary work, regardless of its quality. Rather than compete with museums and art dealers for historical works I decided to concentrate on today's artists, as much contemporary work was so good and botanical artists were so underrated at that time. Even now I have had trouble convincing two Austrian friends that most of the works in my gallery are painted by living artists – that is one of the reasons I always put the date of birth of the artist on the captions during exhibitions.

However, I could not resist acquiring some works by iconic past masters. The oldest is a page from Basilius Besler (1561–1629) which, rather surprisingly, I saw in California. I have always admired the Dietzsch family's work too and over the years acquired two wonderful paintings by Johann Dietzsch (1710–1769) and another by Barbara Regina Dietzsch (1706–1783). The thistle draped with cobwebs is a particular favourite of mine. I was especially delighted by the acquisition of five hand painted lithographs of heathers by Franz Andreas Bauer (1758–1840) who worked at Kew for 40 years, recording the plants sent there from abroad, generally by the botanist-cum-plant collector Francis Masson (1741–1805). I acquired five South African erica studies in 2001 and decided to give one to each of my grandchildren.

I have given away my book *Fleurs, Fruits et Feuillages Choisis de l'Ile de Java* (1863–64) by Berthe Hoola van Nooten (1840–1885) to Singapore Botanic Gardens as its pages of tropical fruits were so appropriate to that garden with its new botanical art gallery. There was a striking exhibition in the Shirley Sherwood Gallery of most of the plates before they were shown in Singapore.

I had exhibitions of my collection in Italy (Venice and Pisa), Germany and Sweden (Oslo) and a particularly satisfactory partnership comparing old works from the Mutis Collection in Madrid with new, in the Shirley Sherwood Gallery and at the Real Jardín Botánico, Madrid. The Mutis Collection had been created in Columbia from 1783 to 1808 by a group of local artists trained by José Celestino Mutis. This collection is stored in the Madrid Botanical Gardens and had never been shown outside Spain before.

I rather expected that France, with its tradition of Redouté, would be a good source of contemporary material but I have not been successful in finding French artists – although Agatha Haevermans has recently started interesting classes in Paris. I found that there were teaching centres in Russia, Italy, Germany and the Netherlands and a number of independent artists creating their own individualistic work.

Most of the European artists in my collection seem to be using a range of techniques and varied subject matter, many working in isolation. I find Regine Hagedorn's work unique in its superb quality and design while Barbara Oozeerally, now based in England, is nearing completion of her second book on magnolias, which she has worked on exclusively for many years.

Alexander Viazmensky has taught in St Petersburg and in the States, leading immensely popular fungi forays and showing how to add plant debris found at the fungi's local habitat. In Italy, Luca Palermo has taught in Rome; while in northern Bavaria in Germany, Sylvia Peter has created the Gallery Forum Botanische Kunst. In the Netherlands, Anita Walsmit Sachs leads classes in the Hague and Leiden, concentrating, appropriately, on tulips.

Basilius Besler
I Turk's Cap Cactus: *Melocactus in tortus*
II and III Rose of Jericho open and closed: *Selaginella lepidophylla*
Engraving on paper, single sheet hand coloured copper plate 554, 473 x 380 mm
From Arader Galleries, New York 2012
The Rose of Jericho can be revived after dessication.
[Shirley Sherwood Collection 836]

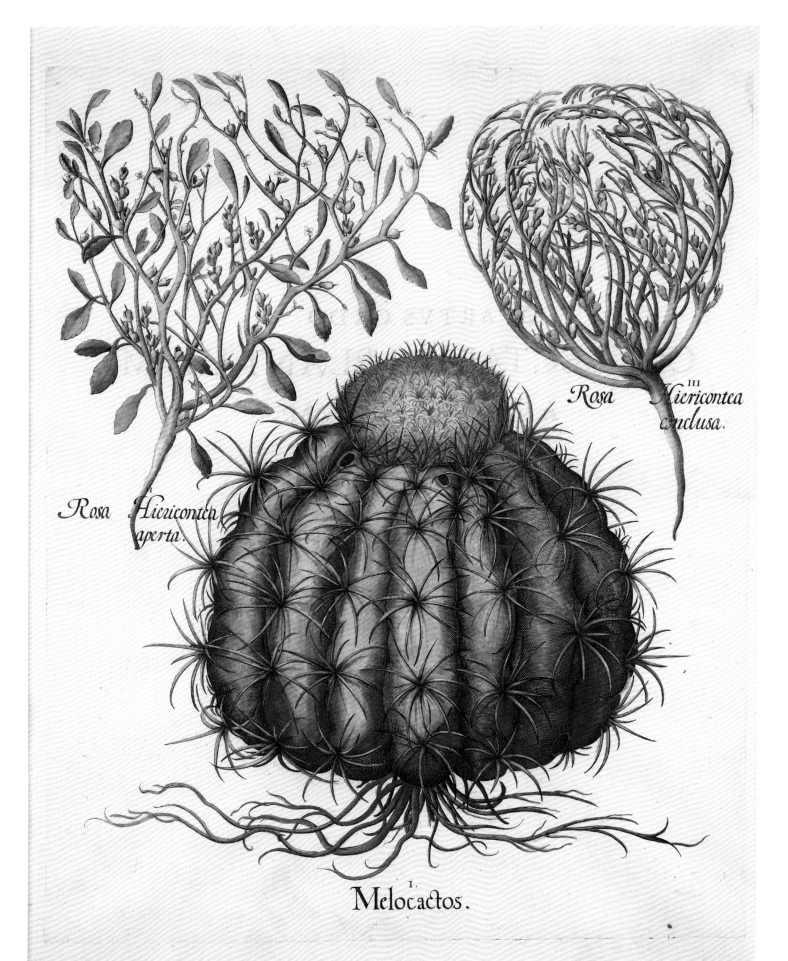

JOHANN CHRISTOPH DIETZSCH | GERMANY

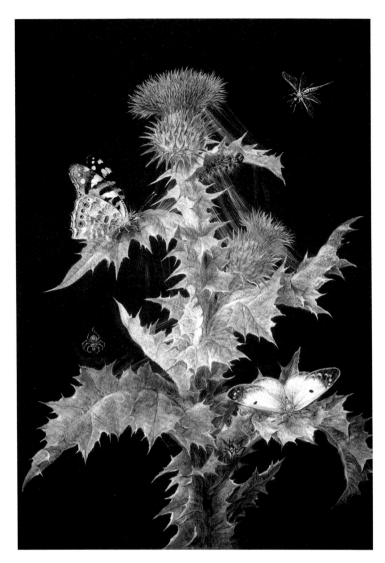

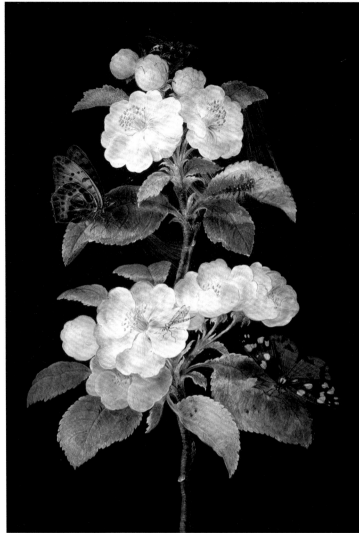

Johann Christoph Dietzsch
Thistle with butterflies: *Cirsium eriophorum*
Watercolour and body colour on prepared vellum 288 x 207 mm
From Bonhams 2004
The dark background is painted over a musical score.
[Shirley Sherwood Collection 575]

Johann Christoph Dietzsch
Apple Blossom: *Prunus cerasus*
Watercolour and body colour on prepared vellum 288 x 210 mm
From Bonhams 2004
As with the previous painting, the dark background is painted over a musical score.
[Shirley Sherwood Collection 576]

Barbara Regina Dietzsch
Redcurrant Branch with Butterfly
Gouache heightened with white on vellum 290 x 200 mm
From Karl & Faber 2018
[Shirley Sherwood Collection 985]
→

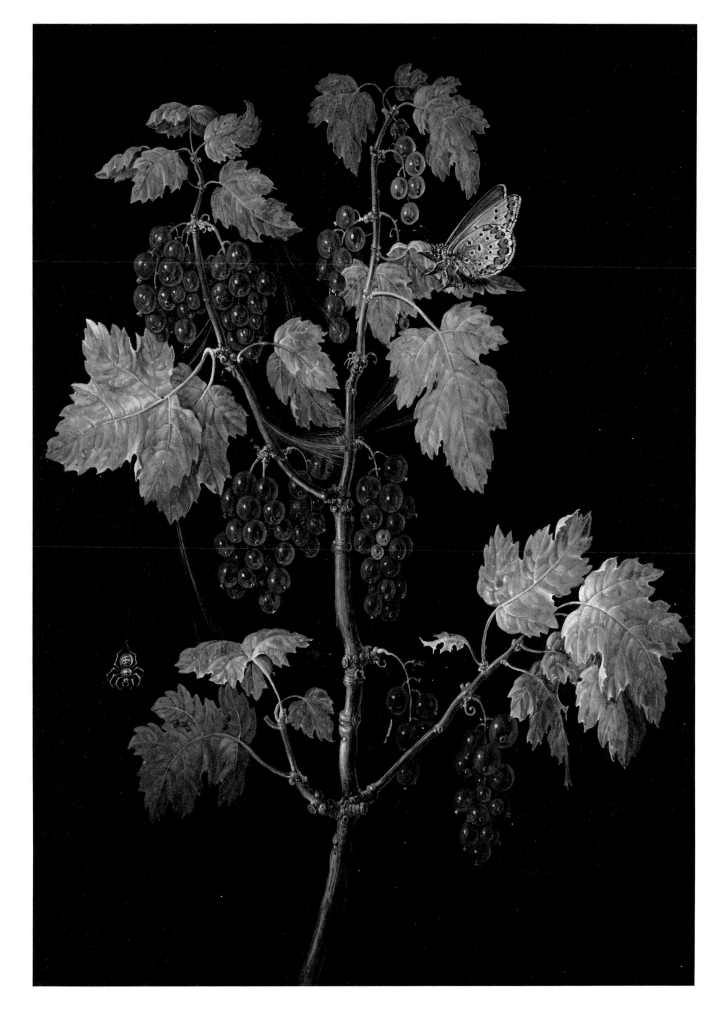

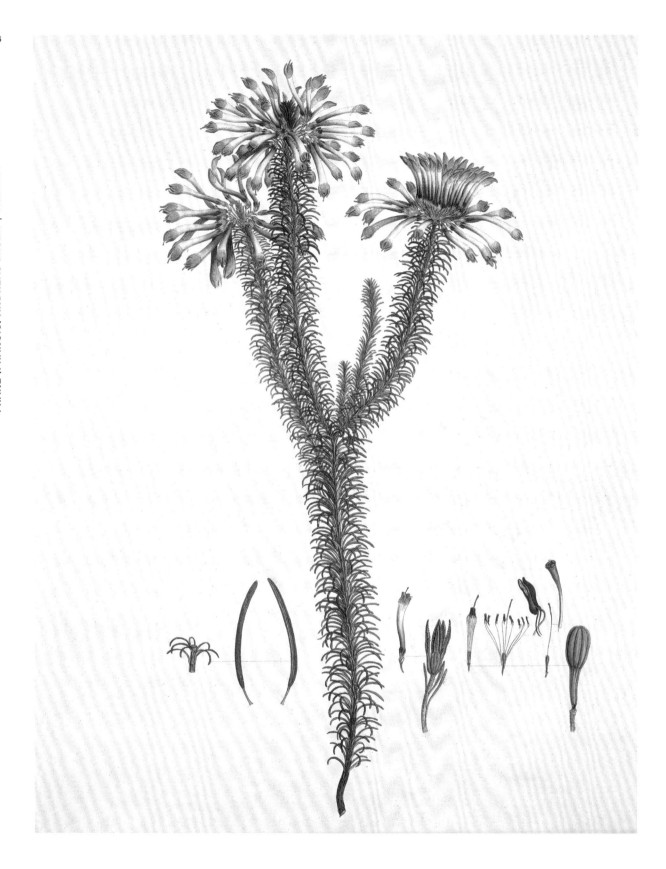

Franz (Francis) Andreas Bauer
Erica fascicularis, numbered '6'
Hand coloured, engraved & etched print
595 x 482 mm
From Christies 2001
[Shirley Sherwood Collection 456]

Franz (Francis) Andreas Bauer
Erica plukenetii, numbered '9'
Hand coloured, engraved and etched
print 615 x 482 mm
From Christies 2001
[Shirley Sherwood Collection 459]
→

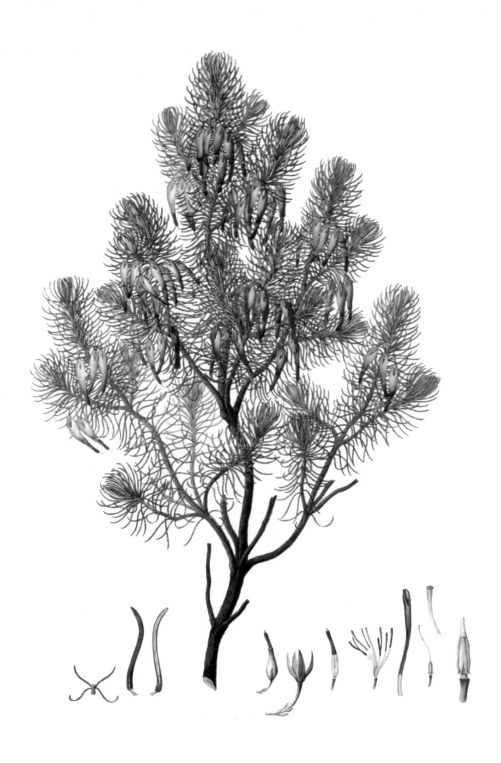

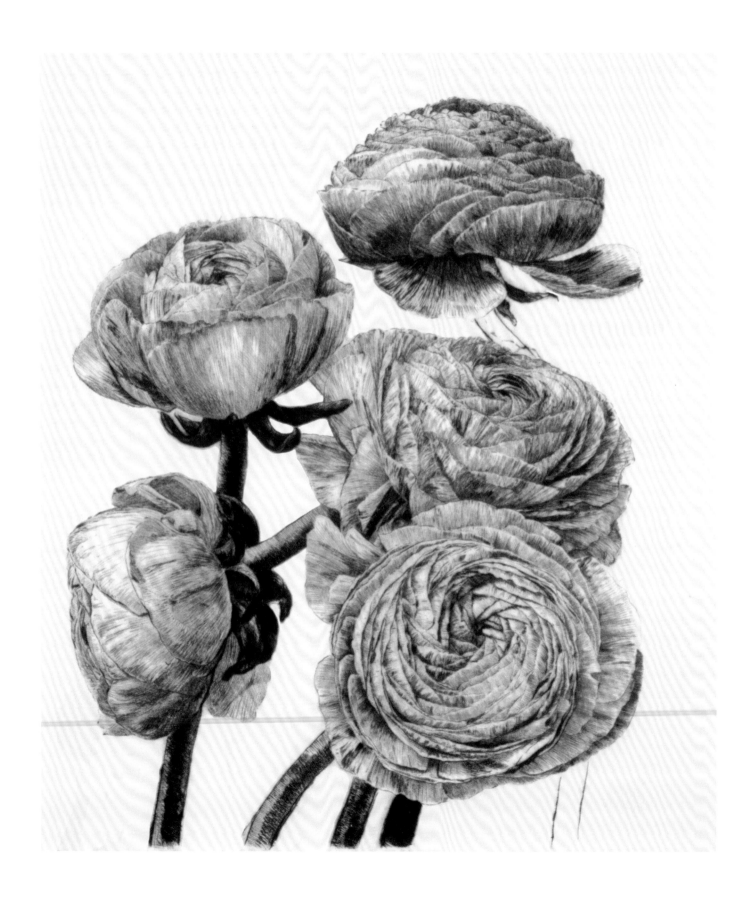

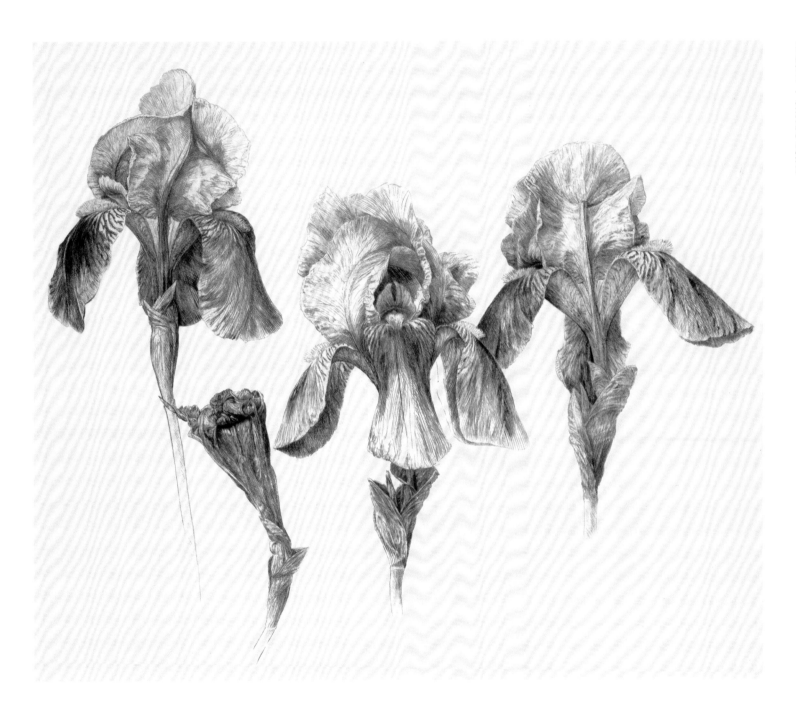

Jakob Demus
Ranunculus asiaticus 1988
Drypoint etching 260 x 210 mm
G C Boemer, New York 1992
[Shirley Sherwood Collection 060]
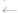

Jakob Demus
Three Iris Flowers 1989
Etching on paper 380 x 540 mm
From the artist 2005
[Shirley Sherwood Collection 625]

GERTRUDE HAMILTON | BELGIUM

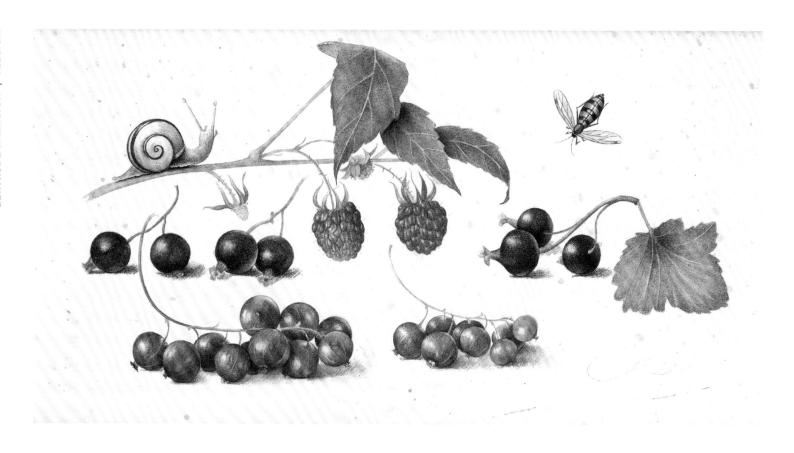

Gertrude Hamilton
Red and Purple Currants, Raspberries, Snail and Bee 2001
Watercolour on paper 120 x 240 mm
From Ursus Books & Prints, New York
2001
Gertrude Hamilton deliberately 'aged' her paper to reflect her inspiration from the past.
[Shirley Sherwood Collection 441]

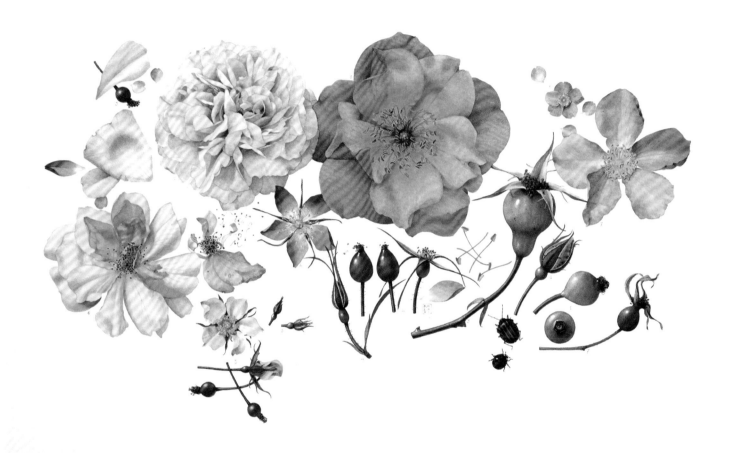

Regine Hagedorn,
Roses (2): *Rosa* **spp. 2001**
Watercolour on paper, 305 x 450 mm
Tryon Gallery 2001
[Shirley Sherwood Collection 443]

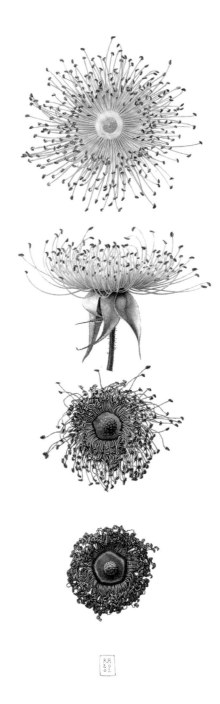

Regine Hagedorn
Mermaid Rose Stamens: *Rosa* **sp. 2002**
Watercolour on paper 240 x 150 mm
From the artist 2004
Hagedorn's sense of design creates an iconic sequence of development and decay of the mermaid rose stamens.
[Shirley Sherwood Collection 524]

Regine Hagedorn
Nigella Fruit: *Nigella damascene* **2004**
Watercolour on paper 360 x 400 mm
From the artist 2005
The seed head can sway in the wind, scattering the small seeds out of pores at its top.
[Shirley Sherwood Collection 596]
→

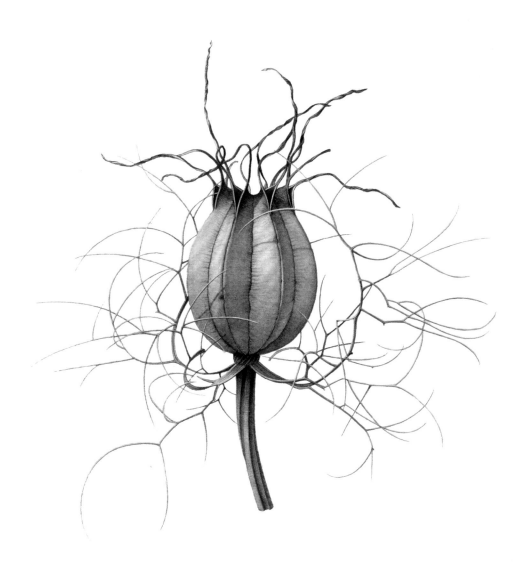

REGINE HAGEDORN | GERMANY

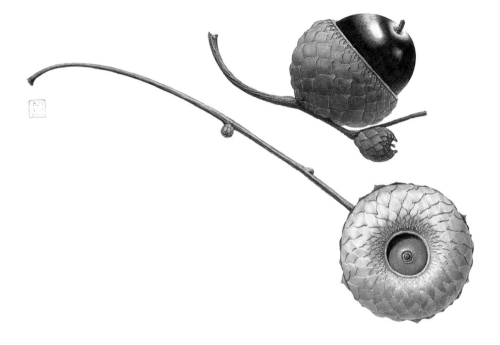

Regine Hagedorn
Acorns from the Jura: *Quercus robur*
2000
Watercolour on paper 390 x 345 mm, magnified x 3.5
Commissioned 2000
Acorns are dispersed by animals, being stored by squirrels and jays. The magnification of the acorns increases the impact of this work.
[Shirley Sherwood Collection 419]

Sylvia Peter
Rat's tail, Spitzwegerich: *Plantago lanceolata* 2002
Acrylic on linen on wood 670 x 430 mm
From the artist 2002
[Shirley Sherwood Collection 466]
→

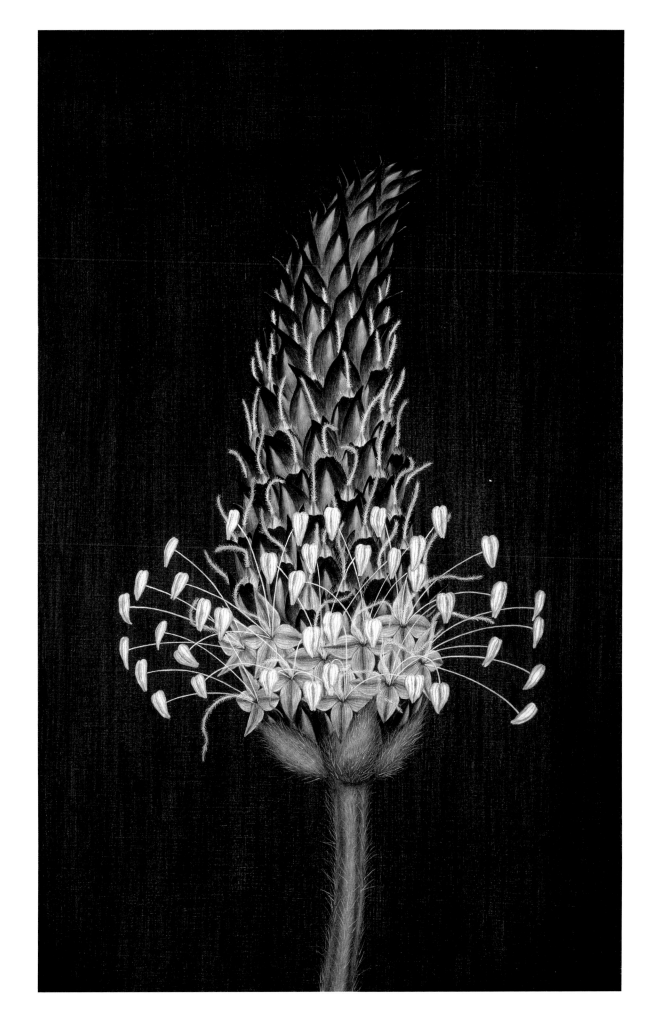

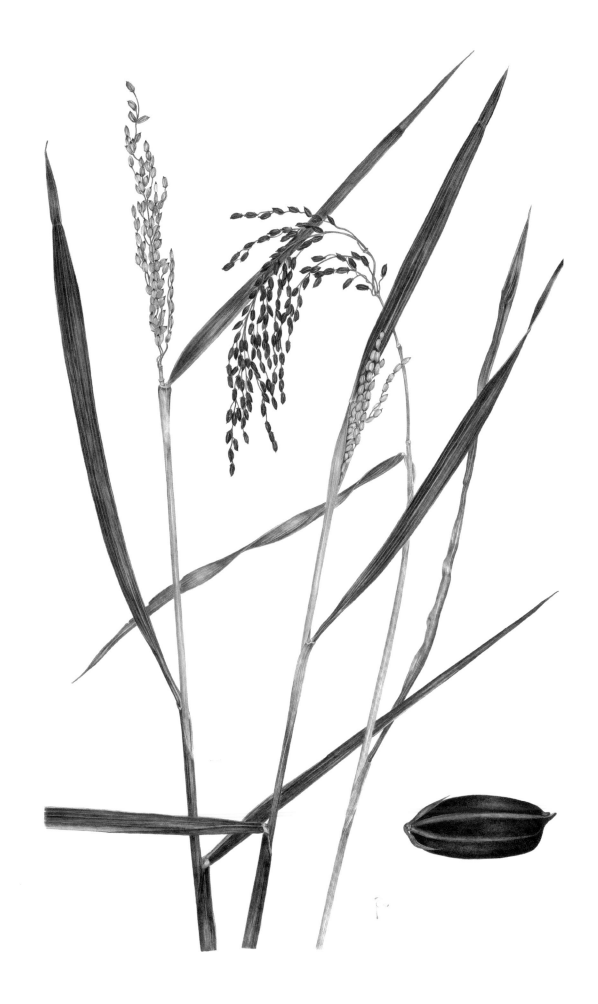

Angela Petrini
Black Rice 'Gioiello': *Otyza sativa* subsp. *japonica* 'Gioiello' 2018
Watercolour on paper 695 x 530 mm
From the artist 2018
Exhibited at the 2018 RHS show, where she was awarded a gold medal.
[Shirley Sherwood Collection 994]
←

Angela Petrini
Rice Seeds Rice Caryopses 2018
Watercolour on paper 590 x 590 mm
From the artist 2018
Exhibited at the 2018 RHS show, where she was awarded a gold medal.
[Shirley Sherwood Collection 995]

MARILENA PISTOIA | ITALY

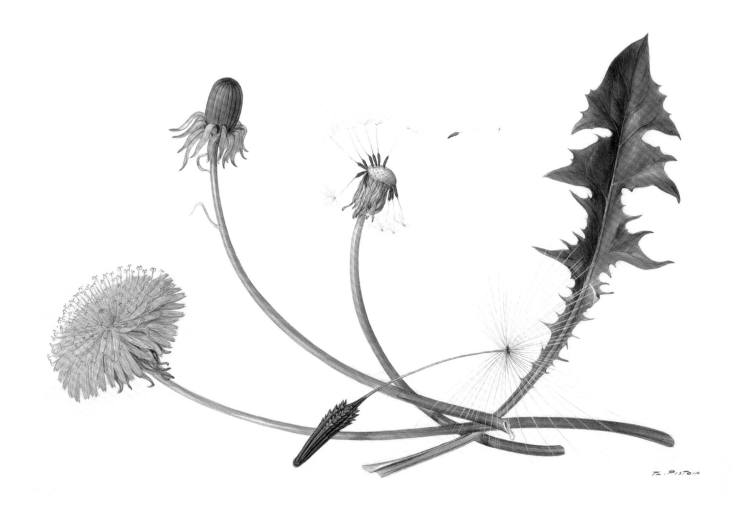

Marilena Pistoia
Dandelion: *Taraxacum officinale*
Watercolour on paper 175 x 265 mm
From the artist 1994
[Shirley Sherwood Collection 176]

Aurora Tazza
Vine: *Vitis vinifera* 2003
Watercolour on paper 385 x 285 mm
From the artist 2004
Dispersed by birds and wild pigs. Vineyards now need electric fence protection from the prolific wild pig population which raid and destroy the ripe crops.
[Shirley Sherwood Collection 532G]
→

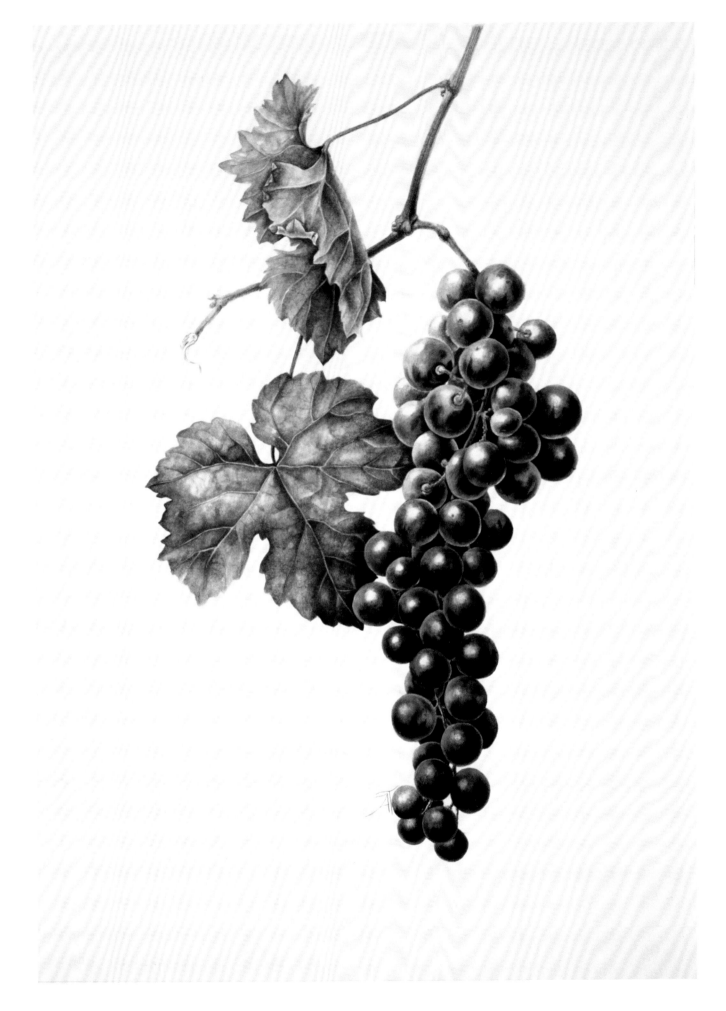

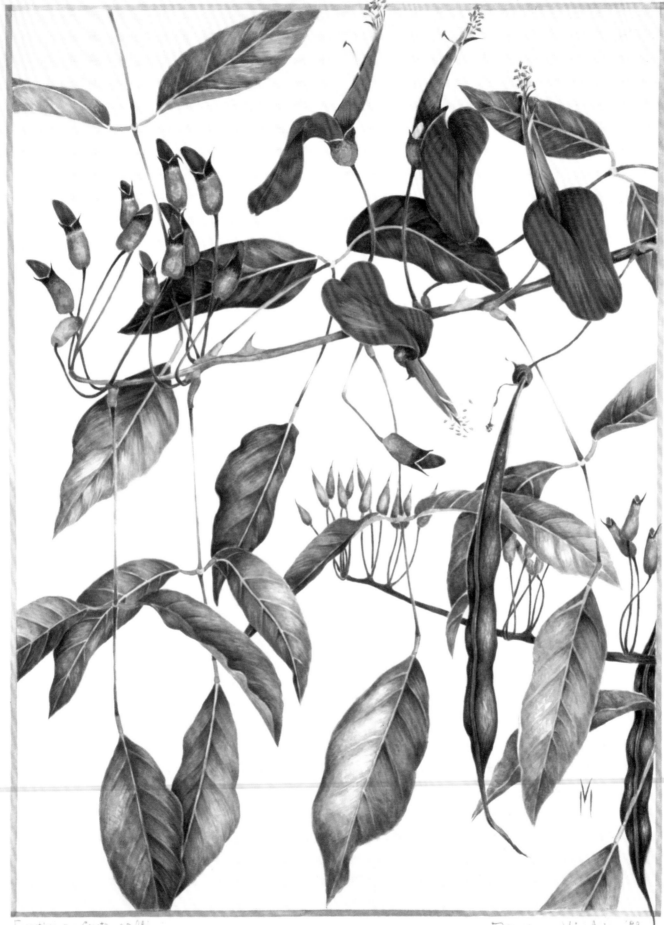

Erythrina Crista-galli

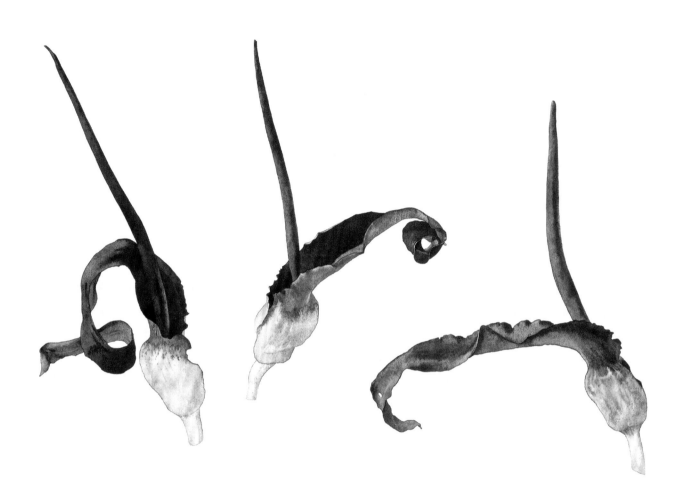

Marina Virdis
Erythrina crista-galli 1998
Watercolour on paper 400 x 300 mm
From RHS show 1999
Native to South America, the bright red, poisonous and buoyant seeds germinate over 3 years. Floating seeds can be dispersed by flood water and ocean currents.
[Shirley Sherwood Collection 367]
←

Dasha Fomicheva
3 arums triptych: *Biarum angustatum* 2001
Watercolour on paper 230 x 265 mm
From the artist 2001
Dasha Fomicheva created a triptych of Jordanian arum paintings showing its many strange shapes.
[Shirley Sherwood Collection 427]

YURI IVANCHENKO | RUSSIA

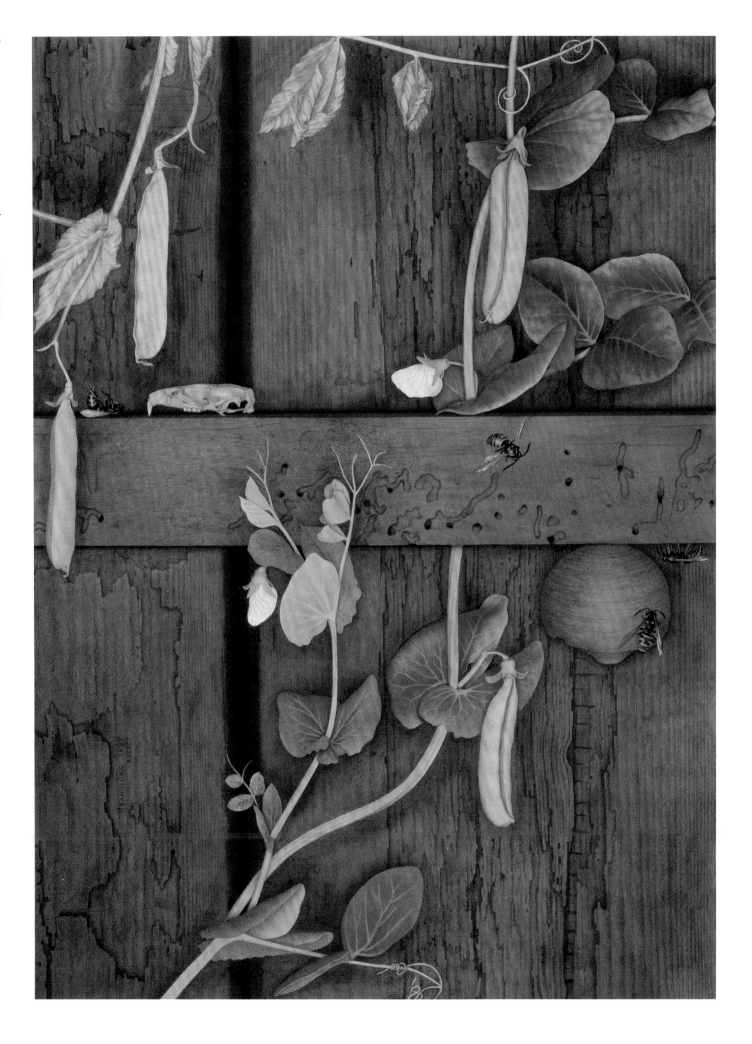

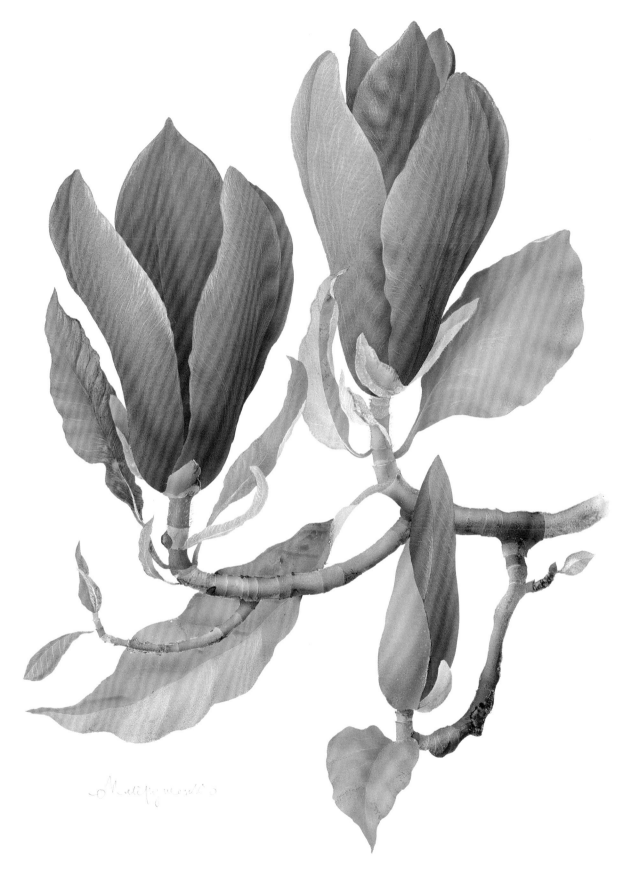

Yuri Ivanchenko
August (pea): *Pisum sativum* 1997
Watercolour on paper 378 x 278 mm
From Colnaghi & Co 2003
[Shirley Sherwood Collection 508]
←

Olga Makrushenko
Deep Pink Magnolia: *Magnolia* sp.
2005
Mixed media on paper 470 x 360 mm
From the artist 2005
[Shirley Sherwood Collection 597]

OLGA MAKRUSHENKO | RUSSIA

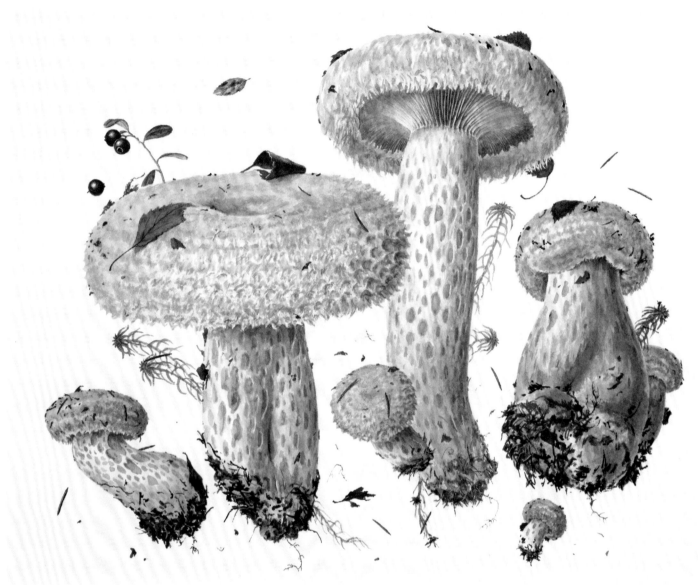

Alexander Viazmensky
Yellow Bearded Milkcap: *Lactarius repraesentaneus* **2007**
Watercolour on paper 300 x 380 mm
From the artist 2008
[Shirley Sherwood Collection 704]

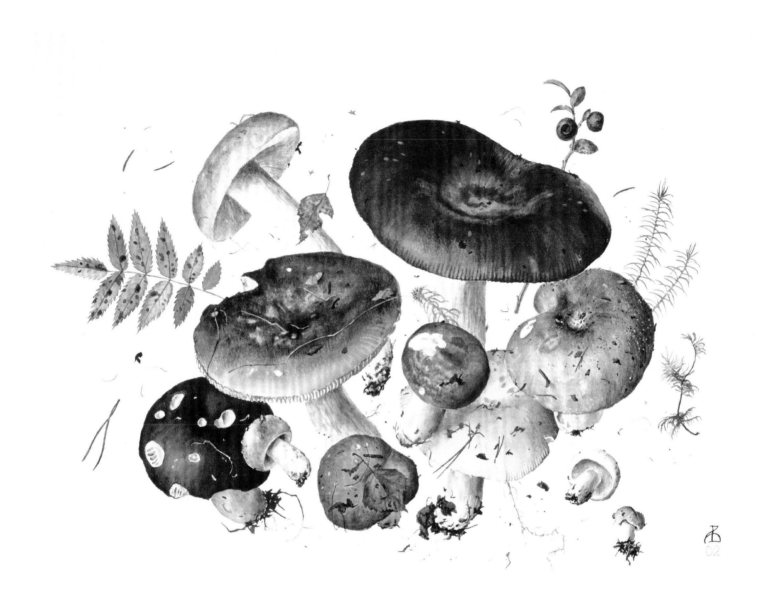

Alexander Viazmensky
The Colours of Brittlegills: *Russula*
spp. 2002
Watercolour on paper 280 x 380 mm
From the artist 2004
[Shirley Sherwood Collection 560]

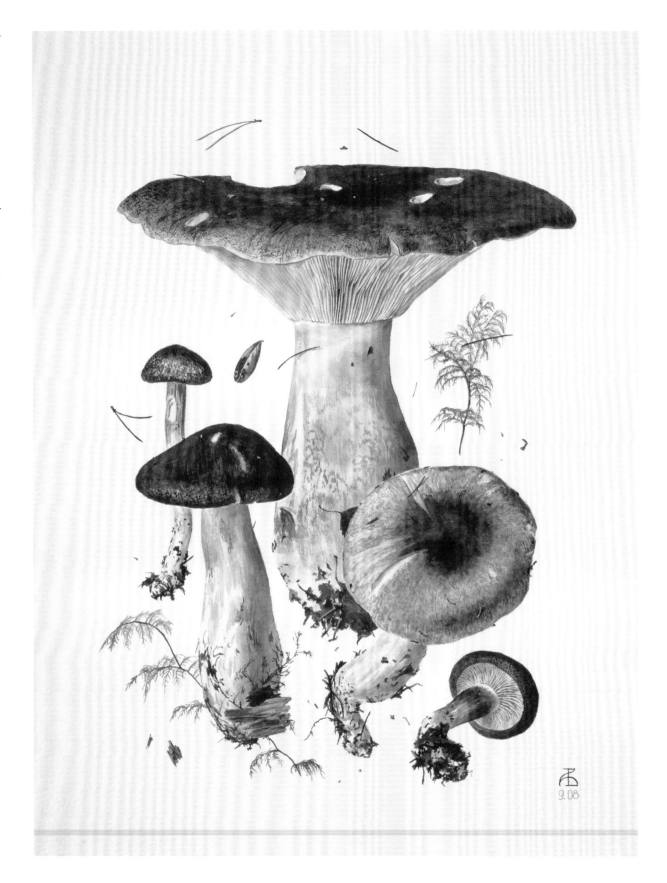

Alexander Viazmensky
Plums and Custard: *Tricholomopsis rutilans* 2008
Watercolour on paper 380 x 280 mm
From the artist 2008
[Shirley Sherwood Collection 702]

Alexander Viazmensky
Black Morel: *Morchella elata* 2007
Watercolour on paper 380 x 280 mm
From the artist 2008
Viazmensky described this as the most challenging fungus to paint.
[Shirley Sherwood Collection 703]
→

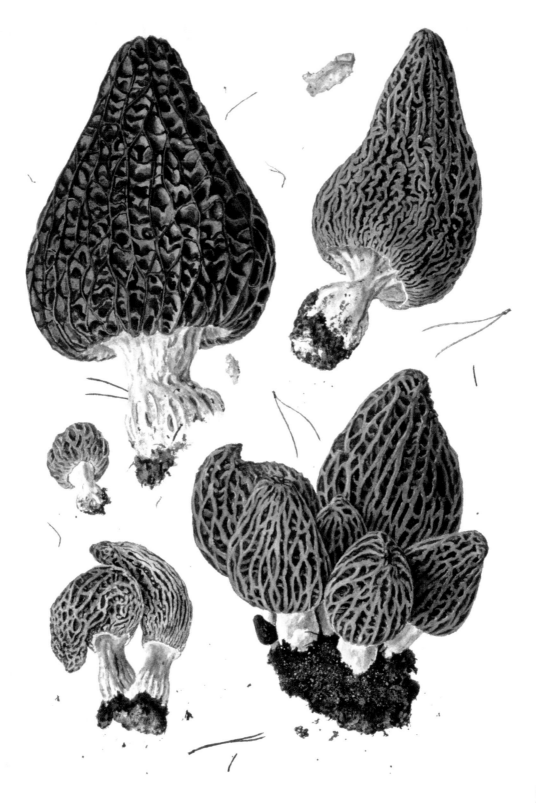

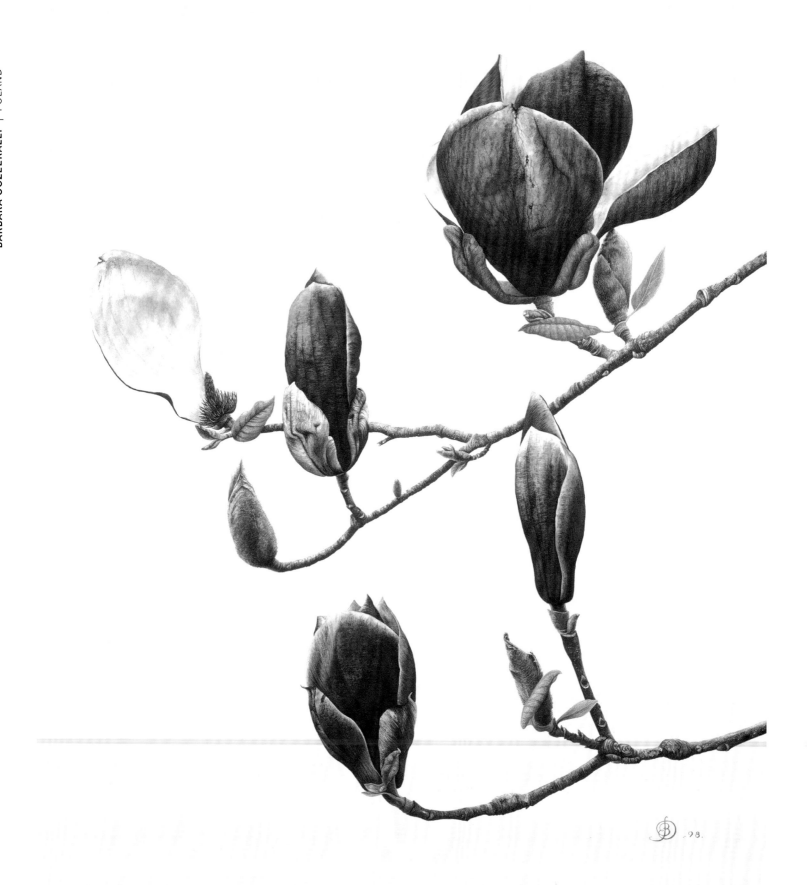

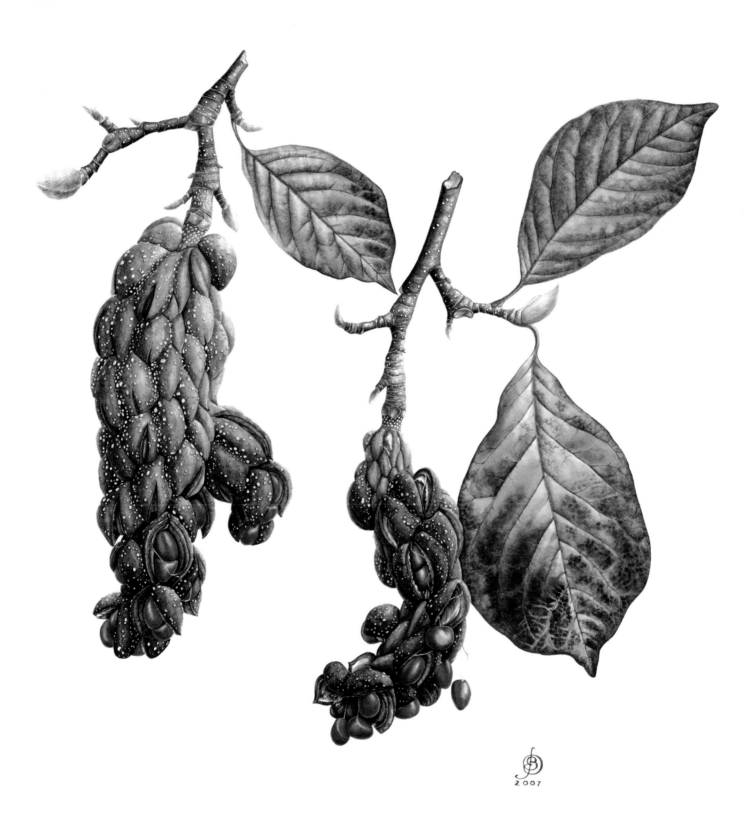

Barbara Oozeerally
Magnolia x *soulangeana* 1998
Watercolour on paper 430 x 350 mm
From RHS show 1998
[Shirley Sherwood Collection 339]
←

Barbara Oozeerally
Fruits of *Magnolia soulangeana*
'White Giant' 2007
Watercolour on paper 360 x 330 mm
From the artist 2014
The seeds of these fruits are dispersed by birds.
[Shirley Sherwood Collection 872G]

Juan Luis Castillo
Dragon Tree: *Dracaena draco* subsp. *draco* 2017
Digital drawing print on paper
483 x 329 mm
From the artist 2017
[Shirley Sherwood Collection 968]

Annika Silander-Hökerberg
Siberian Iris: *Iris siberica* 1994
Watercolour on paper 760 x 560 mm
From the artist 1995
[Shirley Sherwood Collection 210]
→

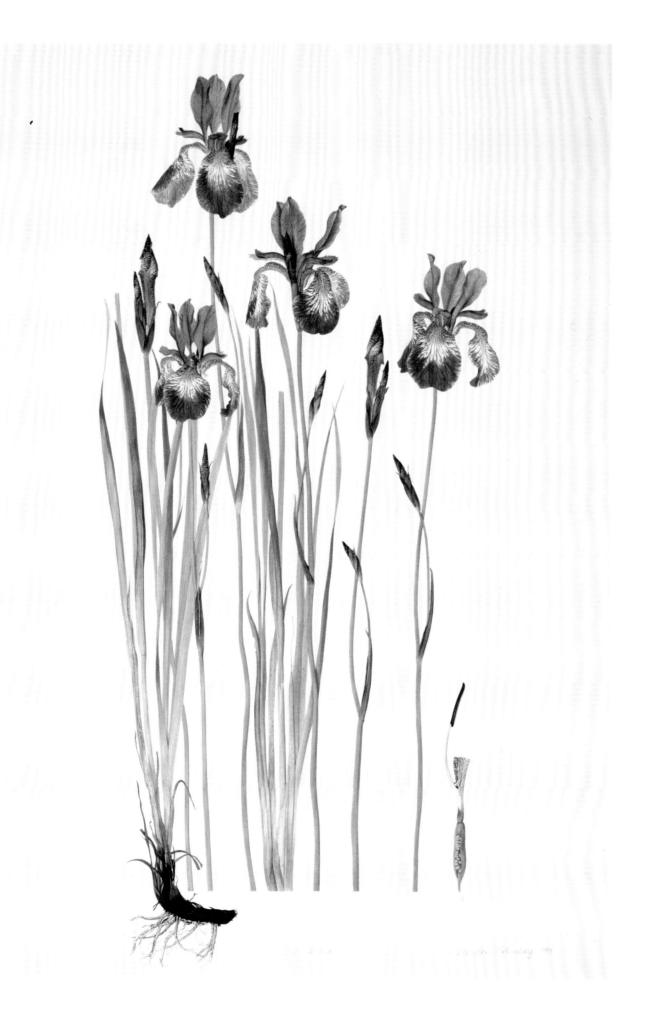

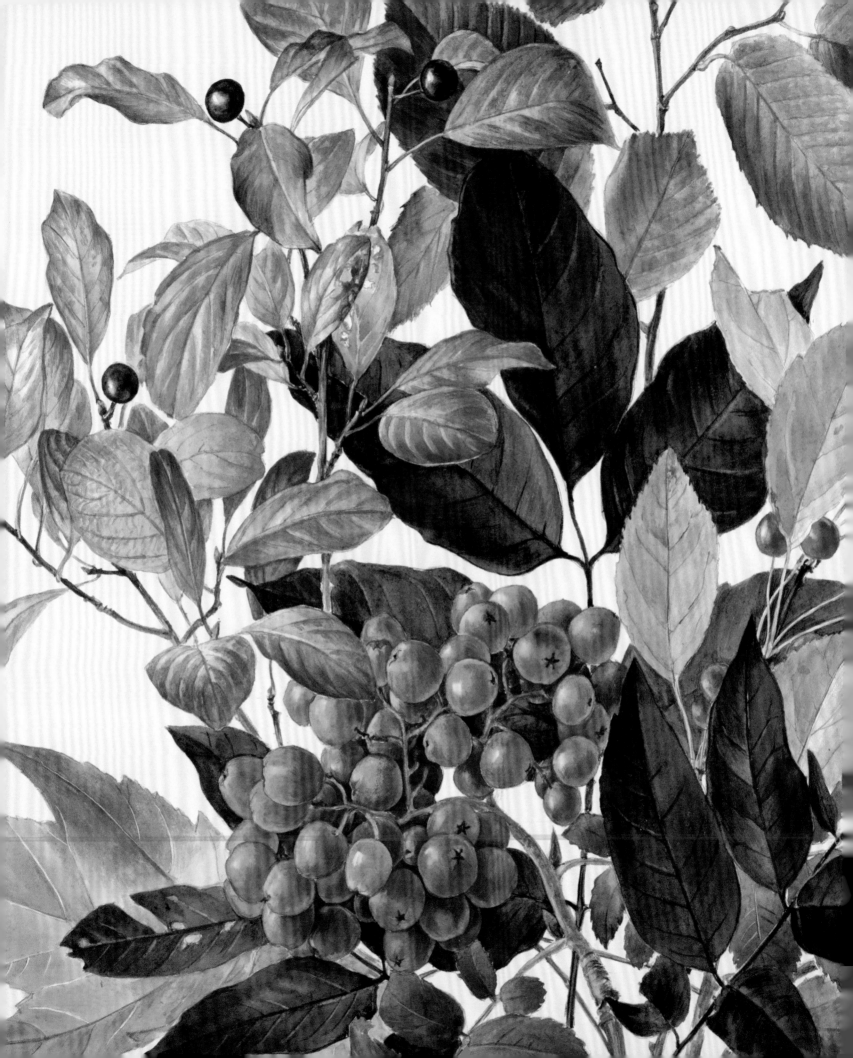

North America

North America

MY FIRST CONTACTS in the north American scene of botanical art were in 1991. I met Katie Lee by chance in New York Botanical Garden (NYBG) taking down an exhibition and visited her home soon afterwards. I also bought a beautiful portrait of a crown imperial fritillary from Shepherd's Gallery in New York by Jessica Tcherepnine, who also became a friend. I had decided that I 'dared' collect away from my familiar hunting ground at Kew and the RHS and made up my own mind, from that time onwards. I met Francesca Anderson and she introduced me to Brooklyn Botanic Garden where local artists started a florilegium, documenting the plants in the gardens with a watercolour portrait. Some of these paintings were eventually shown in an exhibition of the florilegium's work in the Shirley Sherwood Gallery.

Anne Ophelia Dowden (1907–2007) was the earliest groundbreaking US artist during and after World War II, marking her career with a series of illustrated books encouraging children to look at nature. I treasure my three works from her, two as gifts in 1998 when I visited her in Boulder, Colorado. By then I had mounted a number of exhibitions in the States, and Anne understood my 'mission' to promote botanical art.

Rather surprisingly, Jonathan Cooper's Gallery in Chelsea, London proved an introduction to the Canadian artist Pamela Stagg and later to Kate Nessler, one of the most outstanding American artists, especially on vellum. Another already established artist was Katherine Manisco. Born in Britain she lives between New York and Italy. I acquired paintings in New York, my first being a sunflower in 1992. The one illustrated here was from the Colnaghi Gallery in New York.

I collected the strong, dramatic paintings of Leslie Berge from 1992 until after her death in 2017. She was particularly effective executing the symmetry of cycads and, at my urging, she visited Kirstenbosch, the botanical gardens in the Cape, to see the best collection of cycads in the world. Her gift to me of the Moth Protea was admired for its extreme rarity as well as her treatment of its hairy leaves.

Currently, I have no doubt that the American Society of Botanical Artists (ASBA) is one of the most active societies in the field today. Its magazine is particularly useful and its instigation of Botanical Art Worldwide Day in 2018, led by the orchid artist Carol Woodin, was a marvel of organisation, linking 25 countries in a digital display of 40 native plant portraits from each country. It uncovered the work of many new artists and showed a number of fascinating and unfamiliar species.

Various botanic gardens created their own florilegium societies. Brooklyn Botanic Garden showed the works of Francesca Anderson, Dick Rauh and others, while the NYBG in conjunction with the ASBA hung many exhibitions with entries from abroad as well as local artists' work.

My introduction to Ingrid Finnan came in the *Green Currency* exhibition when I acquired her Common Ginger in New York, while I commissioned her most recent work Snake Branch Spruce for the 2018 exhibition *Trees: Delight in the Detail* in the Shirley Sherwood Gallery.

The US is so large that the ASBA has created a number of regional chapters. One of the most interesting is in Denver, Colorado. I put on a large exhibition in the Denver Art Museum in 2002/03, which sparked a lot of enthusiasm. The teaching there is by Mervi Hjelmroos-Koski and the focus is on the Rocky Mountain flora. Another lively group is in California, orchestrated by Catherine Watters at the Filoli gardens.

Angela Mirro went on an authorised expedition in Peru to document a newly discovered orchid with remarkably enormous pink flowers. *Phragmipedium kovachii* had hit the headlines by being illegally smuggled out of Peru to Florida by the orchid collector Michael Kovach in 2001. Angela painted the first portrait of this spectacular and legally sourced plant in a village high up in the Andes where she had waited for the flower to open. I saw the painting and the recently cultivated plants bred by Alfredo Manrique in Lima at the Peruvian Orchid Society in 2003. I was so intrigued that I commissioned Carol Woodin to paint me a life-sized flower when she was in Peru in 2004.

I have been occasionally involved with the ASBA's New York exhibitions and have acquired the work of currently active artists such as Ingrid Finnan, Joan McGann, Jean Emmons and Monika de Vries Gohlke. One of the major influences of my collecting in the States was that I became a member of the Advisory Board of the National Museum of Natural History, Smithsonian. This meant that I went to Washington at least twice a year, usually from New York, so I saw a good range of material in New York and Washington exhibitions and galleries. I also had a big exhibition there in 2003 visited by half a million people.

Francesca Anderson
Cyclamen: *Cyclamen persicum* **1992**
Pen and ink 730 x 580 mm
From the artist 1993
[Shirley Sherwood Collection 213]

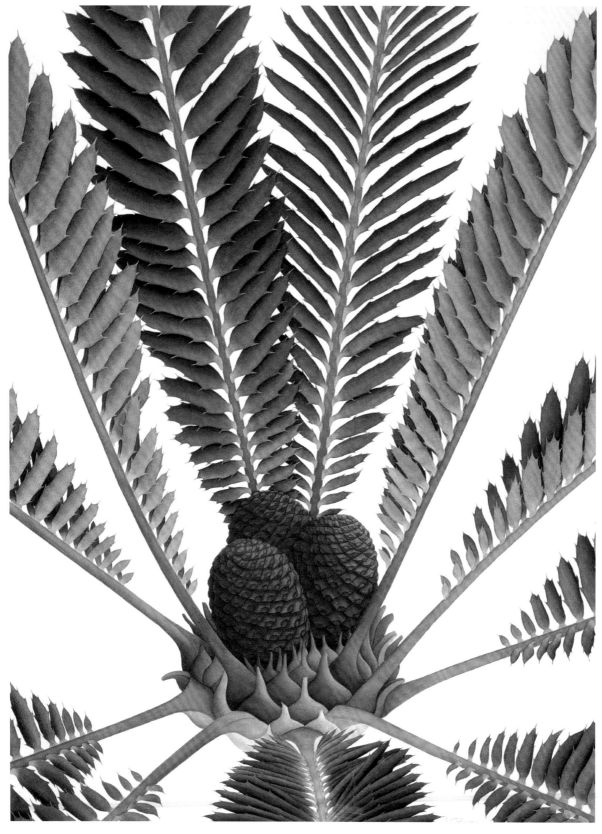

Leslie Carol Berge
Cycad: Female Cones of *Encephalartos ferox* 1998
Watercolour and pencil 700 x 510 mm
From the Tryon & Swann Gallery 1998
It has extremely sharp points to the end of its leaves.
[Shirley Sherwood Collection 340]

Leslie Carol Berge
Bushman's River Cycad: *Encephalartos trispinosus* 2001
Watercolour on paper 390 x 290 mm
From the artist's family 2018
A silvery blue leaved cycad from the Cape, used in horticulture. The painting was a gift from the artist's family after her death.
[Shirley Sherwood Collection 942G]
→

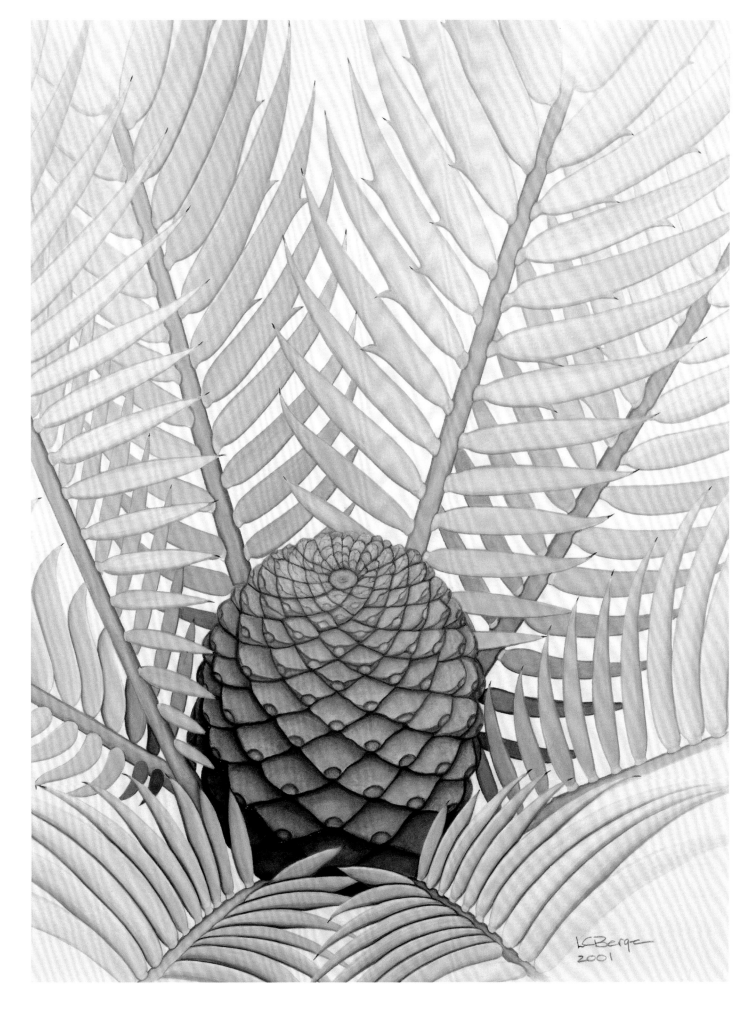

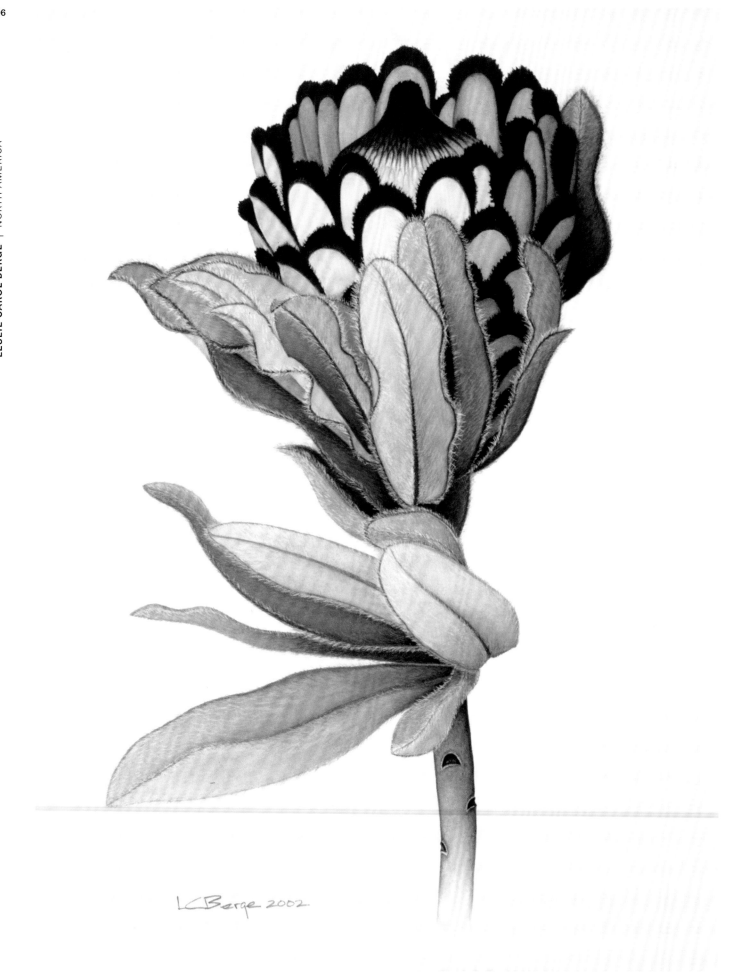

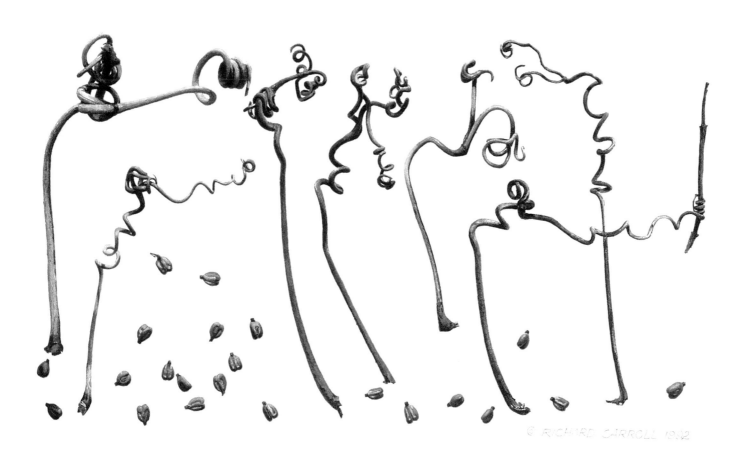

Leslie Carol Berge
Moth Protea: *Protea holosericea* 2002
Watercolour on paper 410 x 300 mm
From the artist 2004
A very rare South African protea, identified from the painting by Kirstenbosch's librarian.
[Shirley Sherwood Collection 557G]
←

Richard Carroll
Grape Tendrils: *Vitis vinifera* 1992
Egg tempura on Arches paper
140 x 240 mm
From the artist's daughter 2013
The seeds are dispersed by birds, rodents and pigs after being eaten and excreted. The painting was a gift from the artist's daughter, following his death.
[Shirley Sherwood Collection 854]

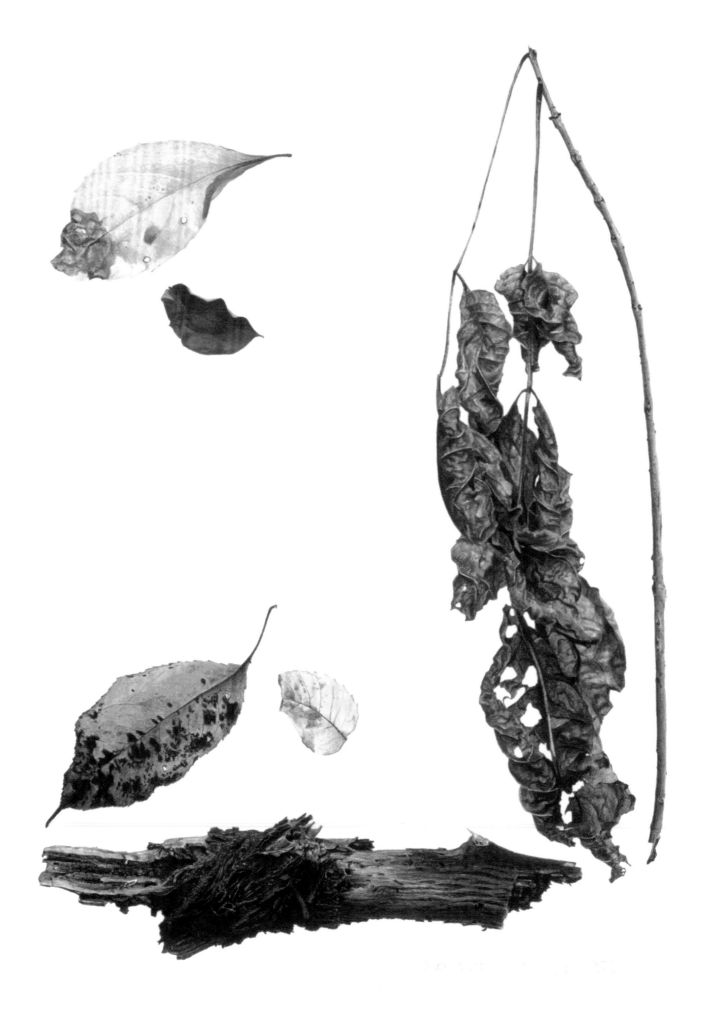

Richard Carroll
Almost Like Spinach 1990
Egg tempura 240 x 180 mm
From the artist 1992
[Shirley Sherwood Collection 053]
←

Monika de Vries Gohlke
Latania loddegesii
Watercolour on paper 500 x 340 mm
From the artist 2011
[Shirley Sherwood Collection 788G]

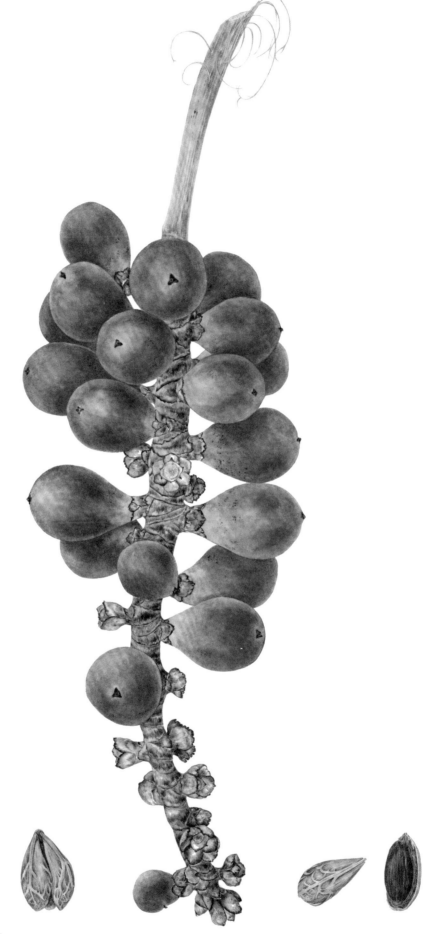

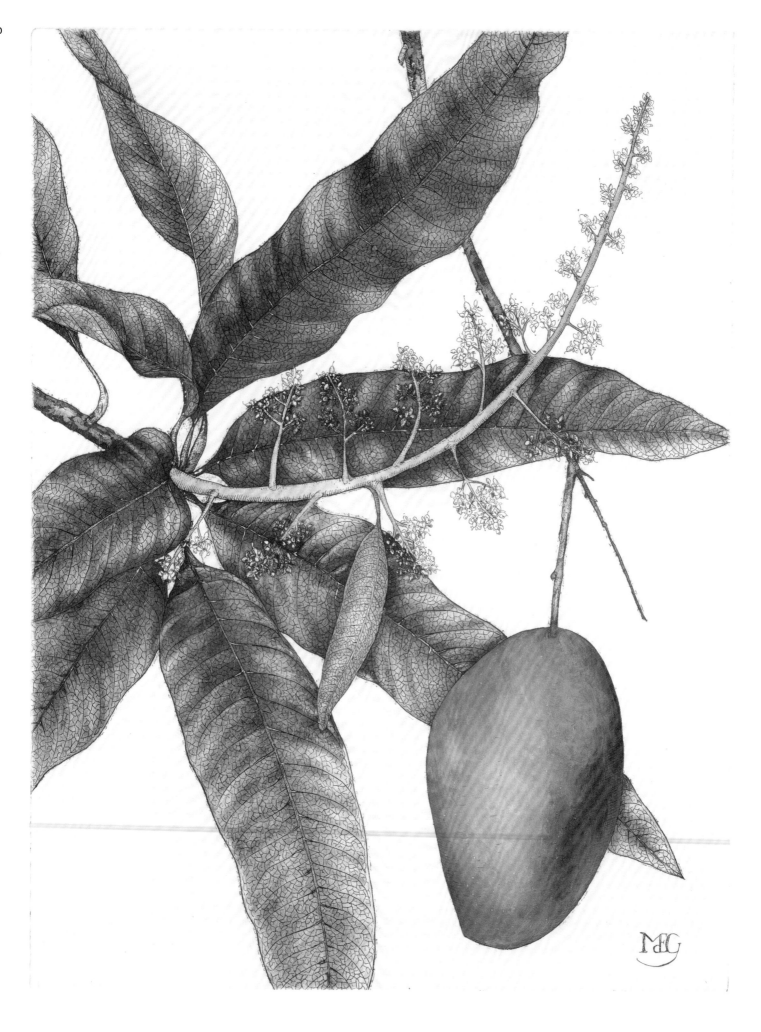

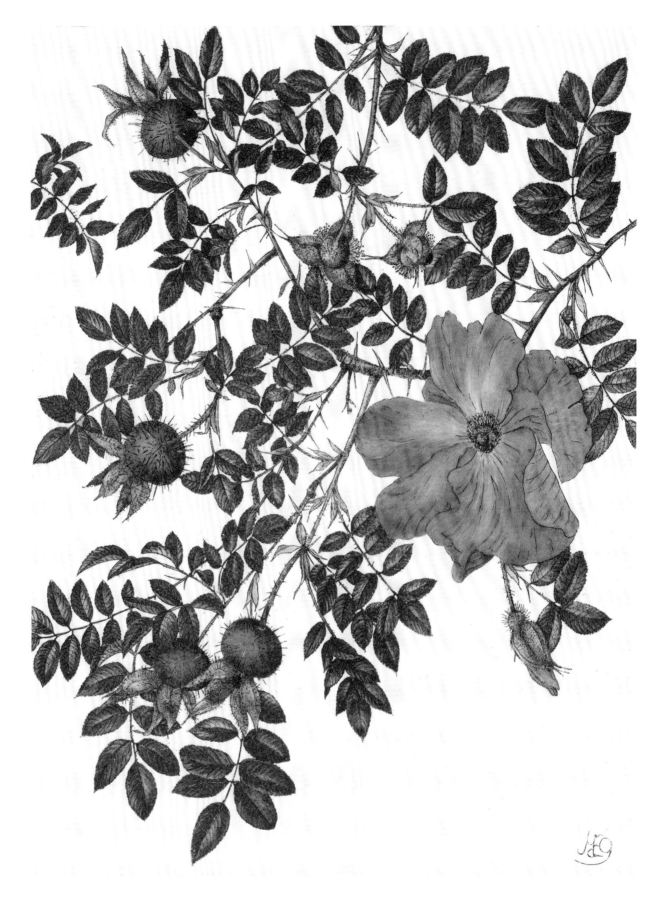

Monika de Vries Gohlke
Mangifera indica
Copper plate etching on paper, hand painted aquatint 380 x 280 mm
From the artist 2010
[Shirley Sherwood Collection 773]

Monika de Vries Gohlke
Rosa micrugosa
Copper plate etching on paper, hand painted aquatint 380 x 280 mm
[Shirley Sherwood Collection 776]

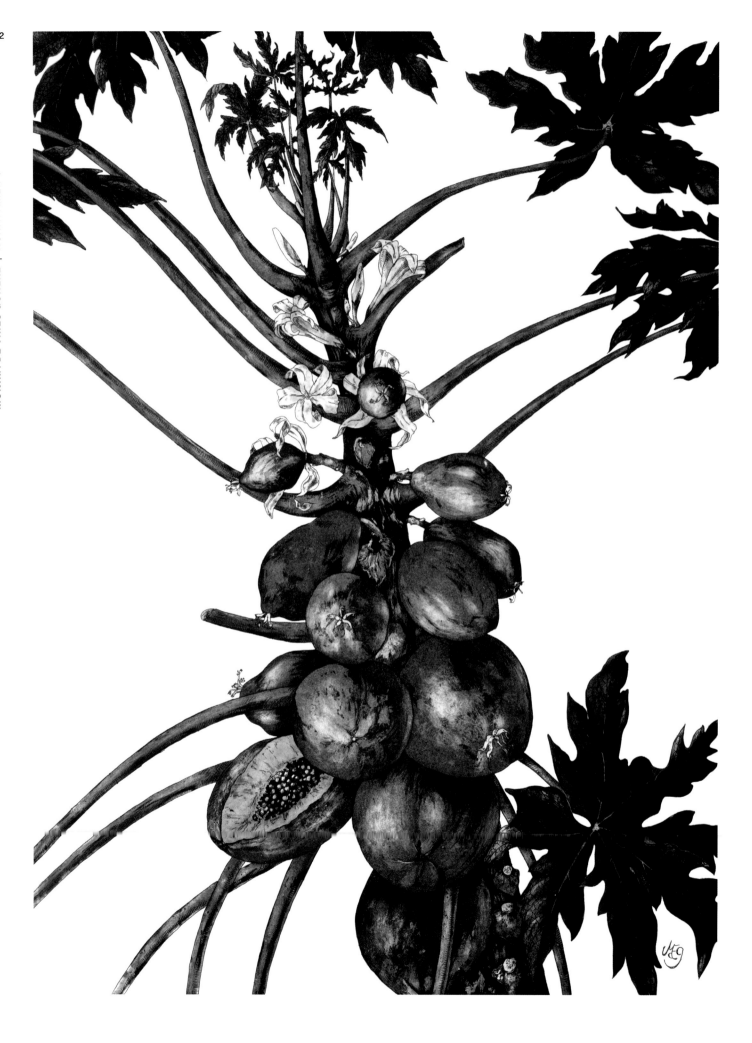

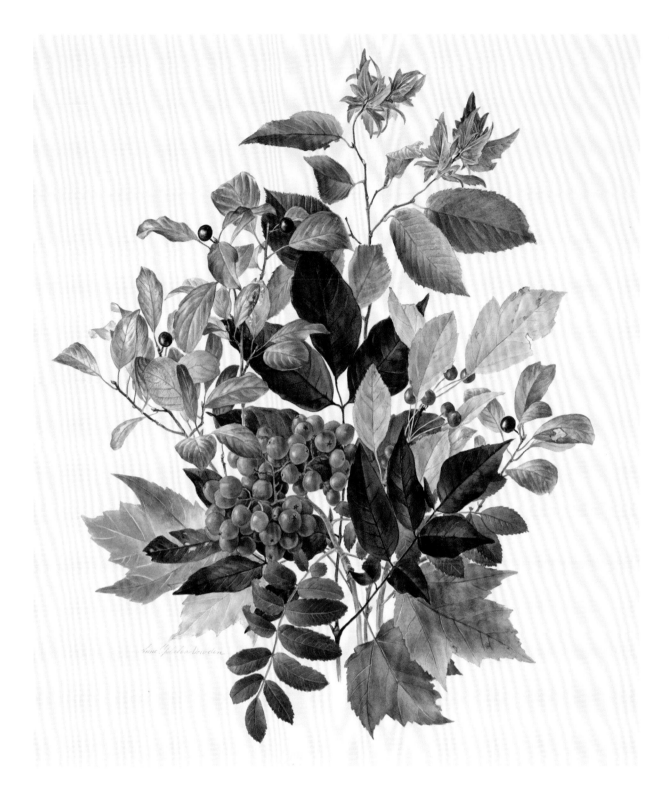

Monika de Vries Gohlke
Papaya: *Carica papaya* 2011
Hand coloured aquatint etching
600 x 450 mm
From the ASBA show 2012
Copper-plate etching is an old technique which Gohlke uses in a very modern way, with strong and memorable design. The seeds of this fruit are now dispersed by bats and pigs, but may possibly have originally adapted to be dispersed by extinct ice age mammals in the Americas.
[Shirley Sherwood Collection 841]
←

Anne Ophelia Dowden
Autumn Foliage & Berries
Watercolour on paper 500 x 390 mm
From the artist 1998
[Shirley Sherwood Collection 329]

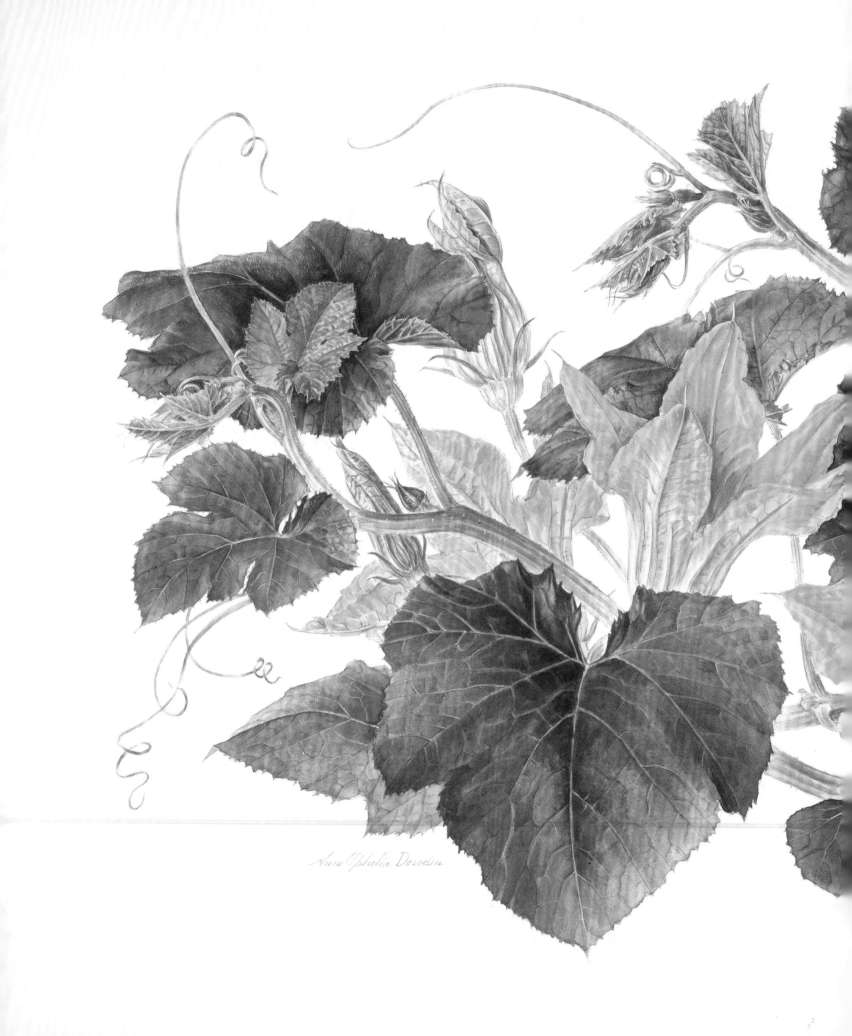

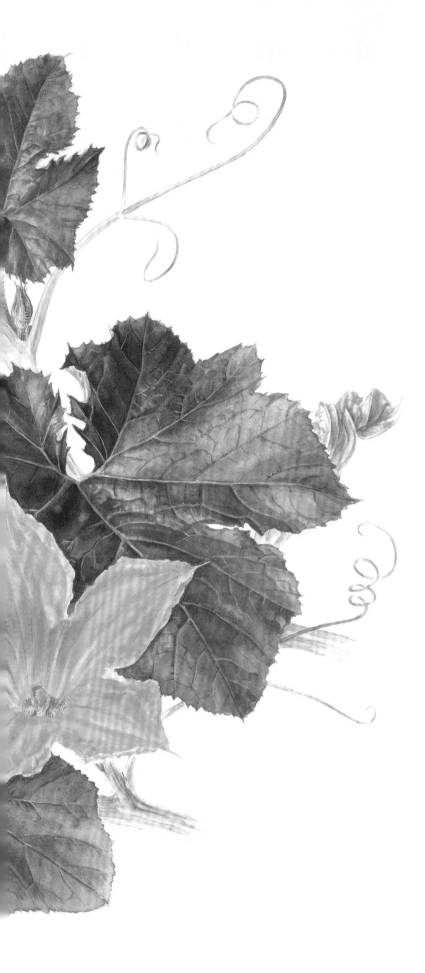

Anne Ophelia Dowden
Squash Blossom: *Cucurbita pepo* **1978**
Watercolour on paper 350 x 460 mm
From the artist 1994
[Shirley Sherwood Collection 171]

JEAN EMMONS | NORTH AMERICA

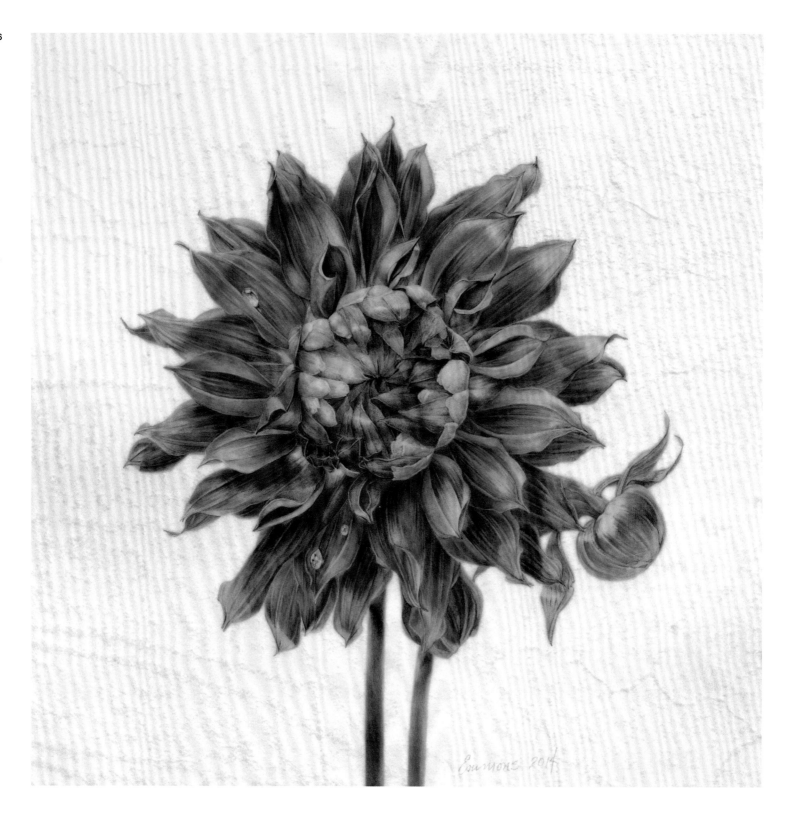

Jean Emmons
Dark Dahlia 'Rip City' 2014
Watercolour on vellum 160 x 167 mm
From the artist 2014
[Shirley Sherwood Collection 893]

Jean Emmons
Celeriac III: *Apium graveolens* var. *rapaceum* 2008
Watercolour on vellum stretched over board 310 x 240 mm
From the artist 2008
[Shirley Sherwood Collection 687]
→

Jean Emmons
Toadstool and Berries 2018
Watercolour on paper 145 x 100 mm
From the artist 2018
[Shirley Sherwood Collection 927G]

Ingrid Finnan
Snake Branch Spruce: *Picea abies*
'Virgata' 2018
Oil on paper 460 x 355 mm
Commissioned 2018
[Shirley Sherwood Collection 986]
→

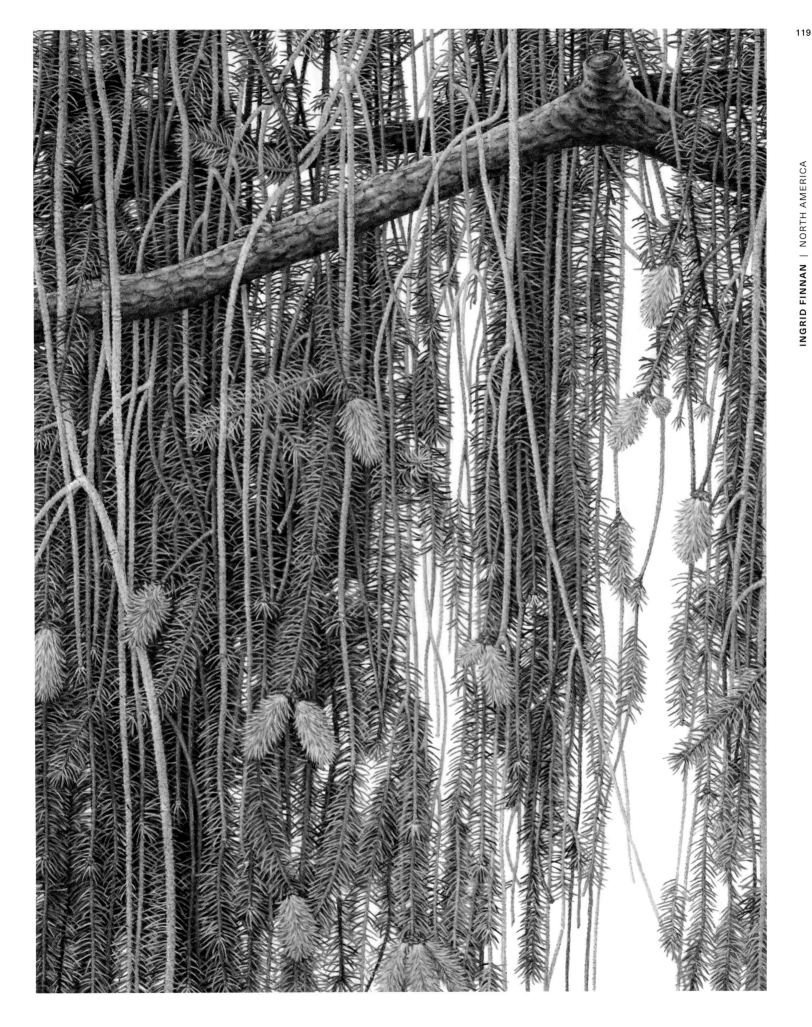

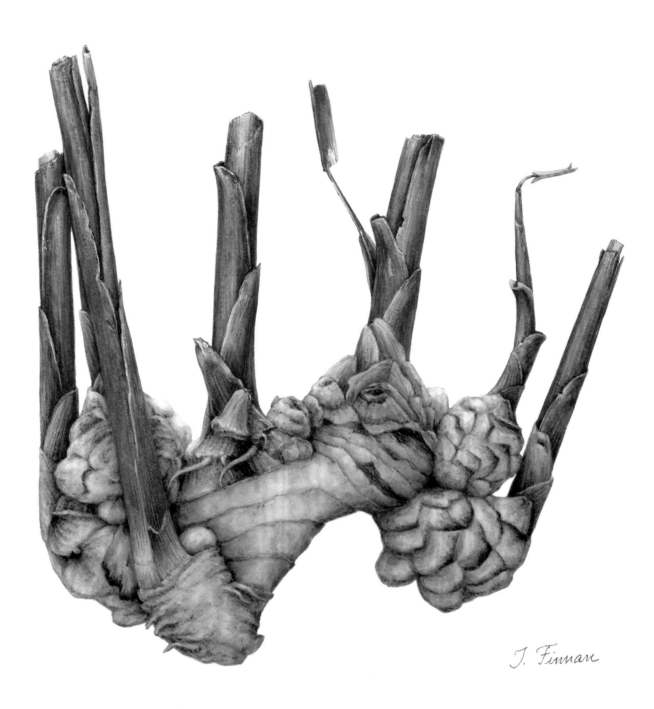

Ingrid Finnan
Common Ginger: *Zingiber officinale*
2010
Oil on paper prepared with gesso
300 x 330 mm
From the *Green Currency* exhibition,
New York 2011.
[Shirley Sherwood Collection 783]

Ingrid Finnan
White Bat Flower: *Tacca nivea* 2013
Oil on 600 gsm Fabriano Artistico paper
prepared with gesso 580 x 485 mm
From the artist 2014
[Shirley Sherwood Collection 862]
→

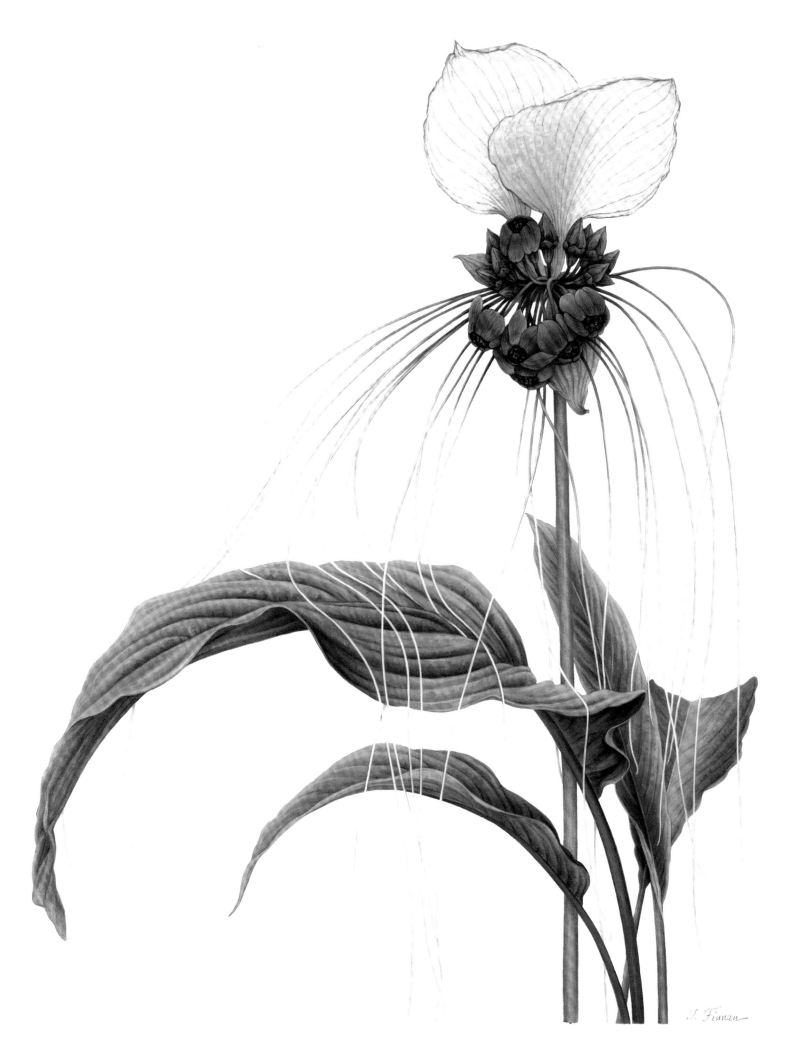

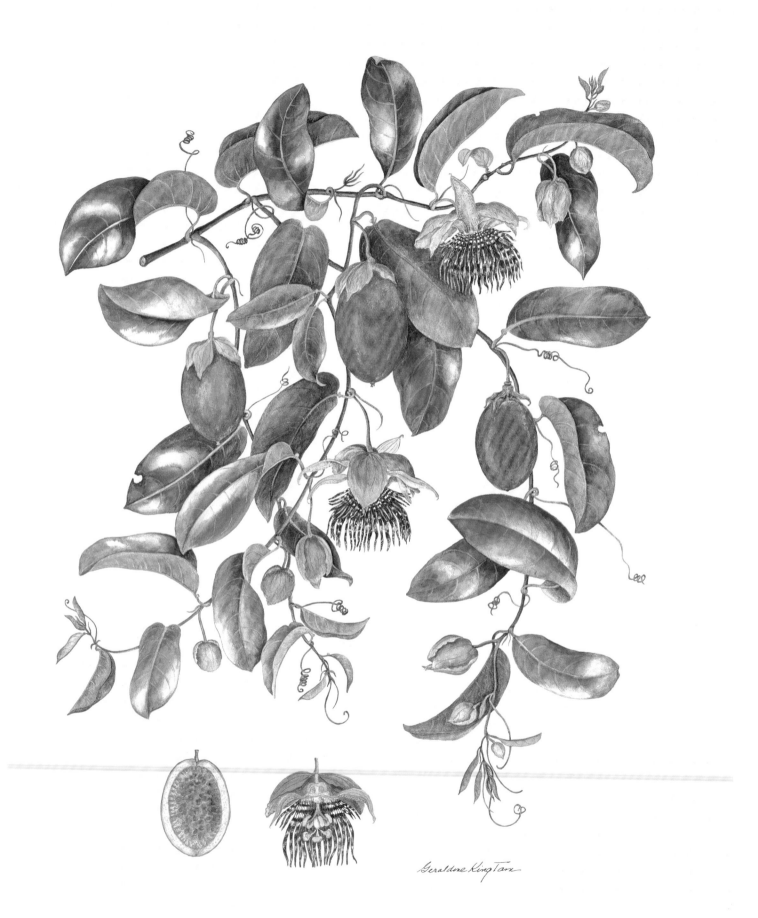

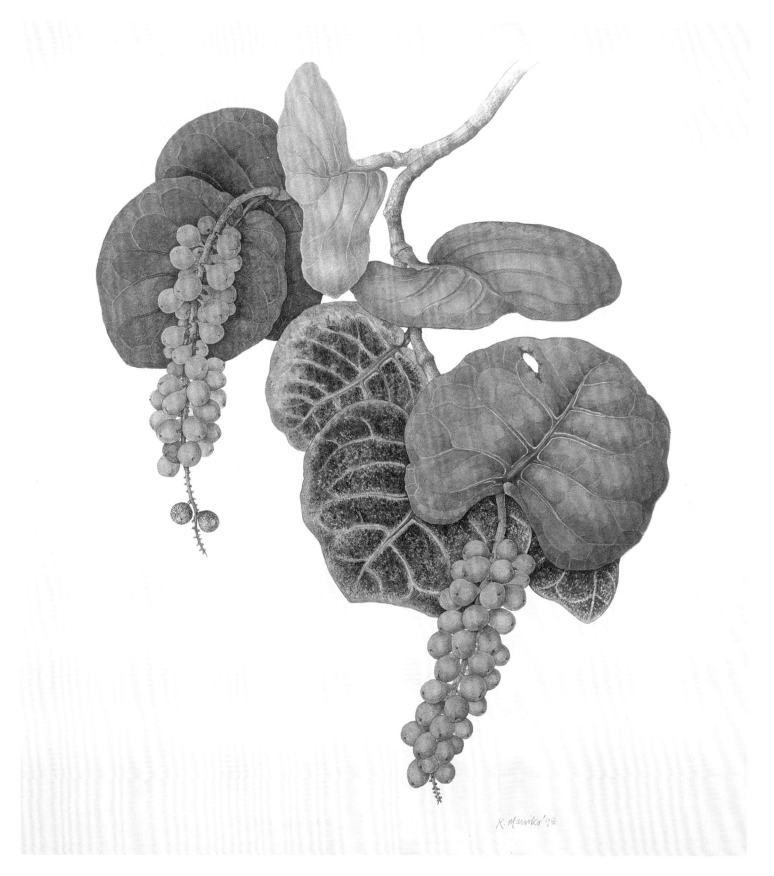

Geraldine King Tam
Passiflora laurifolia 1995
Watercolour on paper 610 x 510 mm
From the artist 2000
This tropical rainforest plant climbs into trees and produces edible fruit.
[Shirley Sherwood Collection 408]
←

Katherine Manisco
Sea Grapes: *Coccoloba uvifera* 1998
Watercolour on paper 475 x 406 mm
From Colnaghi Gallery 2003
[Shirley Sherwood Collection 485]

JOAN McGANN | NORTH AMERICA

Joan McGann
Crested Saguaro: *Carnegiea gigantea* forma *cristata* 2013
Pen and ink on paper 430 x 635 mm
From the ASBA show 2014
The crest on the cactus only appears after about a century of growth.
[Shirley Sherwood Collection 878]

Angela Mirro
Phragmipedium kovachii 2003
Watercolour on paper 740 x 575 mm
From the artist 2003
The first painting of this spectacular orchid discovered in the Andes, north-east Peru, in 2001.
[Shirley Sherwood Collection 506]
→

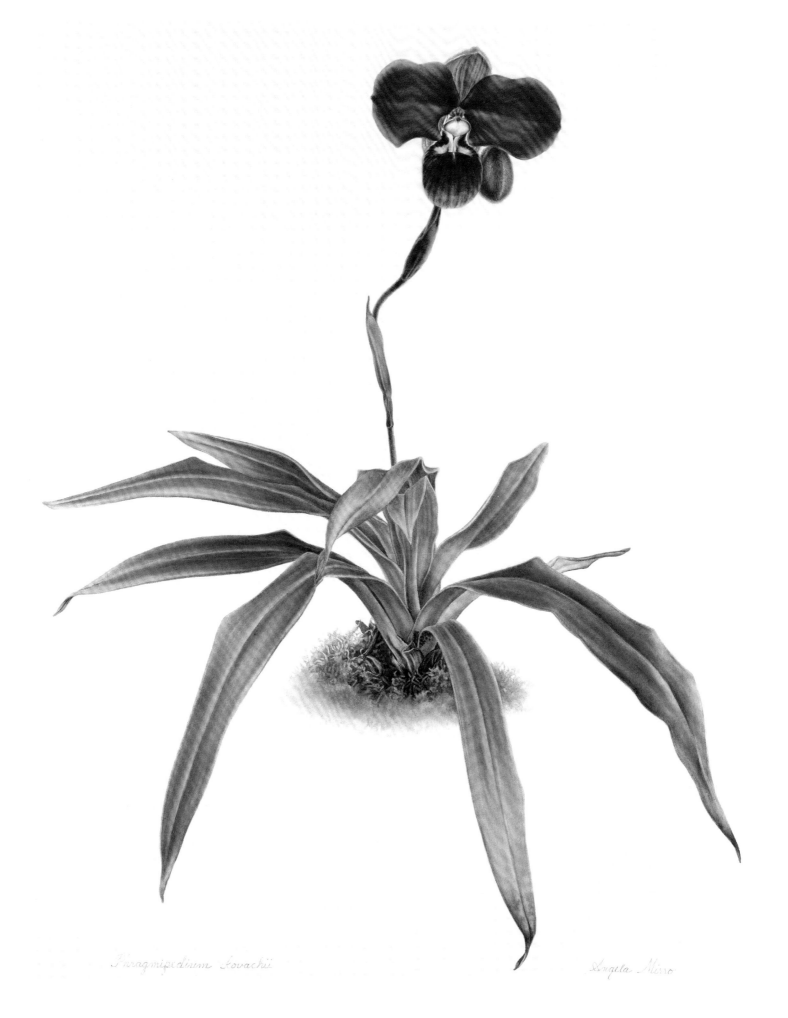

Phragmipedium kovachii

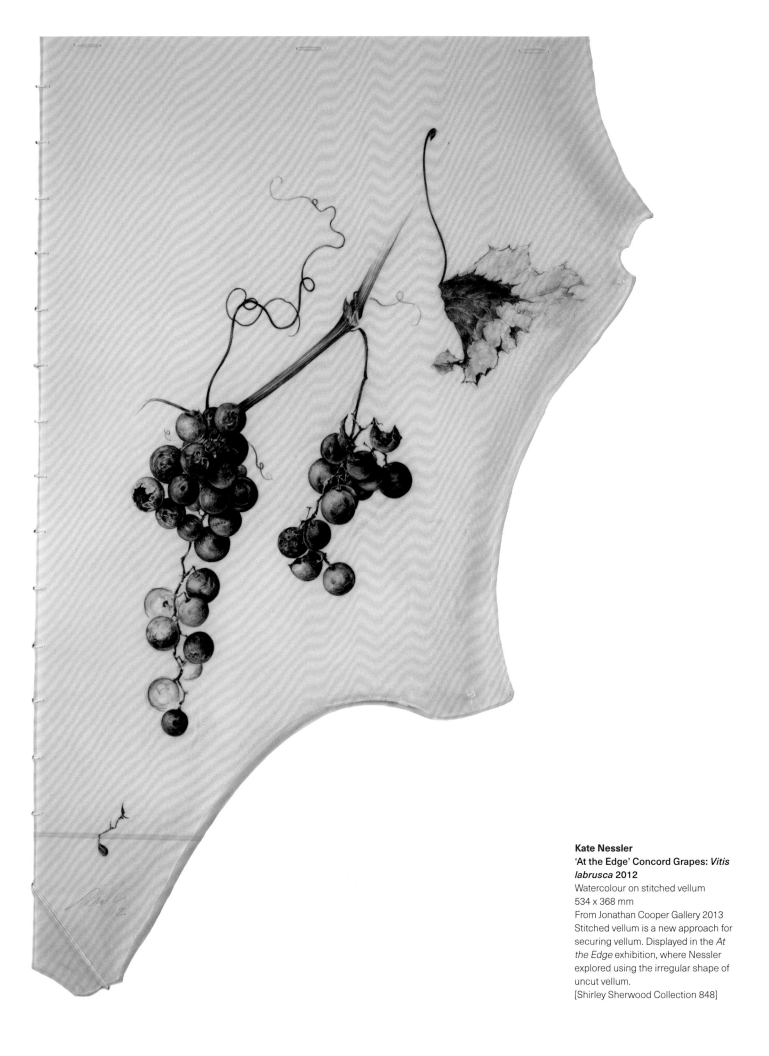

Kate Nessler
'At the Edge' Concord Grapes: *Vitis labrusca* **2012**
Watercolour on stitched vellum
534 x 368 mm
From Jonathan Cooper Gallery 2013
Stitched vellum is a new approach for securing vellum. Displayed in the *At the Edge* exhibition, where Nessler explored using the irregular shape of uncut vellum.
[Shirley Sherwood Collection 848]

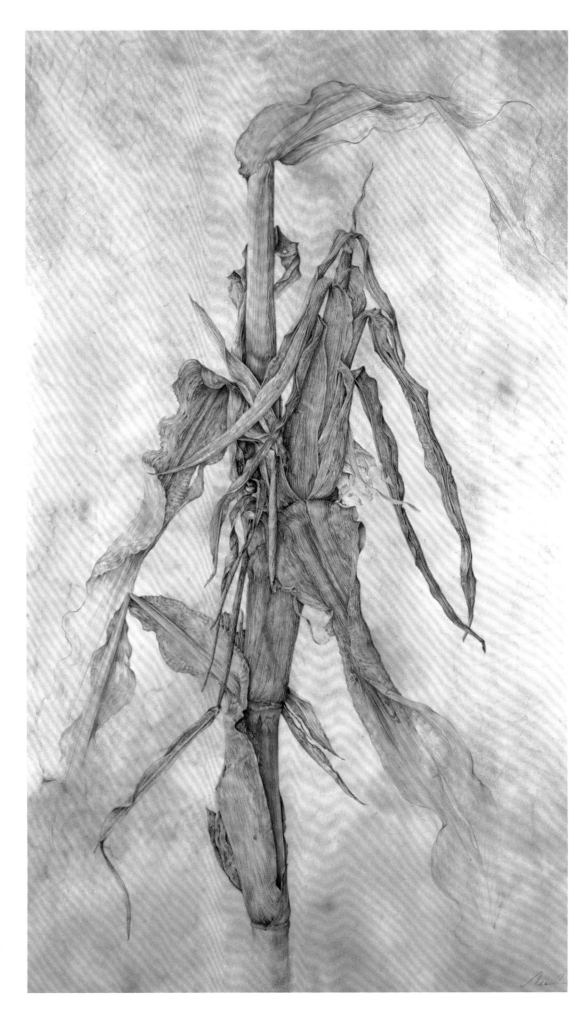

Kate Nessler
Corn: *Zea mays* **2006**
Watercolour on vellum 762 x 483 mm
From Jonathan Cooper Gallery 2006
Naturally stained vellum was deliberately chosen by Nessler for this evocative portrait of corn at the end of the season.
[Shirley Sherwood Collection 632]

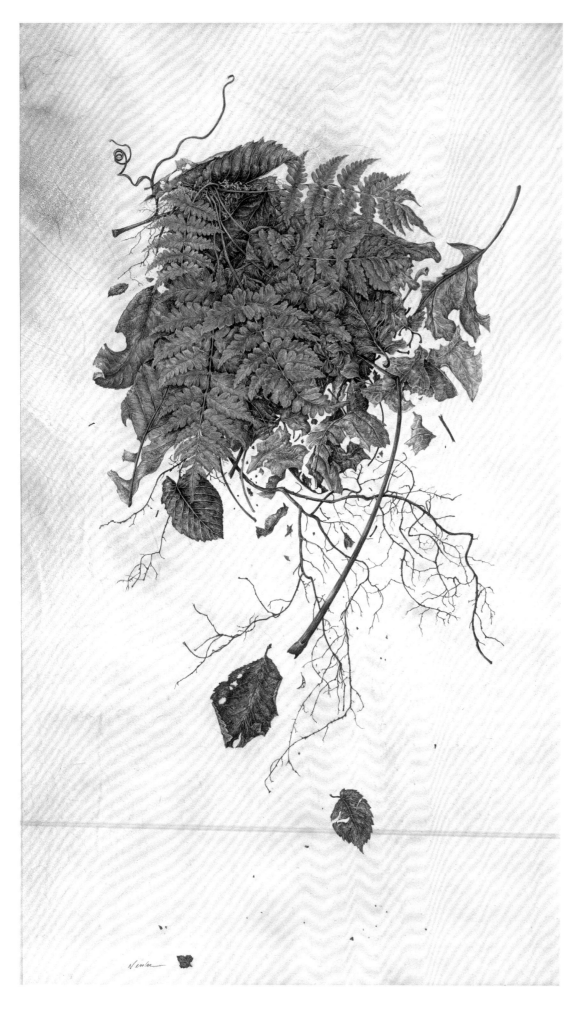

Kate Nessler
Fern 2000
Watercolour & body colour on vellum
480 x 275 mm
From Jonathan Cooper Gallery 2001
[Shirley Sherwood Collection 442]

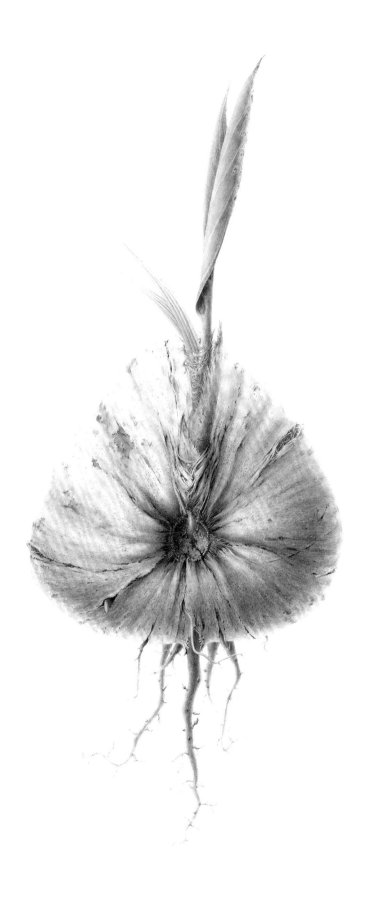

Hillary Parker
Emerging Seedling, Coconut Palm:
Cocos nucifera **2017**
Watercolour on paper 580 x 360 mm
From the artist 2018
[Shirley Sherwood Collection 976]

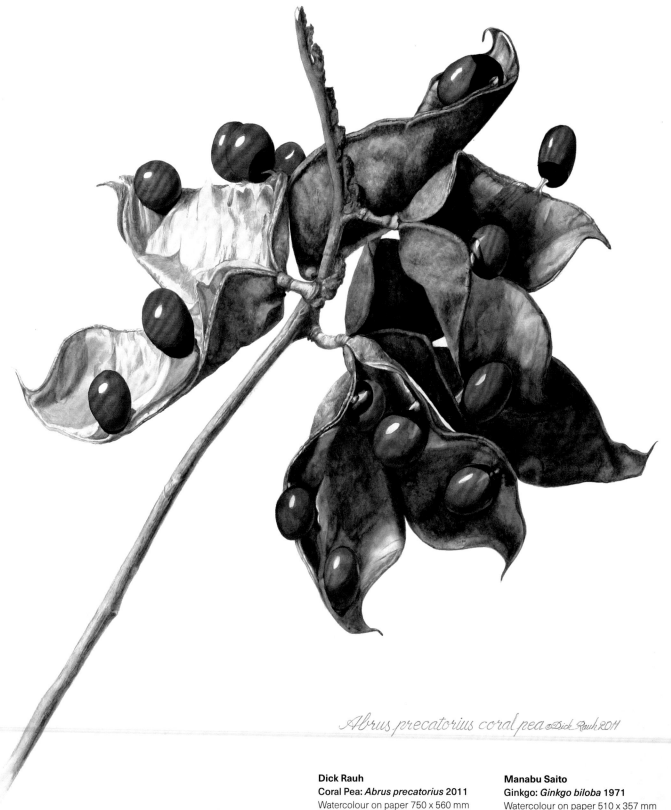

Abrus precatorius coral pea ©Dick Rauh 2011

Dick Rauh
Coral Pea: *Abrus precatorius* 2011
Watercolour on paper 750 x 560 mm
From the artist 2015
Displayed at a solo show in Brooklyn Botanic Garden. The plant's poisonous seed is dispersed by birds.
[Shirley Sherwood Collection 892]

Manabu Saito
Ginkgo: *Ginkgo biloba* 1971
Watercolour on paper 510 x 357 mm
From the artist 1996
[Shirley Sherwood Collection 254]

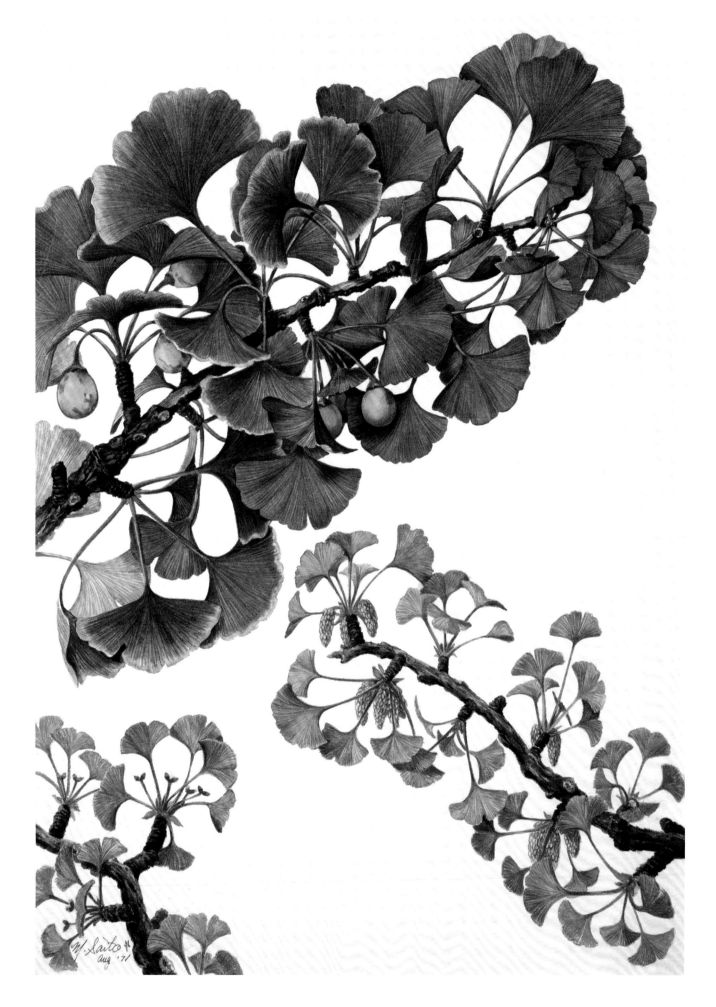

Alice Tangerini
Globba sherwoodiana 2012
Watercolour on paper 640 x 420 mm
Gift from the artist 2012
This ginger was named for me by Dr W John Kress and the National Museum of Natural History, Smithsonian, where I was on the Board for 10 years.
[Shirley Sherwood Collection 825]

Jessica Tcherepnine
Cocos nucifera 2005
Watercolour on paper 700 x 595mm
From Harris Lindsay Gallery 2005
A strong and memorable study.
[Shirley Sherwood Collection 626]
→

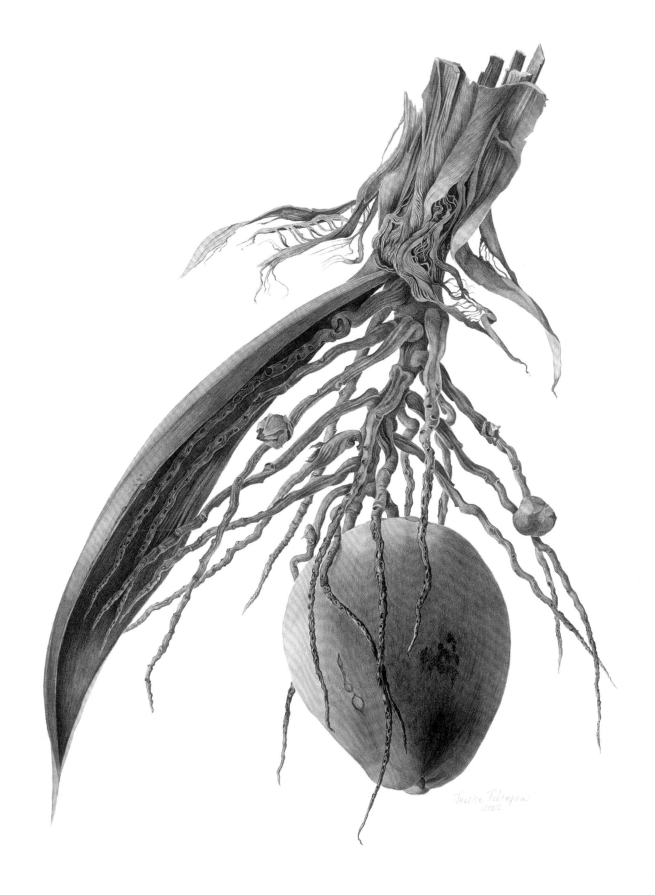

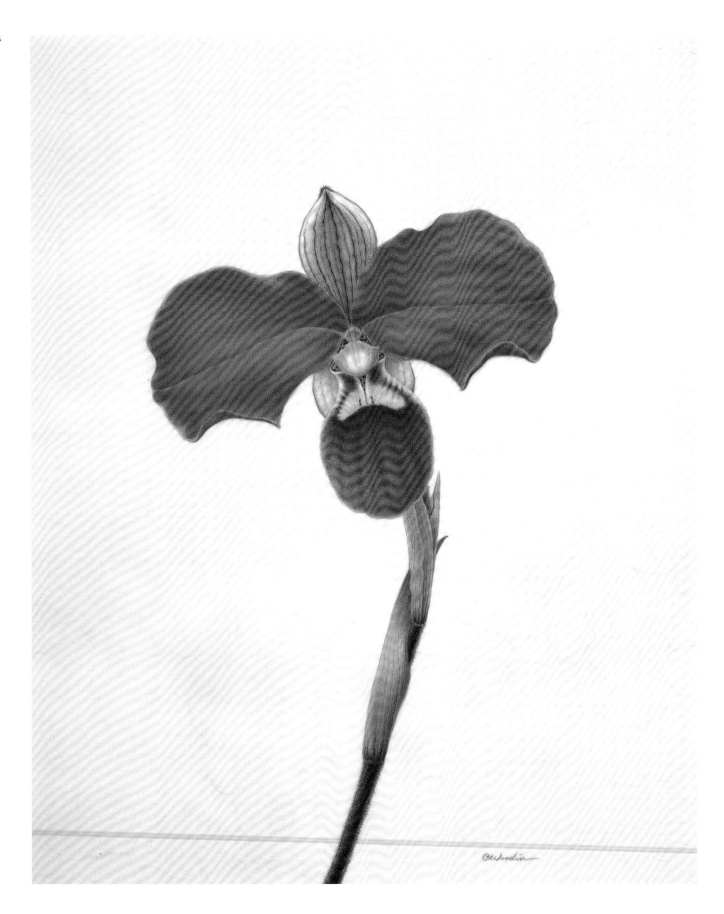

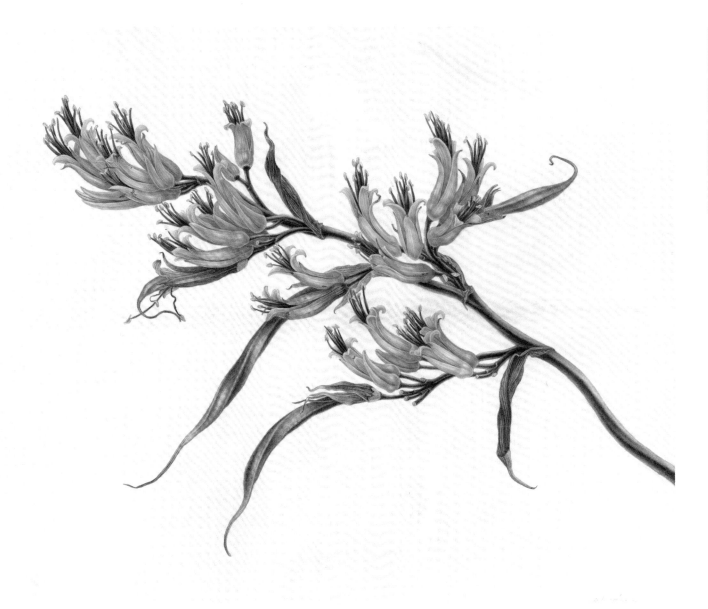

Carol Woodin
Phragmipedium kovachii 2004
Watercolour on vellum 370 x 320 mm
Commissioned, delivered 2005
This spectacular Peruvian orchid, discovered in 2001, is now being hybridised.
[Shirley Sherwood Collection 585]

Carol Woodin
New Zealand flax: *Phormium tenax* 2015
Watercolour on vellum 324 x 406 mm
From the artist 2014
Exhibited at the Jonathan Cooper Gallery in 2014.
[Shirley Sherwood Collection 917]

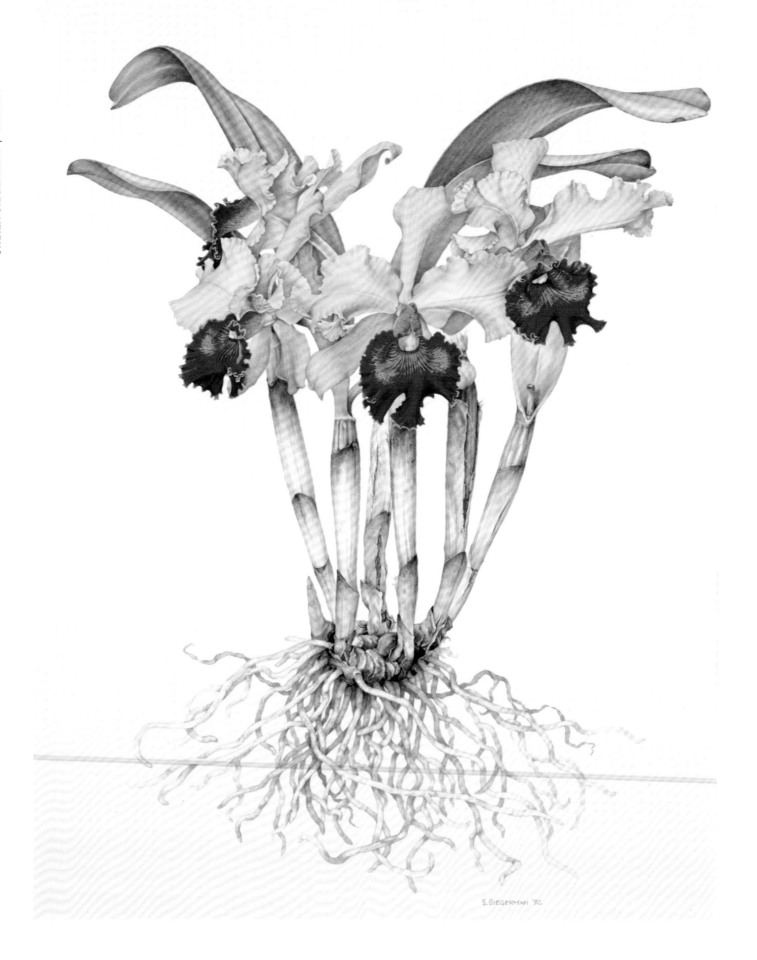

PAMELA STAGG | CANADA

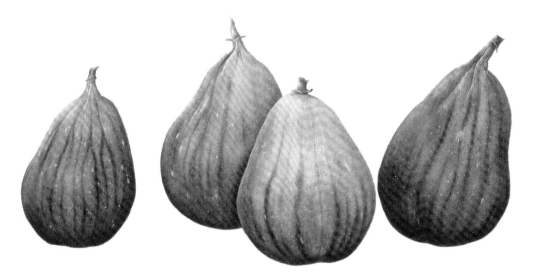

Sheila Siegerman
Amber Glow: *Laeliocattleya* 1992
Watercolour on paper 650 x 485 mm
From the artist 1993
[Shirley Sherwood Collection 072]
←

Pamela Stagg
Four Figs: *Ficus carica* 1993
Watercolour on paper 200 x 326 mm
From the Jonathan Cooper Gallery 1993
[Shirley Sherwood Collection 101]

Latin America

Latin America

THE ENGLISH WOMAN Margaret Mee (1909–1988) had a huge influence on the development of botanical art in Brazil. I have included her in this Latin American section as her work mainly concentrated on Amazonian plants. Her magnetic personality and superb work stimulated the Margaret Mee Fellowship Programme at Kew. Also very important were the Brazilian Demonte family who painted in the Atlantic Rainforest. They all wanted to save and protect the endangered flora of Brazil.

When Mee died in 1988 a large collection of her paintings came to Kew and the Margaret Mee Foundation was created to send promising Brazilian artists to Kew to train under the gifted teacher Christabel King. I used to see the students' work at the end of their stay at Kew and usually acquired some of their paintings for my collection. The students returned to Brazil and often taught others there, leading to a high standard of execution. We had an excellent exhibition in the Shirley Sherwood Gallery of Margaret Mee's work together with the work of the Margaret Mee scholars in 2016. In addition we showed a gallery of paintings by Etienne Demonte, his sisters Rosália and Yvonne and his sons André and Rodrigo Demonte.

One of the outstanding Brazilian artists today concentrates on the fruits, rather than the flowers that so captivated Margaret Mee. Álvaro Evandro Xavier Nunes often used to travel to Rio when I was visiting, bringing a portfolio of interesting paintings which I eventually hung in two separate galleries for the exhibition at Kew in 2016. He has collected his subjects from other areas of Brazil too, with works from the Cerrado and Pantanal.

I have not visited Brazil for some years, but there seems to be a concentration of excellence in Curitiba, as well as Rio, and that is where many of the artists who were involved with Botanical Art Worldwide in Brazil seem to be centred.

In 2010/11 I persuaded the Madrid botanical garden, Real Jardín Botánico de Madrid, to lend the Shirley Sherwood Gallery some of the originals of the Mutis group of historical studies of plants from Columbia, exhibiting them for the first time out of Spain.

In this Latin collection I have also included Mexico and the artist Elvia Esparza. I have two excellent paintings by her.

Elvia Esparza
Pelyecyphora aselliformis **1999**
Watercolour on board 360 x 500 mm
From the artist 2011
[Shirley Sherwood Collection 787]
←

Malena Barretto
Neoregelia magdalenae **1997**
Watercolour on paper 660 x 480 mm
From the artist 1999
Malena Barretto was the first artist scholar in the Margaret Mee Fellowship Programme, in 1989. This painting depicts a bromeliad endemic to Brazil.
[Shirley Sherwood Collection 350]

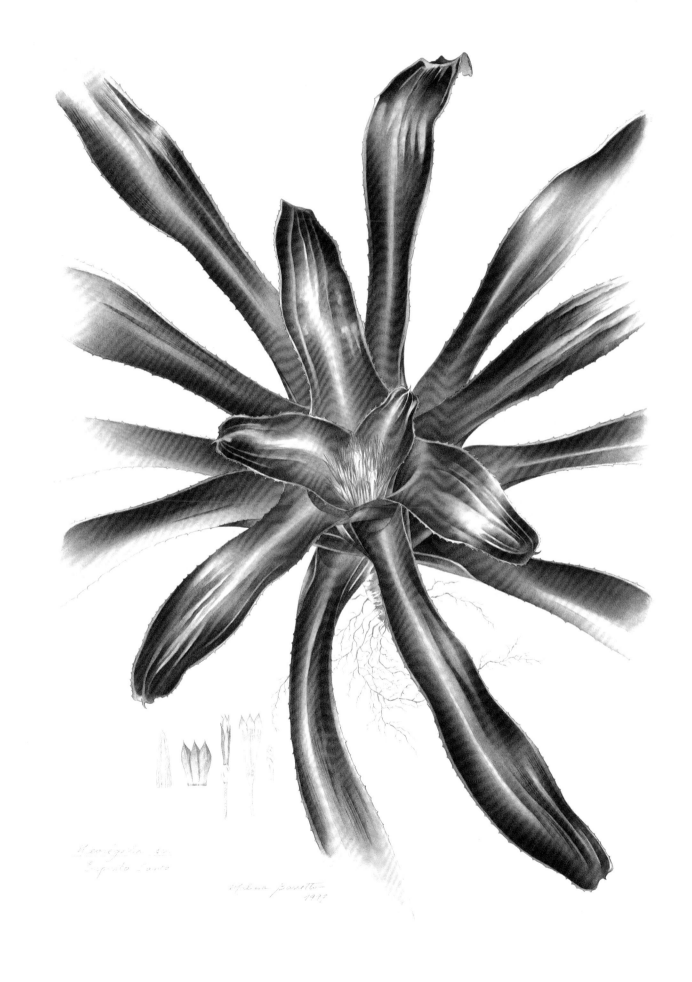

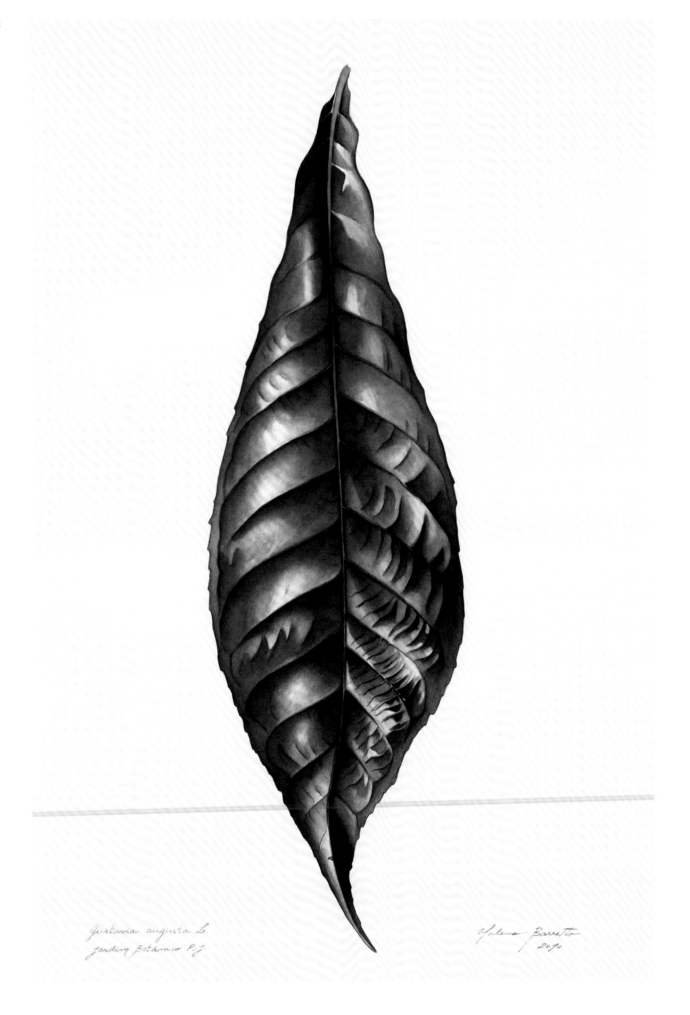

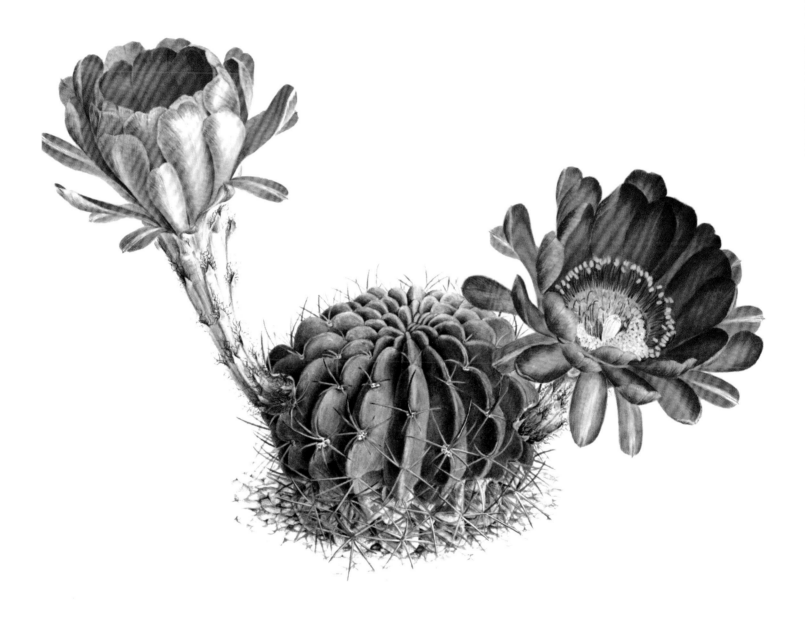

Malena Barretto
Leaf of *Gustavia augusta* 2010
Watercolour on paper 575 x 380 mm
From the artist 2010
[Shirley Sherwood Collection 771]
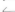

Alessandro Candido
Echinopsis ancistrophora 2016
Watercolour on paper 220 x 200 mm
From the artist 2016
Alessandro Candido was the Margaret Mee Fellowship artist scholar for 2016.
[Shirley Sherwood Collection 956]

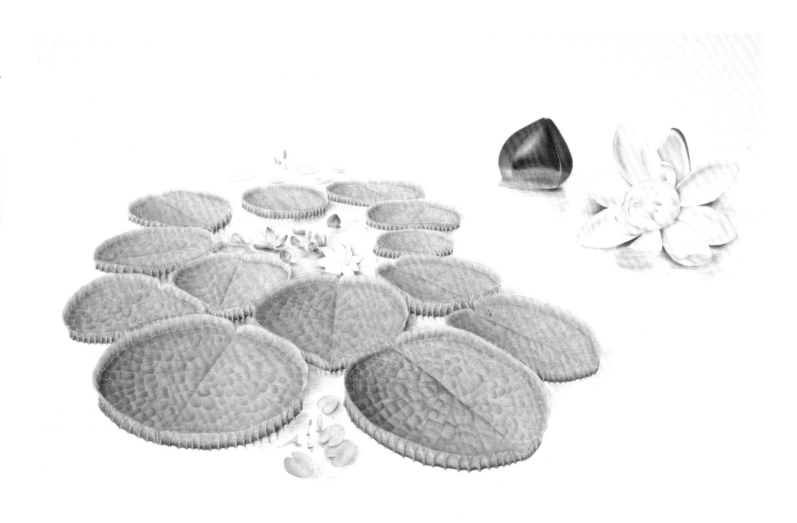

Maria Alice de Rezende
Victoria cruziana 2004
Watercolour on paper 455 x 665 mm
From the artist 2007
Native to S America
Maria Alice de Rezende, the Margaret
Mee Fellowship artist scholar for 2004,
painted this native South American
waterlily while at Kew.
[Shirley Sherwood Collection 673]

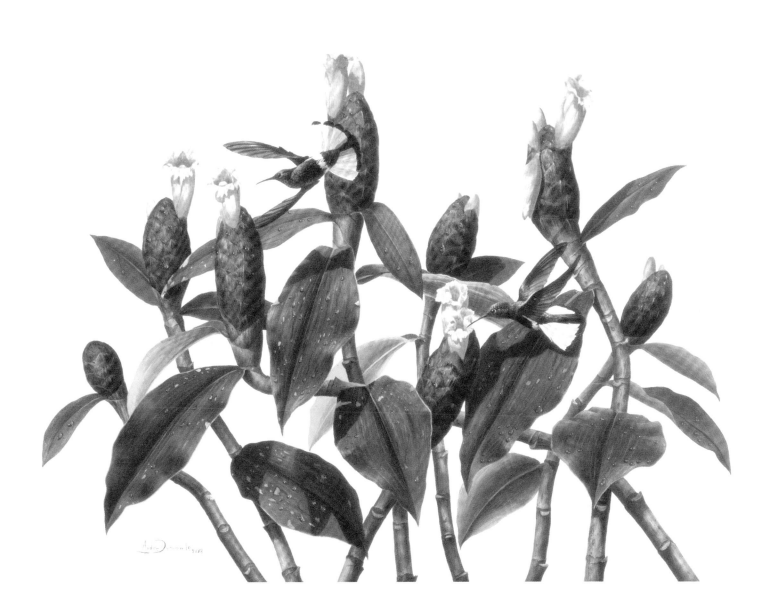

André Demonte
Costus spiralis and Black Jacobin Hummingbirds (*Florisuga fuscus*)
1998
Watercolour on paper 510 x 730 mm
From the artist 2010
A cultivated ginger from the West Indies. The hummingbirds are from eastern and south-central Brazil and were seen in the artist's garden near Rio de Janeiro.
[Shirley Sherwood Collection 766]

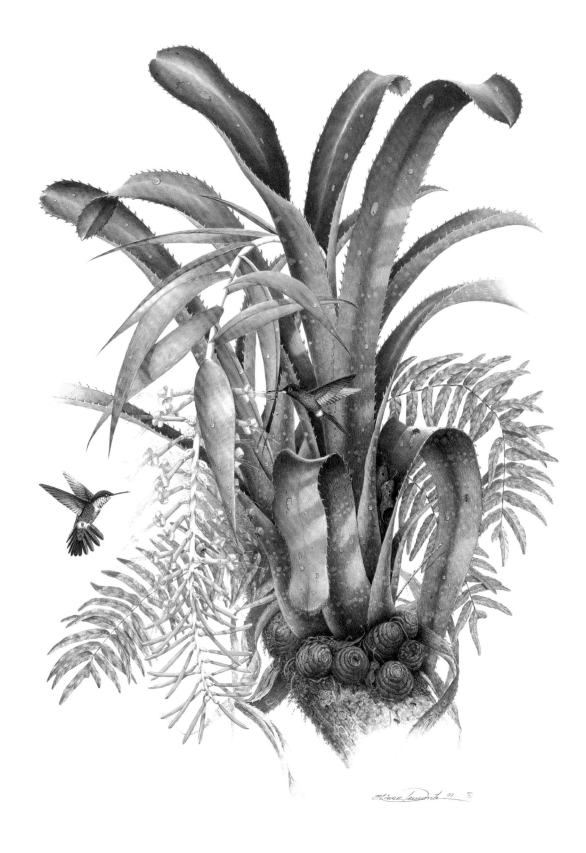

Etienne Demonte
Bilbergia sanderiana **and the White-Chinned Sapphire Hummingbird** *Hylocharis cyanus* **1997**
Gouache and watercolour on paper
700 x 480 mm
From Tryon & Swann Gallery 1998
[Shirley Sherwood Collection 342]

Rosália Demonte
Langsdorffia hypogaea **1992**
Gouache on vellum 550 x 410 mm
Commissioned 1992
A root parasite found in the Pantanal, Brazil.
[Shirley Sherwood Collection 042]
→

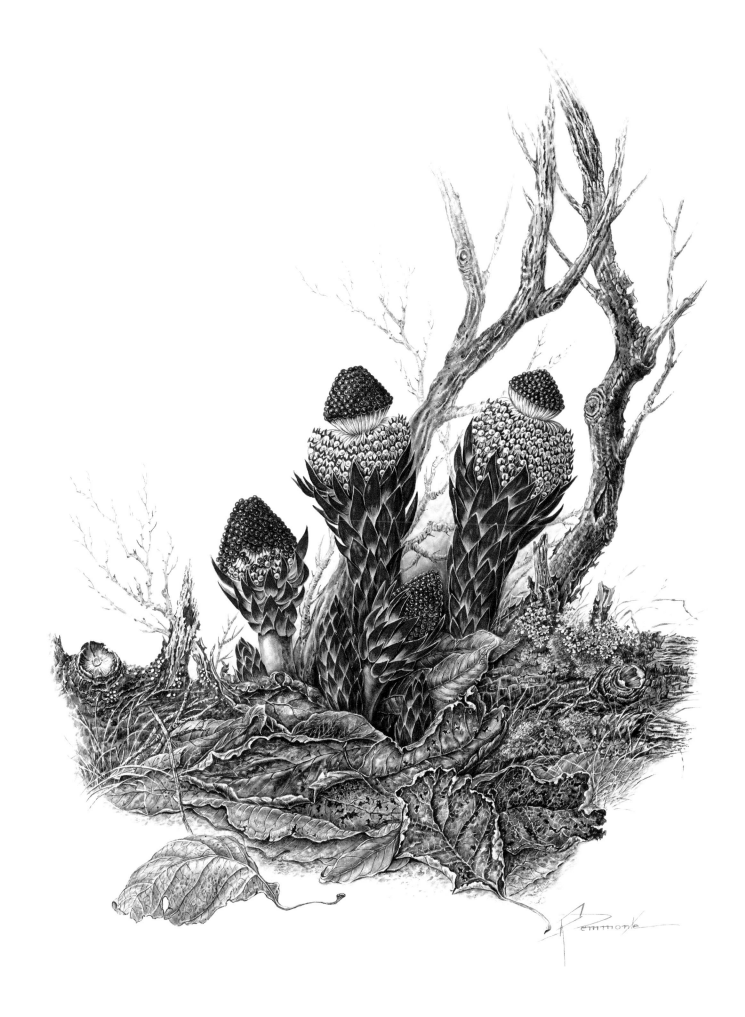

ELVIA ESPARZA | MEXICO

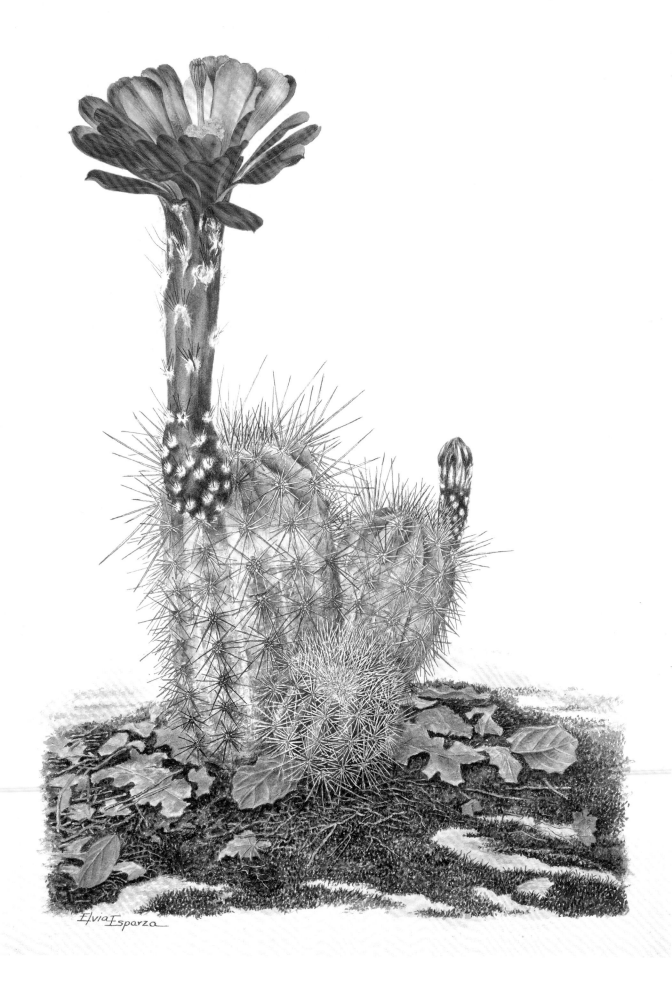

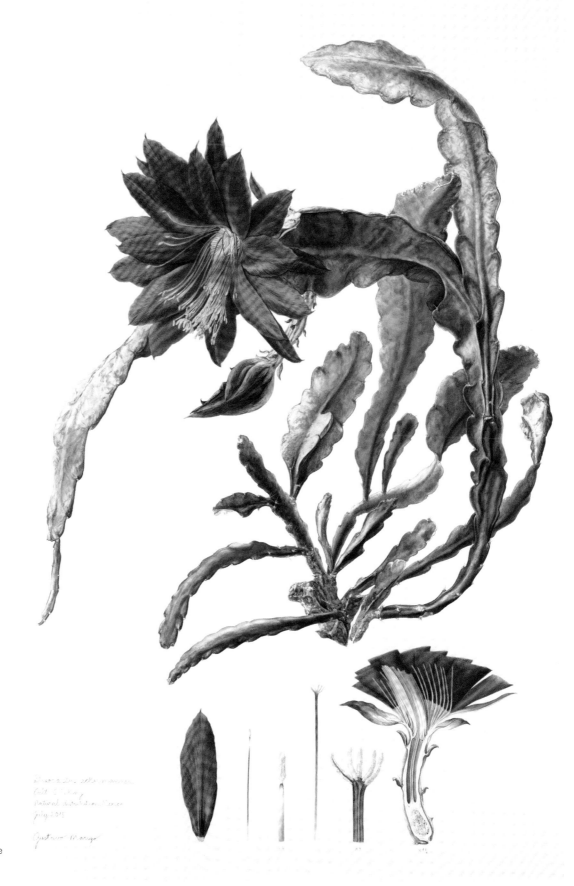

Elvia Esparza
Echinocereus polycanthus 2000
Watercolour on paper 370 x 265 mm
From Gordon Craig Gallery 2000
[Shirley Sherwood Collection 413]
←

Gustavo Marigo
Disocactus ackermanii 2015
Watercolour on paper 700 x 550 mm
From the artist 2015
The artist painted this at Kew in 2015, while artist scholar in the Margaret Mee Fellowship Programme.
[Shirley Sherwood Collection 930]

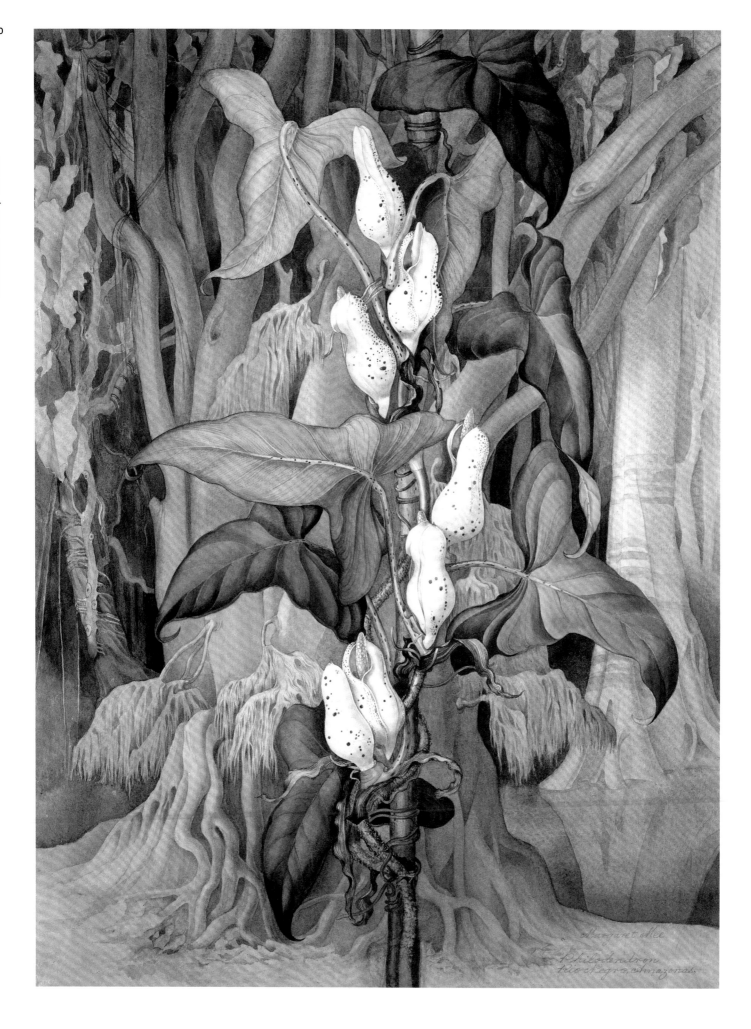

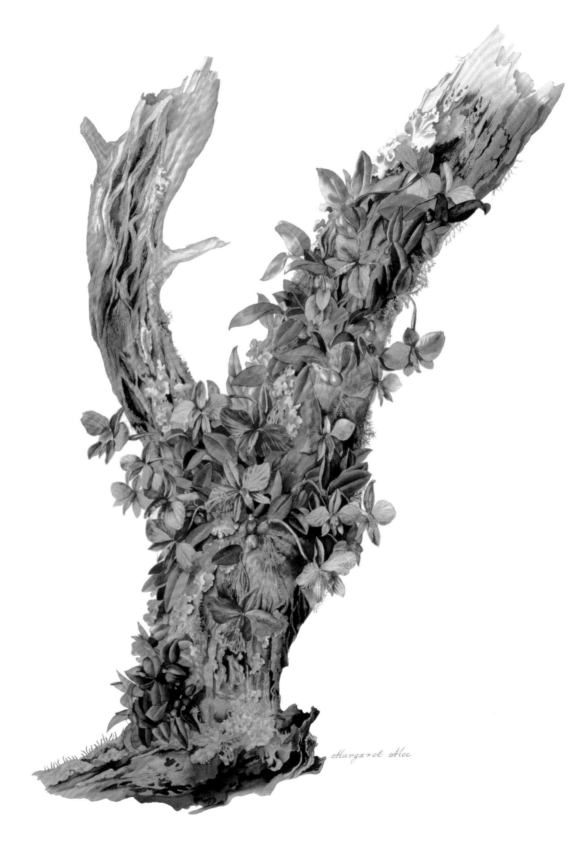

Margaret Mee
Philodendron sp.
Rio Negro, Amazonas
Pencil and gouache on paper
640 x 470 mm
From Tryon Gallery 1992
Margaret Mee explored the Amazon, painting many plants that were new to science. Her fortitude and skill encouraged many followers, who also became worried by the destruction of the rainforest. Her study of *Philodendron* shows a backdrop of rainforest intended to alert environmentalists about the dangers to this habitat.
[Shirley Sherwood Collection 024]
←

Margaret Mee
Cattleya coccinea
Pencil and gouache on paper
560 x 390 mm
From Tryon Gallery 1992
[Shirley Sherwood Collection 058]

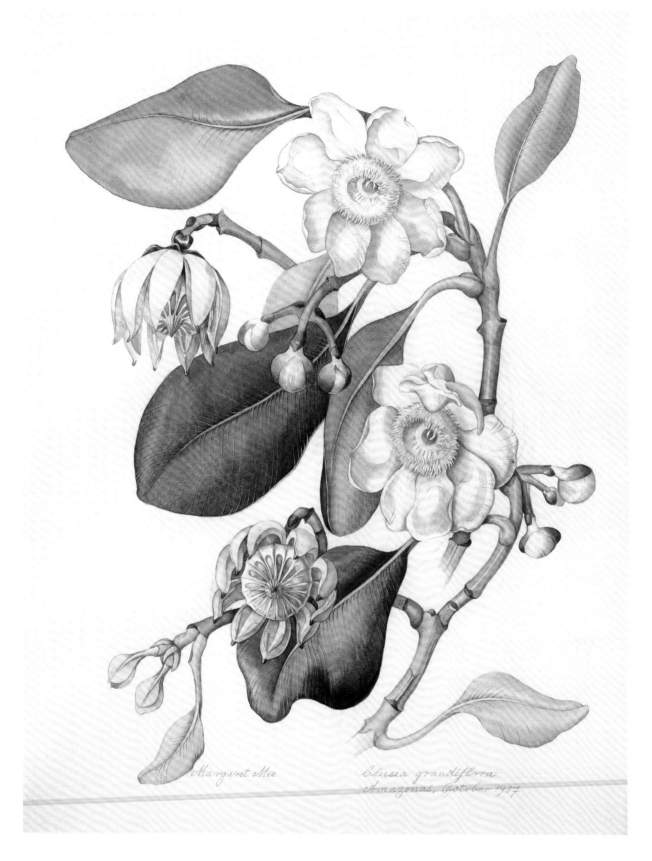

Margaret Mee
Clusia grandiflora 1987
Pencil and gouache on paper
660 x 485 mm
From Sylvia Brautigam, Brazil 2002
[Shirley Sherwood Collection 446]

Margaret Mee
Neoglaziovia variegata 1964
Pencil and gouache on paper
620 x 430 mm
From Mallams Auction House Oxford
2013
[Shirley Sherwood Collection 858]
→

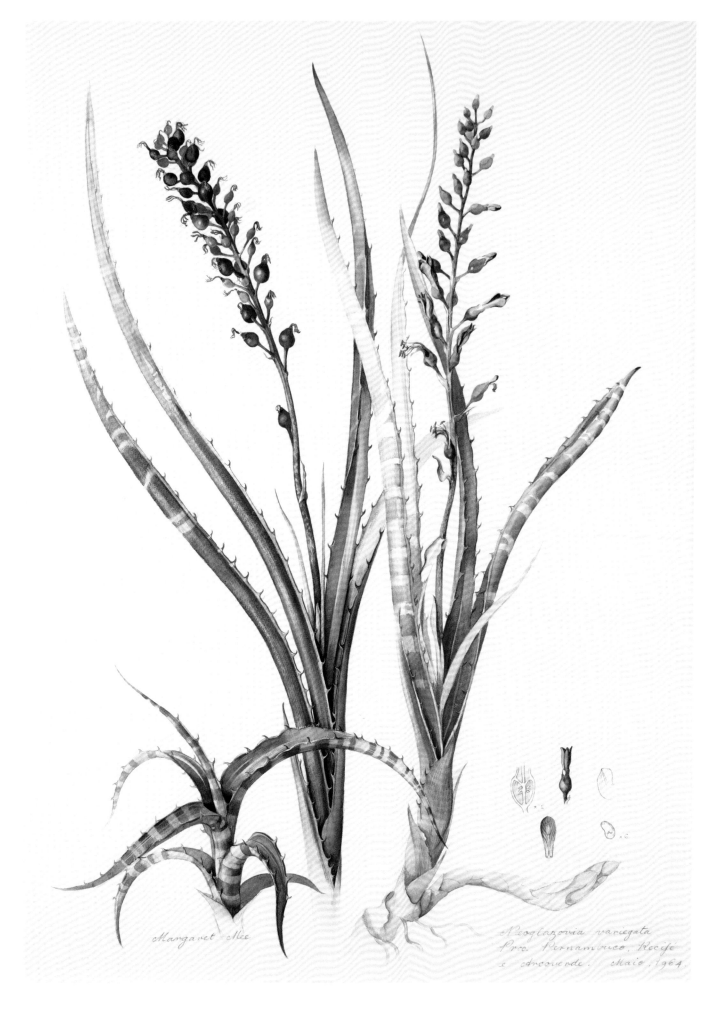

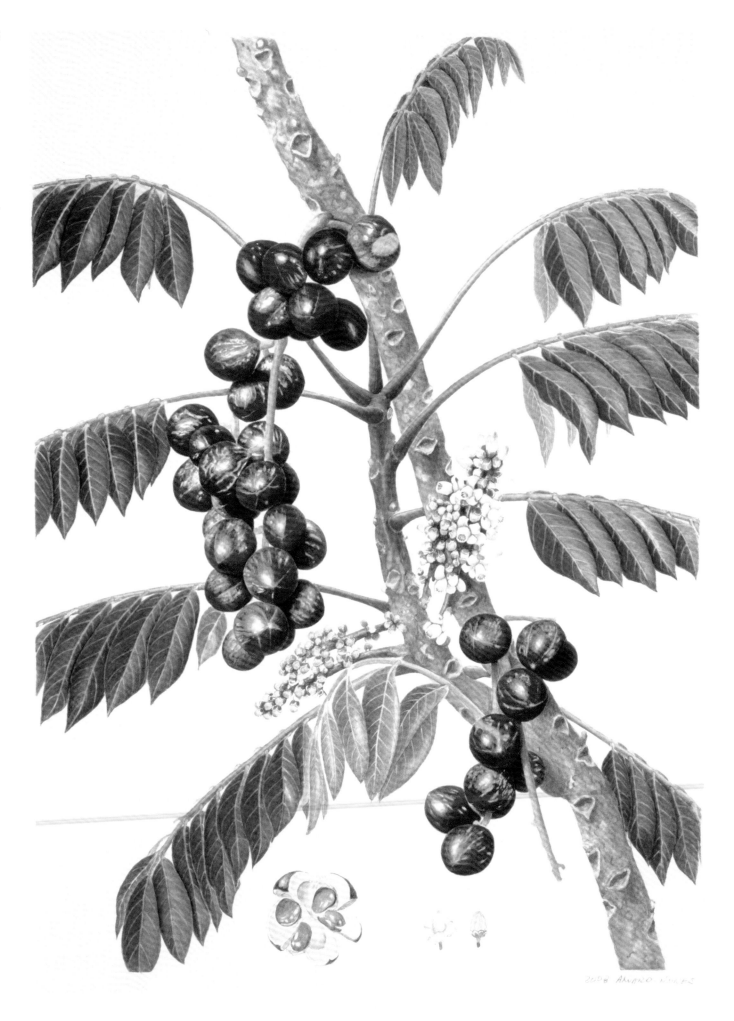

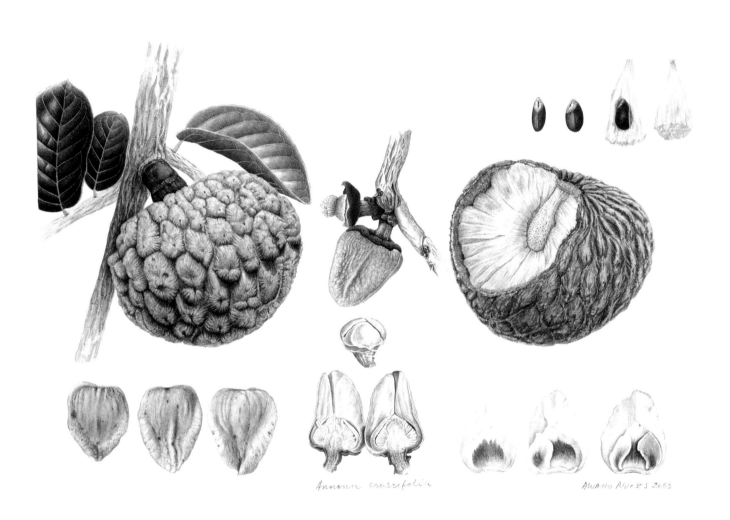

Álvaro Nunes
Cabralea canjerana 2008
Watercolour on paper 650 x 500 mm
From the artist 2009
Atlantic Rainforest
[Shirley Sherwood Collection 716]

Álvaro Nunes
Annona crassiflora 2003
Watercolour on paper 378 x 537 mm
From the artist 2005
This native species has an anachronistic fruit adapted to be dispersed by the now extinct ice age megafauna. Today it is dispersed by the maned wolf *Chrysocyon brachyurus* and crab-eating fox *Cerdocyon thous*. In inundated forest it may possibly be ingested by fish.
[Shirley Sherwood Collection 588]

Álvaro Nunes
Bromelia sp. 2009
Watercolour on paper 500 x 650 mm
From the artist 2010
A birds-eye view of a terrestrial bromeliad.
[Shirley Sherwood Collection 767]

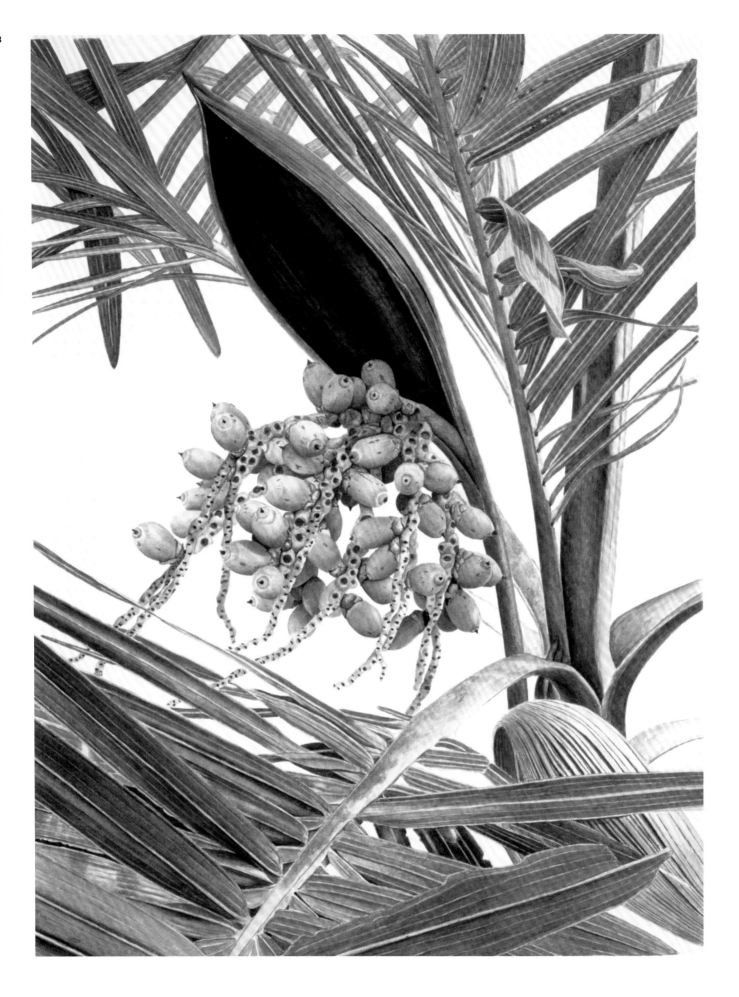

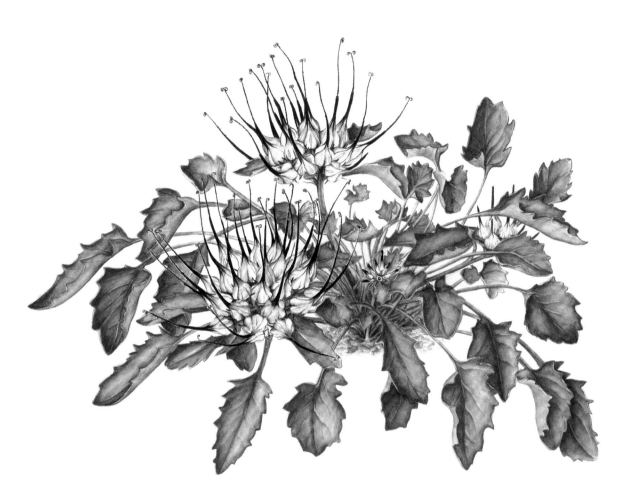

Álvaro Nunes
Syagrus sp. 2010
Watercolour on paper 650 x 500 mm
From the artist 2010
Nunes has developed a new style, filling the paper with a detailed, complicated and dramatically intense study. The painting depicts an ornamental garden tree, native to South America.
[Shirley Sherwood Collection 769]
←

Rosane Quintella
Physoplexis comosa 2005
Watercolour on paper 350 x 440 mm
From the artist 2005
Painted at Kew in 2009, during the artist's Margaret Mee Fellowship Programme scholarship.
[Shirley Sherwood Collection 623]

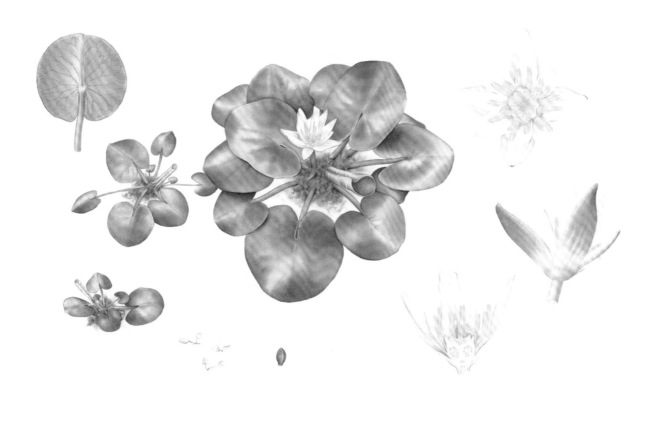

Gustavo Surlo
Pygmy Rwandan Waterlily: *Nymphaea thermarum* 2018
Watercolour on paper 355 x 500 mm
From the artist 2018
The world's smallest waterlily, with leaves 2 cm across.
It grew in one small hot water spring in Rwanda which dried up and it became extinct in the wild. However, before this seeds had been rescued and it was grown at Kew, keeping it at 25°C.
[Shirley Sherwood Collection 1004]

Gustavo Surlo
Cereus pernambucensis 2017
Watercolour on paper 520 x 350 mm
From the artist 2018
Painted at Kew in 2018, during the artist's Margaret Mee Fellowship Programme scholarship.
[Shirley Sherwood Collection 1002]
→

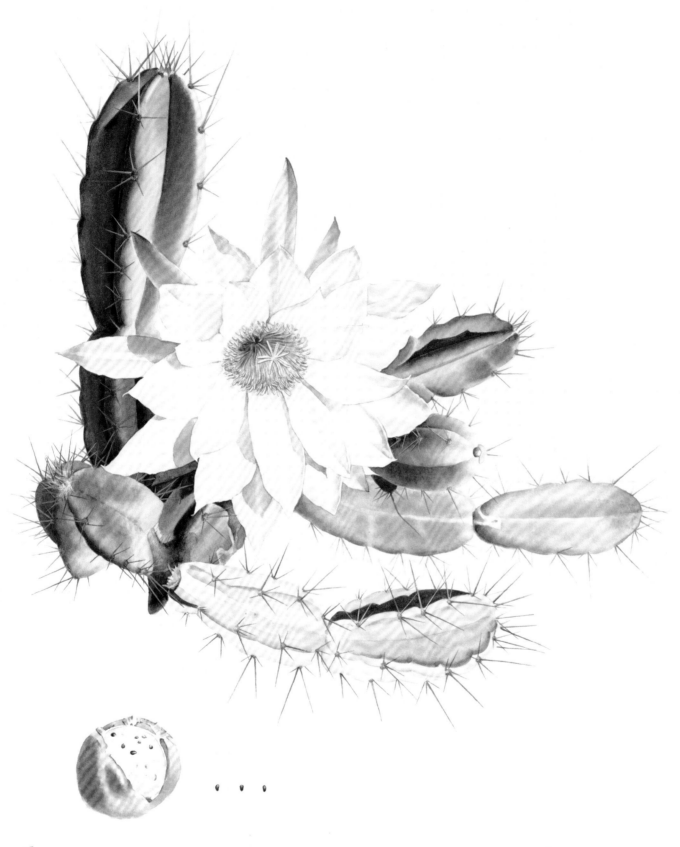

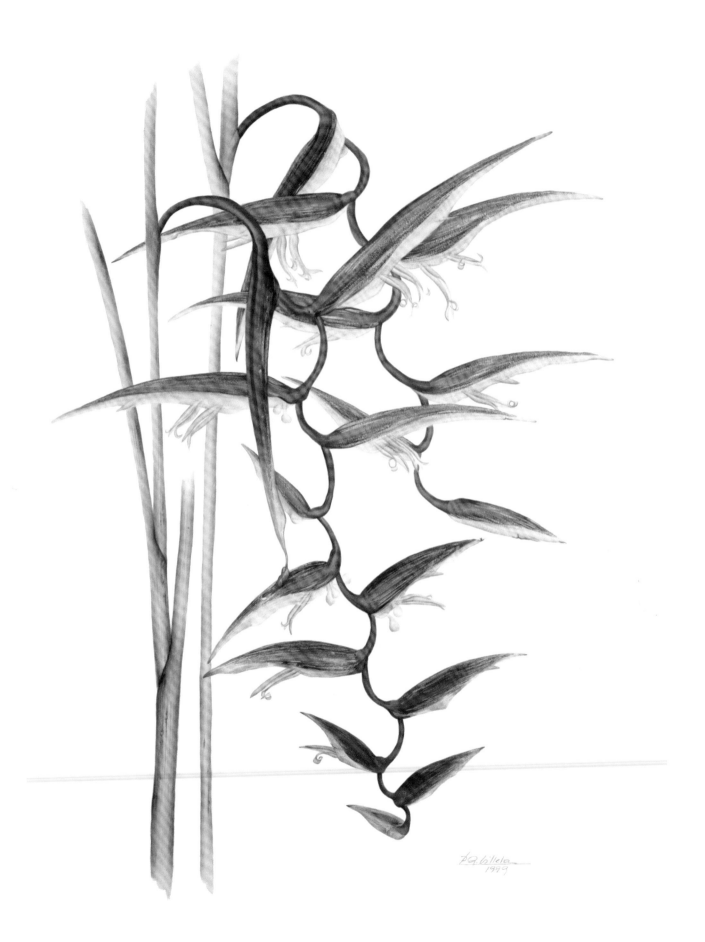

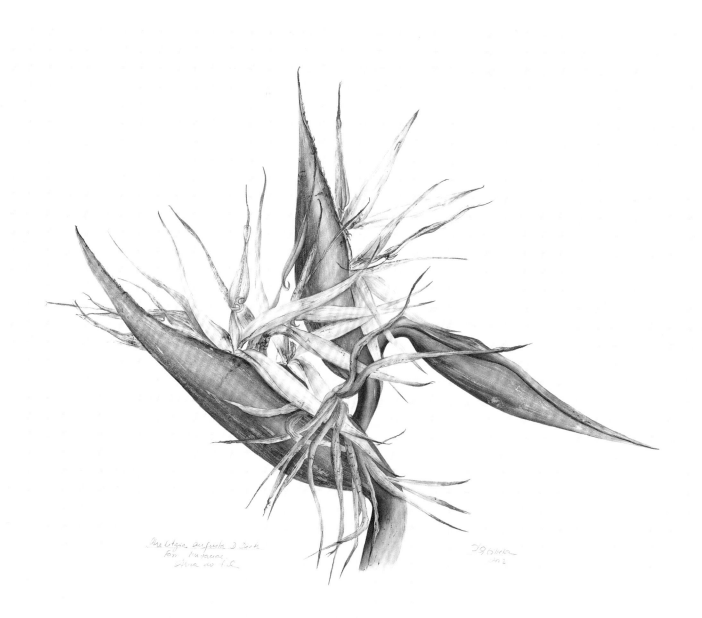

Patricia Villela
Heliconia chartacea 1999
Watercolour on paper 850 x 690 mm
From the artist 2003
This plant originates in the upper Amazon and was painted in Rio Botanic Gardens.
[Shirley Sherwood Collection 479]
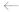

Patricia Villela
Strelitzia: *Strelitzia nicolai* subsp. *augusta* 2002
Watercolour on paper 560 x 760 mm
From the artist 2003
[Shirley Sherwood Collection 480]

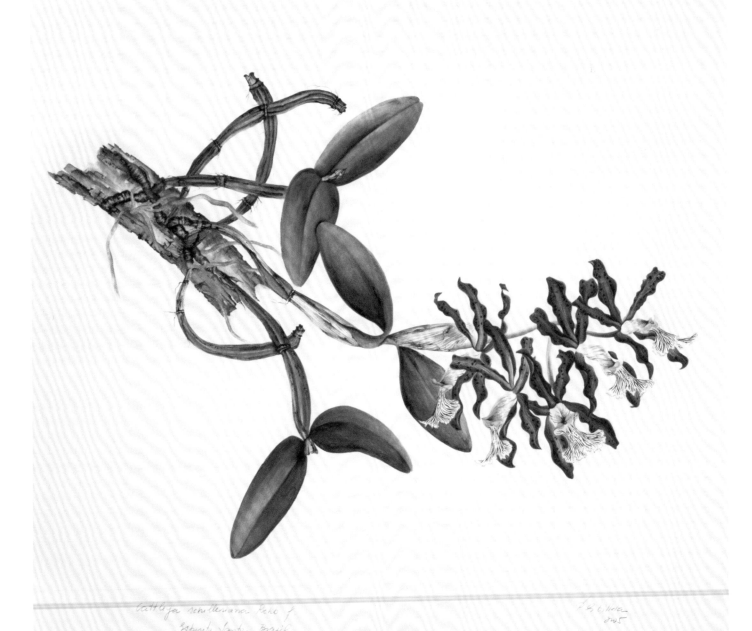

PATRICIA VILLELA | BRAZIL

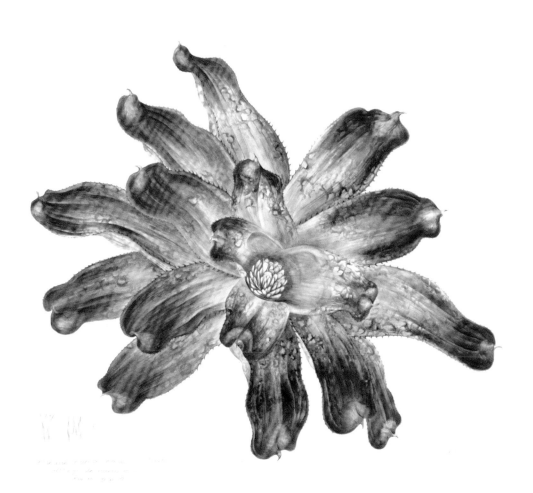

Patricia Villela
Cattleya schilleriana 2005
Watercolour on paper 575 x 760 mm
From the artist 2009
[Shirley Sherwood Collection 730]
←

Patricia Villela
Neoregelia cruenta 2009
Watercolour on paper 570 x 760 mm
From the artist 2010
Endemic to Brazil.
[Shirley Sherwood Collection 765]

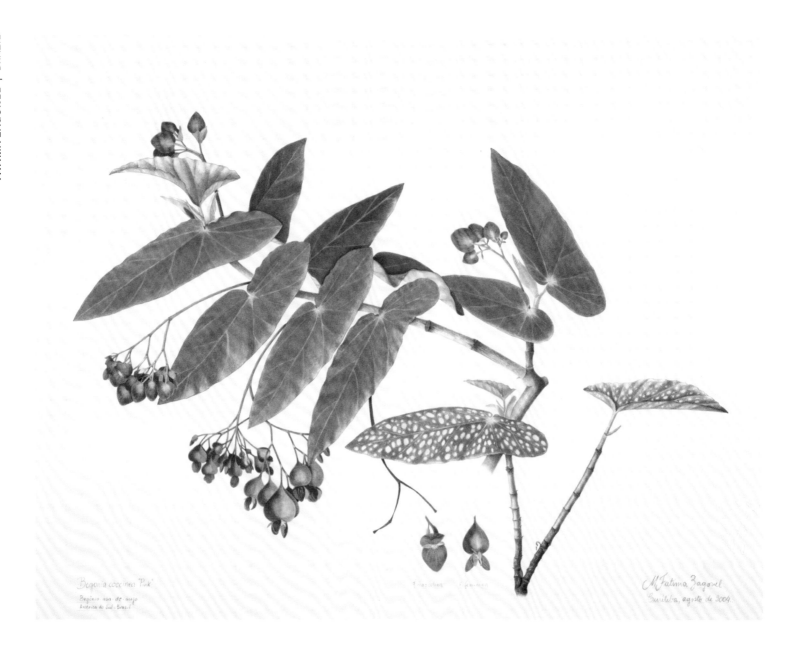

Fátima Zagonel
Begonia coccinea 'Pink' 2004
Watercolour on paper 500 x 640 mm
From the artist 2010
Fátima Zagonel was the artist scholar for the Margaret Mee Fellowship Programme during 1999. This plant is found in the Atlantic Rainforest and Iguazú.
[Shirley Sherwood Collection 764]

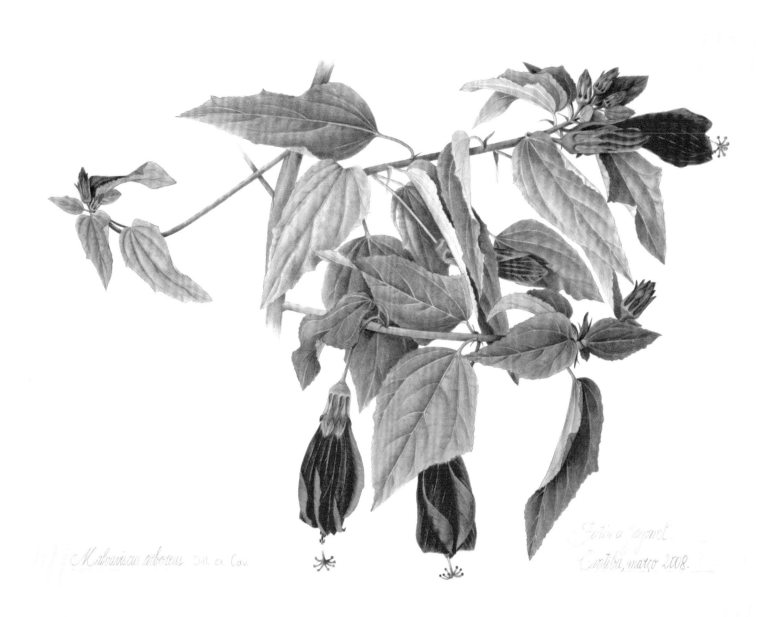

Fátima Zagonel
Malvaviscus arboreus 2008
Watercolour on paper 230 x 305 mm
From the artist 2009
[Shirley Sherwood Collection 724]

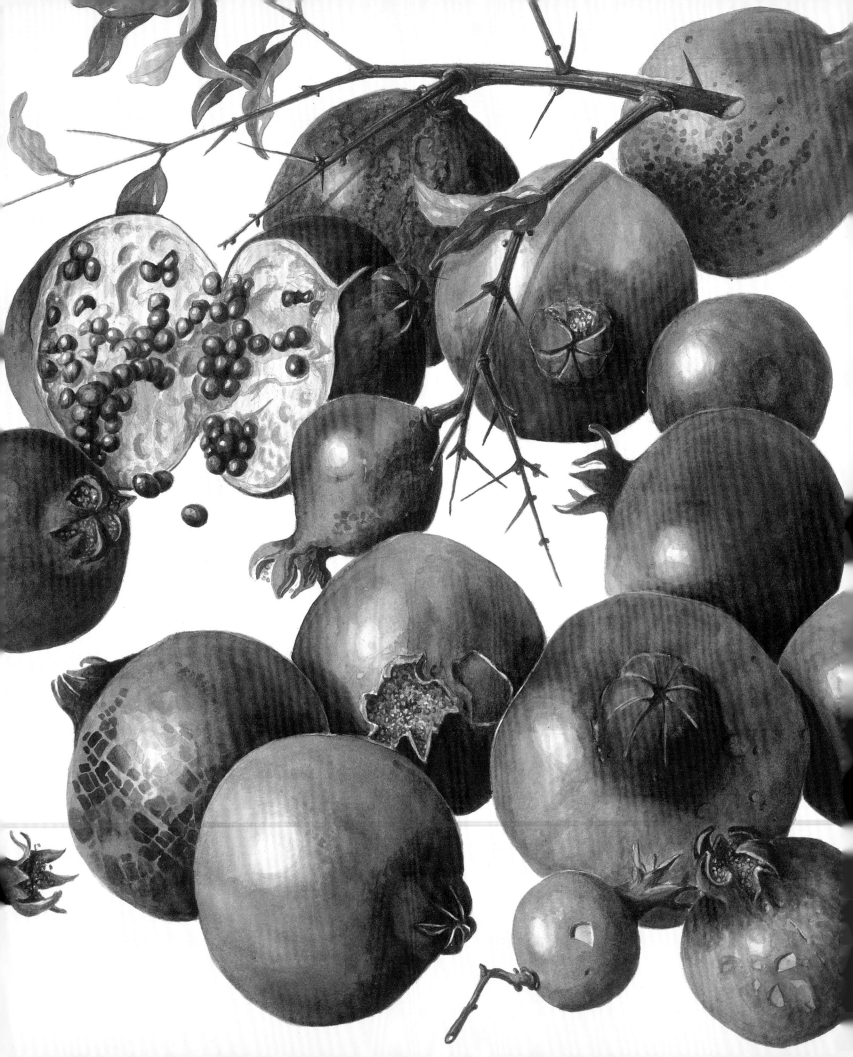

South Africa

South Africa

THERE HAVE BEEN artists recording the flora of South Africa since plant collector Francis Masson (1741–1805) was sending back plants to Kew where they were grown and then painted by Franz Bauer (1758–1840). Bauer portrayed a group of heathers/ericas from the Cape superbly and I acquired five of these hand-painted engravings, one for each for my grandchildren.

I have collected portraits of the remarkable flora of the Cape for almost 30 years and have works by established artists Ellaphie Ward-Hilhorst, Barbara Pike, Fay Anderson, Ann Schweizer and Barbara Jeppe. More recently I have bought new work from Gillian Condy who has just retired from the South African National Biodiversity Institute (SANBI), Pretoria Botanic Garden. I have also acquired paintings from the prominent artist Vicki Thomas, who lives in Betty's Bay and works with Kirstenbosch as well as organising many workshops and exhibitions, and Peta Stockton, whose mastery of fine detail is superb. Now there is another wave of artists doing fascinating work including Sibonelo Chiliza, Margaret de Villiers, Lynda de Wet, Jenny Hyde-Johnson, Jenny Pharaoh and Carol Reddick.

South African artists are extremely knowledgeable about their local flora and fauna and some have complex stories to tell within their paintings. I remember Vicki Thomas racing home to Betty's Bay to rescue seed pods of a plant she was painting for me in case they got burnt in a sudden fire in the fynbos. Jenny Hyde-Johnson shows the wealth of insect life associated with plants from the fynbos while Elbe Joubert has a snake resting near her *Aloe ferox*. Working on rare plants, Margaret de Villiers has concentrated single-mindedly on ericas until recently and recorded the first sighting of a newly re-discovered erica near Hermanus.

I have been very impressed by the *Red Data List of South African Plants*, first published in 2010 and regularly updated online. It has been compiled by SANBI led by Domitilla Raimondo. There are 20,456 plant species occurring naturally in South Africa and each year some go extinct because of population expansion, fires and so on. Local botanical artists are intensely aware of the pressures on native plants and create records of endangered plants, as well as newly discovered species that may have been triggered to flower by fire.

I have met all the established artists except Barbara Jeppe (1921–1999). All of them paint the local flora of South Africa, and many know a great deal about the rare and fragile environment of the many habitats and extraordinary plants in this unique plant kingdom. I have been particularly intrigued by the fynbos and its strange, perilous existence between the sea and the mountains, its dependence on fire and its adaptations for seed dispersal, germination and survival. While at Fernkloof, Hermanus, in the Cape during 2009 and 2019, I saw an almost magical sight. Just 12 days after fire, scarlet *Cyrtanthus ventricosus* flowers appeared amid the blackened ash in the burnt fynbos.

Fay Anderson
Nivenia stokoei
Watercolour on paper 370 x 275 mm
From the artist 1998
A woody iris native to the Kogelburg, Western Cape, it flowers on eroded Table Mountain sandstone rocks in late summer.
The artist found the blue colour of the flowers very hard to achieve.
[Shirley Sherwood Collection 332]

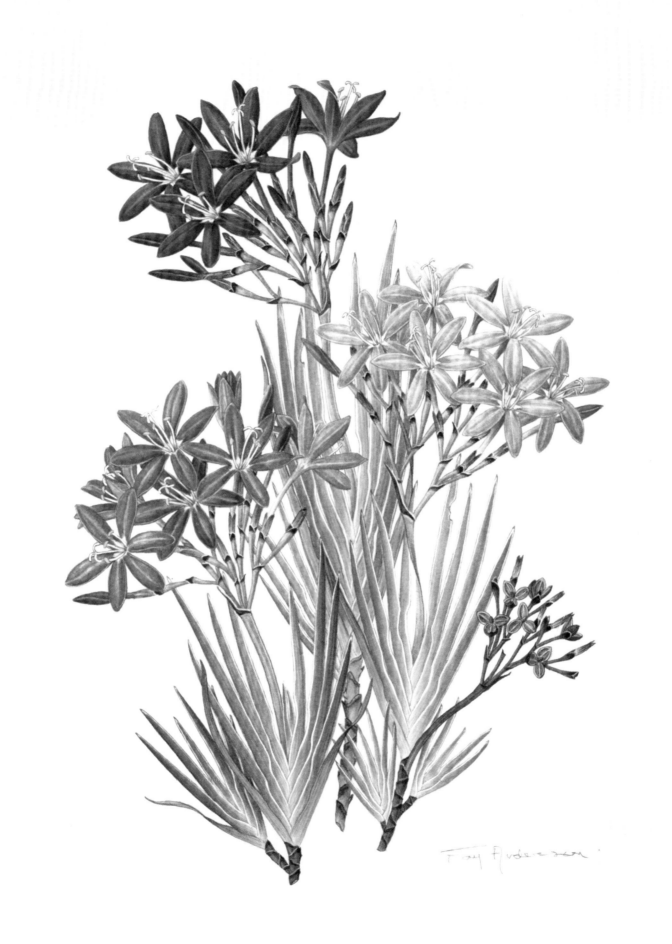

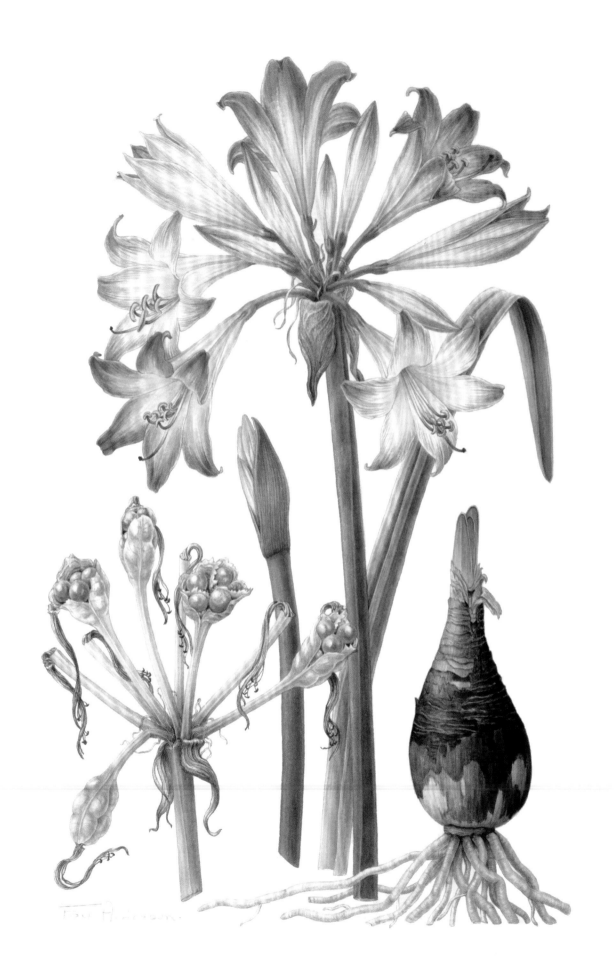

Fay Anderson
Belladonna Lily: *Amaryllis belladonna*
Watercolour on paper 470 x 320 mm
From the artist 1994
This plant, native to the Cape Province but widely naturalised, can be seen flowering in March in the Cape.
[Shirley Sherwood Collection 165]

Sibonelo Chiliza
Paint brush lily: *Scadoxus puniceus*
2012
Pencil on Arches 300 gsm paper
760 x 580 mm
From the artist 2015
A beautiful pencil study of a very showy bulb with a scarlet head of many flowers with bright yellow anthers. The bulb is poisonous, and used in traditional medicine.
[Shirley Sherwood Collection 897]

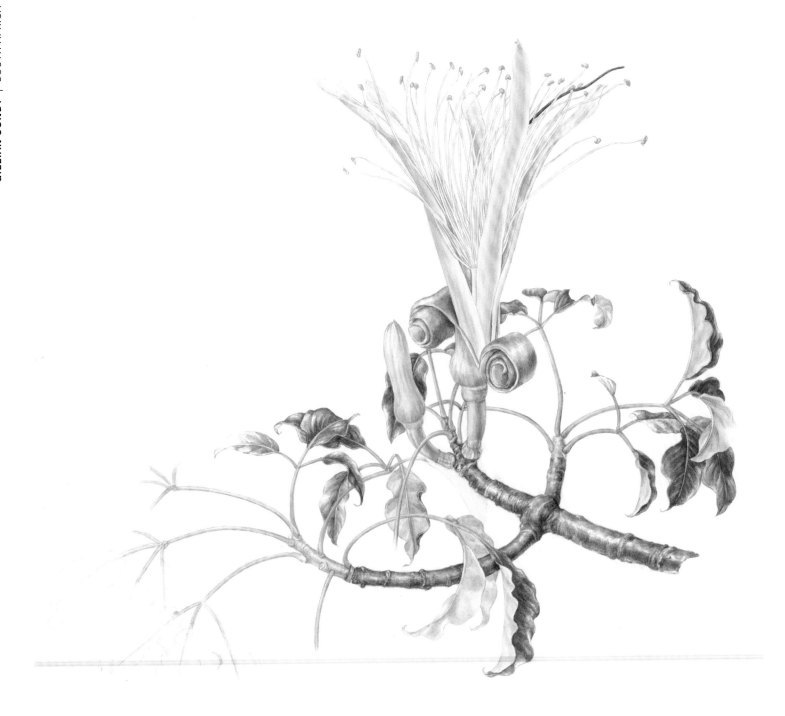

Gillian Condy
Baobab Flower: *Adansonia za* **2014**
Watercolour on paper 360 x 320 mm
From the artist 2015
This near threatened baobab species is endemic to Madagascar, where it is found in coastal regions.
[Shirley Sherwood Collection 901]

GILLIAN CONDY | SOUTH AFRICA

Gillian Condy
Waratah: *Telopea speciosissima*
2010/2016
Watercolour on Arches 300 gsm paper
560 x 760 mm
From the artist 2016
Endemic in New South Wales.
[Shirley Sherwood Collection 935]

Gillian Condy
Turk's Cap Aloe: *Aloe peglerae*
2007/16
Watercolour on Arches 300 gsm paper
760 x 560 mm
From the artist 2016
A small aloe restricted to Gauteng, South Africa.
[Shirley Sherwood Collection 936]

Margaret de Villiers
Satyrium coriifolium 2016
Watercolour on paper 300 x 450 mm
From the artist 2017
Artist's notes The orchid *Satyrium coriifolium* was one of the first Cape plants to be brought to the attention of European botanists. Various plant specimens were collected by Paul Hermann, a young physician employed by the Dutch East India Company as chief medical officer in Ceylon. On his passage homeward in 1680 he botanised in the Cape and collected plant specimens. Part of his collection, including *Satyrium coriifolium*, is now lodged in the Sherard Herbarium, Oxford. Because of recent devastating fires in the Overberg region in 2018/19 there are a large variety of seasonal orchids sprouting in the fynbos. *Satyrium coriifolium* responds dramatically to fire and disturbed ground. The specimens were found on the mountain slopes not far from Cape Agulhas at the southern tip of Africa, where it flowers in the spring. It is one of a number of very spectacular satyriums in the area.
[Shirley Sherwood Collection 966]
→

MARGARET DE VILLIERS | SOUTH AFRICA

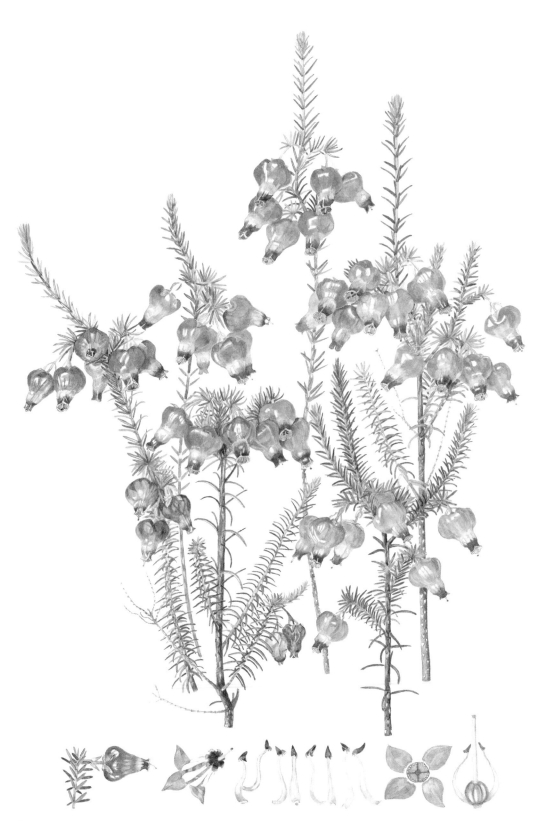

Margaret de Villiers
Erica blenna var. *grandiflora* 2013
Watercolour on paper 895 x 630 mm
From the artist 2014
Artist's notes The unusual green and orange colouring and the shape and stickiness of the flowers of *Erica blenna* var. *grandiflora* make this one of South Africa's best known ericas. The specimens painted were grown in the nursery of the Kirstenbosch Botanical Gardens, the seeds having been collected in the mountains above Swellendam in the South Western Cape.
[Shirley Sherwood Collection 868]

Margaret de Villiers
Erica patersonii 2011
Watercolour on paper 895 x 630 mm
From the artist 2014
Artist's notes Threatened by urban expansion and farming, *Erica patersonii* grows in wet, marshy reed-covered areas along the coast near the southern-most tip of South Africa. The flowering stems resemble corn-on-the-cob, which gives it the common name of mielie heath. *Erica patersonii* is named in honour of Lieutenant William Paterson (1755–1810), who made four collection journeys into South Africa. He was sent by Sir Joseph Banks to make observations of the natural history of the land. The specimens were collected close to the sea near the coastal town of Betty's Bay.
[Shirley Sherwood Collection 866]
→

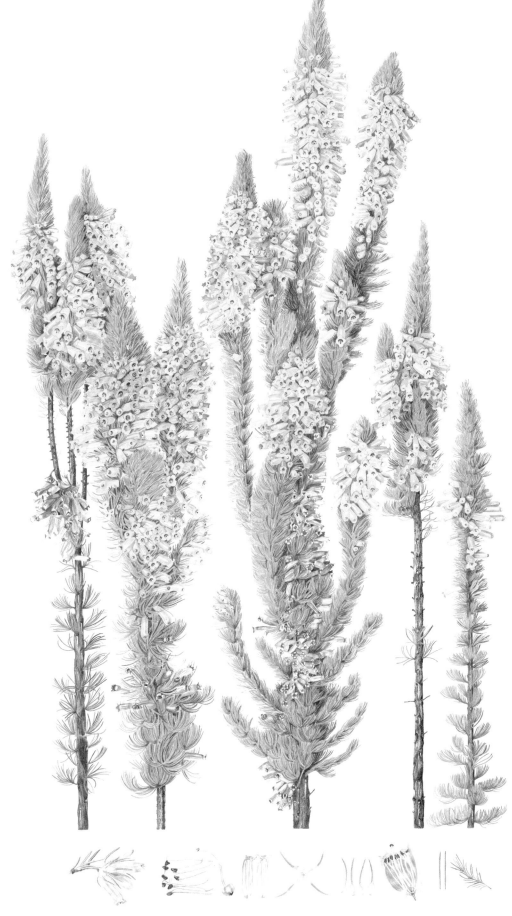

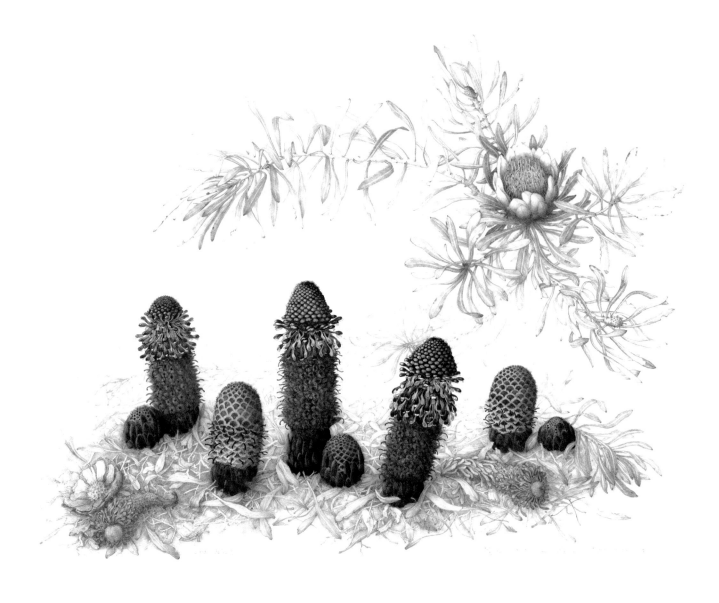

Lynda de Wet
Mystropetalon thomii parasitic on *Protea repens* 2013
Watercolour and graphite 410 x 550 mm
From the artist 2013
The mixed media makes the parasite more prominent in the painting. One of several studies by this artist of plant parasites on *Protea* in the Cape.
[Shirley Sherwood Collection 850]

Lynda de Wet
Horsetail restio: *Elegia capensis* 2017
Watercolour on paper 570 x 380 mm
From *Botanical Art Worldwide* exhibition, Everard Read Gallery, South Africa 2018.
The reed-like plant looks like a horsetail when young. Can be grown in southern England but I was unsuccessful in Oxfordshire.
[Shirley Sherwood Collection 977]

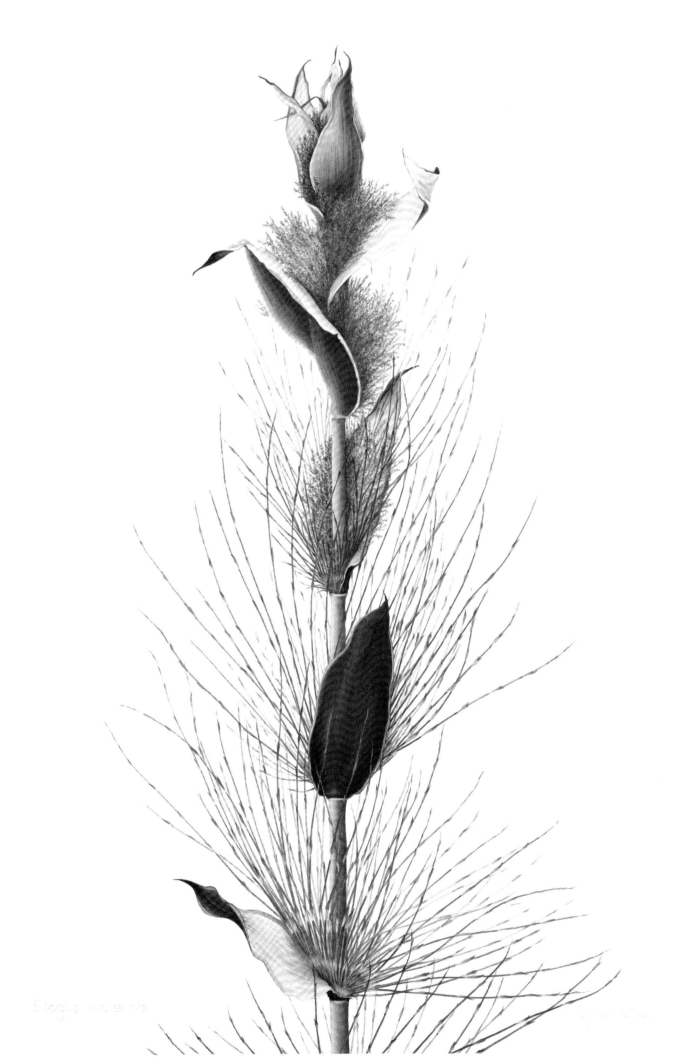

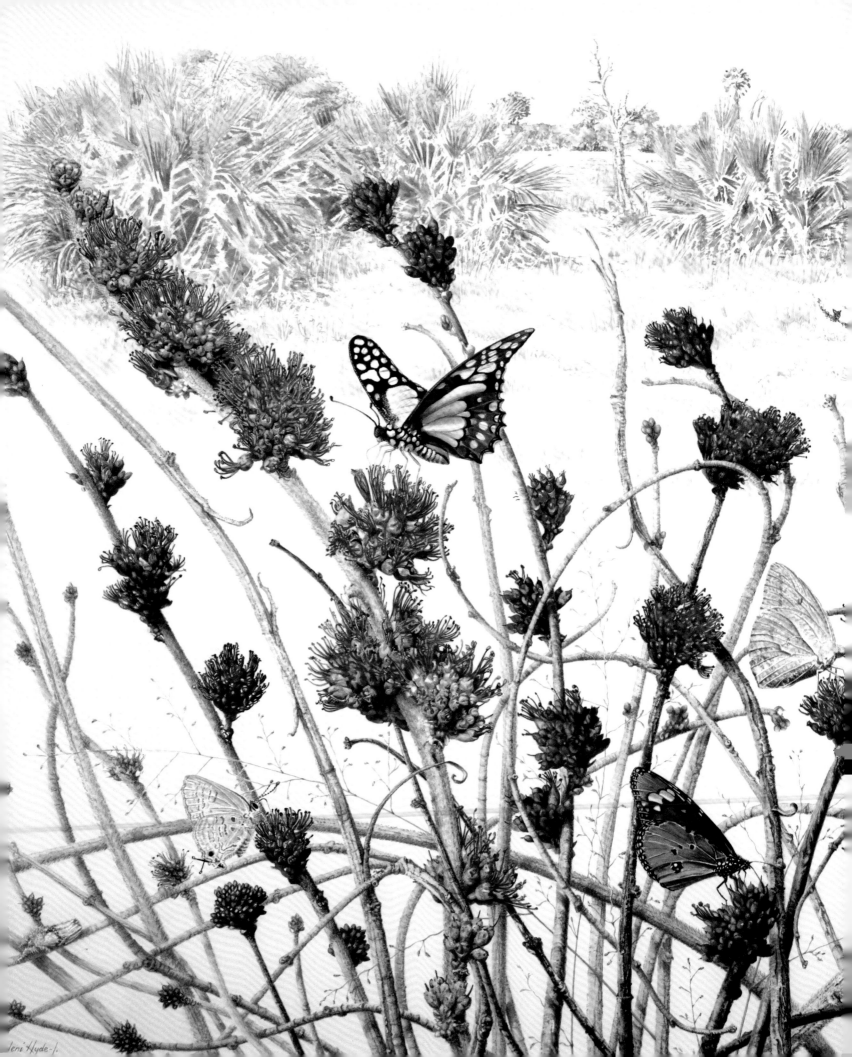

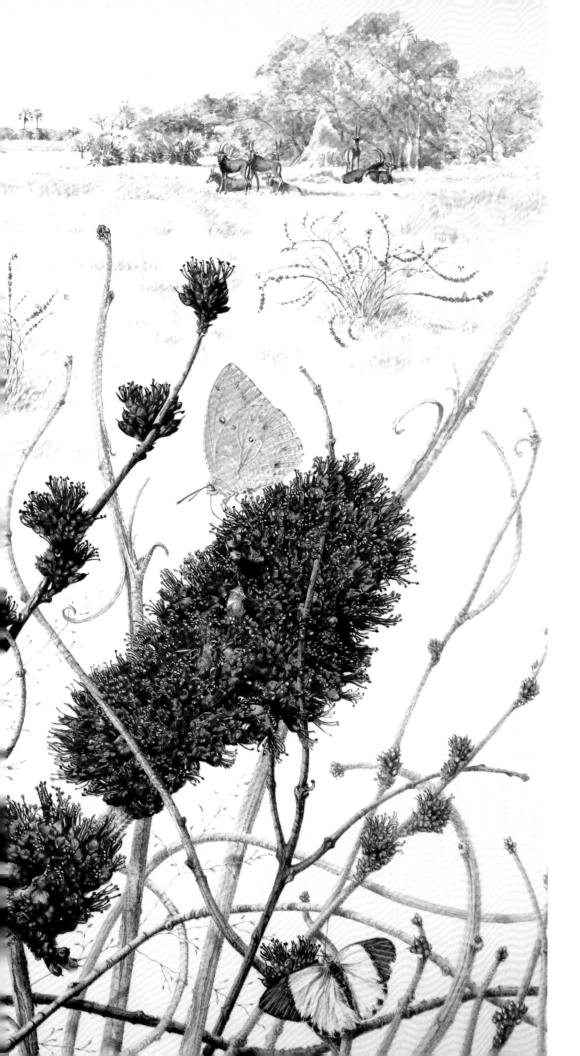

Jenny Hyde-Johnson
Mahango Firebush: *Combretum platypetalum* **2018**
Watercolour and gouache on paper
500 x 698 mm
From the artist 2018
Artist's notes
Butterflies, top row from left to right: Angola white lady, *Graphium angolanus* and African migrant or common vagrant, *Catopsilia florella* – the green butterfly is male and the yellow is female.
Bottom row, from left to right: apricot playboy, *Deudorix dinochares*; African monarch, *Danaus chrysippus*; Kalahari orange tip, *Colotis lais*; gypsy moth, *Lymantria dispar*; banded euproctis, *Knappetra fasciata*.
Mahango firebush can be used medicinally. The very hairy gypsy moth (just above the artist's signature) utilises this plant for its larval stage. The grass is *Eragrostis*.
[Shirley Sherwood Collection 1001]

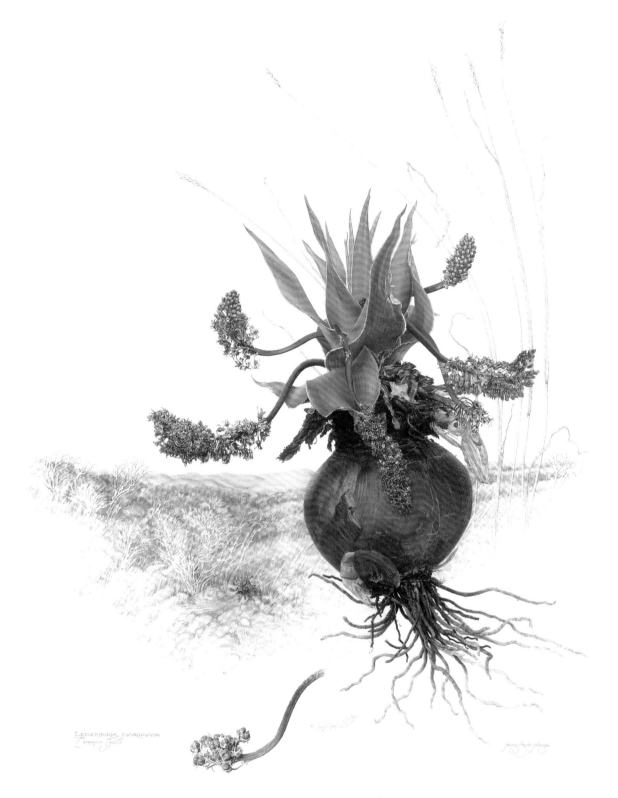

Jenny Hyde-Johnson
Common Squill: *Ledebouria marginata*
2016
Watercolour and gouache on paper
700 x 500 mm
From the *Plant* exhibition, Kirstenbosch
2016
The artist found this very large squill lying in the open. It may have been illegally harvested and intended for a traditional medicine market. Probably decades old, it is now flourishing in the artist's garden.
[Shirley Sherwood Collection 953]

Jenny Hyde-Johnson
Friends, Foes and Pre-Rain Forbs
2015
Gouache on paper 700 x 500 mm
From the *Plant* exhibition, Kirstenbosch 2016
Forbs are non-grass, non-woody herbaceous plants found in grassland. They often flower only after fire. Some may live hundreds of years underground.
[Shirley Sherwood Collection 954]

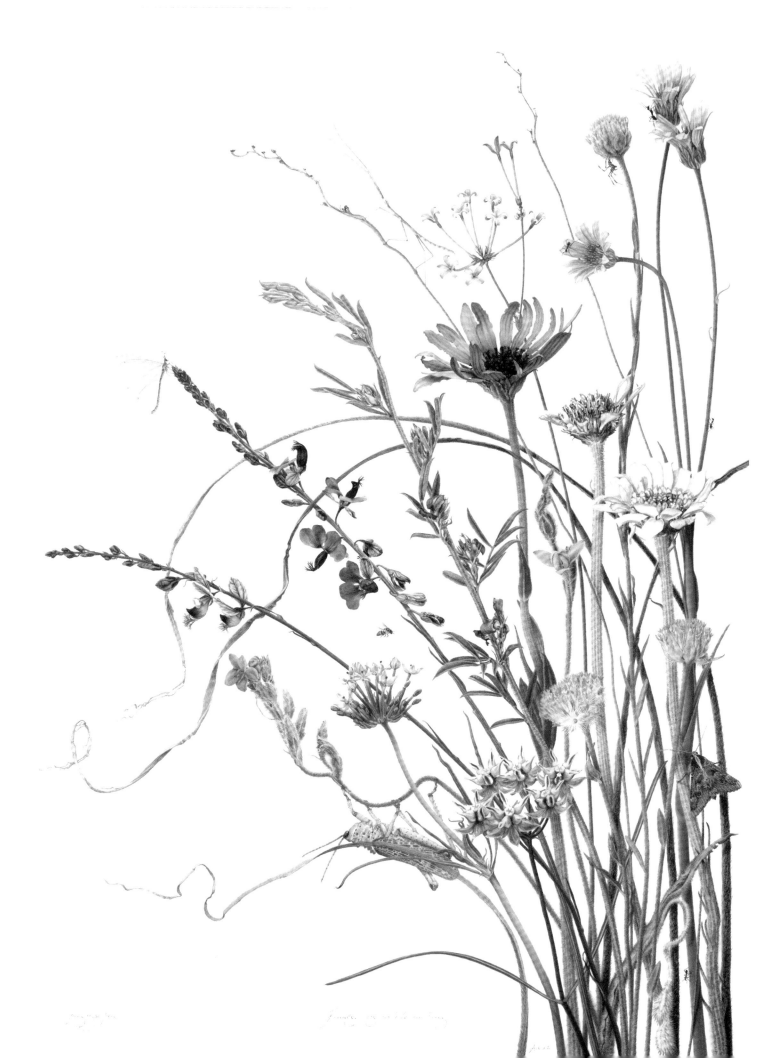

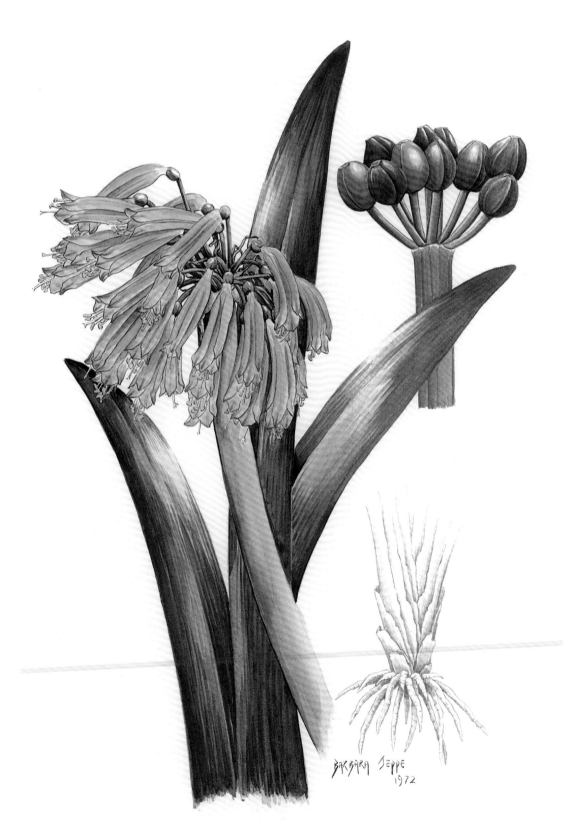

Barbara Jeppe
Clivia gardenii 1972
Watercolour on paper 396 x 282 mm
From the Everard Read Gallery, South Africa 2017
A preliminary sketch for *Amaryllidaceae of Southern Africa* by Graham Duncan, 2017
[Shirley Sherwood Collection 963]

Elbe Joubert
Aloe ferox 2013
Watercolour on Arches 300 gsm paper
1330 x 950 mm
From the artist 2014
The pollinating birds were observed in the wild and painted from photos. The wasp's nest was on the plant. The mouse was observed in the wild and painted from a photograph. The puff adder snake *Bitis arientans* was painted from photos.
[Shirley Sherwood Collection 865]
→

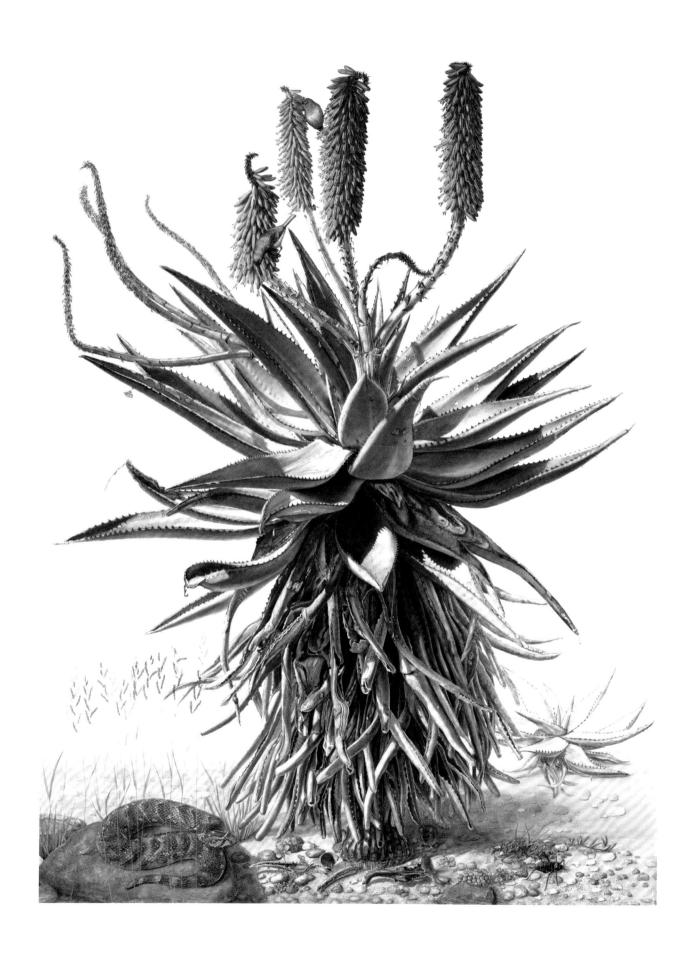

ELBE JOUBERT | SOUTH AFRICA

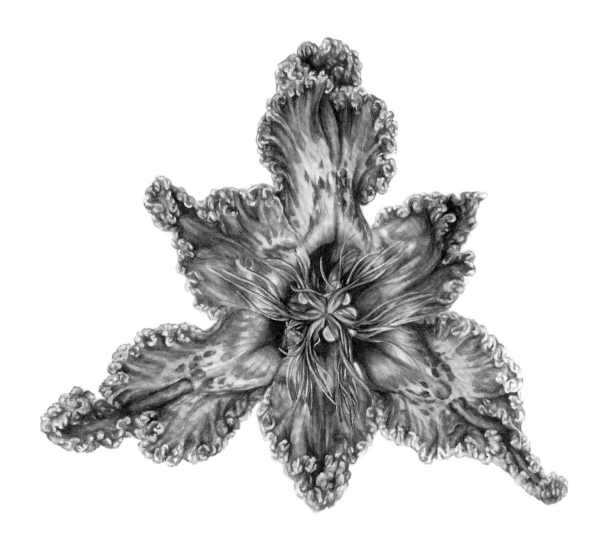

Jenny Pharaoh
'Geelspinnekopblom': *Ferraria variabilis* 2018
Watercolour on paper 360 x 260 mm
From the *Botanical Art Worldwide* exhibition, Everard Read Gallery, South Africa 2018
The flower grows from a corm, 6–20 cm tall. Found from Namibia to Little Karoo on sandy shale flats and rocky slopes, it has a slightly putrid smell.
[Shirley Sherwood Collection 979]

Barbara Pike
Strelitzia nicolai 1996
Watercolour on paper 502 x 304 mm
From the artist 1998
This strelitzia can reach 6 m in height, and is often used in cultivation.
[Shirley Sherwood Collection 315]
→

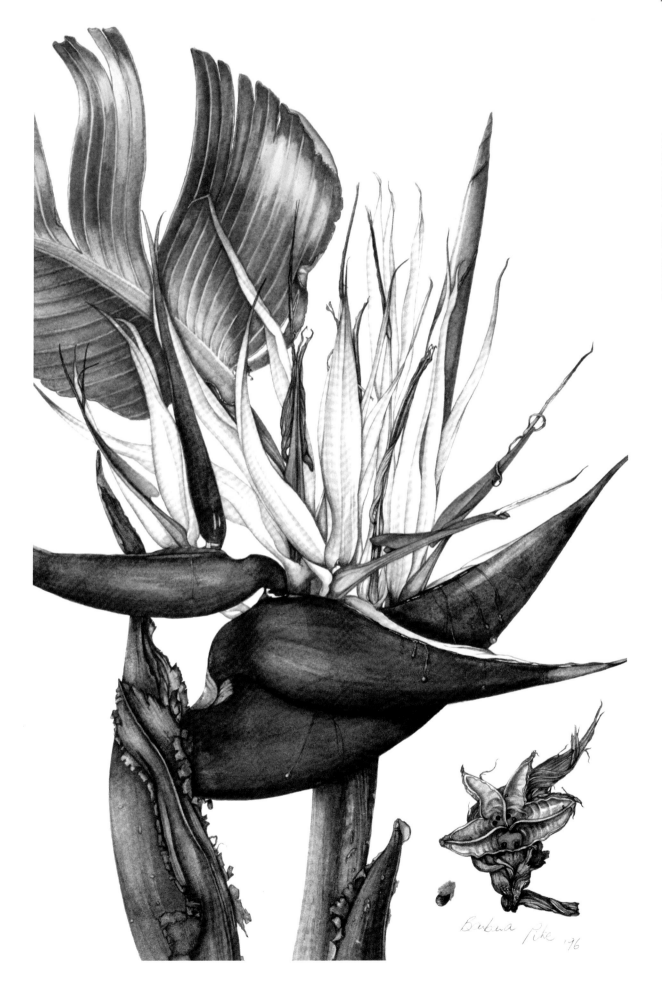

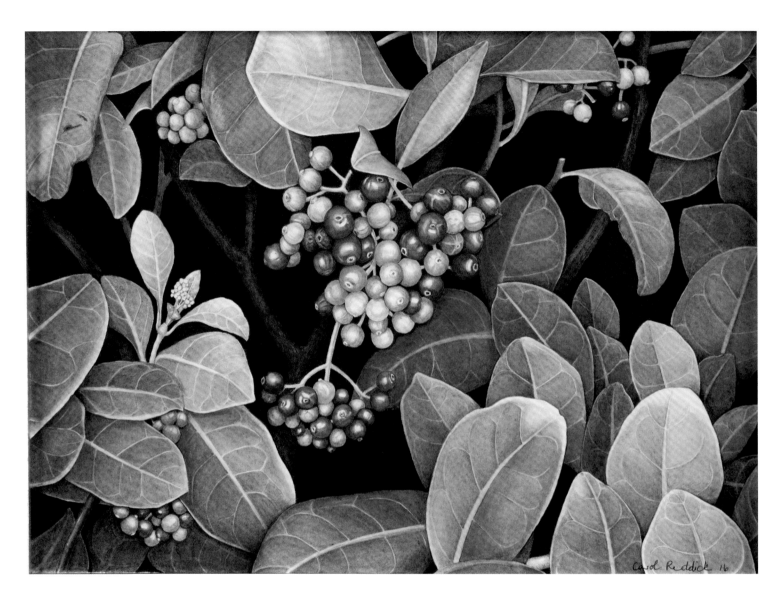

Carol Reddick
Black Bird-Berry: *Psychotria capensis*
2016
Watercolour on paper 230 x 320 mm
From the *Botanical Art Worldwide* exhibition, Everard Read Gallery, South Africa 2018
Easy to grow in the Eastern Cape, black bird-berry can reach 3–8 metres tall and is attractive to birds.
[Shirley Sherwood Collection 980]

Ann Schweizer
Bushman's Melons: *Citrullus lanatus*
Watercolour on paper 380 x 560 mm
From the artist 2009
Animals such as the brown hyena and monkeys eat the bitter wild watermelon and disperse the seed. Originates in South Africa.
[Shirley Sherwood Collection 720]
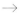

Ann Schweizer
Pomegranates: *Punica granatum*
Watercolour on paper 420 x 520 mm
From the Tryon Gallery 2001
When the fruit splits open its seed is dispersed by animals, especially birds. Native from Iran to northern India.
[Shirley Sherwood Collection 440]
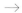

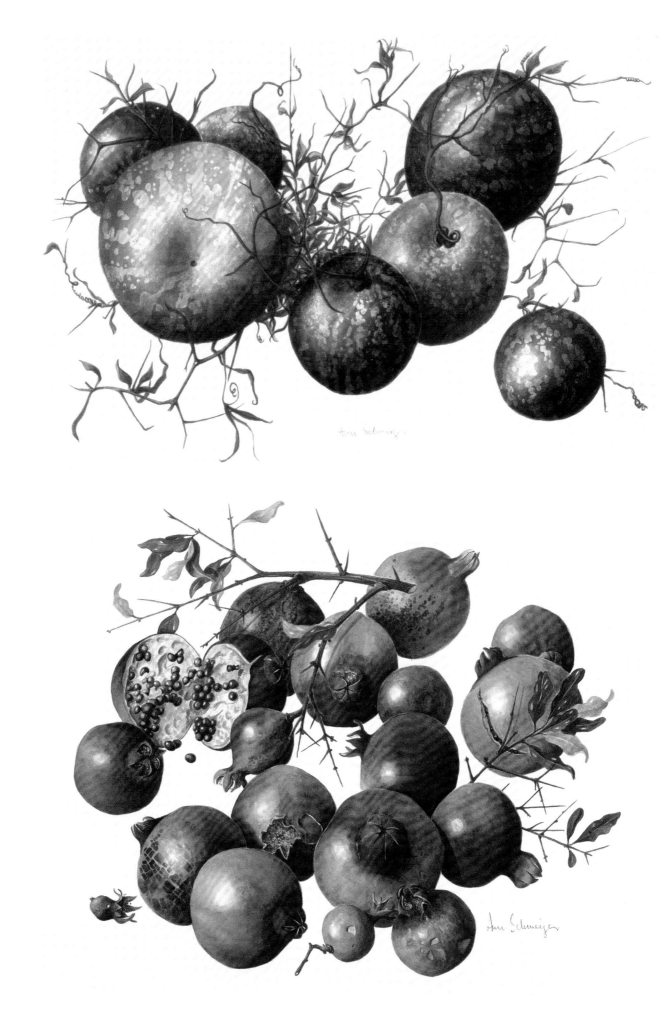

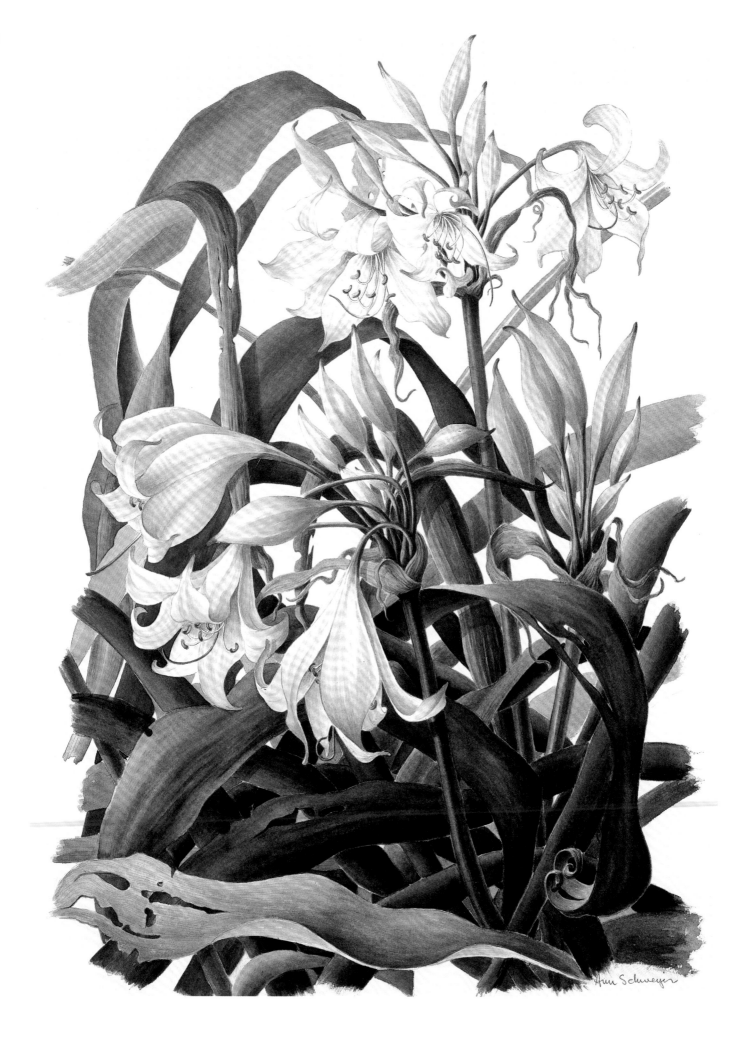

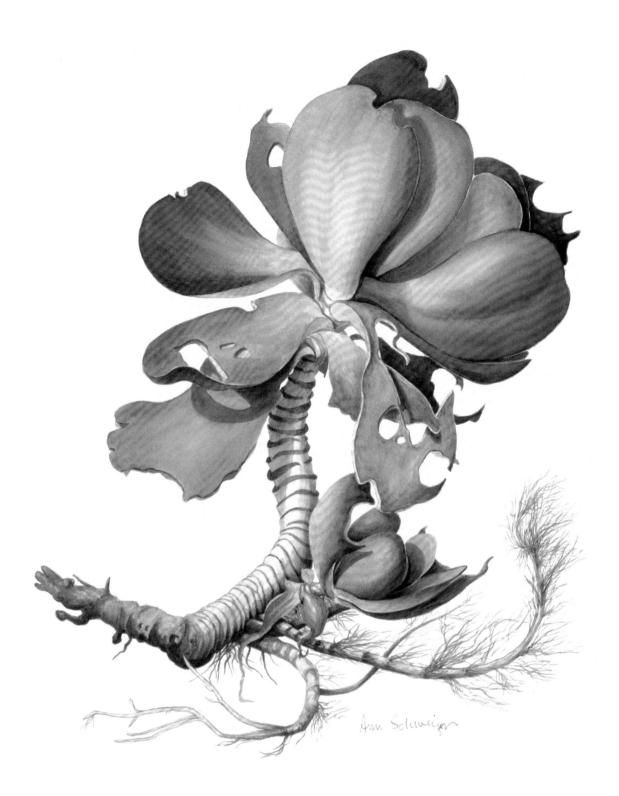

Ann Schweizer
Natal Lily: *Crinum moorei*
Watercolour on paper 750 x 656 mm
From the artist 2007
A South African native often seen in cultivation.
[Shirley Sherwood Collection 655]
←

Ann Schweizer
White Lady: *Kalanchoe thyrsiflora*
Watercolour on paper 510 x 395 mm
From the artist 2009
[Shirley Sherwood Collection 721]

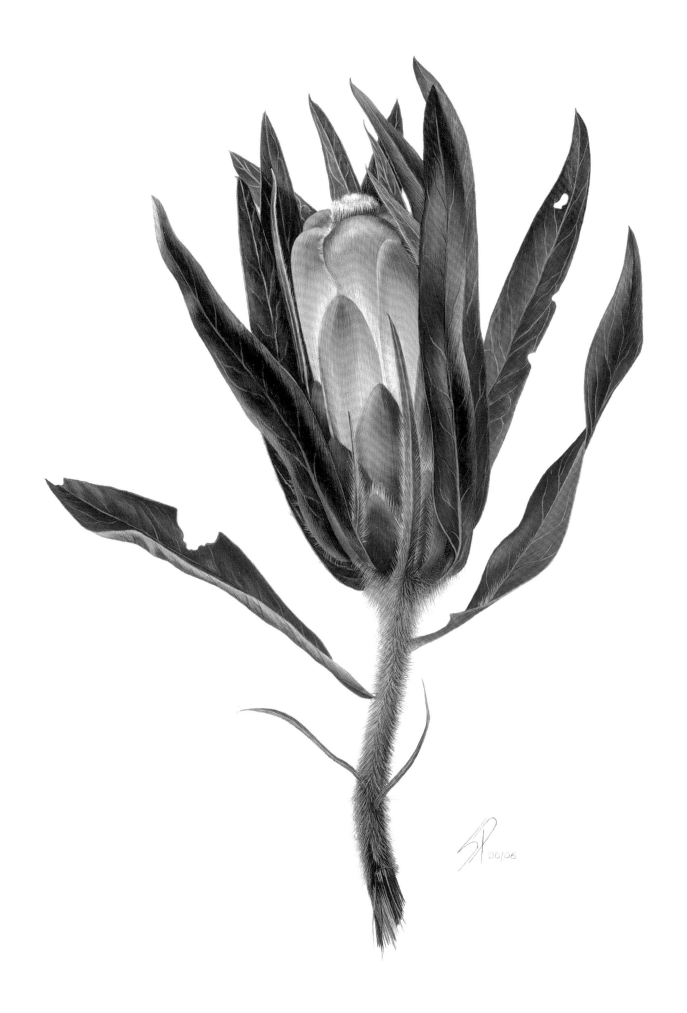

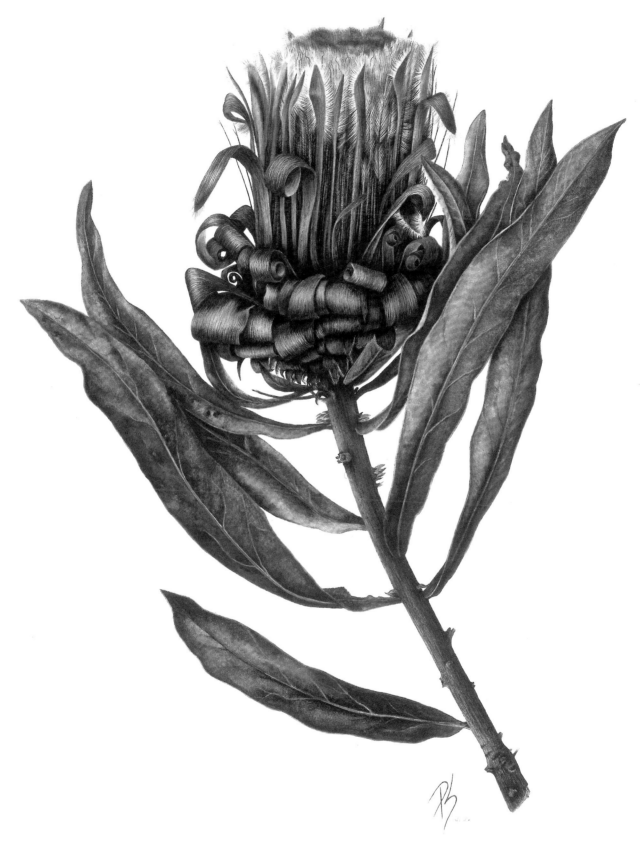

Peta Stockton
Protea coronata 2006
Watercolour on paper 345 x 280 mm
From the artist 2006
The apple-green flower looks almost unreal and is used widely in floristry.
[Shirley Sherwood Collection 644]
←

Peta Stockton
Protea neriifolia 2005
Watercolour on paper 440 x 345 mm
From the artist 2005
Seeds are retained in the seed head, until eventually dispersed by wind, after a fire.
[Shirley Sherwood Collection 614]

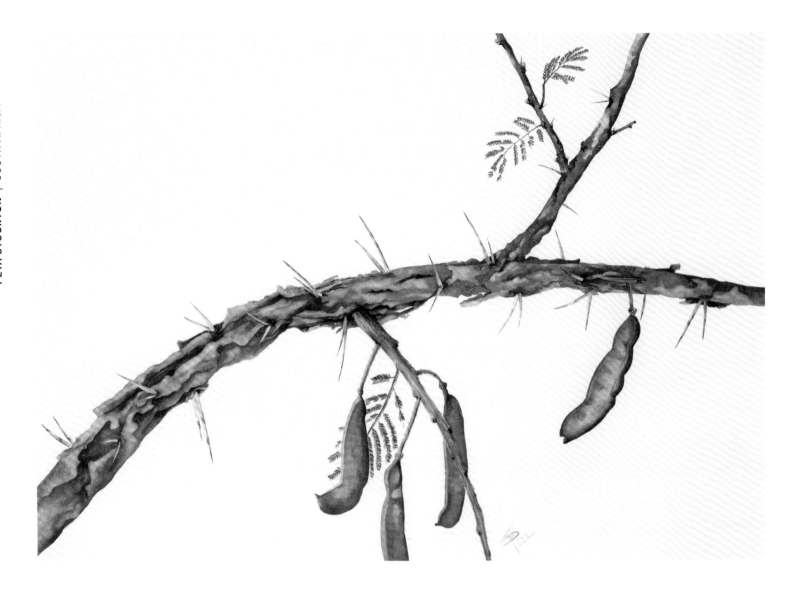

Peta Stockton
Single Stem Paperbark: *Vachellia sieberiana* 2013
Gouache on Paper 340 x 495 mm
From the artist 2014
The bark and roots are a remedy for stomach ache, colds, fever. Roots fix nitrogen via *Rhizobium* bacteria. Game animals forage for the leaves and pods.
[Shirley Sherwood Collection 877]

Vicki Thomas
Pillansia templemannii 2008
Watercolour on paper 510 x 360 mm
From the artist 2008
Artist's notes *Pillansia templemannii* is believed to be an ancient fynbos plant, and is found in remote mountain localities; it may be only distantly related to contemporary Iridaceae. There is only one species and it occurs on the lower stony slopes and flats from False Bay to Hermanus. It seldom flowers except after fire although its twisting, evergreen leaves persist for years. After a fire has swept the area, the large stands of *Pillansia* can make an incredible flowering display of various shades of orange. *Pillansia* is pollinated by bees and monkey beetles. In bloom, it can reach a height of 1.2 m and is unusual in flowering at the top bloom first, those lower down opening later.
[Shirley Sherwood Collection 689]
→

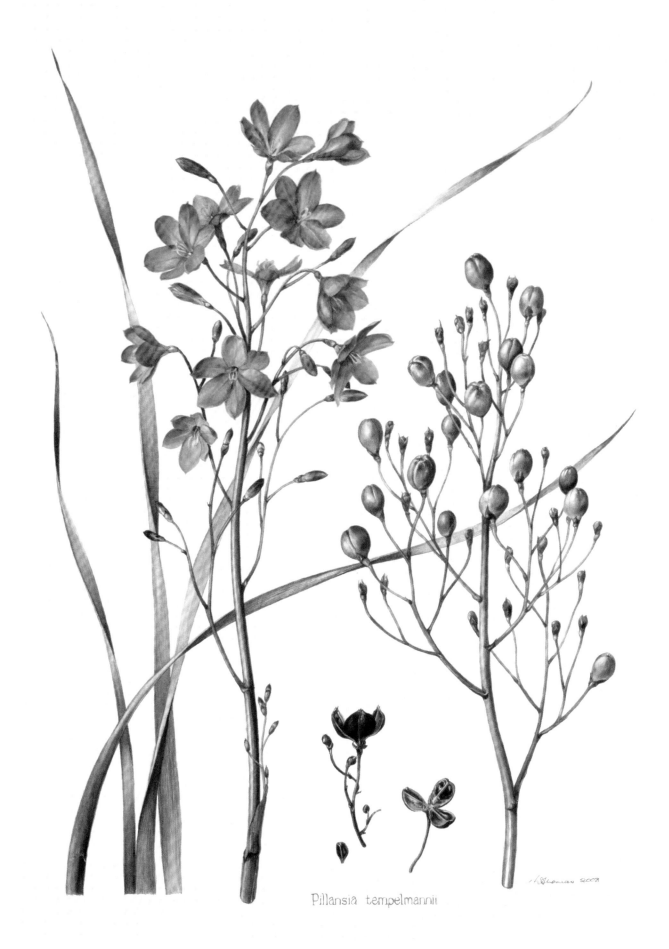

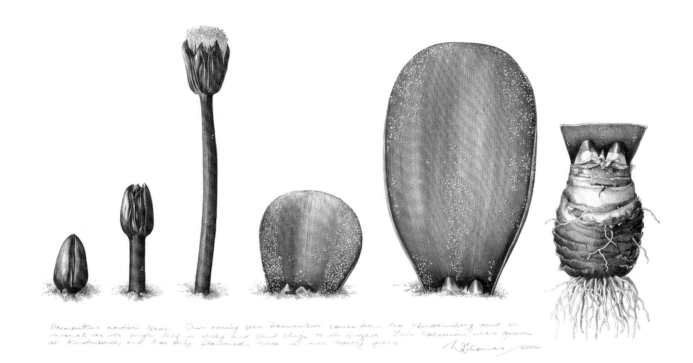

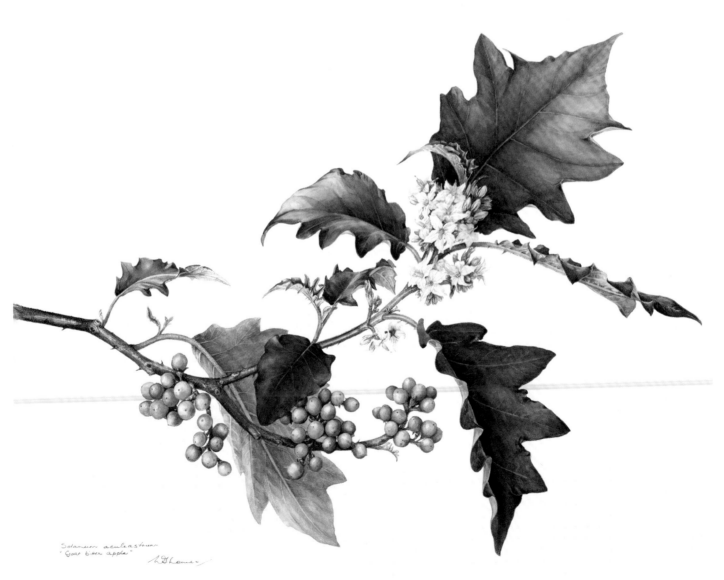

Vicki Thomas
Haemanthus norteri 2002
Watercolour on paper 305 x 535 mm
From the artist 2007
Artist's notes This rare plant comes from mountains in the north-western Cape. Its strange flat leaves are slightly sticky and often covered with sand, which might deter herbivores. This particular bulb was in the Kirstenbosch collection for over 20 years without flowering. Its strange emergence was painted in stages and Vicki's family called it 'the alien' because of its peculiar appearance.
[Shirley Sherwood Collection 654]

Vicki Thomas
Goat Bitter-Apple: *Solanum aculeastrum* 2012
Watercolour on paper 460 x 610 mm
From the artist 2012
Artist's notes Goat bitter-apple grows over quite a large part of Africa, from the tropical regions all the way down to South Africa. It is used by the Zulus as a hedge, due to its prickly nature, and can be either a shrub or a small tree up to 5 m. Goat bitter-apple or bok bitter-appel has medicinal value. The seed, which is poisonous, is used as cattle medicine and ash from the burnt seed is put in wounds.
[Shirley Sherwood Collection 819]

Vicki Thomas
Fire lily: *Cyrtanthus ventricosus* 2009
Watercolour on paper 440 x 340 mm
From the artist 2010
Artist's notes This *Cyrtanthus* only flowers after fires. This fascinating but ephemeral behaviour is not completely understood. Within weeks of vegetation being burnt it can make a marvellous massed display of red against an ashy background. Then it virtually disappears until the next fire comes along.
[Shirley Sherwood Collection 744]

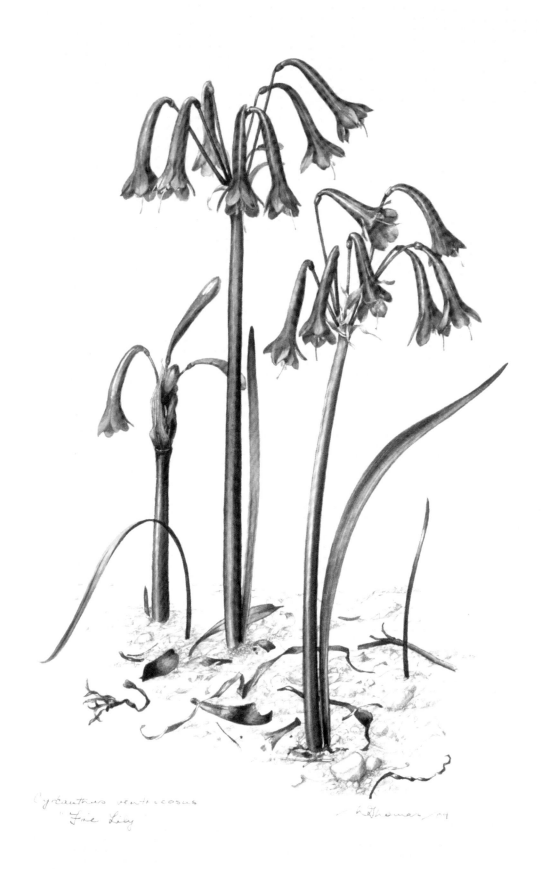

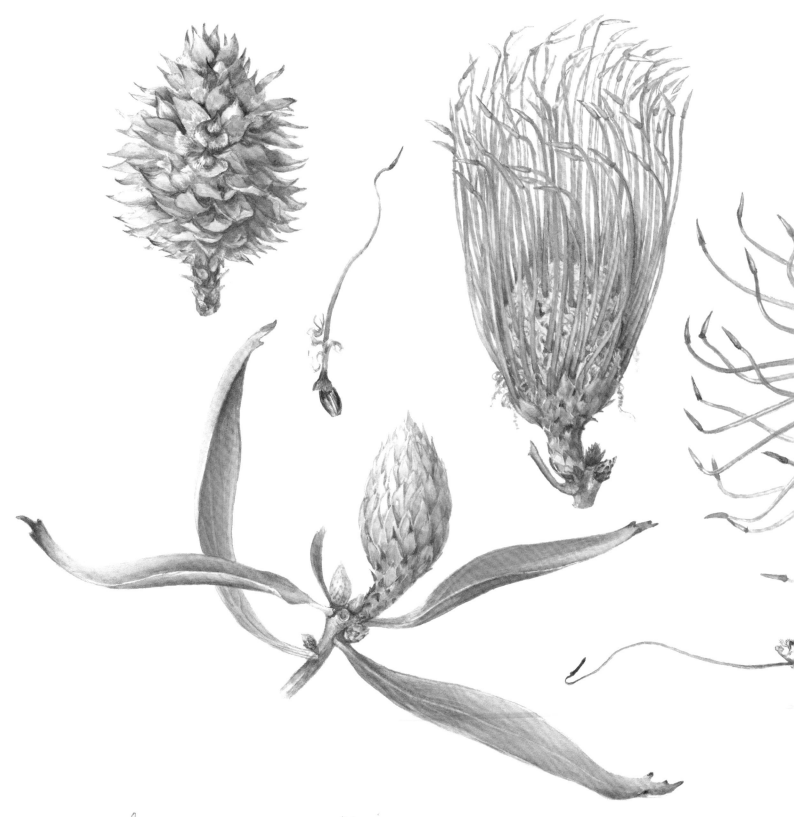

Leucospermum catherinae
"catherine-wheel pincushion"

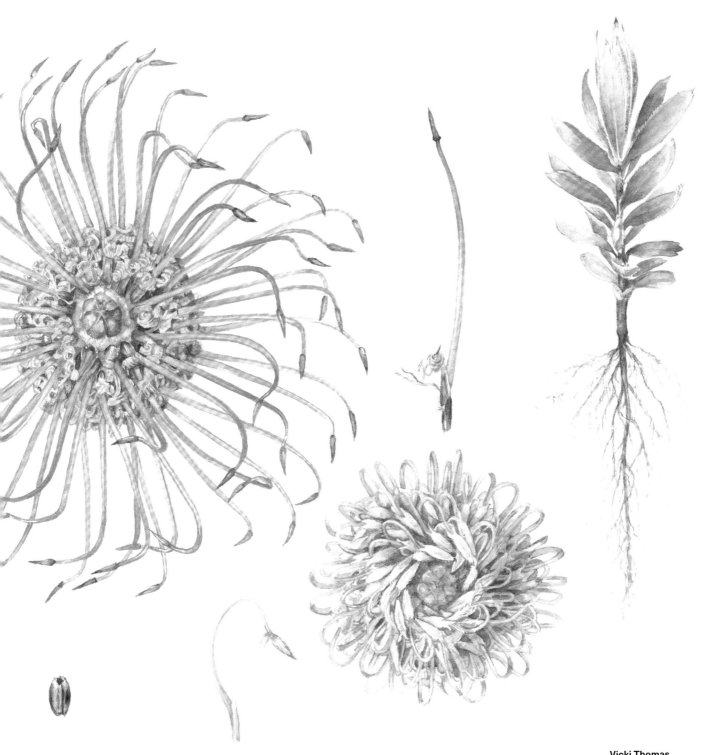

Vicki Thomas
Leucospermum catherinae 2015
Watercolour on paper 267 x 430 mm
From the artist 2015
This lovely tall fynbos plant is endangered. It is pollinated by sunbirds and sugarbirds. Its seeds are buried by ants and germinate after fire.
[Shirley Sherwood Collection 902]

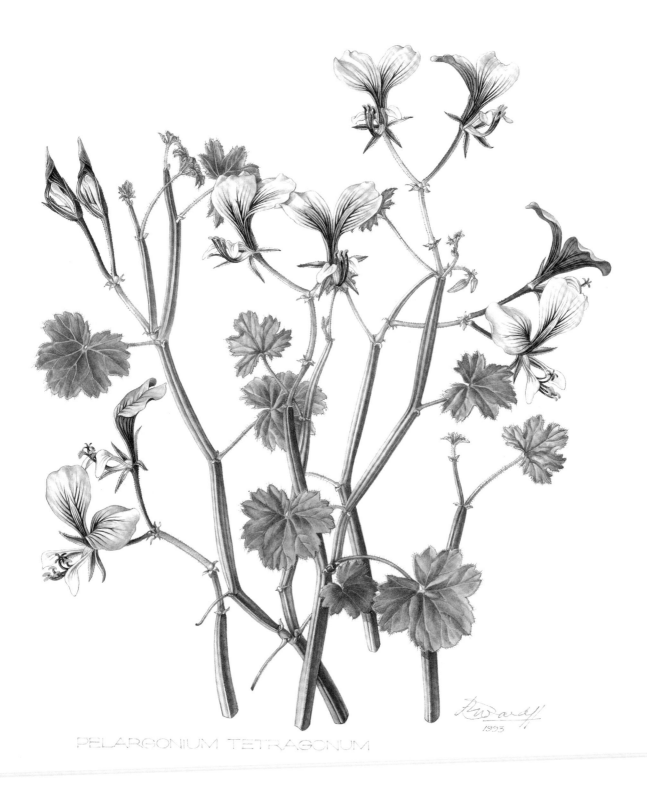

Ellaphie Ward-Hilhorst
Pelargonium tetragonum 1993
Watercolour on paper 480 x 350 mm
From the artist 1994
Ellaphie Ward-Hilhorst was considered the best illustrator of pelargoniums.
[Shirley Sherwood Collection 152]

Ellaphie Ward-Hilhorst
Red Crassula: *Crassula coccinea* 1993
Watercolour on paper 370 x 305 mm
From the artist 1993
This plant was collected on the top of Table Mountain and is more compact than specimens growing at sea level where the plant is less exposed.
[Shirley Sherwood Collection 114]
→

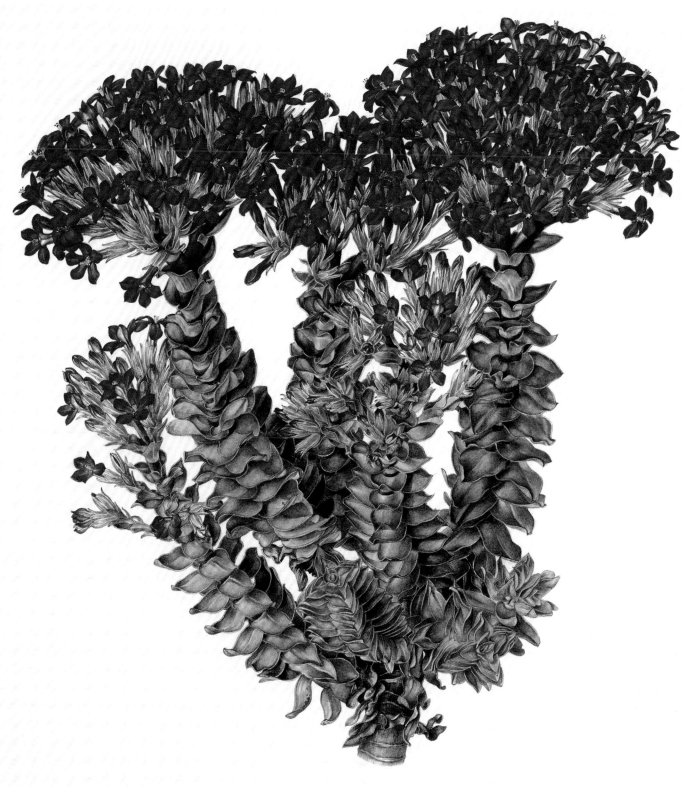

CRASSULA COCCINEA
-TABLE MOUNTAIN

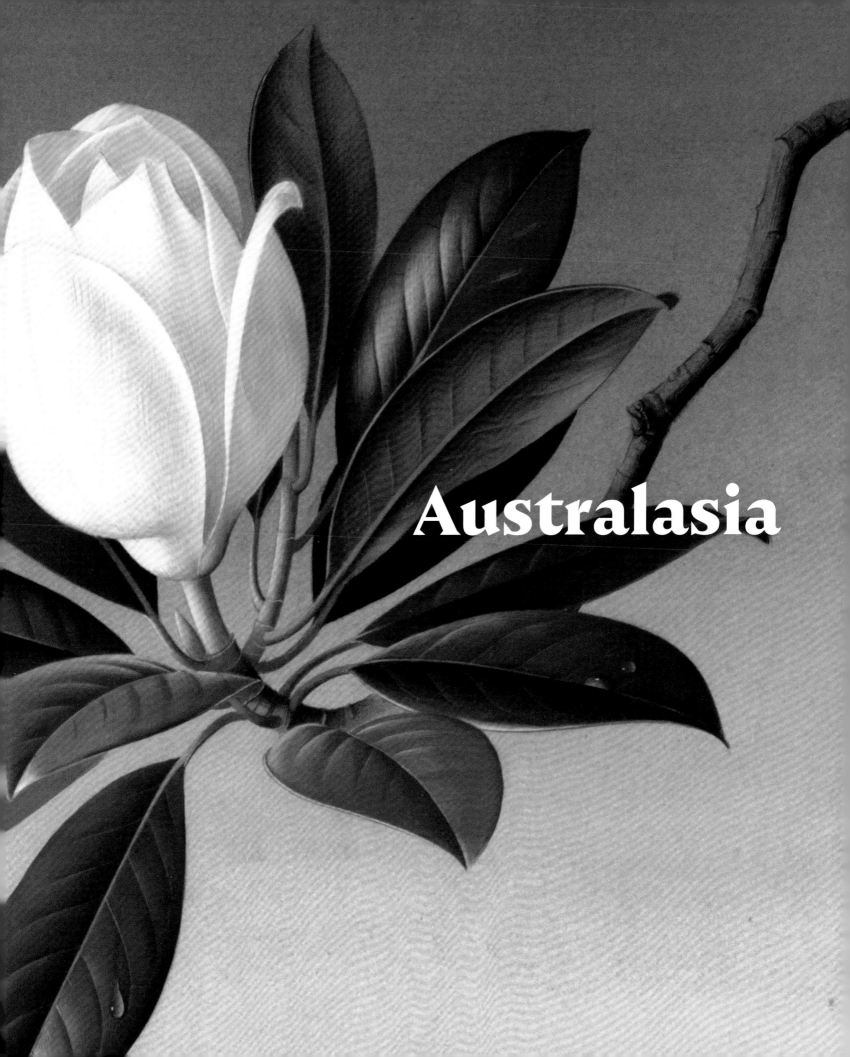

Australasia

Australasia

AUSTRALIA HAS A strong artistic tradition. Its botanical artists seem to fall into two categories: those who paint the native flora, and those who concentrate on studies of cultivated plants, fruits, flowers and still life. The first group is exemplified by Celia Rosser with her monumental banksia studies, and the artists who worked so hard to create the florilegium of Sydney's three botanic gardens. The second group is exemplified by Paul Jones's camellia studies and Susannah Blaxill's beetroot. Both these artists exhibited in London in the 1980s and 1990s before they returned to Sydney.

Celia Rosser is famous for her wonderful studies of banksia, so I flew to see her in Melbourne and persuaded her to paint me *Banksia serrata*. A new species, named for her, was discovered after she had finished the third volume of *The Banksias*. This was called *Banksia rosserae* to mark Celia's great contribution to the understanding of banksias. Her life's work has resulted in three massive books of extraordinary paintings. Jenny Phillips, also in Melbourne, has been one of the great teachers during the period I have been collecting, inspiring students from all over the world at her school there. I have some lovely works of hers.

Beverly Allen in Sydney has proven to be a leader since the early 2000s, painting both large and small studies. Her Wollemi pine appeared in *The Art of Plant Evolution* exhibitions at Kew and the Smithsonian, Washington and she was one of the initiators of the Sydney Botanic Gardens Florilegium, which eventually was shown in the Shirley Sherwood Gallery as well as in Sydney.

New Zealand has been producing new artists on the international scene. Denise Ramsay scored a noted gold medal at the RHS in 2014 with her poppy sequence from bud to fruit in six stages and has gone on to paint me a spectacular enlarged passion flower. Sue Wickison was part of an interesting exhibit in the Shirley Sherwood Gallery where I acquired two of her dramatic strelitizias. Bryan Poole's engravings of the fern *Cyathea dealbata* and the Three Kings Climber are superb portraits of local plants while his two heliconias with humming birds were an important commission for *The Art of Plant Evolution*, a groundbreaking book explaining the new discoveries of plant evolution as shown by recent DNA analysis, illustrated by paintings from my collection.

Beverly Allen
Strelitzia nicolai 2003
Watercolour on paper 510 x 420 mm
From *Botanica*, Sydney 2004
[Shirley Sherwood Collection 529]

BEVERLY ALLEN | AUSTRALIA

Beverly Allen
Wollemi Pine: *Wollemia nobilis* **2009**
Watercolour on paper 650 x 975 mm
From the artist 2009
The Wollemi pine was only known through fossil records until 1994 when it was discovered in a hidden gorge in the Blue Mountains, near Sydney.
[Shirley Sherwood Collection 737]

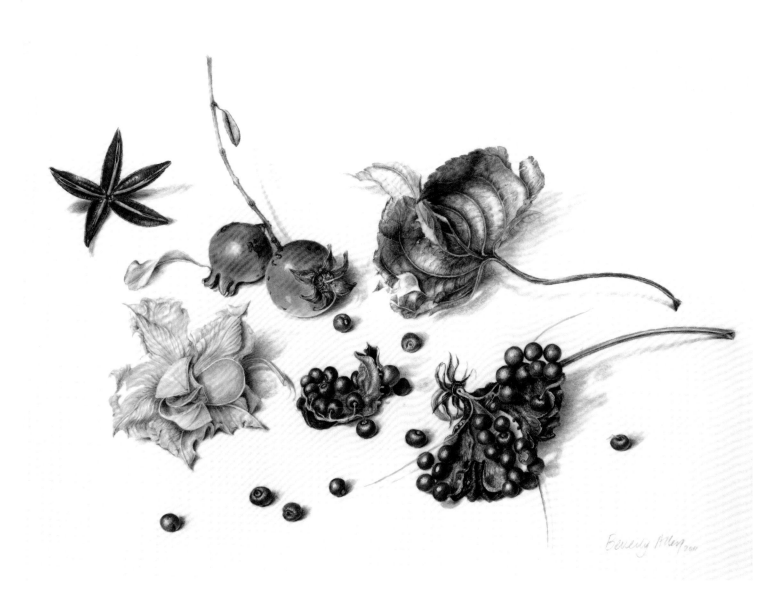

Beverly Allen
Pomegranates and Seed Pods of *Gloriosa superba* **2011**
Watercolour on vellum 200 x 300 mm
From the artist 2012
Beverly Allen's response to working on her first piece of vellum was with a painting that looked back to work by van Kessel or Hoefnagel in the 16th to 17th century. Most of her paintings are on a much larger scale, like her yellow lotus or Wollemi pine.
[Shirley Sherwood Collection 821]

SUSANNAH BLAXILL | AUSTRALIA

Susannah Blaxill
Seaweed: *Laminaria* sp. 2002
Watercolour on paper 650 x 460 mm
From the artist 2002
Kelp found on a Sydney beach.
[Shirley Sherwood Collection 471]

Susannah Blaxill
Camellia 'Star above Star' 2008
Watercolour and gouache on paper
740 x 510 mm
Commissioned 2007
[Shirley Sherwood Collection 692]
→

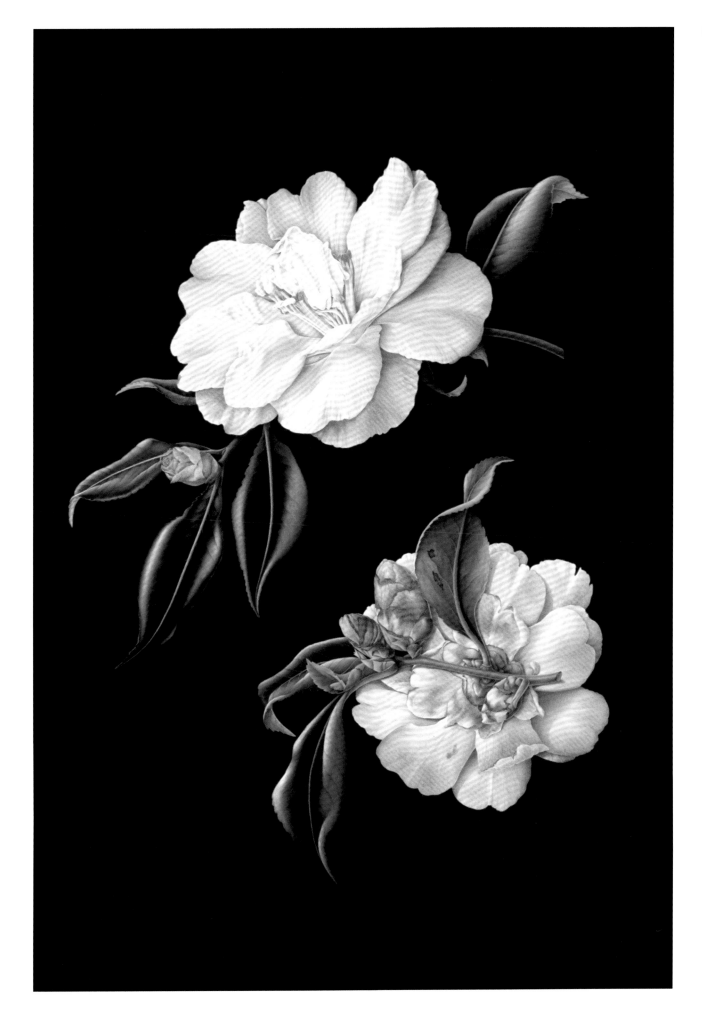

SUSANNAH BLAXILL | AUSTRALIA

Susannah Blaxill
Beetroot: *Beta vulgaris*
Watercolour on paper 480 x 640 mm
Acquired from Spink, London 1994
[Shirley Sherwood Collection 196]

Susannah Blaxill
Pear Study 3: *Pyrus* sp. 2008
Charcoal on paper 455 x 270 mm
From the artist 2008
One of three similarly enlarged studies of pears.
[Shirley Sherwood Collection 713]
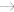

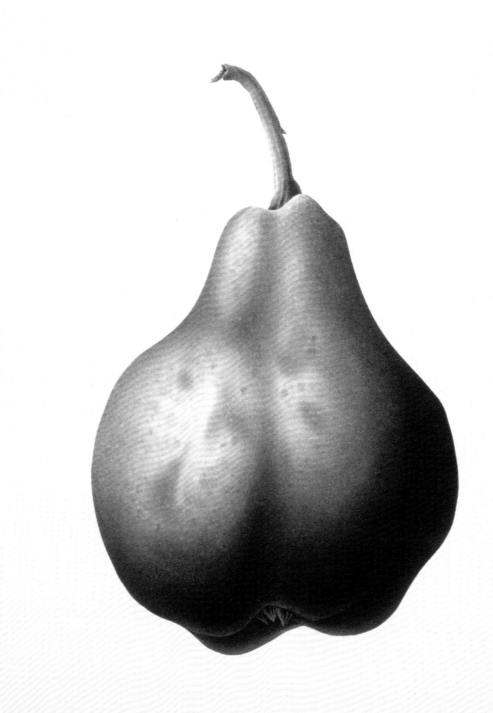

SUSANNAH BLAXILL | AUSTRALIA

ANNIE HUGHES | AUSTRALIA

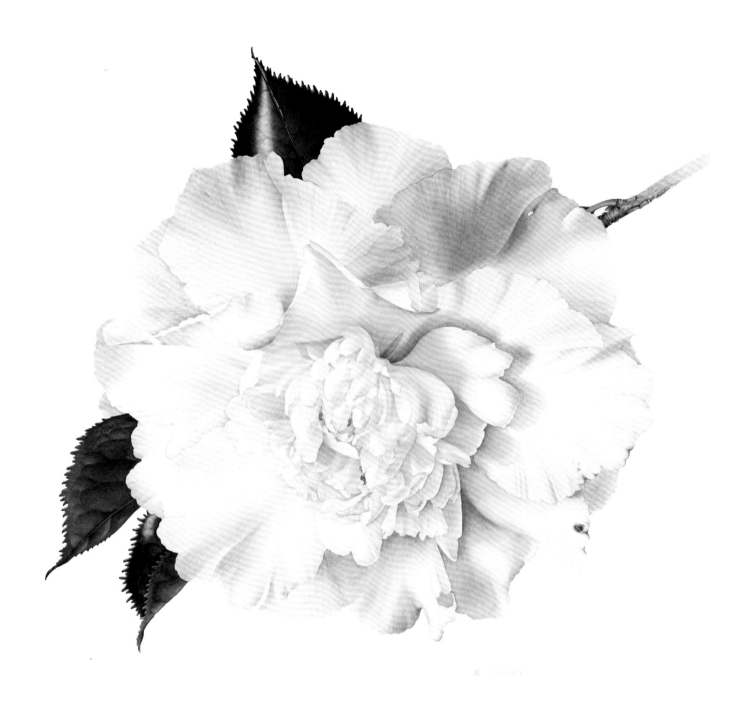

Annie Hughes
Camellia japonica 'Elegans champagne' 2011/2012
Watercolour on paper 800 x 760 mm
Acquired 2012
The camellia flower has been dramatically enlarged.
[Shirley Sherwood Collection 820]

Paul Jones
Violet Plant: *Viola* sp.
Acrylic on paper 245 x 210 mm
From the artist 1997
[Shirley Sherwood Collection 295]
→

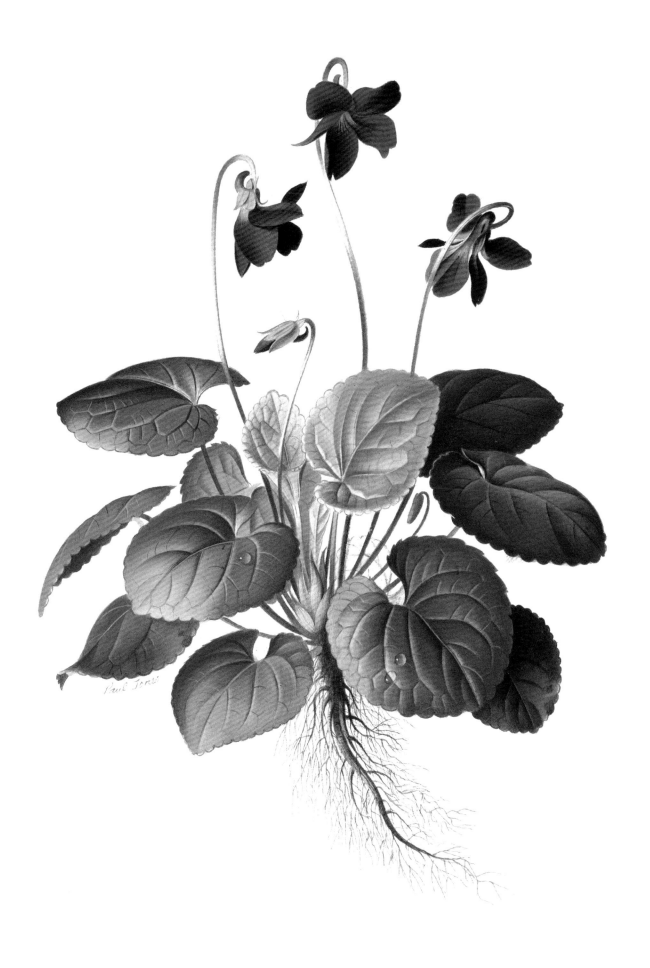

PAUL JONES | AUSTRALIA

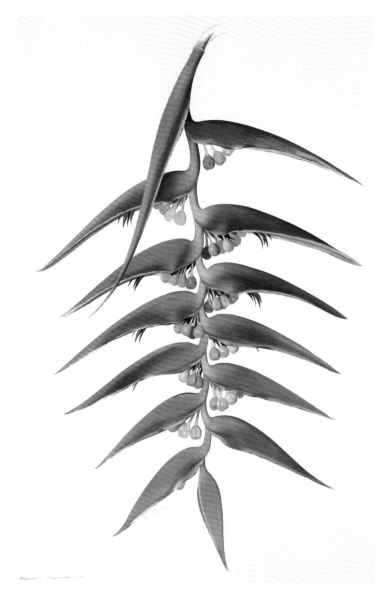

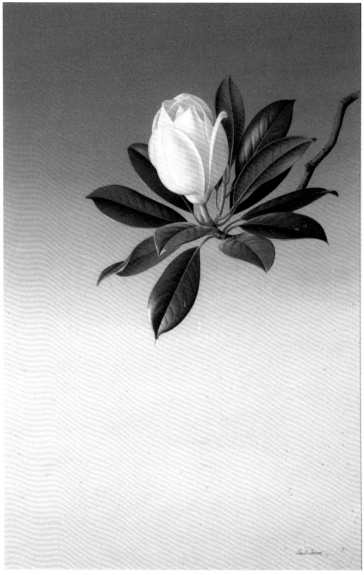

Paul Jones
Heliconia solomonensis 1997
Acrylic on paper 740 x 510 mm
From the artist 1997
The heliconia in this painting was identified by John Kress of the Smithsonian, an expert on heliconias.
[Shirley Sherwood Collection 544]

Paul Jones
Magnolia grandiflora
Acrylic on paper 710 x 540 mm
From the artist 1997
He used a graded background for some paintings after a visit to Japan.
[Shirley Sherwood Collection 292]

David Mackay
Onion Wood: *Syzygium alliiligneum*
2004
Acrylic on paper 700 x 560 mm
From *Botanica*, Sydney 2004
This rainforest tree is native to Australia, endemic to north-east Queensland.
[Shirley Sherwood Collection 530]
→

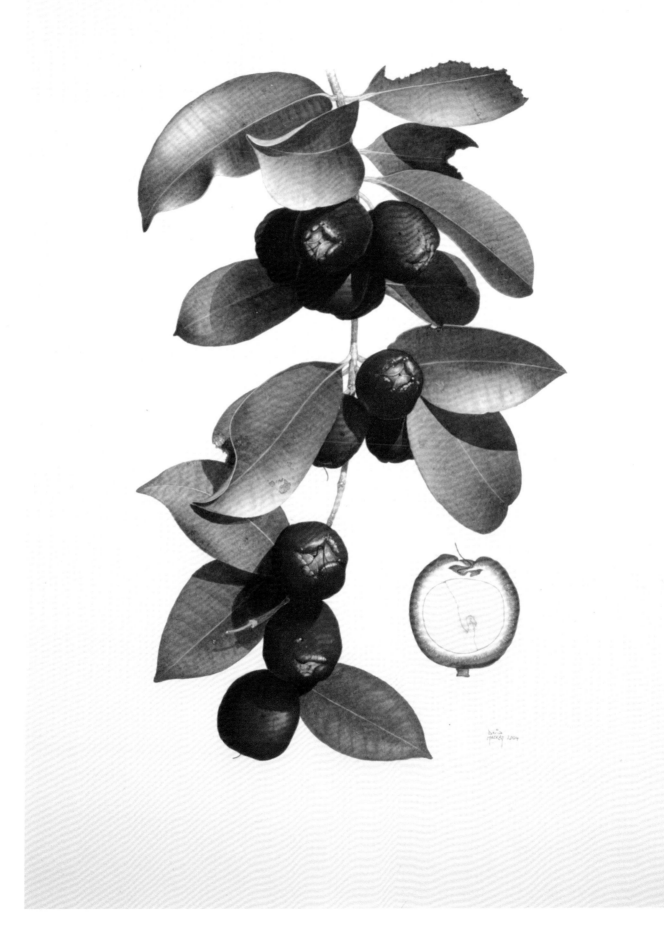

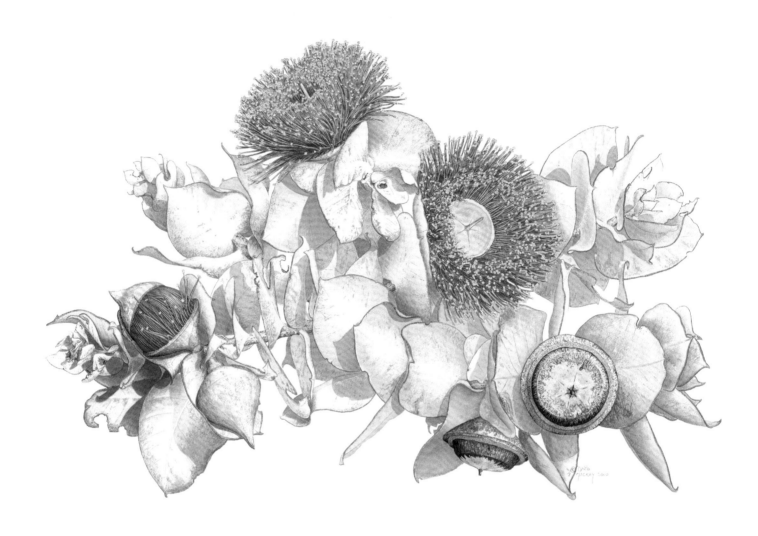

David Mackay
Eucalyptus macrocarpa subsp. *elachantha* 2000
Acrylic on paper 750 x 735 mm
From *Botanica*, Sydney 2000
Australian native.
[Shirley Sherwood Collection 402]

Julie Nettleton
Pink Five-corners: *Styphelia triflora* 2011
Watercolour on paper 440 x 325 mm
From the artist 2014
Endemic to Australia and the Pacific Islands.
[Shirley Sherwood Collection 863]
→

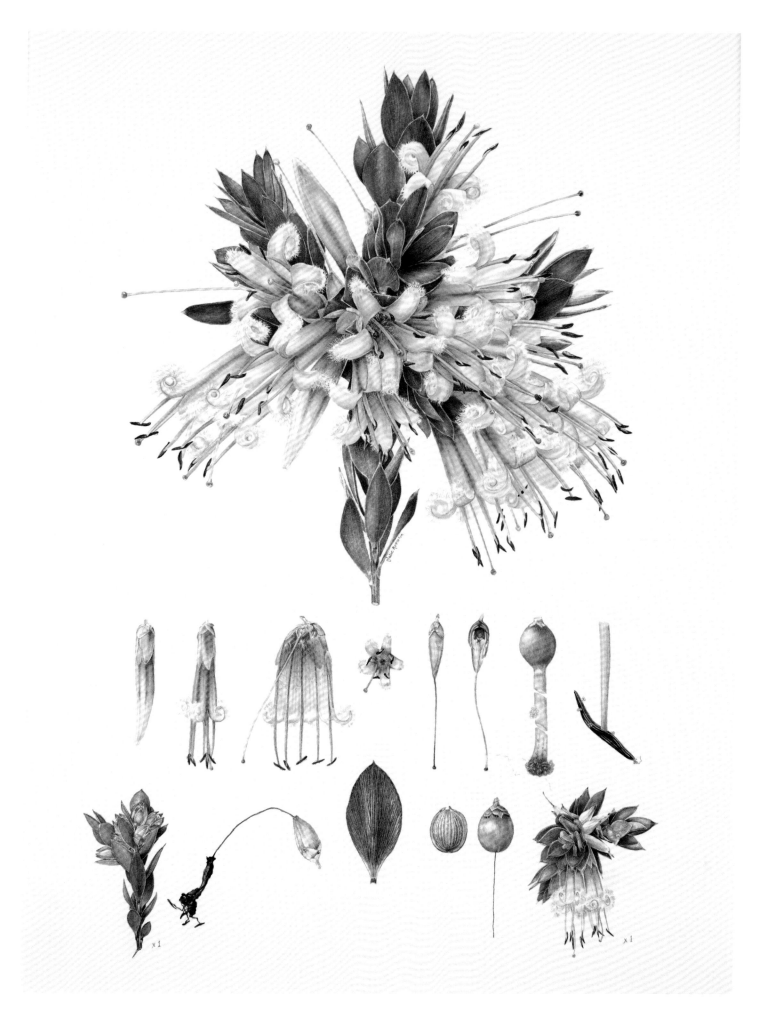

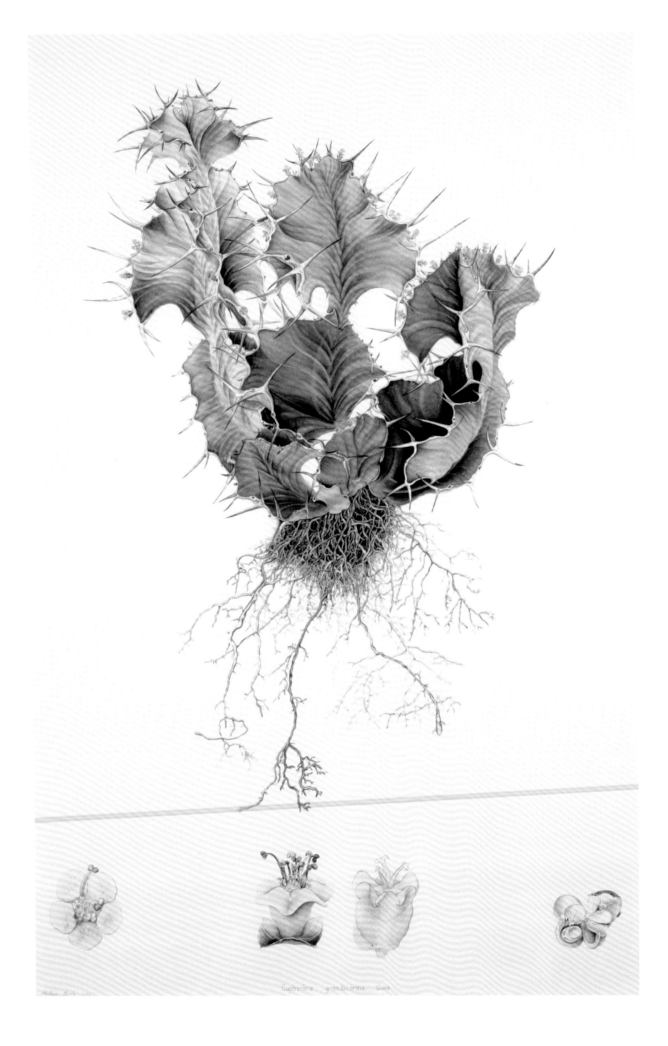

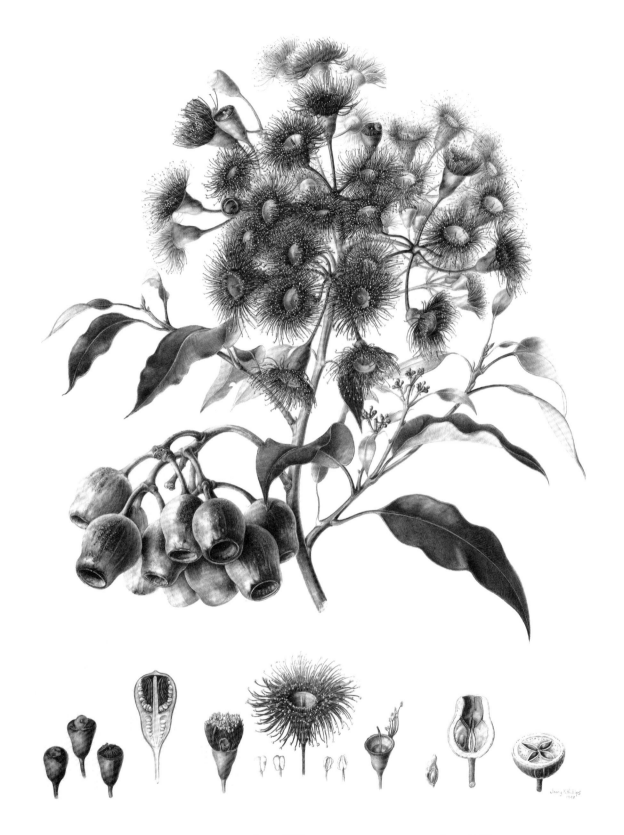

Jenny Phillips
Euphorbia grandicornis 1993
Watercolour on paper 700 x 480 mm
From the RHS show 1993, when she was awarded a gold medal.
[Shirley Sherwood Collection 120]

←

Jenny Phillips
Corymbia ficifolia 1998
Watercolour on vellum 530 x 390 mm
Acquired from Tryon & Swann Gallery 1998
Her first painting on vellum, depicting an Australian native plant.
[Shirley Sherwood Collection 341]

JENNY PHILLIPS | AUSTRALIA

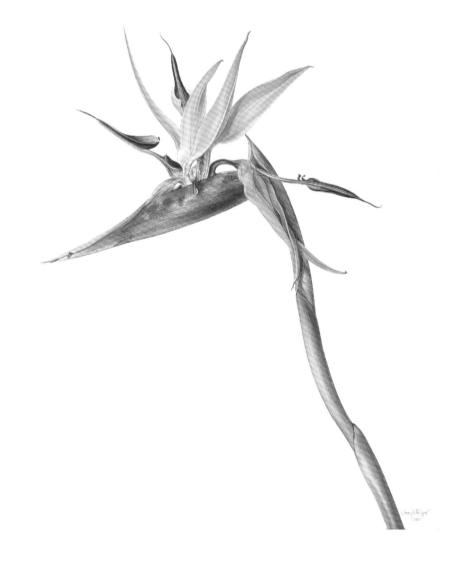

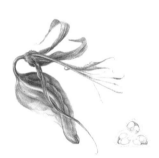

Jenny Phillips
Strelitzia 'Mandela's Gold' 2001
Watercolour on paper 575 x 765 mm
From the artist 2002
A study reminiscent of the work of Francis Bauer (1758–1840) who inspired this outstanding artist and teacher.
[Shirley Sherwood Collection 467G]

Jenny Phillips
Ageing and Looking Silky 2006
Watercolour on paper 173 x 132 mm
From the artist 2015, as a birthday present.
[Shirley Sherwood Collection 926G]
→

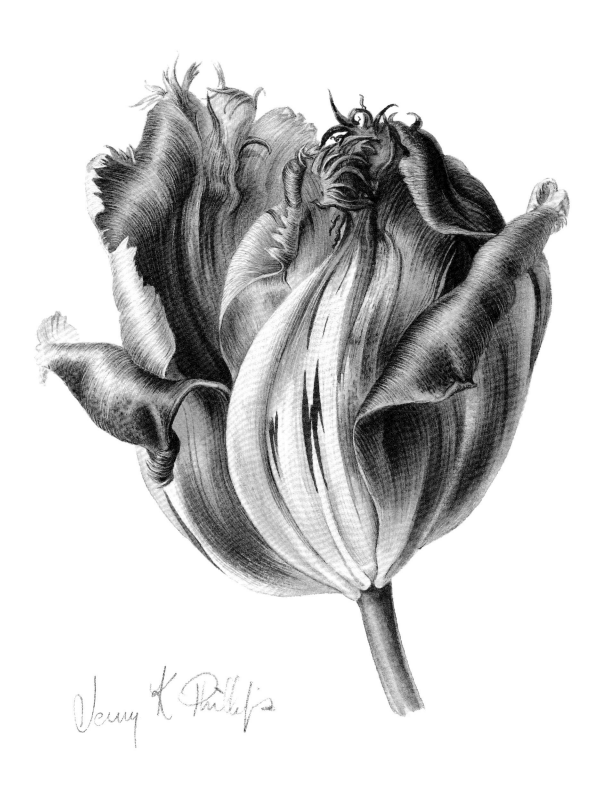

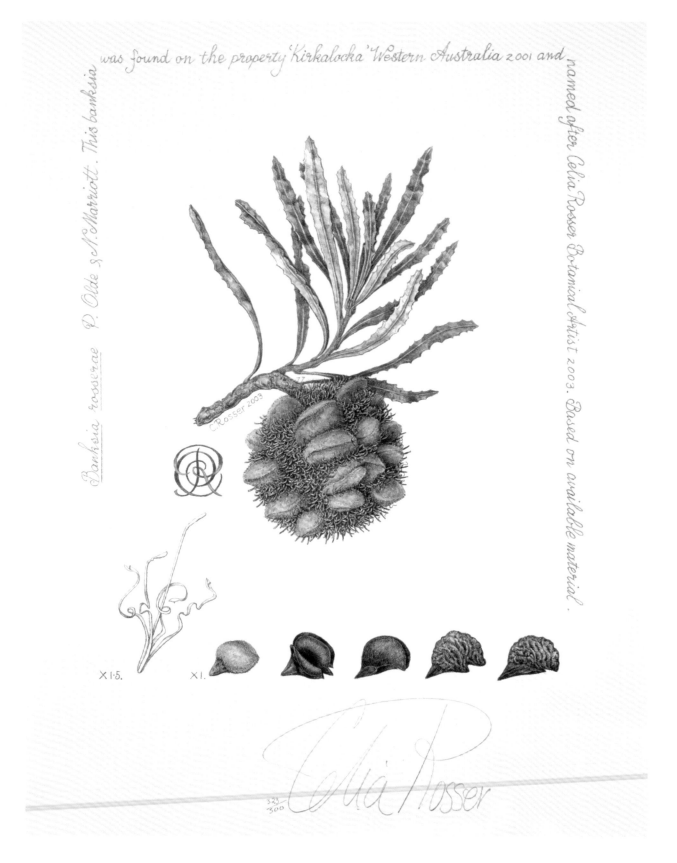

Celia Rosser
Banksia rosserae 2003
Print on paper 323/500, 305 x 220 mm
From the artist 2009
A recently discovered banksia named for the artist. Found after she had completed her 3-volume work *The Banksias*.
[Shirley Sherwood Collection 742G]

Celia Rosser
Saw Banksia: *Banksia serrata* 1995
Watercolour on paper 760 x 560 mm
Commissioned 1993
One of the first plants collected by Joseph Banks on landing in Botany Bay, Australia.
[Shirley Sherwood Collection 235]
→

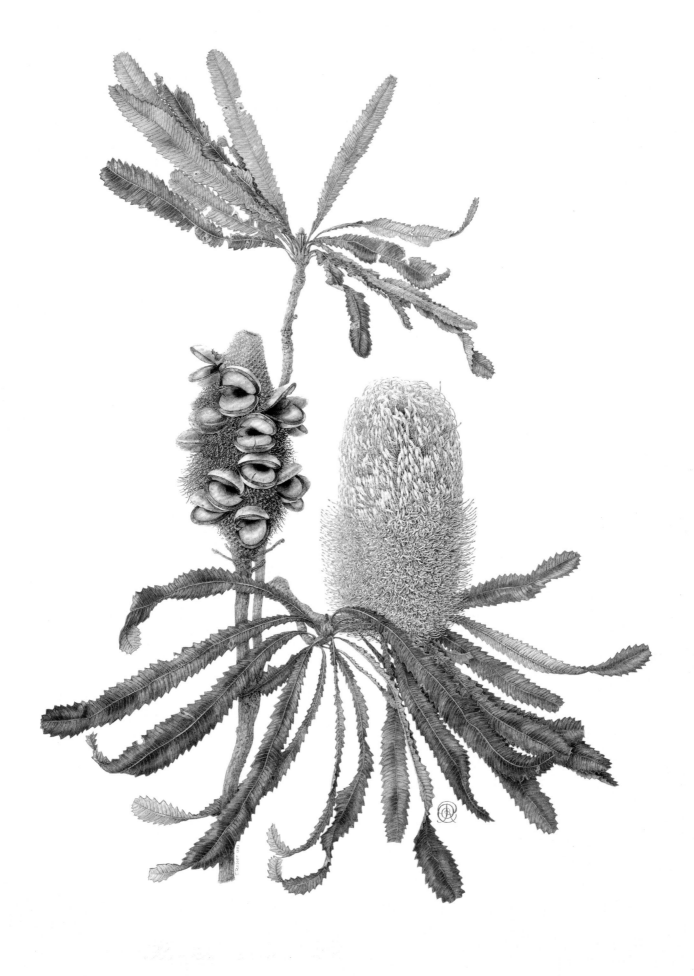

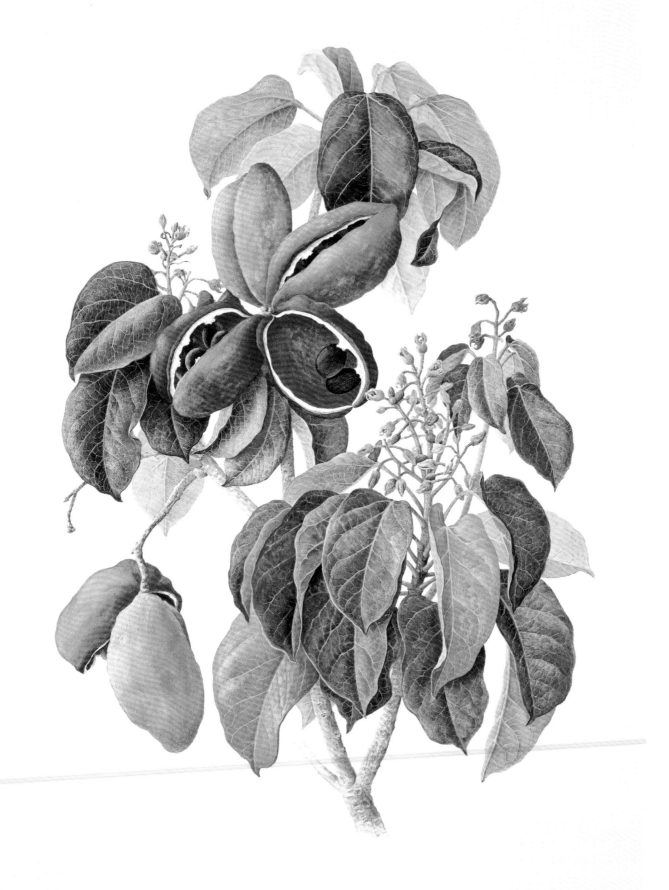

PEANUT TREE *Sterculia quadrifida* Margaret A. Saul. 1995.

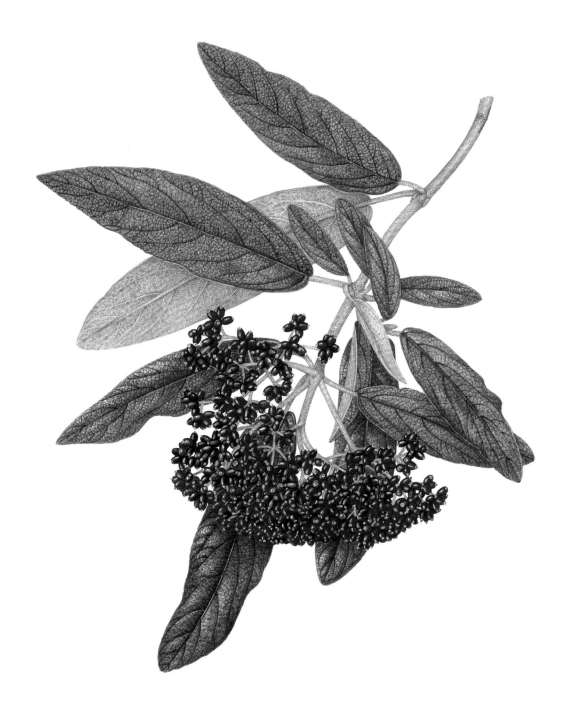

Margaret Anne Saul
Peanut Tree: *Sterculia quadrifida* 1995
Watercolour with coloured pencil and gouache 420 x 300 mm
Commissioned 1995
Native in north west Australia.
[Shirley Sherwood Collection 221]
←

Margaret Stones
Viburnum: *Viburnum rhytidophyllum*
Watercolour on paper 482 x 370 mm
From the artist, 1993
Painted at Kew where she lived for many years.
[Shirley Sherwood Collection 128]

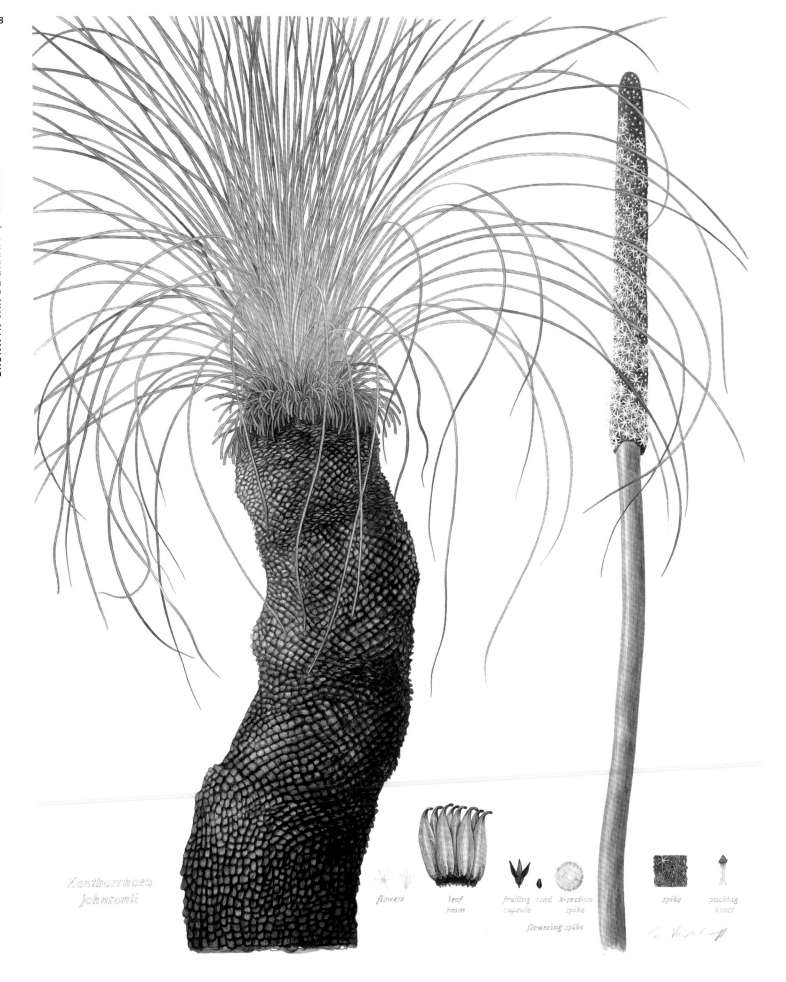

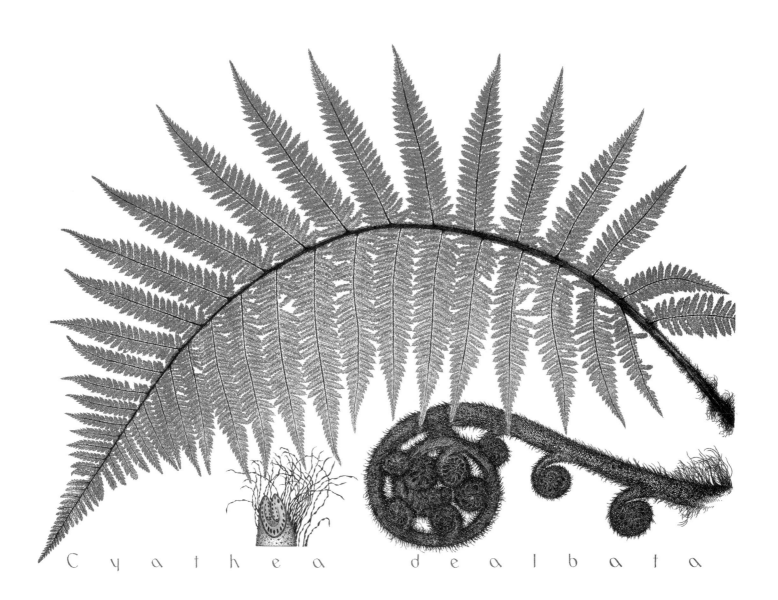

Bronwyn van de Graaff
Grass Tree: *Xanthorrhoca johnsonii*
2005
Watercolour on paper 580 x 463 mm
From the artist 2005
Australian native.
[Shirley Sherwood Collection 610]
←

Bryan Poole
Silver tree fern: *Cyathea dealbata*
2007
Copper plate etching 420 x 560 mm
Endemic to New Zealand.
[Shirley Sherwood Collection 680]

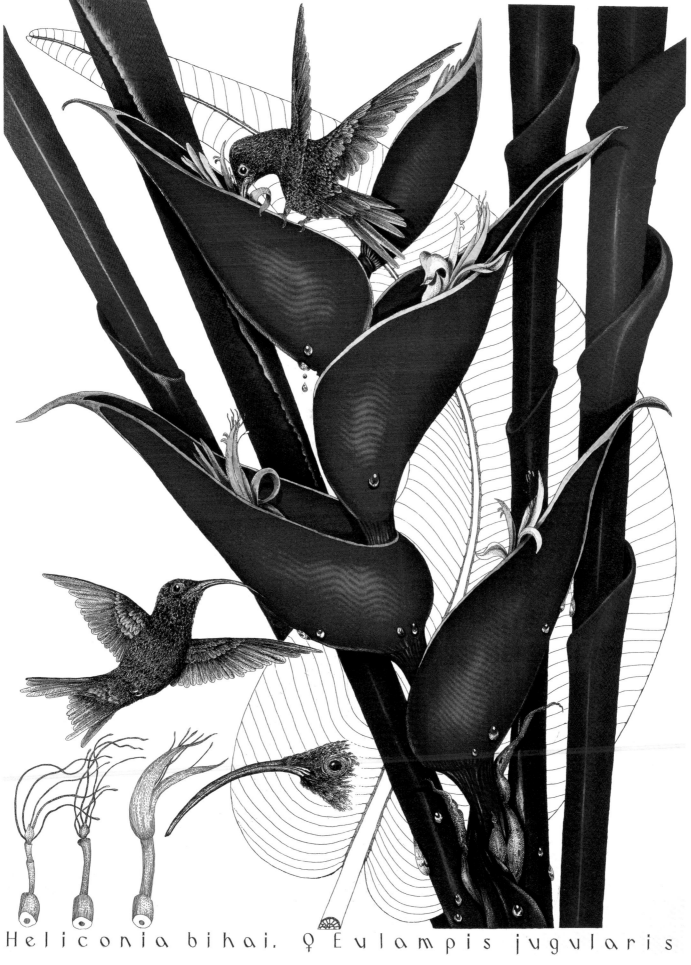

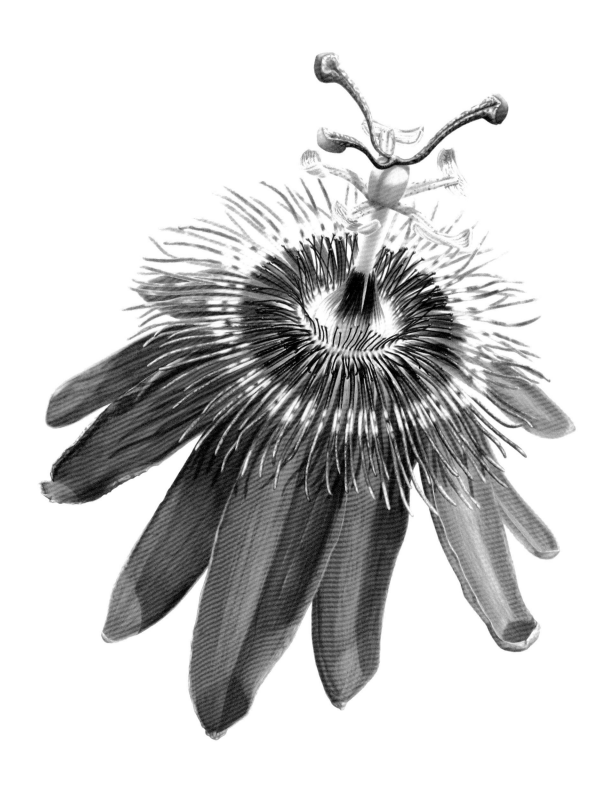

Bryan Poole
Heliconia bihai, Eulampis jugularis
2008
Etching and engraving 1/100,
750 x 550 mm
From the artist 2008
Commissioned for *The Art of Plant Evolution* by John Kress and Shirley Sherwood, 2010
[Shirley Sherwood Collection 698]
←

Denise Ramsay
Flight of Passion: *Passiflora* 'Lavender Lady' 2018
Watercolour on paper 1180 x 1140 mm
From the artist 2018
[Shirley Sherwood Collection 981]

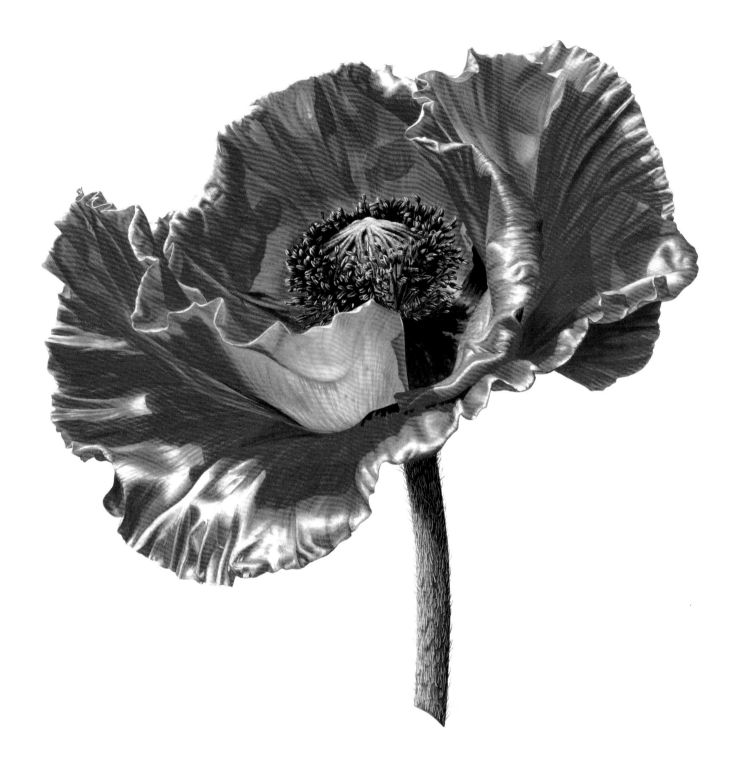

Denise Ramsay
A Brilliant Life – Perfection: *Papaver orientale* 'Brilliant' 2014
Watercolour on paper 710 x 670 mm
From the artist 2014
3/6 in a sequence of poppies from bud to seed head, awarded a gold medal by the RHS.
[Shirley Sherwood Collection 887]

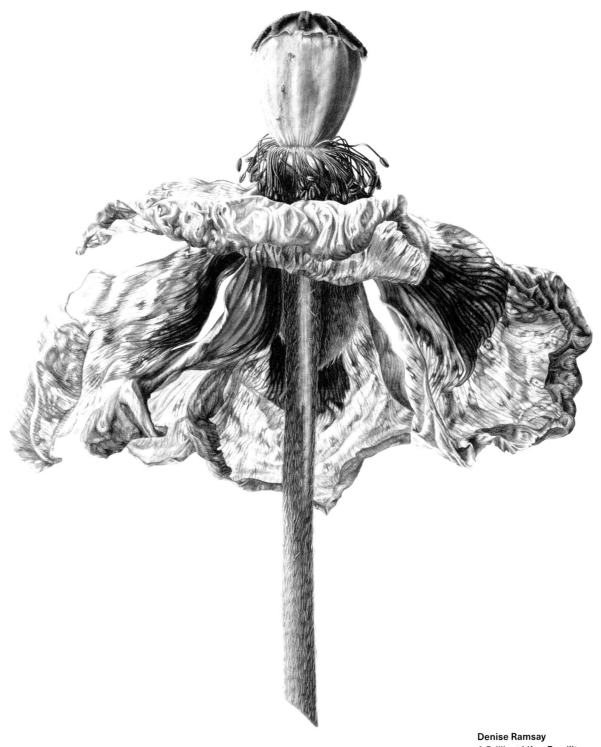

Denise Ramsay
A Brilliant Life – Fragility:
Papaver orientale 'Brilliant' 2014
Watercolour on paper 555 x 420 mm
From the artist 2014
5/6 in a sequence of poppies from bud to seed head, awarded a gold medal by the RHS.
[Shirley Sherwood Collection 889G]

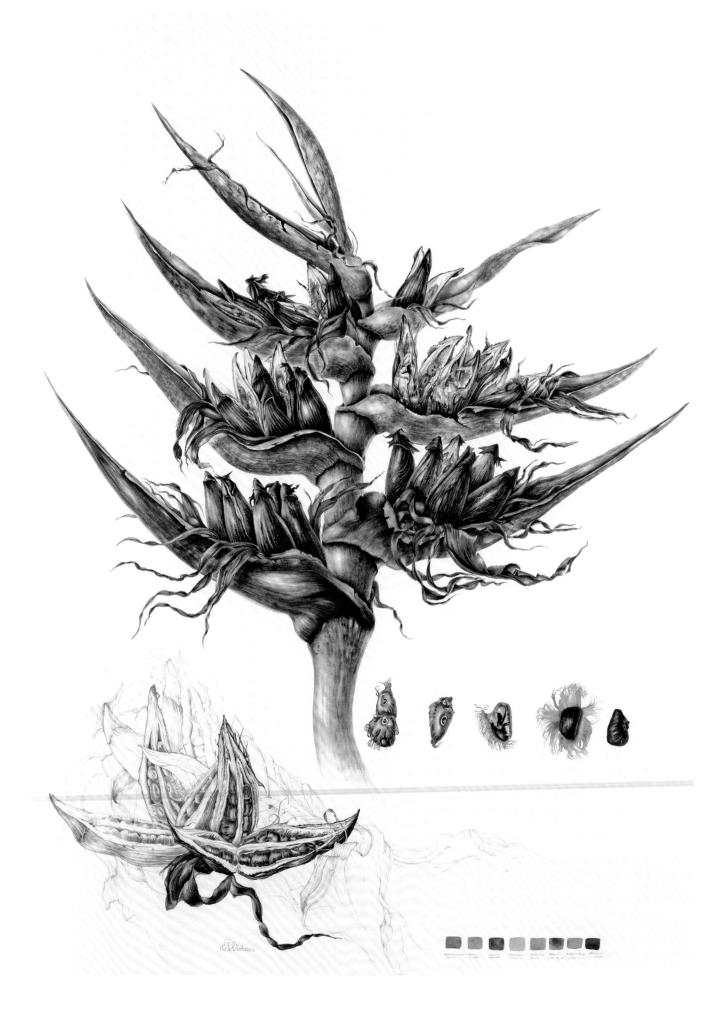

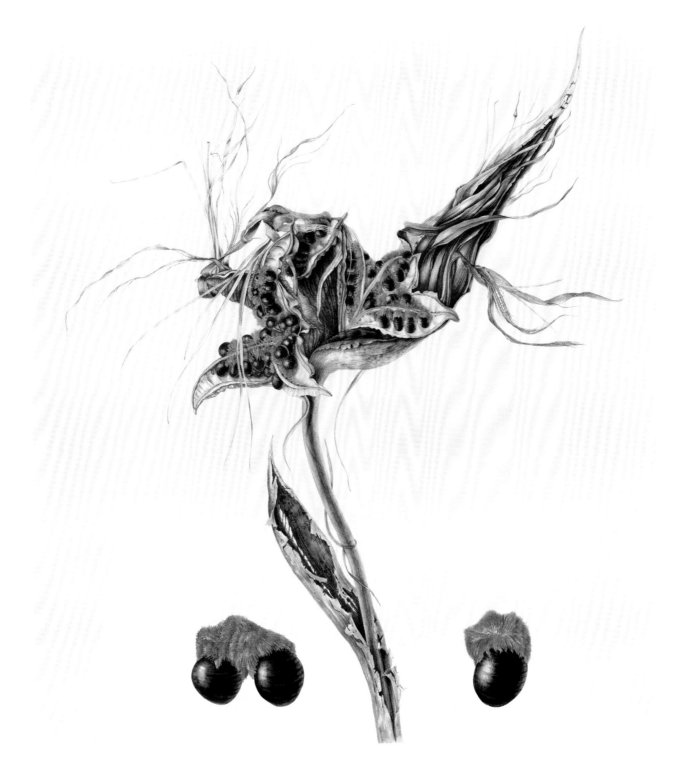

Sue Wickison
The Traveller's Palm: *Ravenala madagasceriensis* 2013
Watercolour and graphite on paper 980 x 710 mm
From the artist 2016
Dispersed by ruffed lemurs who co-evolved with *Ravenala madagasceriensis* on the island of Madagascar. The unusual blue-fringed seeds are attractive to the ruffed lemurs who can see blue and green but, because of their dichromatic vision, cannot see red and so would not be tempted by the scarlet seeds of *Strelizia reginae*.
[Shirley Sherwood Collection 925]
←

Sue Wickison
Bird of Paradise Plant: *Strelizia reginae* 2013
Watercolour on paper 560 x 480 mm
From *Black and White in Colour* at the Shirley Sherwood Gallery 2013
Collected from the Eastern Cape, South Africa, in 2013. The red 'wig' on the seed is edible, helping seed dispersal by animals and birds.
[Shirley Sherwood Collection 855]

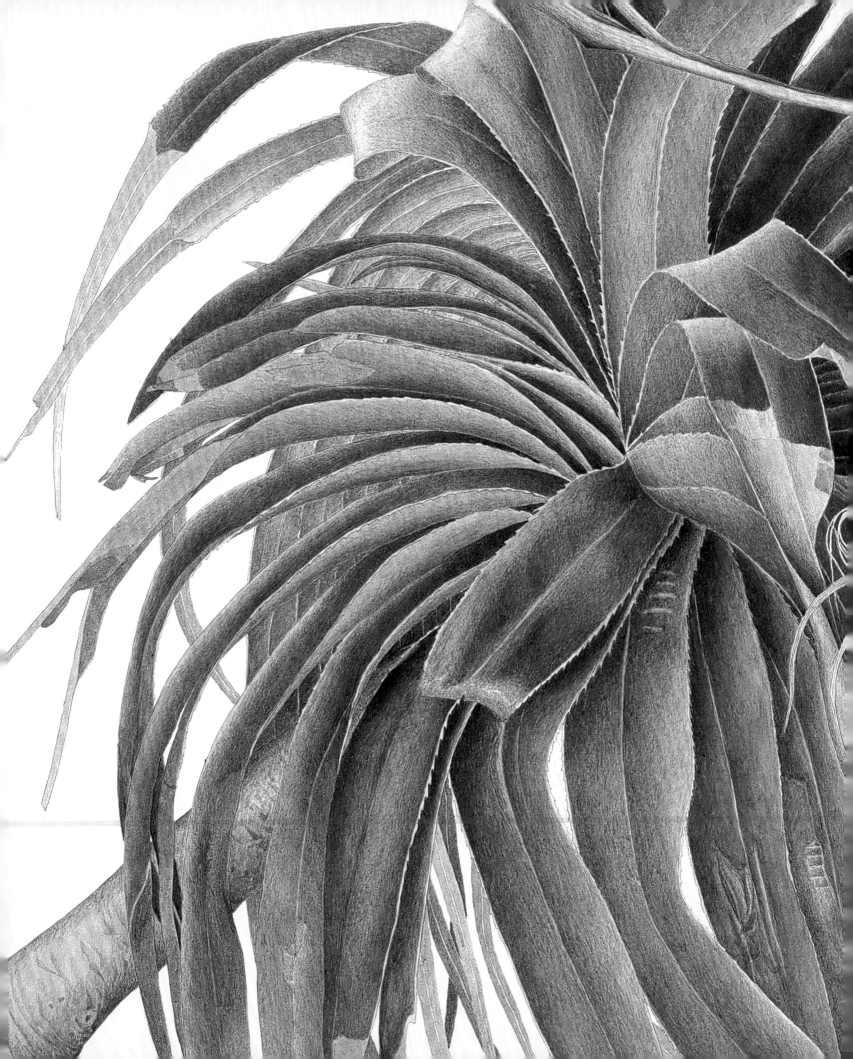

Asia

Asia

Japan

Collecting over many years has taken me to some fascinating places but there is nowhere I find more interesting than Japan. The Japanese botanical artist shows an elegance and a sense of design which is perfectly combined with superb botanical observation. The standard has always been very high, the artists are always meticulous and they are now appearing in international exhibitions where they are greeted with enthusiasm. Gradually an increasing number are putting in for medals at the RHS in London and for awards in the ASBA exhibitions in the States. There was an excellent show by Japanese artists at the Shirley Sherwood Gallery in 2016, which attracted almost 60,000 visitors and had a lovely catalogue, *Flora Japonica* published by Kew. The exhibition was later hosted by the National Museum of Nature and Science, Tokyo in 2017 and in other venues in Japan.

On a trip to Tokyo in 2012 I met up again with Japan's most prominent botanical artist, Mieko Ishikawa, who took me to her house for a delicious lunch. While I was there, I had time to fall in love with 'ET', a splendidly nicknamed painting of a dessicated pitcher from the carnivorous *Nepenthes villosa* which she had found on Mount Kinabalu in Borneo. We then rushed to Mieko's eager class of some 30 students and I admired examples of their meticulous work. It contrasted with some of my early meetings in the 1990s when artists could be very shy and few could communicate with me. But since then I have had two major shows in Tokyo and the internet has been so important, with its access to well-scanned paintings overcoming language barriers. And, of course, by now I have met and become friends with many of the artists who have work in my collection.

Thirty years ago there was an emphasis on painting cultivated plants. Now there is a move towards seeking native and rare or endangered species. This is to some extent triggered by worries about climate change and emphasised by some dramatic storms and temperature swings which have hit Japan particularly hard.

I first became interested in Rankafu (orchid) prints when approached by Professor Stephen Kirby. He had a complete set of the woodblock prints, which he showed me in London. The artist Zuigetsu Ikeda (1877–1944) had painted many of the orchids bred in Japan by the famous, wealthy orchid breeder Shotaro Kaga (1888–1954). These were made into the finest woodblock prints and we had a well-received exhibition of the prints in the Shirley Sherwood Gallery in 2018/19.

China

When I started collecting I had expected that China would be a great source of contemporary botanical art, as many of its plants are spectacular and its artistic traditions are so strong. I started with meeting Professor Jinyong Feng and Mrs Tai-li Zhang in Beijing Botanical Gardens in 1993, acquiring several good paintings from each. But I lost contact with my Chinese artists and have failed since to find any contemporary Chinese work in international exhibitions.

India

I visited India in 1994 and acquired a few works. I've made several later trips but have mainly acquired paintings by Indian artists from James White, the dedicated and respected curator at the Hunt Institute in Philadelphia. In the 1990s I thought the most interesting botanical artist was Damodar Gurjar. I also acquired a lovely undated, stylised painting by Thakur Ganga Singh (1895–1970) in 1999.

Philippines

When visiting Manila in 1997 I found some work by Emmanuel L Cordova in an art shop, tracked him down and eventually asked him to paint something for me. In 2018 he was in London to see his *Areca* palm exhibited in *Trees: Delight in the Detail* and he showed me photographs of his large attractive murals of tropical forests.

Zuigetsu Ikeda 1877–1944
Rankafu print of *Dendrobium victoria reginae*
Woodblock print published 1946,
485 x 320 mm
Acquired 2015, a gift from Professor Stephen Kirby.
[Shirley Sherwood Collection 882G]

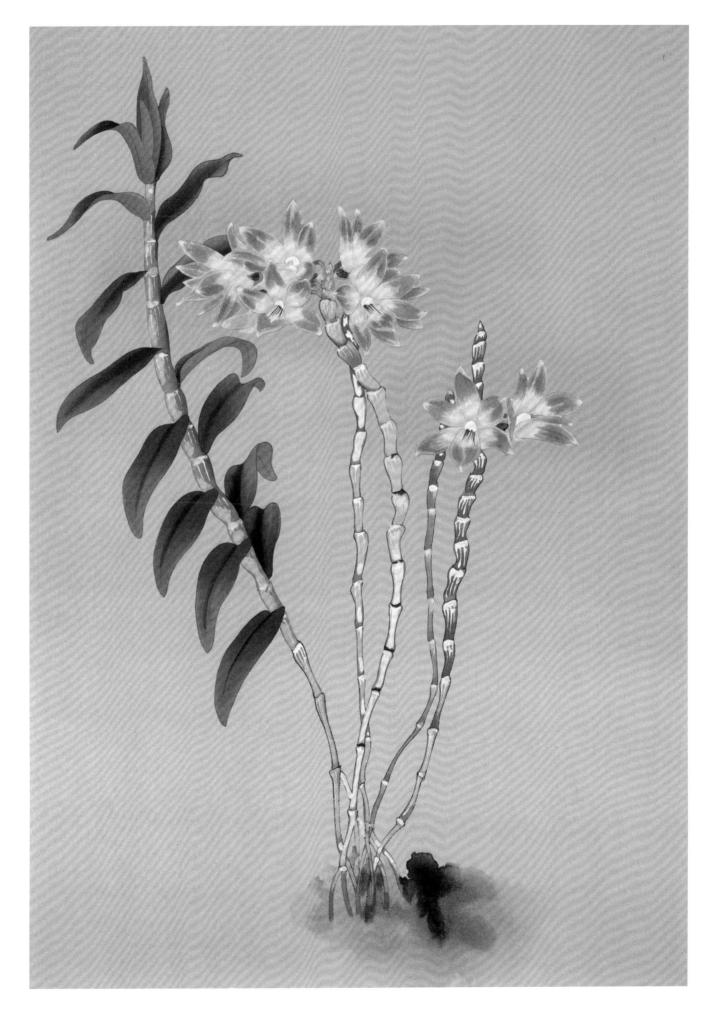

Singapore

Singapore is blessed with two splendid botanical gardens. Singapore Botanic Gardens is the oldest, founded in 1859 and has recently been made a UNESCO World Heritage Site. It acts as a green lung for Singaporeans who throng it with joggers, prams and school children. It has superb old trees, native forest, gorgeous orchids and gingers. The other is the Gardens by the Bay, built on reclaimed land and a very new extravaganza of amazing plants from all over the world, housed in glasshouses cooled by 14 artificial trees. The three enormous towers surprisingly give access to sky-high gambling.

Waiwai Hove, a Malaysian artist who lived in Singapore until recently, has produced an important series of studies on tropical plants growing in the traditional gardens, some of which were used in calendars. As a surprise she did a portrait of 'my' ginger *Globba sherwoodiana* which had been named after me at the Smithsonian in 2012 (see also the study by Alice Tangerini, page 132).

At Singapore Botanic Gardens, director Nigel Taylor oversaw the building of a new botanical art gallery, the CDL Green Gallery. I loaned some of my collection for its first exhibition in spring 2015, on tropical plants from the Shirley Sherwood Collection.

Thailand

I saw my first botanical paintings by Phansakdi Chakkaphak in a hairdressing shop in Bangkok in 2010. It seemed a very unlikely setting but I looked carefully and realised they were originals. Using his elegant signature I traced him through the internet and have acquired and shown a large number of his paintings. He was prominent in Thailand's Botanical Art Worldwide Day, which has been supported by HRH Princess Maha Chakri Sirindhorn. She initiated the School Botanical Gardens Project in 1994, which operates in more than 3,000 schools in Thailand and collaborates with the Sci-Art Network. This partly explains why there were so many young artists taking part in Thailand's Botanical Art Worldwide Day, showing paintings of their wonderful, exotic native plants.

Korea

South Korean botanical art has recently been progressing in an interesting way, influenced by the energetic teaching of Jee-Yeun Koo who has painted many of Korea's endangered plants. I saw the work of Jee-Yeun Suh as a direct result of Botanical Art Worldwide Day 2018, thanks to its inclusion in the Korean catalogue. I made contact and acquired her painting of the thorny giant *Euryale ferox*, which I showed in *Exotica* at the Shirley Sherwood Gallery in 2019. I liked the energy of this painting of an unfamiliar water lily.

Asuka Hishiki
Japanese horseradish, Wasabi:
Eutremia japonicum 2011
Watercolour on paper, 375 x 540 mm
Reserved 2013, received 2016
Shown in *Weird, Wild & Wonderful* at the ASBA's second New York Botanical Garden triennial exhibition (2014–2016), where it was Best in Show.
[Shirley Sherwood Collection 861]

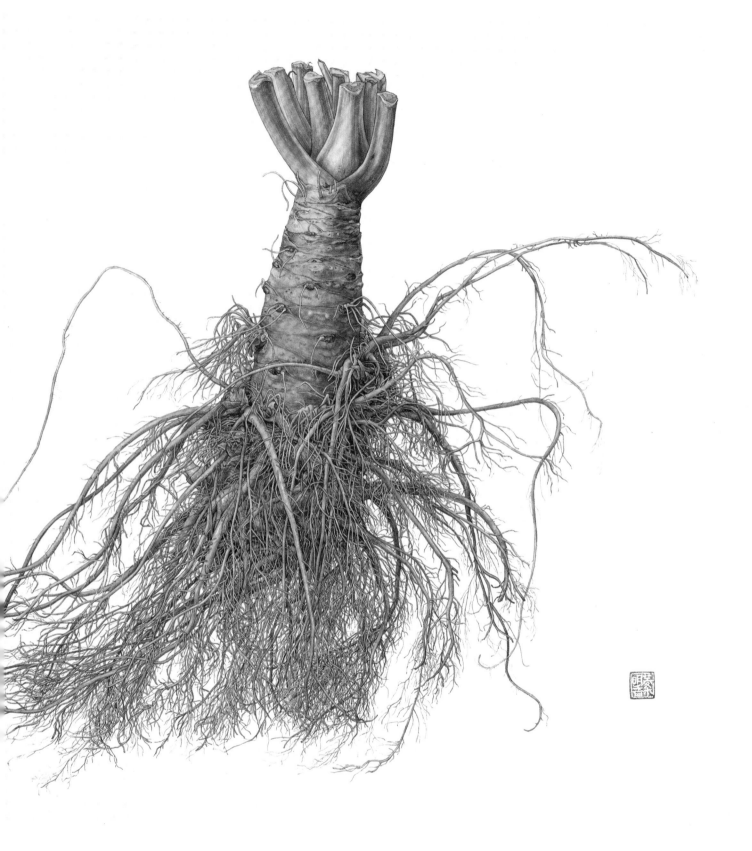

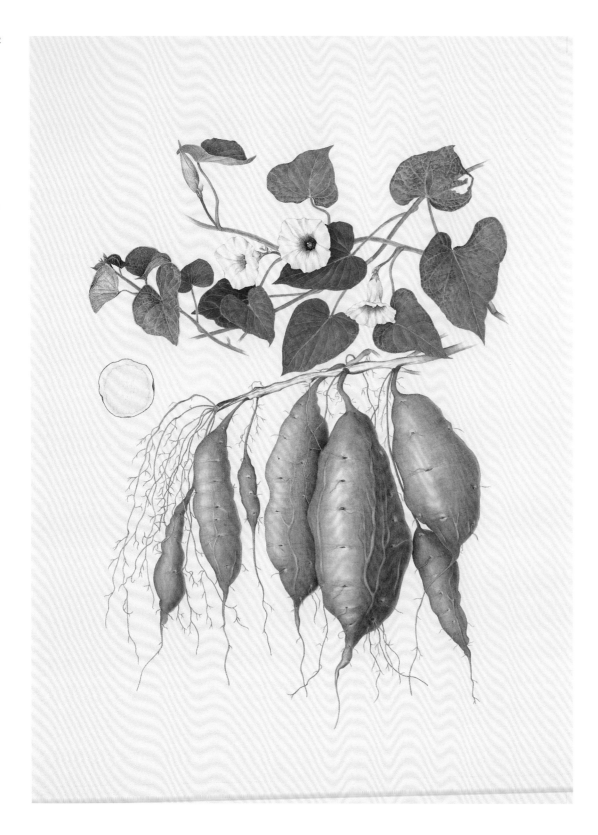

Hideo Horikoshi
Sweet Potato: *Ipomoea batatas*
'Beniaka' 2014
Watercolour on paper, 750 x 550 mm
From the RHS show 2015
[Shirley Sherwood Collection 921]

Hideo Horikoshi
Taro: *Colocasia esculenta* 'Dodear'
2014
Watercolour on paper, 750 x 550 mm
From the RHS show 2015
[Shirley Sherwood Collection 922]
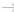

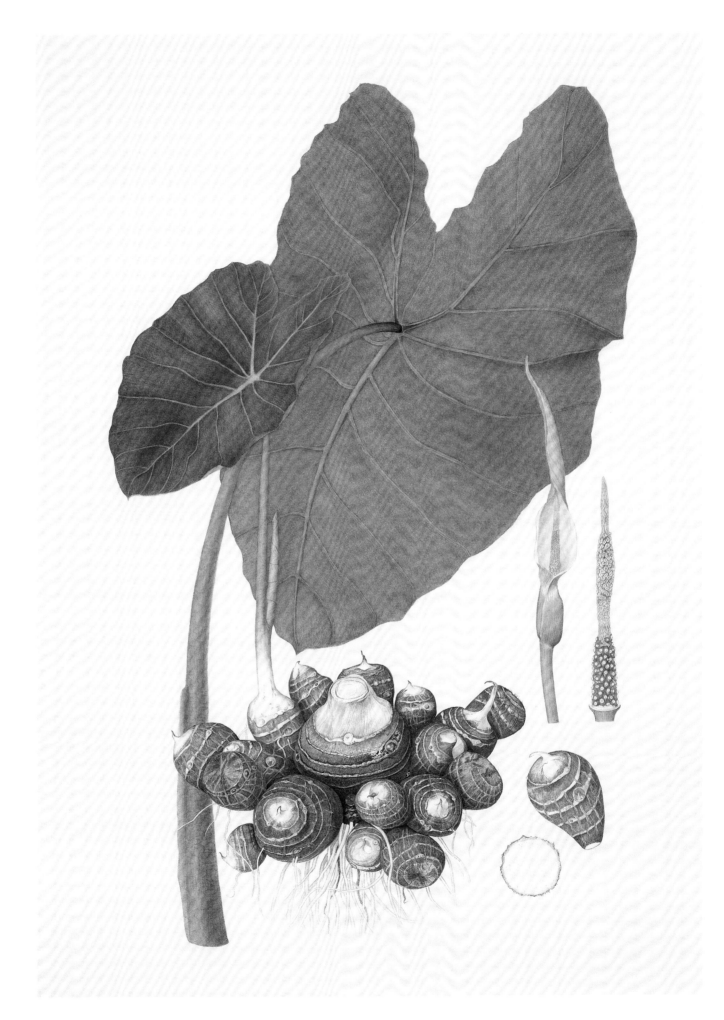

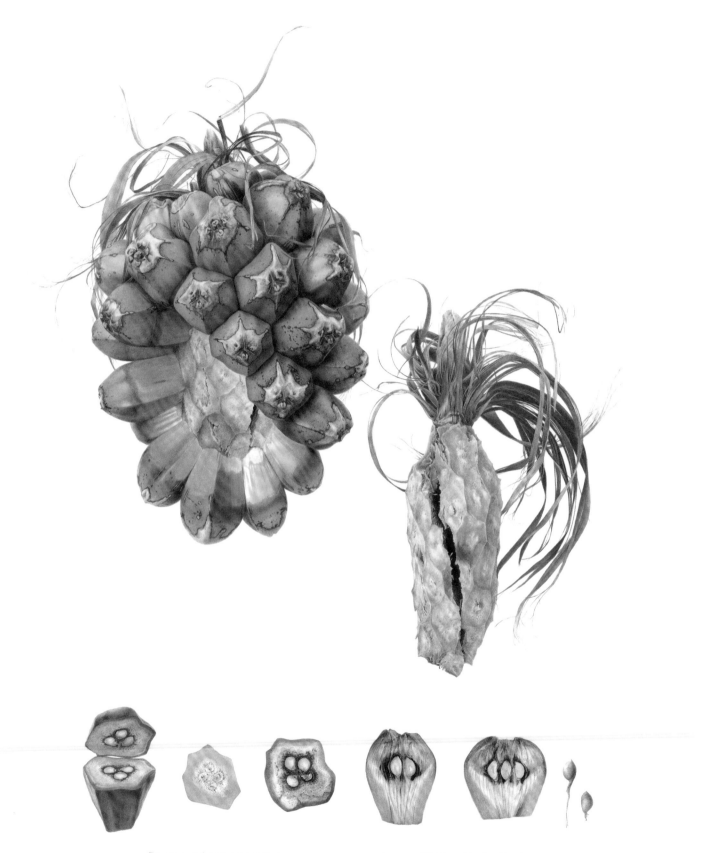

Pandanus boninensis Warburg January 2016 Mariko Ikeda

Mariko Ikeda
Pandanus boninensis 2016
Watercolour on vellum, 700 x 560 mm
From the RHS show 2017
This *Pandanus* species originates in the Japanese Ogasawara Islands and has aerial prop roots.
[Shirley Sherwood Collection 967]
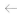

Mariko Imai
Nepenthes truncata
Watercolour on paper, 540 x 385 mm
From the artist 1999
Used as a journal cover for the Royal Horticultural Society, Japan in the 1990s.
[Shirley Sherwood Collection 379]

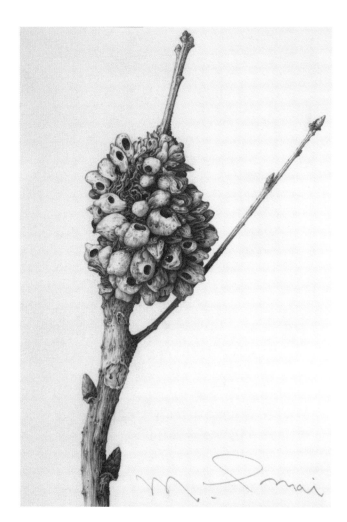
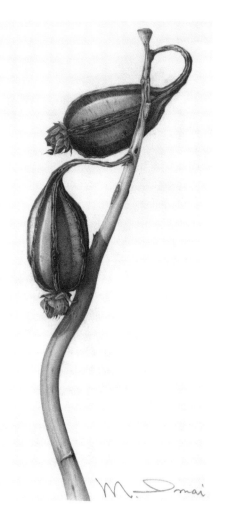
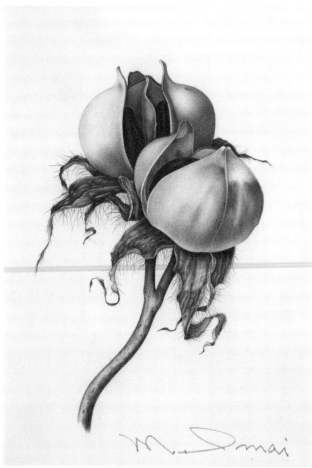

Mariko Imai
Seeds of Ebine or Japanese Wild Orchid
Troubled Tree or Insect Bitten Tree
Seeds of Morning Glory 1972
Pencil on paper, 260 x 120 mm
From the artist 1995
These three early pencil sketches are Imai's earliest botanical sketches.
[Shirley Sherwood Collection 542G]

Mariko Imai
Moustache Wild Ginger: *Asarum minamitanianum* **2016**
Watercolour on paper, 385 x 275 mm
From the artist 2016
This wild ginger is now extinct in its native region of the forests in Kyushu, Japan. Imai, who has done many studies of this family, grew the plant herself.
[Shirley Sherwood Collection 945G]

→

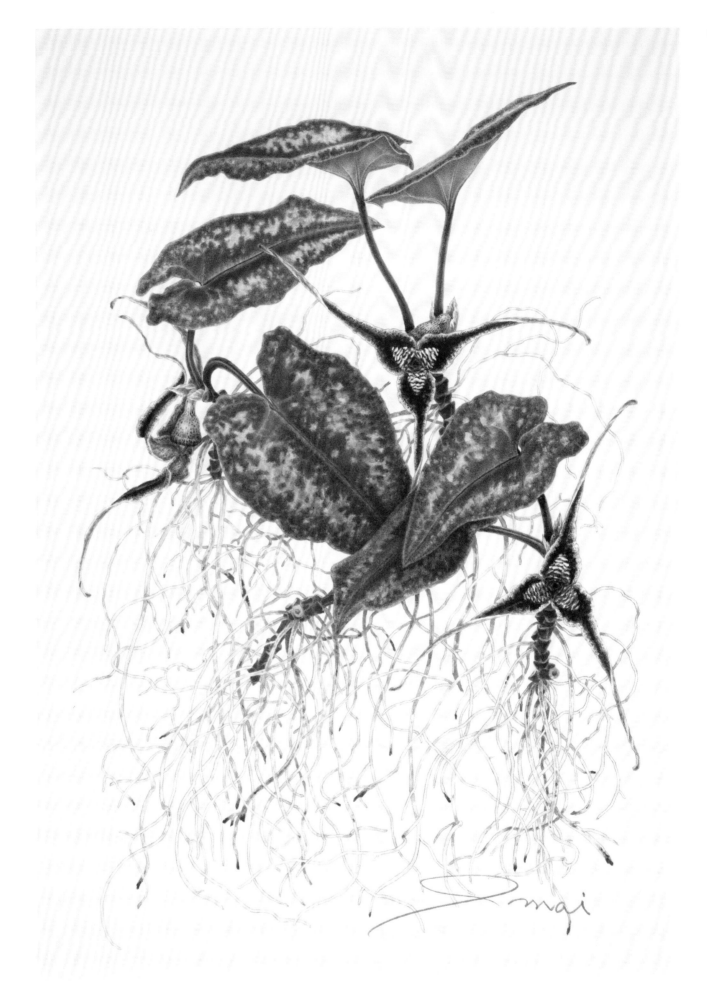

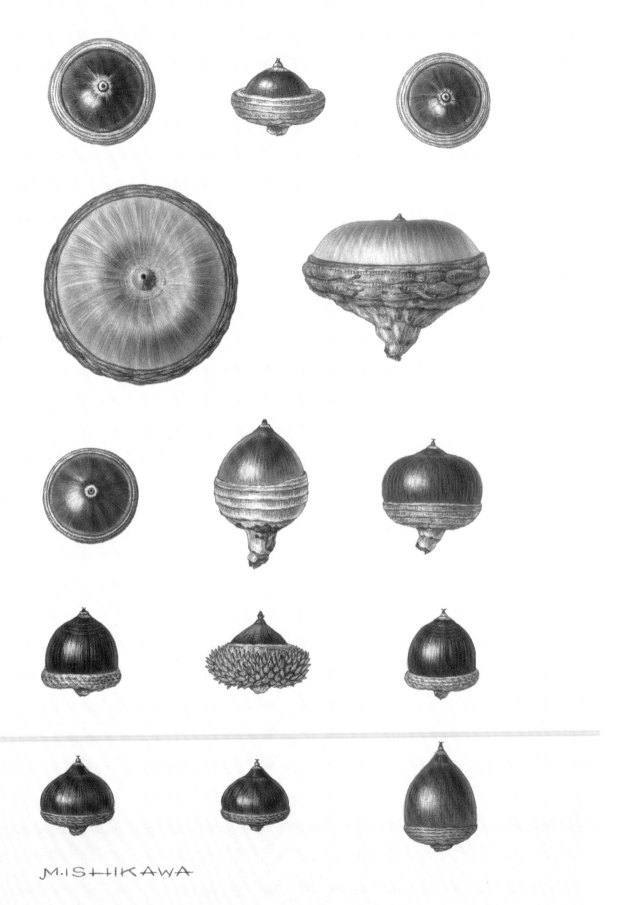

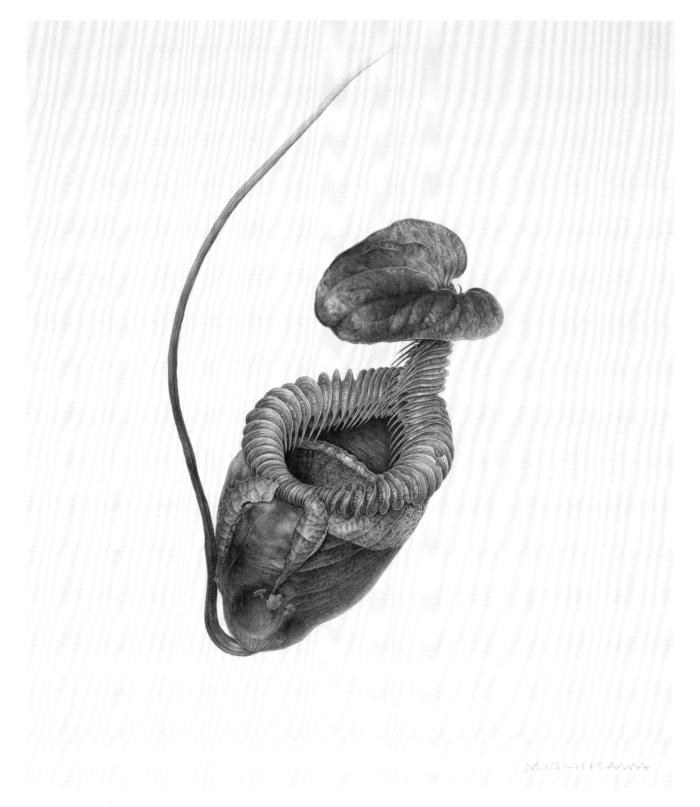

Mieko Ishikawa
Acorns from Brunei
Watercolour on paper, 200 x 130 mm
From the artist 1997
Ishikawa has done many trips to Borneo where she collected these different acorns.
[Shirley Sherwood Collection 298]
←

Mieko Ishikawa
'E.T.' Dessicated pitcher of *Nepenthes villosa* 2012
Watercolour on paper, 405 x 385 mm
From the artist 2012
This pitcher plant is endemic to the upper slopes (3,000 m) of Mount Kinabalu in north-east Borneo, a favourite area for collecting painting material for Ishikawa.
[Shirley Sherwood Collection 835]

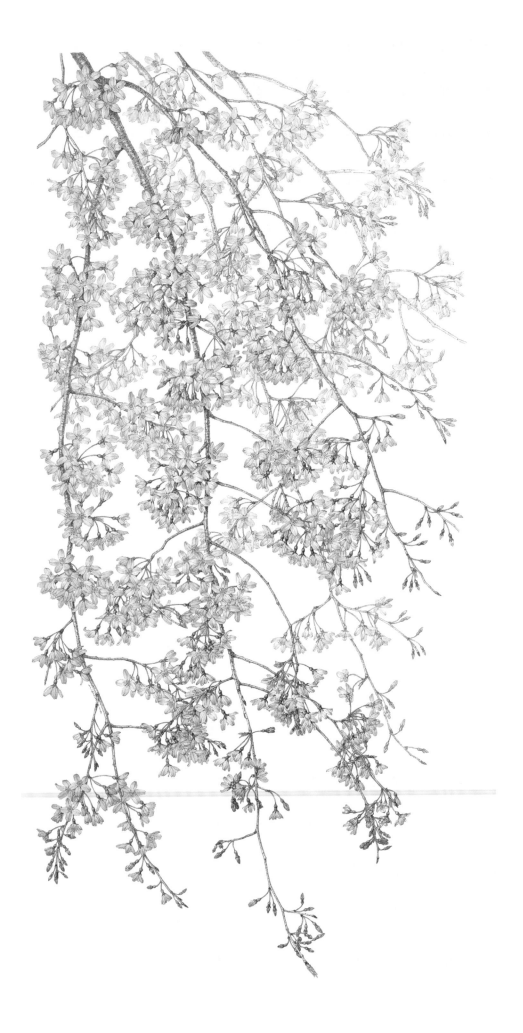

Mieko Ishikawa
Flowering Cherries: *Prunus pendula* **'Pendula-rosea' 2006**
Watercolour on paper on board,
875 x 425 mm
From the artist 2006
Exhibited at the RHS show, 2006.
Cherry blossom is very important to Japanese artists.
[Shirley Sherwood Collection 629]

Mieko Ishikawa
Nepenthes villosa **2015**
Watercolour on vellum (reindeer), 660 x 490 mm
From the artist 2015
The reindeer vellum gives a different background to calf vellum. This is the first work on vellum by a Japanese artist in my collection.
[Shirley Sherwood Collection 920G]

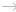

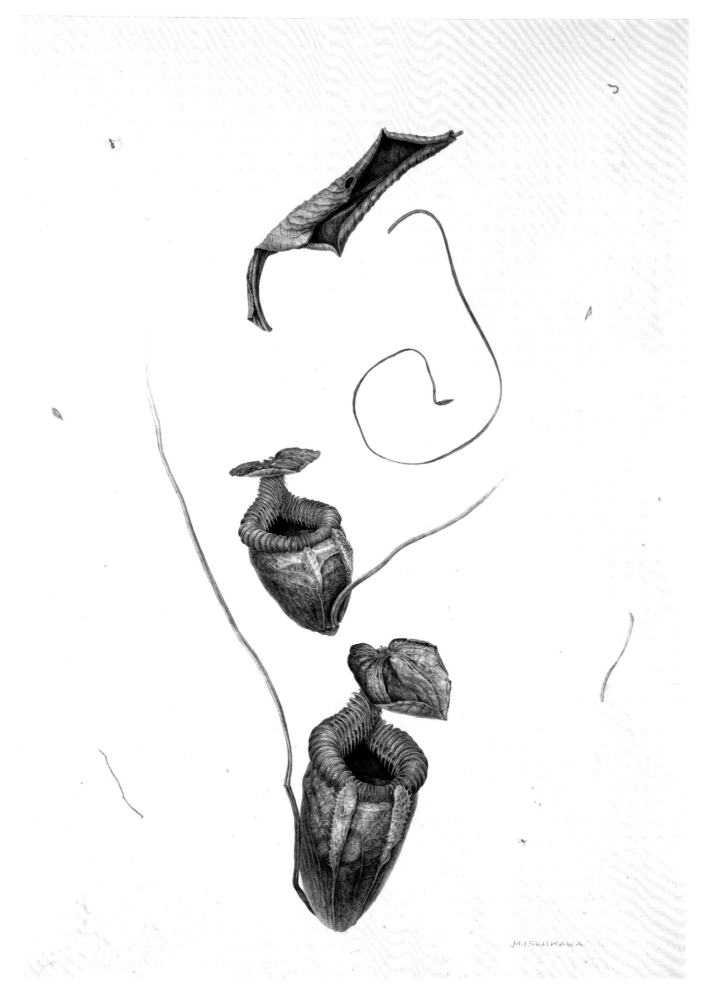

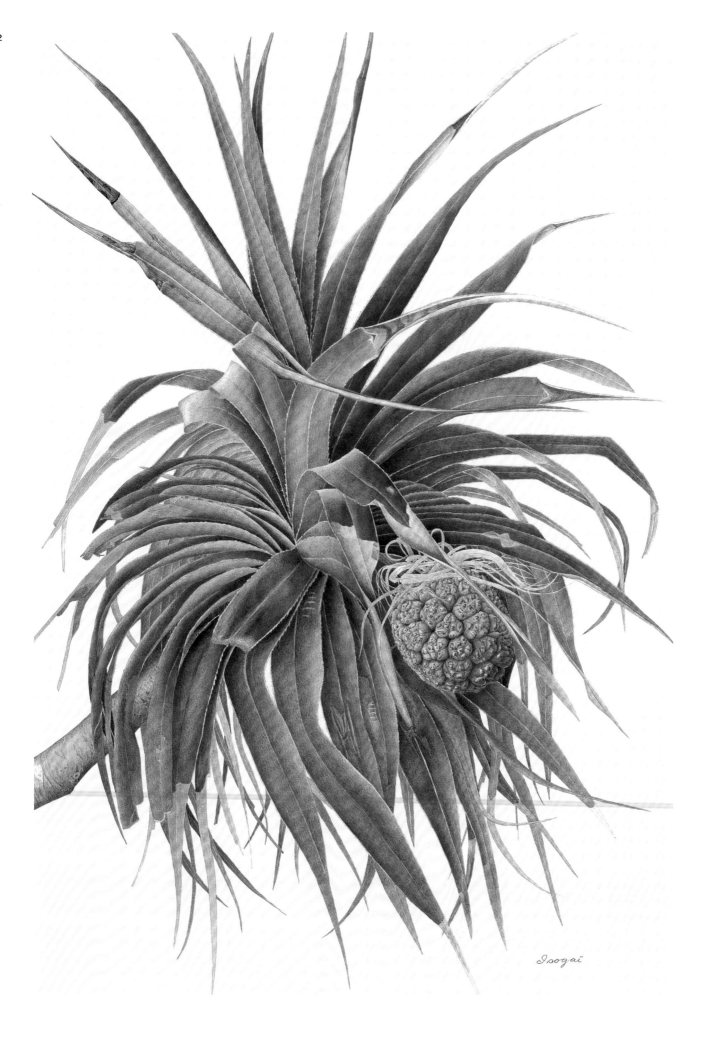

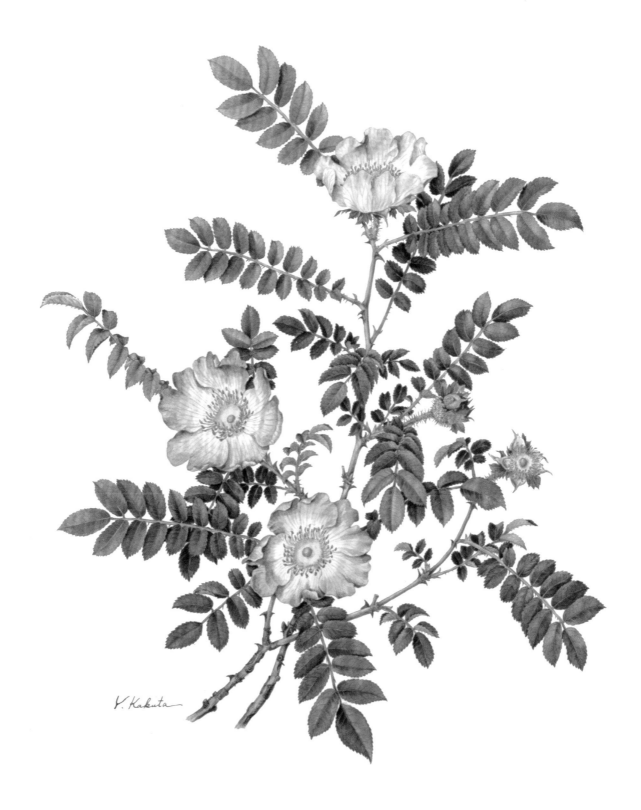

Noboru Isogai
Tahitian Screwpine: *Pandanus tectorius* 2007
Watercolour on paper, 1,190 x 860 mm
From the SBA exhibition 2007
Native to Malesia, the Pacific Islands and Eastern Australia. This screwpine grows on coastal lowlands and has conspicuous prop roots.
[Shirley Sherwood Collection 661]
←

Yoko Kakuta
Rosa hirtula 1994
Watercolour on paper, 420 x 330 mm
From the artist 1994
Endemic to Mount Fuji and Mount Hakone, Japan.
[Shirley Sherwood Collection 173]

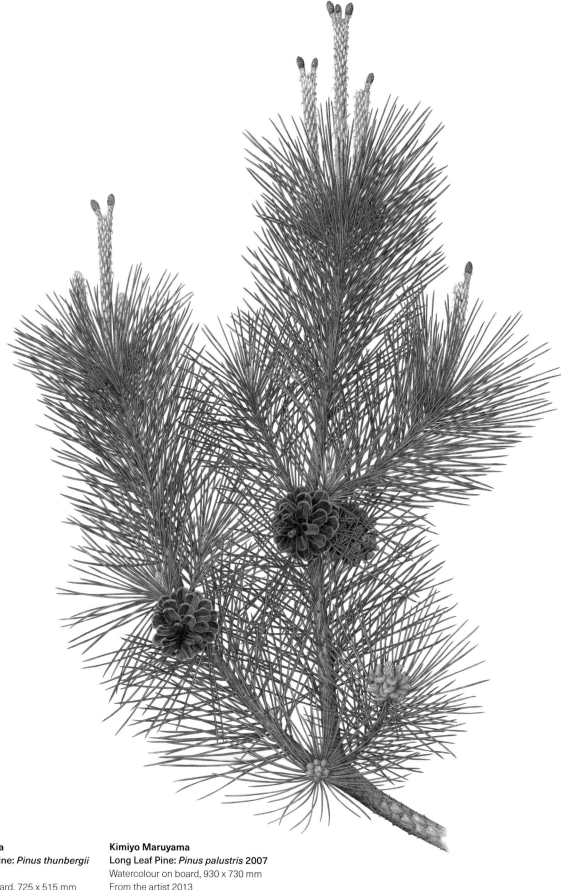

Kimiyo Maruyama
Japanese Black Pine: *Pinus thunbergii*
2005
Watercolour on board, 725 x 515 mm
From the artist 2012
Native to coastal areas of Japan and South Korea.
[Shirley Sherwood Collection 824]

Kimiyo Maruyama
Long Leaf Pine: *Pinus palustris* 2007
Watercolour on board, 930 x 730 mm
From the artist 2013
This endangered pine is native to the south-eastern US. The artist has painted the long needles brilliantly.
[Shirley Sherwood Collection 833]
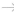

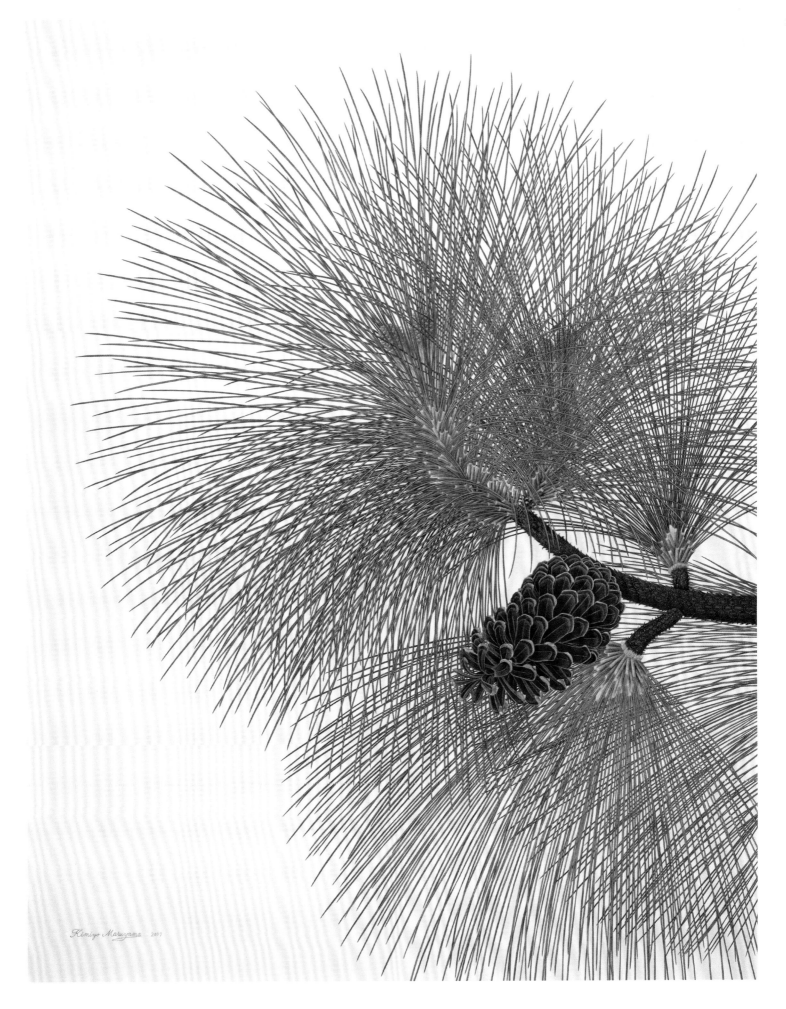

KIMIYO MARUYAMA | JAPAN

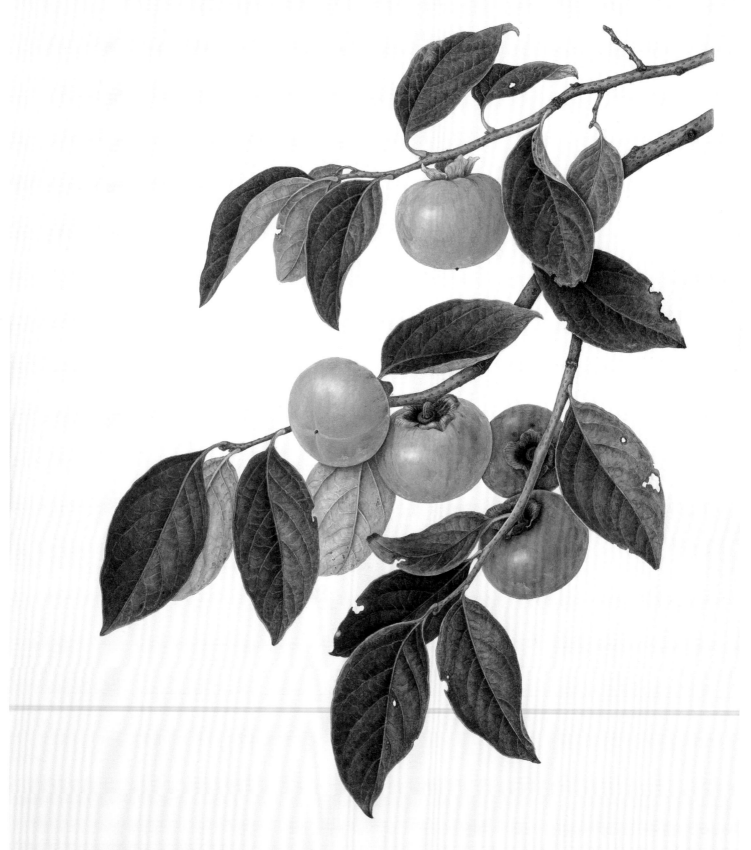

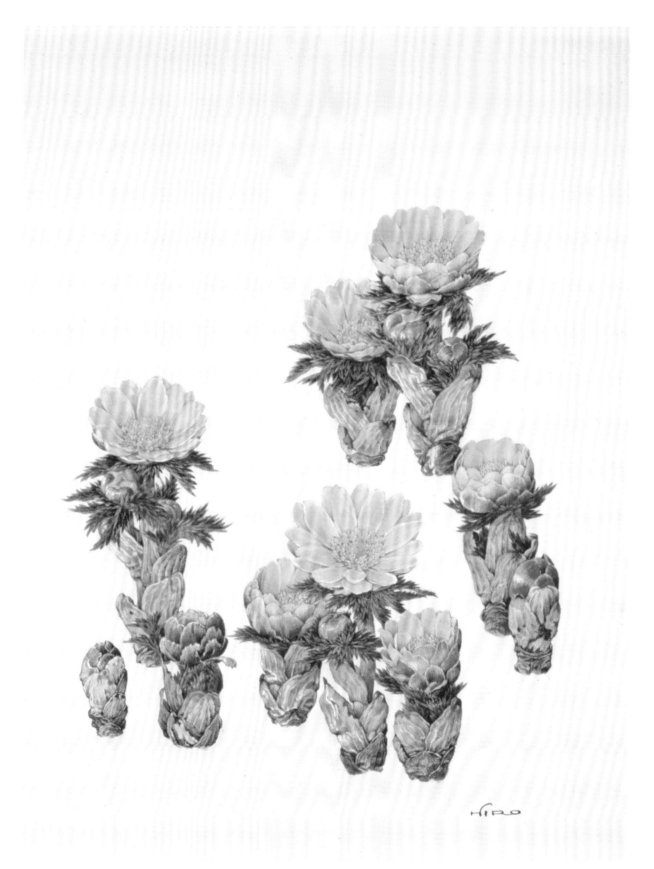

Kimiyo Maruyama
Japanese Persimmon: *Diospyros kaki*
2003
Watercolour on paper, 715 x 550 mm
From the artist 2003
[Shirley Sherwood Collection 512]

Hiroki Sato
Adonis: *Adonis vernalis*
Watercolour on paper, 315 x 235 mm
From the SBA exhibition 1998
[Shirley Sherwood Collection 323]

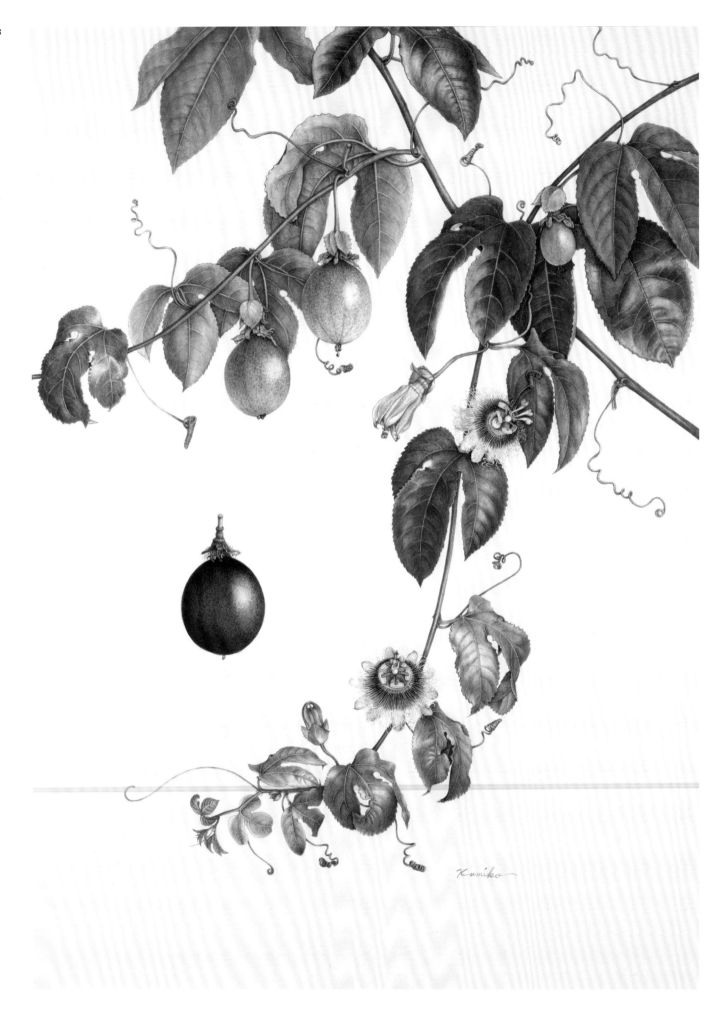

Kumiko Takano
Passiflora edulis 2013
Watercolour on paper, 655 x 480 mm
From the artist 2015
[Shirley Sherwood Collection 908]
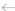

Michiko Toyota
Seedlings of Oak: *Quercus serrata*
1992
Watercolour on paper, 490 x 355 mm
From the artist 1994
[Shirley Sherwood Collection 191]

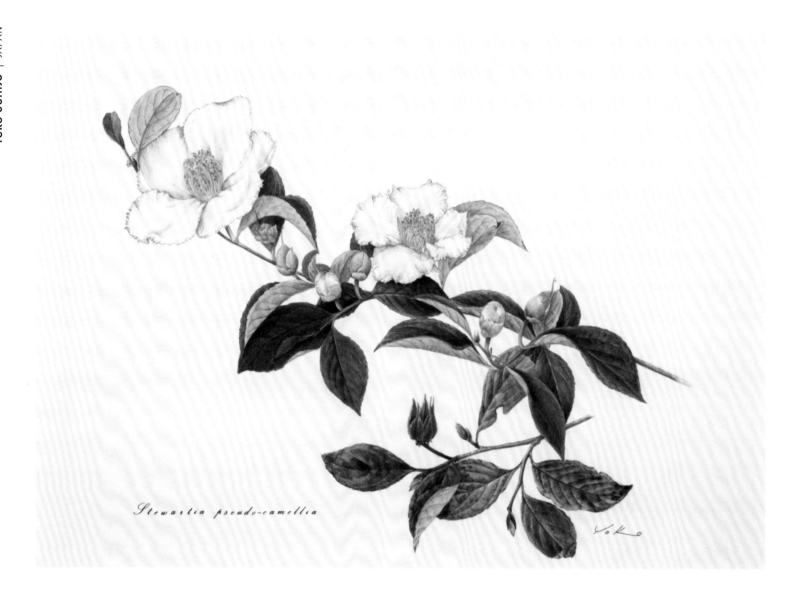

Yoko Uchijo
Japanese Stewartia:
Stewartia pseudocamellia **1993**
Watercolour on paper, 250 x 350 mm
From the artist 1994
[Shirley Sherwood Collection 169]

Noriko Watanabe
Rosa filipes 'Kiftsgate', in May 2011
Watercolour on paper, 680 x 510 mm
From the artist 2013
[Shirley Sherwood Collection 834]
→

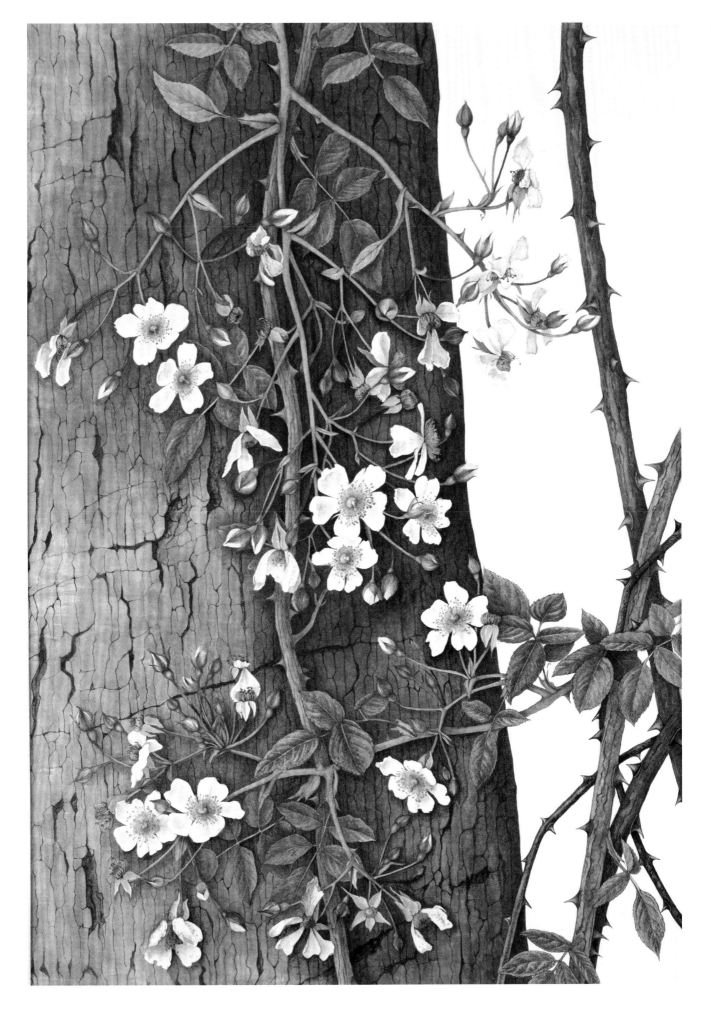

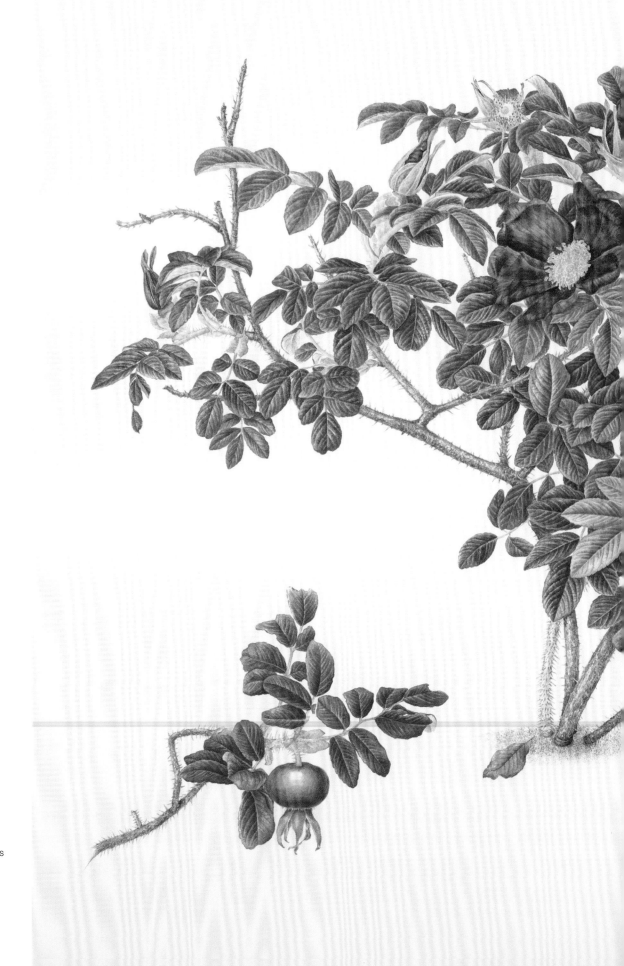

Michie Yamada
Rosa rugosa **2016/18**
Watercolour on paper, 565 x 770 mm
From the artist 2018
Yamada is painting all the native roses of Japan. *R. rugosa* was painted from specimens growing in sand dunes. She was awarded a gold medal and Best in Show at the RHS show, 2018.
[Shirley Sherwood Collection 997]

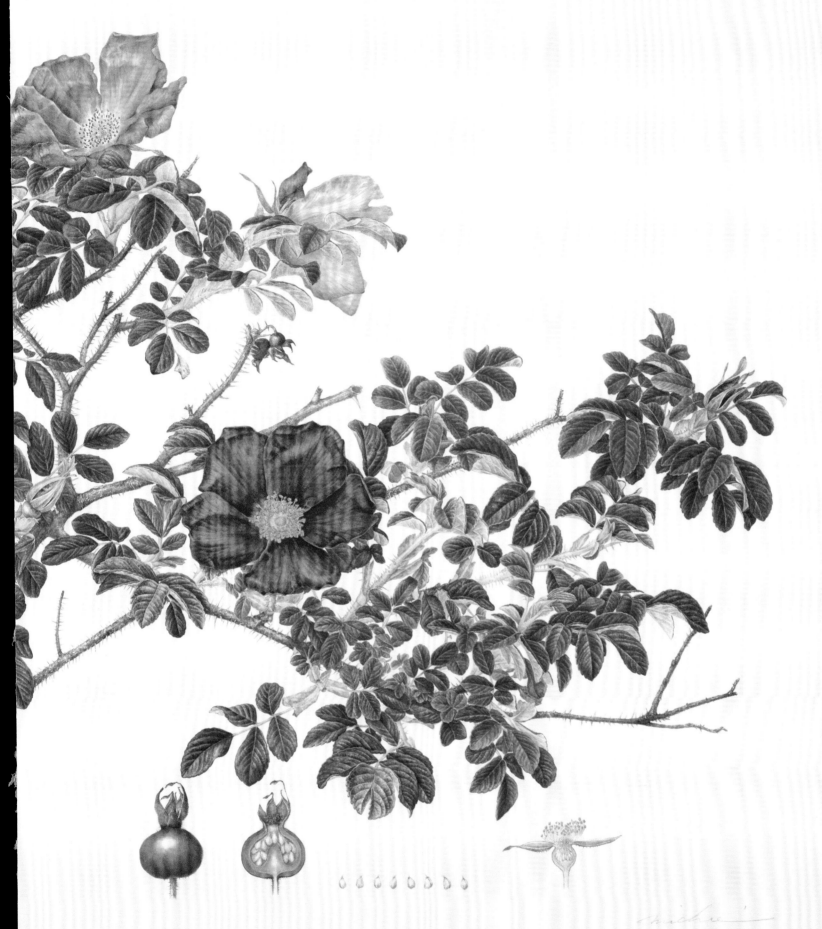

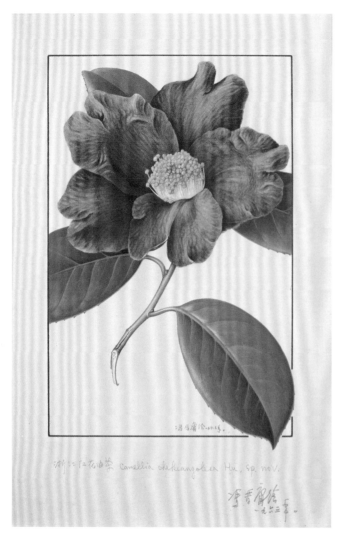
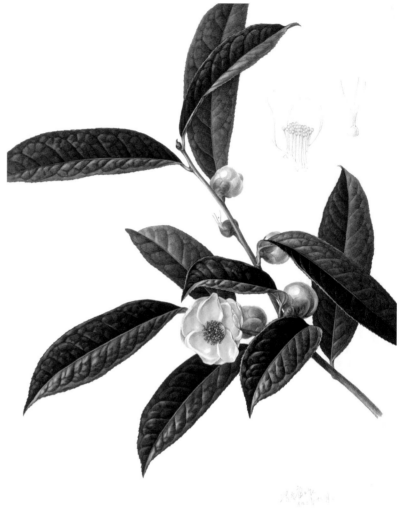

Jinyong Feng
Camellia: *Camellia chekiangolesa*
1994
Watercolour on paper, 245 x 160 mm
From the artist 1994
Professor Feng, who is based in the Botanical Institute, Beijing, has been the most important teacher in China.
[Shirley Sherwood Collection 155]

Jinyong Feng
Camellia chrysantha **1994**
Watercolour & gouache on paper, 410 x 310 mm
Commissioned 1994
Professor Feng showed me this camellia in Beijing Botanic Garden. It had been recently discovered in the wild.
[Shirley Sherwood Collection 156]

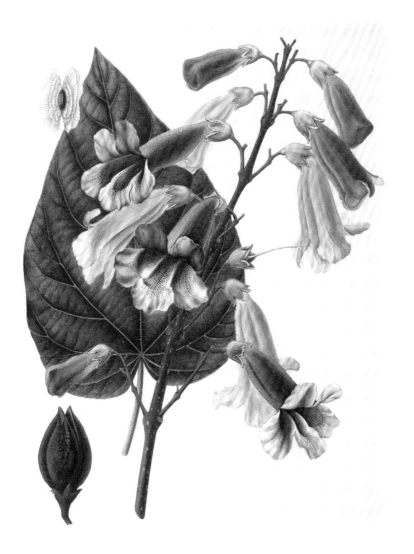
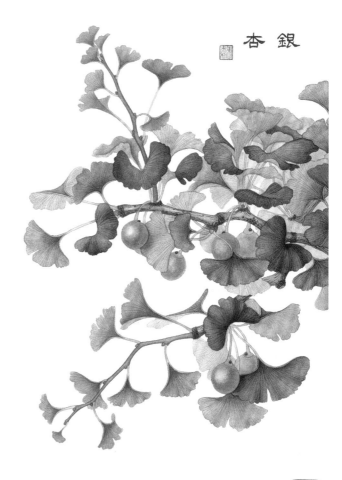

Tai-li Zhang
Paulownia elongata
Watercolour on paper, 285 x 210 mm
From the artist 1994
This is the fastest growing *Paulownia*, used for timber.
[Shirley Sherwood Collection 159]

Tai-li Zhang
Maidenhair Tree: *Ginkgo biloba* 1994
Watercolour on paper, 430 x 300 mm
Commissioned 1994
A tree of ancient lineage. Similar looking shaped leaves are found as fossils dating back 270 million years.
[Shirley Sherwood Collection 183]

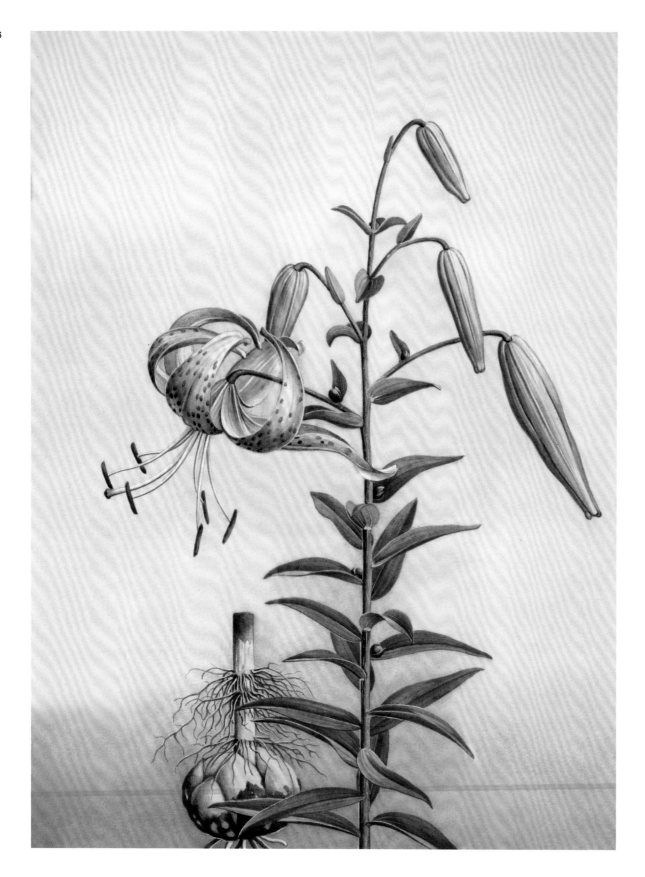

Thakur Ganga Singh (Rai Sahib)
Tiger Lily: *Lilium lancifolium* undated
Watercolour on paper, 370 x 285 mm
From Mallett, London 1999
An Asian species, widely planted as an ornamental.
[Shirley Sherwood Collection 364]

Damodar Gurjar
Nasturtium tropaeolum
Gouache on paper, 160 x 125 mm
Acquired from James White, Hunt Institute 1998
[Shirley Sherwood Collection 335]
→

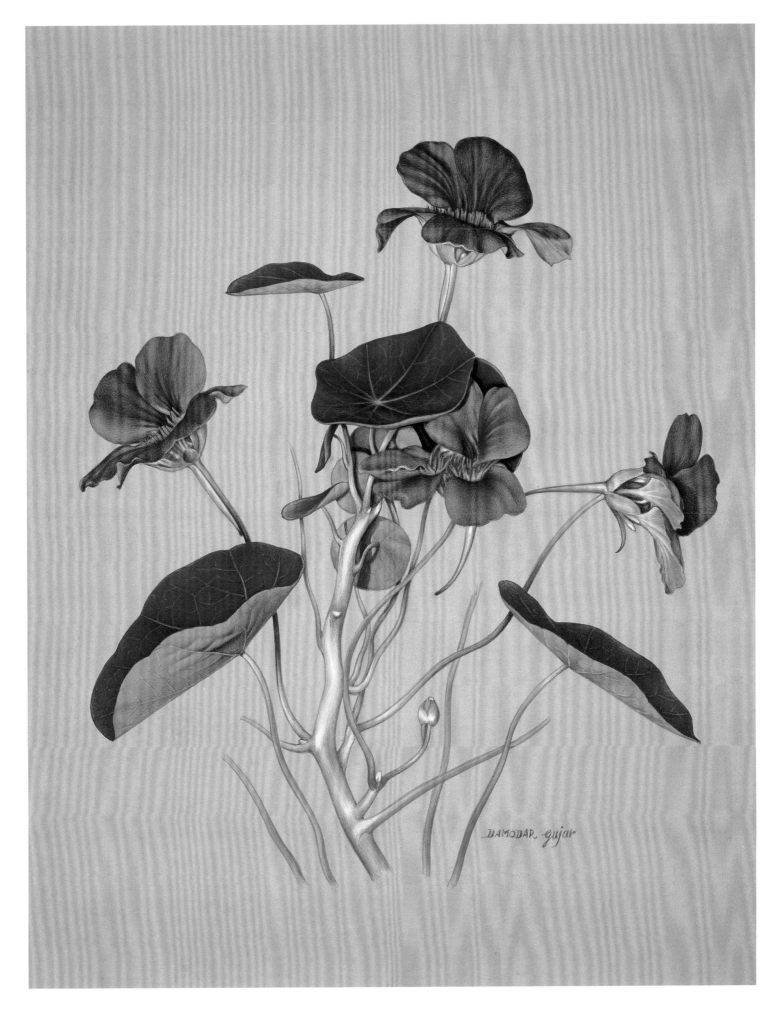

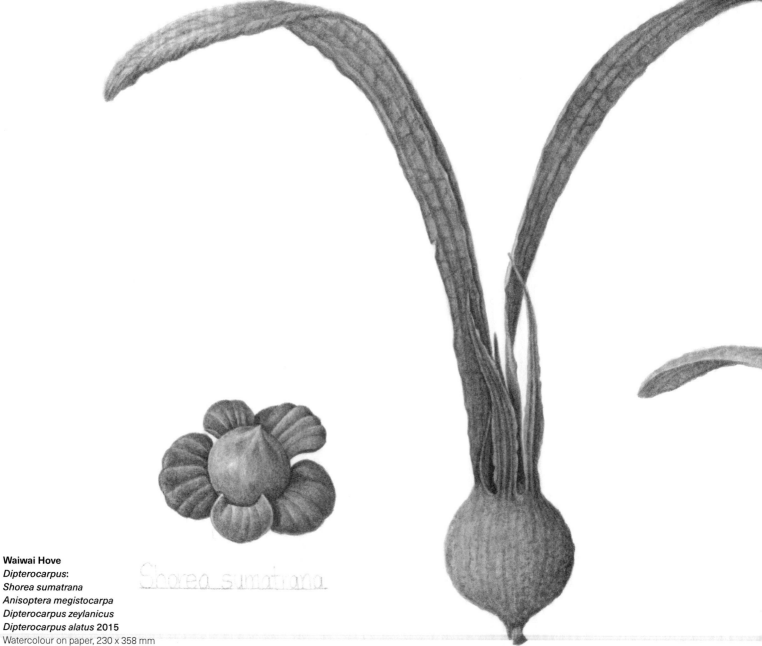

Waiwai Hove
Dipterocarpus:
Shorea sumatrana
Anisoptera megistocarpa
Dipterocarpus zeylanicus
Dipterocarpus alatus **2015**
Watercolour on paper, 230 x 358 mm
From the artist 2016
Painted in 2015 as a demonstration during the first botanical art exhibition at the CDL Green Gallery in Singapore Botanic Gardens.
Some ancient *Dipterocarpus* forests remain in South-East Asia but are highly endangered due to heavy logging for valuable wood. The trees are harvested for resin used in lacquering. Its fruits, which are produced irregularly in heavy crops, auto-gyrate to the ground.
[Shirley Sherwood Collection 940G]

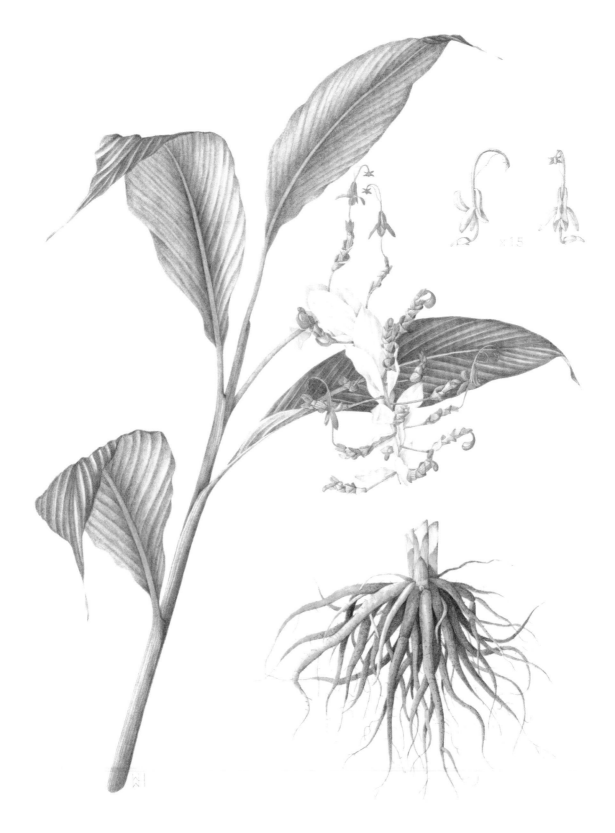

Waiwai Hove
Globba sherwoodiana 2013
Watercolour on paper, 405 x 307 mm
Commissioned by Anna and Hugh Ellerton, painted in Singapore Botanical Garden for my birthday. The plant was named by Dr W. John Kress, the National Museum of Natural History, Smithsonian, in 2013
[Shirley Sherwood Collection 849G]

Emmanuel Cordova
Staghorn Fern: *Platycerium coronarium* 2018
Watercolour on Arches 300 gsm, 990 x 686 mm
From the artist 2019
[Shirley Sherwood Collection 1010]
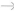

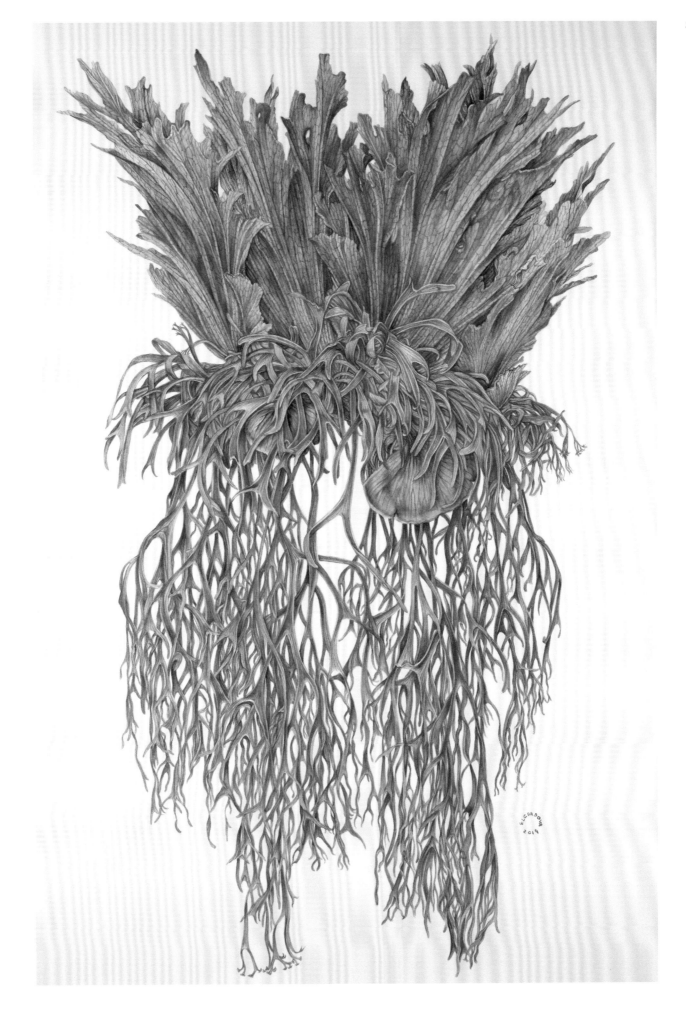

EMMANUEL CORDOVA | PHILIPPINES

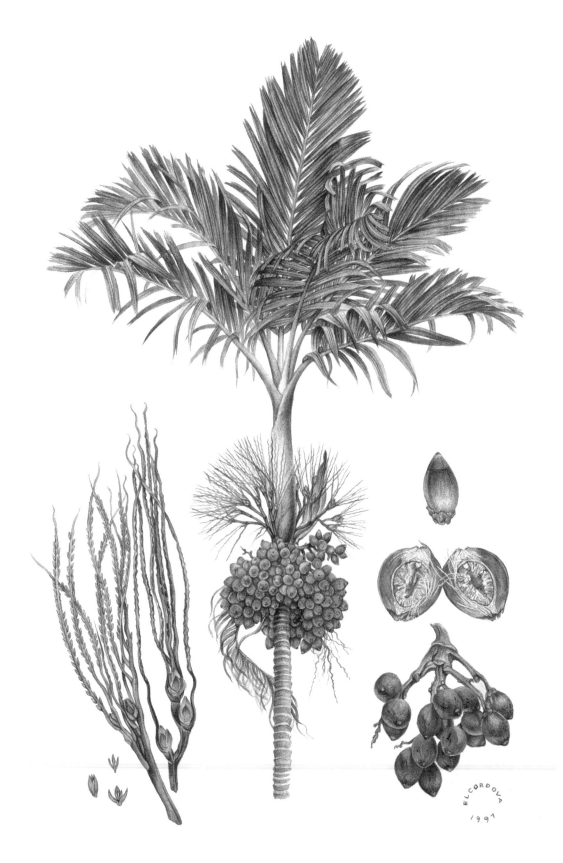

Emmanuel Cordova
Areca Palm: *Areca catechu* 1997
Watercolour on acid free paper,
500 x 380 mm
Commissioned 1997
The betel nut palm is believed to have originated in the Philippines.
[Shirley Sherwood Collection 302]

Phansakdi Chakkaphak
Golden Dewdrop: *Durantia erecta*
2013
Watercolour on thin board,
515 x 375 mm
From the artist 2013
This joyful painting shows fruit and flowers together, a common finding in the tropics.
[Shirley Sherwood Collection 851G]
→

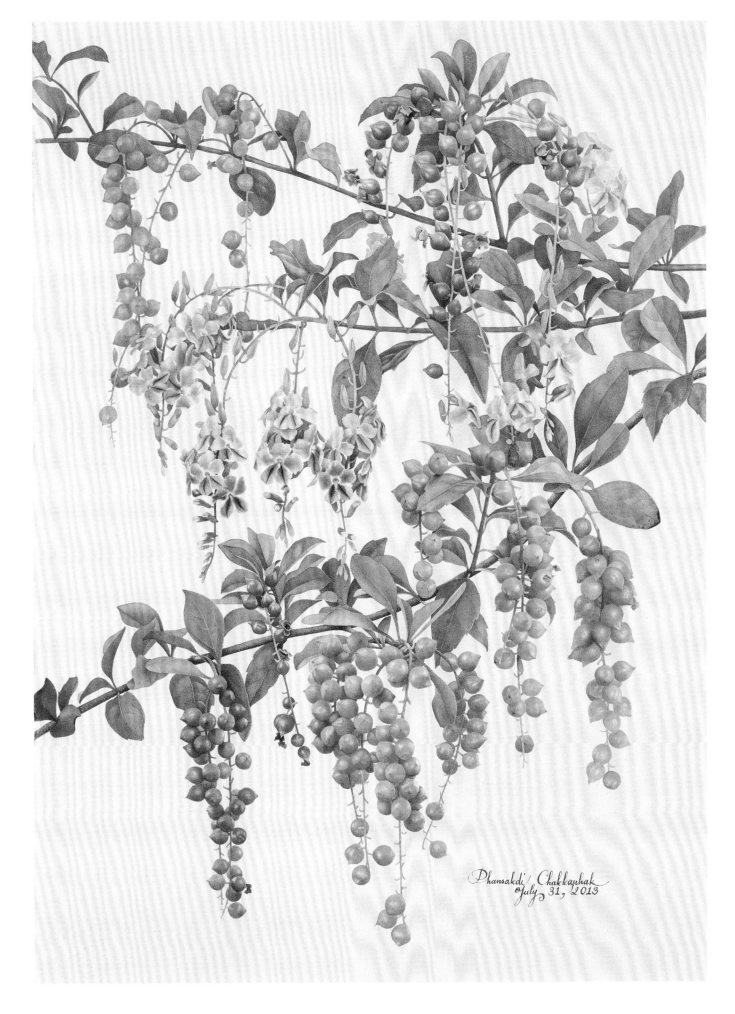

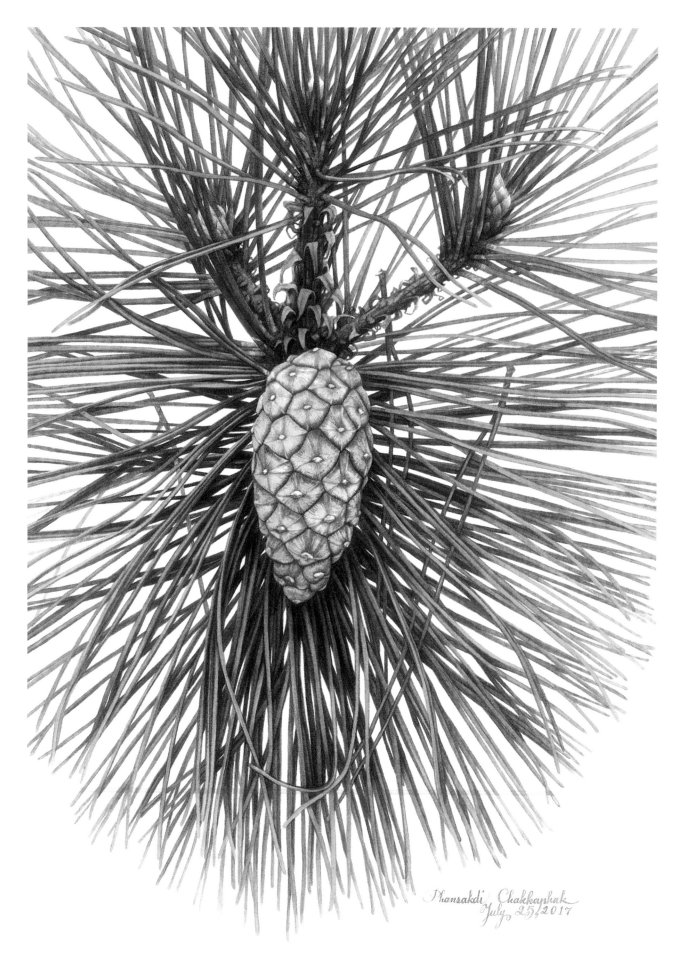

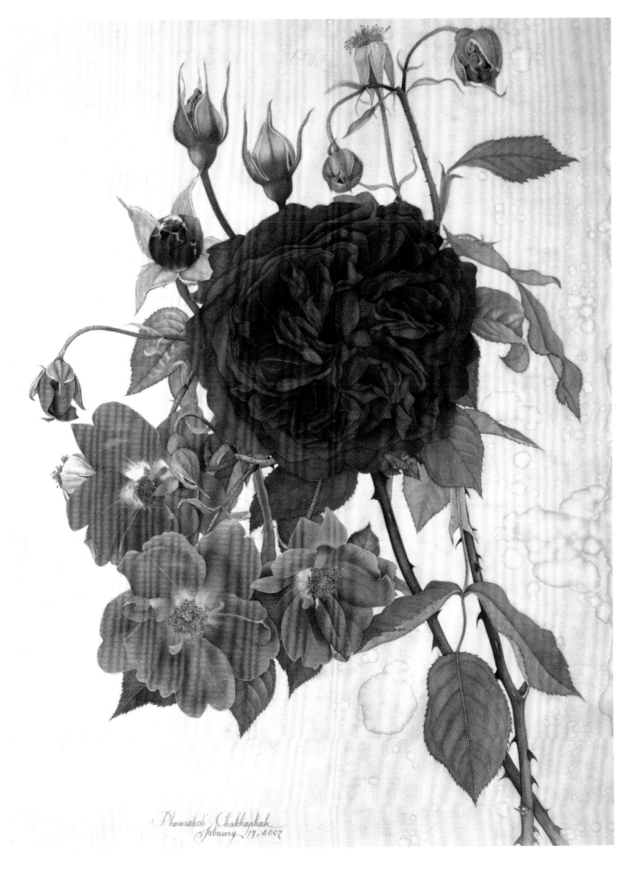

Phansakdi Chakkaphak
Japanese Pine Cone: *Pinus densiflora*
2017
Watercolour and gouache on paper,
520 × 365 mm
From the artist 2017
[Shirley Sherwood Collection 972G]
←

Phansakdi Chakkaphak
Rose: *Rosa* spp. 2007
Watercolour on paper, 560 × 420 mm
From the artist 2010
[Shirley Sherwood Collection 745]

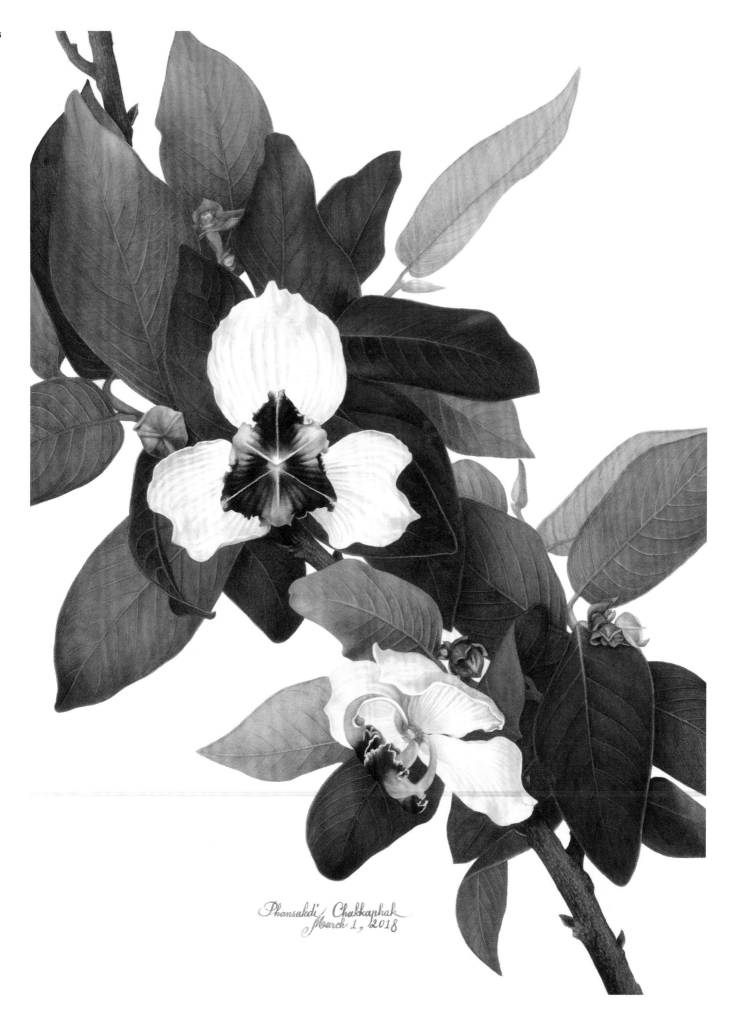

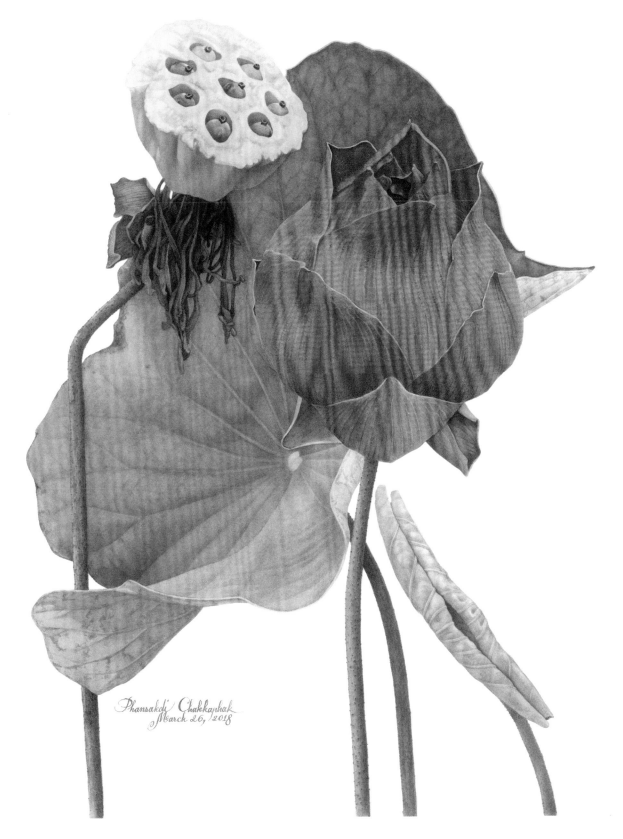

Phansakdi Chakkaphak
Mitrephora winitii 2018
Watercolour and gouache on paper,
515 x 315 mm
From the artist 2018
Used as the cover for Thailand's
Botanical Art Worldwide brochure 2018.
[Shirley Sherwood Collection 987G]
←

Phansakdi Chakkaphak
Sacred Lotus: *Nelumbo nucifera* 2018
Watercolour and gouache on paper,
515 x 315 mm
From the artist 2018
Widely distributed in tropical lakes and
waterways.
[Shirley Sherwood Collection 989G]

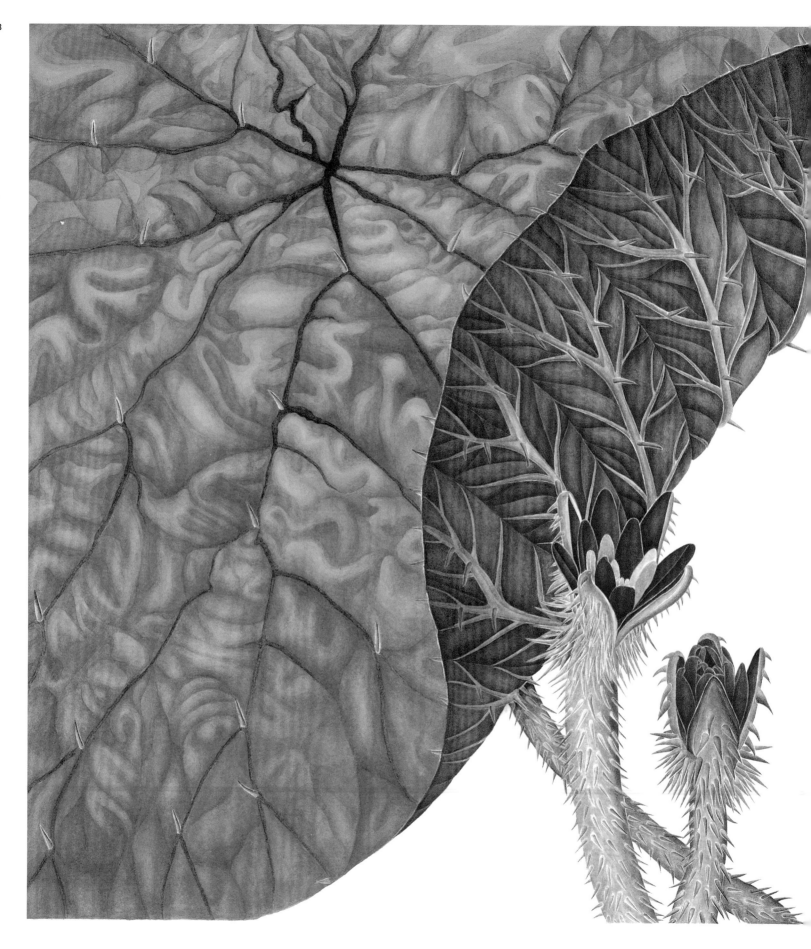

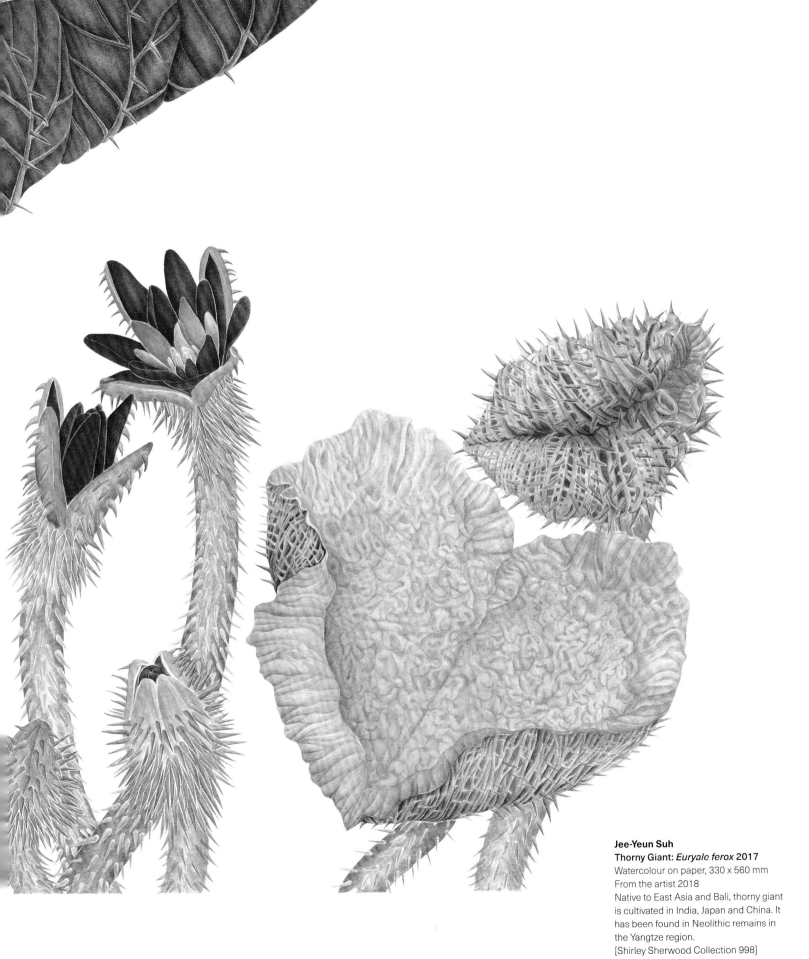

Jee-Yeun Suh
Thorny Giant: *Euryale ferox* **2017**
Watercolour on paper, 330 × 560 mm
From the artist 2018
Native to East Asia and Bali, thorny giant is cultivated in India, Japan and China. It has been found in Neolithic remains in the Yangtze region.
[Shirley Sherwood Collection 998]

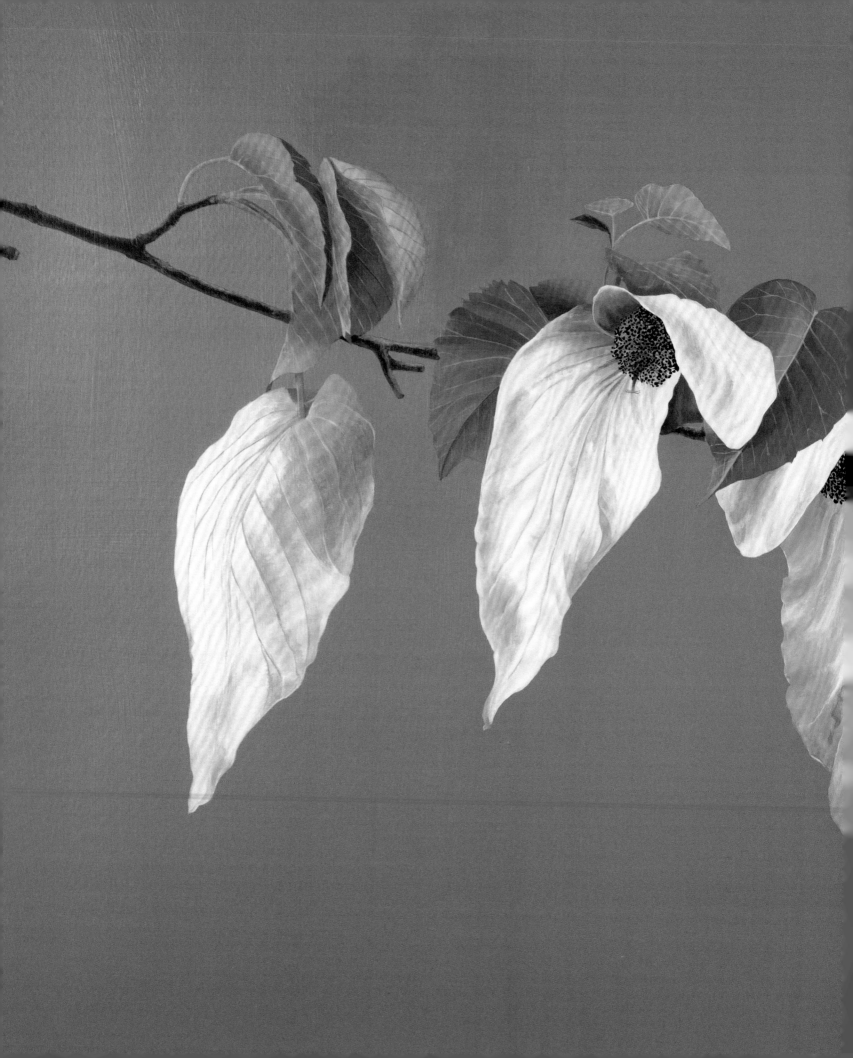

Painting the dove tree
Davidia involucrata

Painting the dove tree
Davidia involucrata

THE CREATION OF the thousandth painting in the Shirley Sherwood Collection was quite a saga, with my family secretly commissioning a plant portrait from Coral Guest of one of my favourite trees. It was only to be unveiled when my assistant Sophie Cooper gave the word that she was about to enter the thousandth painting into my database.

My family – Charles, Rosemary, Simon and Rachel – had set this project in motion months before, deciding the artist and subject after consulting Sophie (and having asked leading questions of me). They knew I loved the pocket handkerchief tree that I had planted on the edge of the moat in Oxfordshire some 30 years ago and which has flowered so beautifully ever since.

Davidia involucrata originated in China and was named for the French missionary Père Armand David (1826–1900) who discovered it in 1869 in Sichuan. It has beautiful pairs of white bracts fluttering in the wind, cradling the flowers, giving rise to the much more romantic name dove tree. Each large pair of bracts surrounds the small ball-shaped flower which is composed of a tight cluster of exclusively male flowers, except for one female flower set obliquely. The flower's slender stem can be up to 18 cm long, so the flower and bracts seem to float and dangle from the branch in the spring. Later in the autumn my tree regularly produces hard green nuts but I have never succeeded in germinating seeds from them or found seedlings near the tree.

It needed to be painted by someone who was capable of subtle interpretation of white – no easy task if the painting is on the traditional white paper background of the classical botanical artist's studio. Coral Guest had already painted me two beautiful studies of white lilies and my family knew she could do it, and knew that I held her work in high regard.

Coral discussed the contract and my family agreed her terms and ensured she was available when the tree was flowering – a limited time from mid-May to mid-June in 2018. She cleared her studio, laid down white cloths to reflect the light and waited for the call from Rachel Sherwood at Hinton telling her when the tree was in flower (making sure I was away as well). She drove over to collect specimens which Simon and Rachel cut from my tree. Coral described how she laid two branches with their rows of delicate bracts on the car seat and drove immediately back home. She sliced the stems with several 45° cuts about 10 cm from the base of the branch and put them into filtered rainwater about 10 cm deep. She was able to keep them in good condition for nearly a month. I have included these details because I have never managed to keep the fragile bracts from flopping beyond a couple of days at most.

The artist Coral Guest and Rachel Sherwood after collecting the branches of *Davidia involucrata* in 2018.

The branches are placed in Coral Guest's studio.

Far right: Preliminary studies and herbarium specimens.

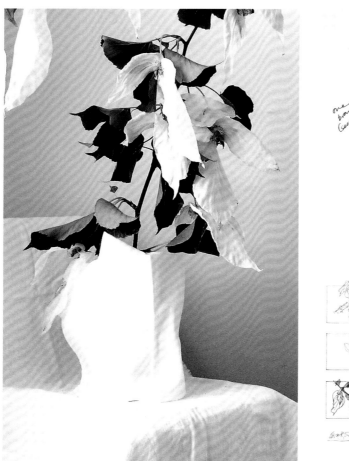

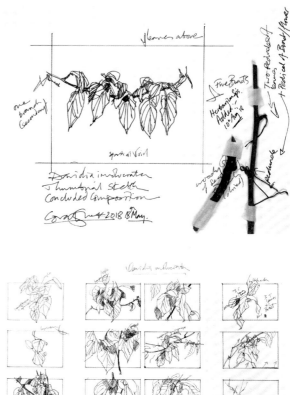

The first study on a white background.

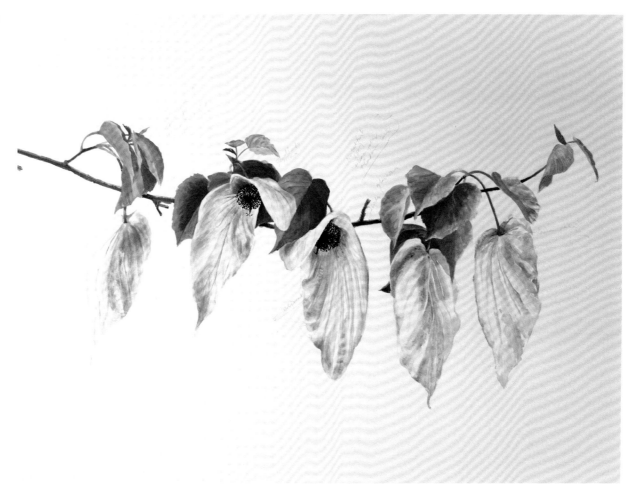

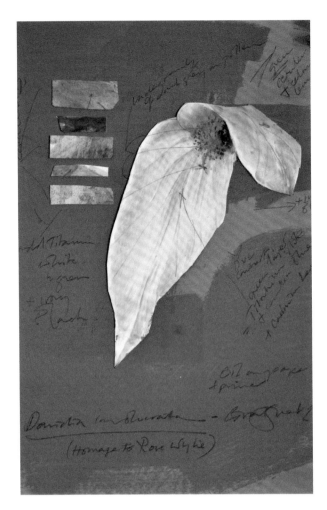
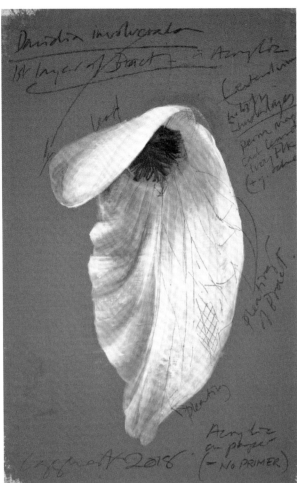

Getting the background right. Sketches of bracts.

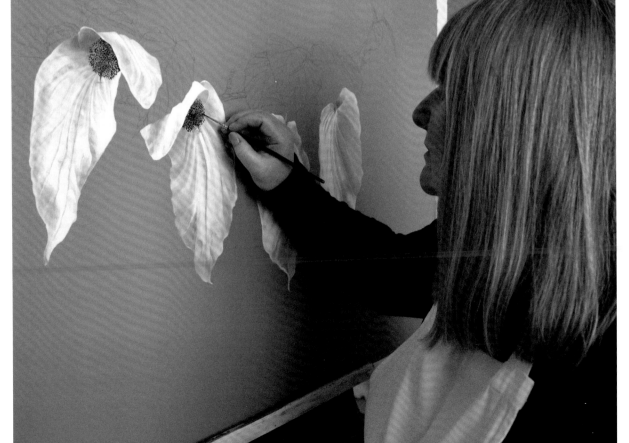

Coral Guest painting the flower on the taupe background.

The finished painting which my family gave me to be the 1,000th entry in my collection.

Coral had a north-facing window in her studio which she left open at night and fortunately she had a spell of steady good weather. She told me that she worked standing up, using her knowledge of Song Dynasty painting to create a form of generalised naturalism, combined with close observations, looking upwards as one would to see the lateral branches on the tree.

She started by rapidly drawing a series of 12 thumbnail sketches and a landscape format sketch using black ink to 'learn' the plant by detailed observation. Later she did a large preparatory watercolour and acrylic study of the whole branch with five pairs of bracts and leaves.

She then decided that she was unhappy with this study on its white background as she felt it lacked the impact she wanted for display in a large gallery like the Shirley Sherwood Gallery at Kew. So she rang Rachel, having e-mailed photographs of the various stages so far. Coral emphasised how important it was to be able to keep in touch with Rachel and Simon, who had initiated the project.

After a discussion with my family Rachel suggested Coral might try using a background colour in the way Paul Jones did after a stay in Japan. I have several paintings by him with subtle graded grey backgrounds and indeed had just used one of them, a camellia, on the cover of the revised edition of *Treasures of Botanical Art*, published 2019.

Coral was delighted by the solution and quickly did a sketch of a single inflorescence in acrylic with a taupe background. She was aiming for a coloured ground that 'was redolent of both pottery clay and unbleached silk, colours that are seen in ancient Song Dynasty painting' (Coral Guest).

Once she was satisfied with the preliminary studies using the taupe background she had to decide whether to use acrylic or oil paint and eventually chose acrylic (which had the advantage of drying in a couple of days). She used acrylic for the actual study too, so she could get the transparency of the fragile bracts successfully.

Sophie kept everyone (except me) discreetly informed about the approaching 1,000th painting to be entered into my collection, although I couldn't understand why the database entries were all taking so long. Eventually my family invited themselves to dinner in our house in London one October evening in 2018 and unveiled the beautifully framed painting.

I thanked them profusely for marking this milestone so brilliantly and sent the following message to Coral:

Oct 22nd 2018

Dear Coral,

I was overwhelmed by my family's gift of the pocket handkerchief tree. Your painting is so lovely, so unexpected, so really thrilling.

I know it was a challenging commission with its short flowering time and propensity to flop, but you achieved such a wonderful result. I shall treasure it and it's a very spectacular and worthy number 1,000 in the Shirley Sherwood Collection.

Thank you for creating such a special portrait,

Love and best wishes
Shirley

Artist biographies
Shirley Sherwood

The number following each artist's name, birthplace and dates denotes the number of works by the artist held in the SSC.

Abbreviations
ABBA – Association of British Botanical Artists www.britishbotanicalartists.com
ASBA – American Society of Botanical Artists www.asba-art.org
BISCOT – Botanical Images Scotia (exhibition) https://thecaley.org.uk/biscot-2
Botanical Art Worldwide www.botanicalartworldwide.info
Hunt Institute – Hunt Institute for Botanical Documentation, Carnegie Mellon University, Pittsburgh www.huntbotanical.org/about
Kew – Royal Botanic Gardens, Kew www.kew.org
RHS – Royal Horticultural Society www.rhs.org.uk
SBA – Society for Botanical Artists www.soc-botanical-artists.org
SFIB – La Société Française d'Illustration Botanique www.sfib.fr
SSC – Shirley Sherwood Collection
SSG – Shirley Sherwood Gallery of Botanical Art, Kew Gardens
V&A – Victoria and Albert Museum, London https://www.vam.ac.uk

ALLEN, Beverly (born Sydney, Australia, 1945) 6
Beverly Allen graduated from Sydney University (1995) and started her career as a botanical artist in 1998. I first saw her work through *Botanica*, an excellent annual exhibition of Australian artists in Sydney. She has shown at the Royal Botanic Garden Sydney since 1999. My first purchase there was a blue ginger followed by a spectacular *Strelitzia nicolai*. A scan of her yellow lotus was sent to me and I reserved it otherwise unseen, only to be surprised at its large size when I eventually saw it. I checked in the garden and the lotus flowers are indeed just as big as she had portrayed them. She has exhibited widely in Melbourne as well as Sydney, in New York, Washington and at the Hunt Institute. I showed the lotus in 2006 at the Sompo Japan Museum of Art, Tokyo. After being awarded an RHS gold medal her work was selected for Kew and the RHS Lindley Library. She initiated the Florilegium Society at the Royal Botanic Gardens Sydney with Margot Child, another great supporter of botanical art. Their ambition was to commission portraits of significant plants in the Mount Tomah and Mount Annan Botanical Gardens, the Domain and the Royal Botanic Garden, Sydney. Florilegium has been a project of both artistic and scientific value, with an added satisfaction that the artists' donated work is held in an archive, exhibited already in Sydney and at Kew.

ANDERSON, Fay (born Lahore, now Pakistan 1931) 3
Fay Anderson, a British citizen now with permanent residence in South Africa, was educated in India and England. She received a diploma in fine arts from the Michaelis School of Art, Cape Town (1955) where she still lives. She has travelled widely in Europe, Africa, Asia and Australia but almost exclusively concentrates on plants growing in southern Africa for her subjects. She has completed a wealth of paintings, with many hundreds of plant studies, published regularly in books and journals since 1967. These include *The Moraeas of Southern Africa*, *The Genus Watsonia* and *The Woody Iridaceae.* She was awarded the RHS Grenfell Gold Medal twice and the South African Botanical Society Cythna Letty Award for botanical illustration (1988). She has shown widely throughout South Africa, including the Everard Read Gallery, Johannesburg, which has encouraged so many wildlife artists. Her work is in collections such as the Hunt Institute, Missouri Botanical Garden and at Kirstenbosch and Pretoria. In 1998 Fay came to see me in Cape Town and told me that her house had burnt down about a year before. She lost many paintings, although, thankfully, much had been published. She wanted me to have an example of *Nivenia stokoei* which she particularly treasured as she felt she had got the very difficult blue of the petals exactly right, a colour not easy to capture. The 9 species of *Nivenia* are rare and grow in very limited areas of the South Western Cape mountains. In 2013 Fay published a limited edition of 4 of her most iconic paintings to celebrate the Kirstenbosch Biennale and she gave me a copy.

ANDERSON, Francesca (born Washington DC, US 1946 13
Francesca Anderson's vigorous yet elegant pen and ink studies are full of energy. She lives in Brooklyn, New York, and at her farm out on the end of Long Island, in what has become her own nature reserve. She has had many solo exhibitions all over the US and for 10 years prepared the plates for 2 books with M. Baldick on the palms of Belize and Ayurvedic herbs. She has been awarded 2 RHS gold medals and Artist of the Year (2009) by the ASBA. Francesca is a Founder of the Brooklyn Botanic Garden Florilegium and a Fellow of the Linnean Society, London. Her work is always full of movement and she chooses large subjects which swirl across her pages. She prefers to work on 10 or more similar subjects such as her series of amaryllis, brassicas, poisonous plants, vegetables and bulbs. She draws birds on scratchboard, something that has always fascinated her. She undertook a commission to draw 13 orchid portraits to decorate the elegant Orchid Room in the '21' Club in New York and has exhibited her birds in New York state.

BARLOW, Gillian (born Khartoum, Sudan 1944) 7
Gillian Barlow has always had a career in the arts, attending the Slade School of Fine Art, University College London in the early 1960s and gaining a BA and MA in history of art at the University of Sussex. In 1987 she went to India as a visiting professor for the British Council where she staged solo exhibitions during her tenure. In 1988 she became Herald painter for the College of Arms, London which involved designing and painting coats of arms for newly elevated peers. She has won two RHS gold medals and was appointed assistant recording artist for their Orchid Committee in 1995. She has to paint new varieties of orchids immediately after they have won awards in order to register their idiosyncrasies. She also taught in the English Gardening School at the Chelsea Physic Garden and has worked for years promoting their Florilegium Society, overseeing its archive of paintings and helping with exhibitions. She was awarded Best of the Show at Longwood's Flora 2000. She is a member of the RHS Picture Panel. She has tutored many courses, illustrated for *Curtis's Botanical Magazine* and participated in the Transylvania Florilegium. She has been awarded the RHS Veitch Memorial Medal (2015) and the Finnis-Scott Award.

BARRETTO, Malena (born Rio de Janeiro, Brazil 1952) 4
Malena Barretto lives in Rio but has spent a great deal of time travelling and painting on projects all over Brazil. In 1989, supported by the Margaret Mee Foundation, she came to Britain to study at the Royal Botanic Gardens, Kew with Christabel King. Her paintings are held in both private and public collections. She has a substantial amount of published work and has recently been working on a portfolio of rare bromeliads for Banco Boavista. She is much influenced by Margaret Mee's work, giving her plants a similarly strong outline that sometimes fades near the edge of the paper. Malena Barretto has taught at the Rio de Janeiro Botanical Gardens, as well as Belem, Fortaleza, Recife and various other botanically interesting places; she has illustrated a book on Brazilian medicinal herbs called *Segredos e Virtudes das Plantas Medicinais*. Her book *Malena Barretto: Watercolours and Drawings of the Brazilian Flora* was published in 2005. Recently she had a solo exhibition in Paris.

BAUER, Franz (Francis) Andreas (born Feldsberg, Austria, now Valtice, Czech Republic, 1758–1840) 5
Franz Bauer's father was court painter to the Prince of Liechtenstein. After early artistic training he illustrated plants for Nikolaus Joseph von Jacquin, director of the botanic garden at the University of Vienna. In 1788 he accompanied Nikolaus' son to England, where his skill was spotted by Sir Joseph Banks, President of the Royal Society and *de facto* director of Kew. Banks employed Bauer as 'Botanick Painter to his Majesty' and to draw new plants flowering at Kew, an arrangement which continued for the rest of Bauer's life. Banks had a high regard for his work, which is not only artistically satisfying, but also notably precise and scientifically accurate; he examined the plants he drew minutely under a microscope and had an excellent knowledge of botany. Among his finest works are 30 plates of ericas, painted for *Delineations of Exotic Plants Cultivated in the Royal Garden at Kew* (1796–1803). He illustrated *Strelitzia Depicta: or Coloured Figures of the Known Species of the Genus Strelitzia from the Drawings in the Banksian Library* (1818), and worked with John Lindley on *The Genera and Species of Orchidaceous Plants* (1830–8), and *Genera filicum; or Illustrations of the Ferns, and other Allied Genera* (1842) by Sir William Jackson Hooker.

BERGE, Leslie Carol (born Taunton, Mass., US 1959–2017) 8
Leslie Berge was born into an artistic and musical family of French origin and educated at the American College in Paris. Her first degree in art history, painting and drawing from Bennington College, Vermont was followed by an MA in illustration at the Art Institute of Boston, with an emphasis on children's books. She worked as a freelance artist and exhibited at the Hunt Institute in their 7th International Exhibition (1992). Later she visited South Africa where she enjoyed the South African flora, in particular the most important collection of cycads in the world, growing in Kirstenbosch, the botanical garden on the slopes of Table Mountain. Her dramatic 1998 painting of the female cones of the cycad *Encephalartos ferox* was chosen to decorate a ceramic plate by Wedgwood for a special series commemorating the Shirley Sherwood Collection. Leslie entered another cycad, *Encephalartis woodii* for Longwood's Flora 2000, Delaware. This painting looks like a giant nest where a goose has laid a cluster of golden eggs, a far cry from that elegant garden's normal image, but appropriate nevertheless, as Longwood has one of the few specimens of this endangered cycad. Sadly, she died in 2017. Her family gave me two of her interesting works. It was a great loss of a dear friend.

BERNI, Stephanie (born Bristol, England 1949) 2
One of a growing number of British artists trained by Anne-Marie Evans at the English Gardening School, Stephanie Berni has shown in a number of exhibitions in London, including one at Hortus in 2001 and another at the Ebury Galleries in 2004, where I acquired an intense painting of a fern crozier unfurling. She has two paintings in the Hunt Institute, and has contributed to the Highgrove Florilegium, an initiative by HRH the Prince of Wales to record the plants in his garden.

BESLER, Basilius (fl. Nürnberg, Germany 1561–1629) 1
Basil Besler was an apothecary, the author of probably the most impressive of the early 17th century florilegia, *Hortus Eystettensis*, published in two large volumes in 1613, under the patronage of the Prince-Bishop of Eichstatt, in whose gardens most of the plants illustrated were grown. Besler worked on the drawings for 16 years, which were then engraved by a team of at least 6 people. The resulting 374 plates show the plants at life-size, arranged in chronological order of flowering, starting with spring and moving through the seasons, providing a wonderful record of what was grown in a plantsman's garden. The range is most impressive for such an early date, featuring plants from as far away as Spain, Corsica, Turkey and the Americas. The garden, in which the plants were arranged geographically, had been started by the botanist Camerarius in 1596 and was continued after his death by Besler. Three hundred copies of this remarkable work were produced on the largest size paper then available. Some deluxe copies were hand-coloured and sold at a price of 500 florins, then a fifth of the cost of the large town house in Nürnberg which Besler bought himself with profits from the book.

BLAXILL, Susannah (born Armidale, New South Wales, Australia 1954) 13
Susannah Blaxill trained and worked for a period in England, with exhibitions at the David Ker Gallery, London and at Spink in 1994 after she had returned to Australia. Her spectacular beetroot has been chosen by virtually every exhibition curator when the Shirley Sherwood Collection has been shown around the world. Her painting of seaweed took several months to complete, producing the most arresting and subtle watercolour with dense, amazing depths of painting tones. Recently she worked on a camellia, striped pink on a dark background and comparable to paintings by Dietzsch. The background comprises 32 layers of paint and the flower is in gouache overlaid with watercolour. She exhibited in the Sydney Botanic Garden show, *Botanica*, in 2005, 2006, 2007 and 2019. She won the 2016 Botanic Art Prize, BDAS Gallery, Bowrai, NSW and received first and third places in the People's Choice Award in Botanical Art Worldwide, Australia (2019). There is no doubt that she is one of the great contemporary botanical artists and an example of the strength of botanical art in Australia.

BOOTH, Raymond (born Leeds, England 1929–2015) 4
Raymond Booth was considered to be one of the best British painters of plants who, unusually, worked in oil on paper. He went to Leeds College of Art in 1945, but his training period was interrupted by National Service. His work has appeared in a number of publications such as the *Kew* magazine and *The New Plantsman*. He illustrated several plates for the camellia book that Mrs Urquart commissioned

in 1956. However, his most important collection of published paintings is in the *Japonica Magnifica* written by Don Elick. The originals were mounted as a touring show in the US. He lived in Yorkshire and exhibited at The Fine Art Society, London. His final show was in the spring of 2007, but he continued to paint, as he said, 'for fun'.

BRAITHWAITE, Victoria (born Glasgow, Scotland 1973) **2**
Working mainly in watercolour, Victoria has focused for the last several years exclusively on botanical subjects, becoming interested in weathering, decay and transformation. She aims to capture the individuality of her subject at a specific point in time when it's at its most visually interesting, rather than looking for a 'perfect' botanical example. She likes to work larger than life to highlight detail and texture. Having exhibited in specialist botanical society exhibitions, as well as open national competitions, her work has been admired for its light, drama and impact. She is a founding member of the Scottish Society of Botanical Artists, a member of the ASBA and was previously elected to associate membership of the SBA.

BRASIER, Jenny (born Alvechurch, England 1936) **6**
Like many other botanical artists today Jenny Brasier had no formal training and only started painting seriously in her later years. She was encouraged to do so by the late Wilfrid Blunt, co-author of *The Art of Botanical Illustration* with William T. Stearn. Her work appears in the revised edition of 1994. Another source of influence and constructive criticism was John Whitehead. She has been awarded 4 RHS gold medals and was one of the only 2 contemporary painters included in the V&A exhibition *Picturing Plants* (1995). Her work has been shown at the Smithsonian, the Hunt Institute, and has been acquired by the RHS and the Natural History Museum, London. She provided illustrations for *Hosta: The Flowering Foliage Plant* by Diana Grenfell (1990). Her work is highly versatile and beautiful; some of her brilliant, jewel-like watercolours on vellum have the intense quality of medieval illuminated manuscripts.

BRIGGS, Norah (born Yorkshire, England 1905–1989) **1**
My mother, Norah Bailey, trained at Leeds School of Fine Art, now part of the University of Leeds. After she married my father Geoffrey Masser Briggs they moved to St Albans, Hertfordshire where she continued painting every day of my childhood. She executed the watercolour of a pressed, dried specimen of *Aristolochia* that I had collected on a visit to Pakistan in 1948, shortly after partition from India. It was the first work she had done of a pressed plant and it is beautifully painted.

BROWN, Andrew (born Carshalton, England 1948) **3**
Andrew Brown retired from teaching at Westminster School in 2001. Since then he has illustrated plants for botanists at Kew, and has completed some 200 pen and ink drawings to date. Outside Kew, his work is held by the Prince of Wales's Highgrove Florilegium, the Transylvania Florilegium, the Hunt Institute and Chelsea Physic Garden. He has received 4 individual gold medals and 3 group medals from the RHS, concentrating mainly on bulbs and iris. From 2001 to 2007 he was chairman of the Chelsea Physic Garden Florilegium Society, which is producing a modern florilegium for the garden initiated by Anne-Marie Evans.

CANDIDO, Alessandro (born Iretama, Paraná, Brazil 1990) **1**
Having started his scientific illustration career in 2014 at Paraná Botanical Center, Alessandro Candido came to Kew in 2016 as a Margaret Mee Artist Scholar where he was taught by Christabel King. Currently he is working on a series of endemic plants which are endangered or extinct in Brazil. He participated in Botanical Art Worldwide (2018), exhibiting in the Botanical Garden of Curitiba, a centre that has a number of outstanding botanical artists, started by Fatima Zagonel in 2000 as the Center of Botanical Illustration of Paraná (CIBP). I acquired a very attractive small watercolour of a cactus while Alessandro was at Kew.

CARROLL, Richard (born Springfield, Mass., US 1931–2001) **2**
An artist painting with incredible photo-realism whose sense of design is unfailingly strong, Richard Carroll studied painting and illustration at Syracuse University in the 1950s and then worked for Young & Rubicam in New York and Detroit. He left advertising in 1974, becoming a fine artist in 1987. He has had solo exhibitions in the Alexander F. Milliken Gallery, New York, (1989), the Hokin/Kaufman Gallery, Chicago, (1990) and was in the Hunt Institute's 7th International Exhibition (1992). He often works with egg tempera achieving an extraordinary degree of detailed perfection, an artist whose work must almost be examined with a magnifying glass, before one stands back to admire it as a whole. In 2013 I acquired a painting of vine tendrils and seeds, painted in egg tempera in 1992 which had been part of his wife's estate.

CASTILLO, Juan Luis (born Bilbao, Spain 1964) **3**
Juan Luis Castillo is a biologist by training with a degree in biological sciences and more than 25 years of experience in scientific illustration. During this time he has collaborated closely with members of scientific staff in national and international institutions, facilitating the development of projects and papers, contributing to high-quality dissemination of science. He received the Margaret Flockton award (highly recommended) for excellence in scientific botanical illustration in 2018.

CHAKKAPHAK, Phansakdi (born Chonburi, Thailand 1949) **44**
In 2010, I discovered Phansakdi's work hanging in a Bangkok hair salon. At the age of 42 he had begun to teach himself watercolour painting, developing a pencil-free technique and working in natural light only. His art has been exhibited in numerous solo and group shows in Bangkok, San Francisco, New York, Pisa, Pittsburgh, Paris and London. His paintings are included in private and corporate collections worldwide. He is an outstanding and prolific artist, both accurate and fluid, painting his country's magnificent flora.

CHILIZA, Sibonelo (born South Africa, 1979) **1**
Sibonelo Chiliza was born in a rural area of Mthwalume in South Africa and obtained a national diploma in textile design and technology. He is mentored by the renowned botanical artist Gillian Condy. He has exhibited at 3 Kirstenbosch Biennales winning 3 medals and participated in Botanical Art Worldwide, South Africa (2018). His piece in the SSC is a splendid pencil study of the paint brush lily with particularly beautiful observation of the bulb and stem.

CHRISTOPHER-COULSON, Susan (born Durham City, England 1955) **2**
Susan Christopher-Coulson trained as a fashion and textile designer, gaining a degree at Kingston Polytechnic in 1977. She then

worked in the fashion industry and taught on the Art Foundation Course at Colchester Institute. In 1994 she began concentrating on botanical work and by 1997 was exhibiting and selling her drawings. She was awarded 2 RHS gold medals with a technique of coloured pencils used dry. She has showed in exhibitions in the north of England including Leeds, Harrogate and York. Elected to the SBA in 2001 she has shown regularly in their annual shows, which is where I acquired her work of scattered violets. The drawing has a delightfully fresh look but is also reminiscent of the violets that can sometimes be found decorating the borders of old illuminated manuscripts. A study of a charming group of spring flowers has been a recent addition to the SSC.

CONDY, Gillian (born Nairobi, Kenya 1952) 5
Gillian trained in London and worked for 35 years as resident botanical artist in the National Herbarium at the South African National Biodiversity Institute. She has organised and participated in numerous national and international botanical art exhibitions and was a founding member of the Botanical Artists Association of southern Africa. She has received various awards, participated in the Highgrove, Transylvanian and Sydney Florilegia, illustrated 2 books and curated Botanical Art Worldwide, South Africa (2018). Recently retired from the National Herbarium she continues a remarkably fruitful career, currently as artist in residence at Tswalu Kalahari Reserve, and illustrating world baobabs.

CORDOVA, Emmanuel L. (born Pasay City, Philippines 1960) 2
Emmanuel Cordova took a degree in advertising at the University of Santo Thomas and joined an advertising company for a few years before going freelance in 1990. He has had annual solo exhibitions called Botanicals Elcordova at the Ayala Museum, Makati City since 1991 and in 2008 held a solo show in Cebu in the Southern Philippines. He has executed large commissions for top hotels in Manila, including murals, botanical paintings and prints. In 1999 he completed the largest botanical paintings he had ever attempted, for a private home, creating 8 panels from floor to ceiling, featuring plants that can be found around Mindoro. He sent me a photograph of this lovely project, with panels showing examples of palms, bamboos and ferns. He completed 26 illustrations for the a new illustrated edition of a medicinal plant book first produced in 1892. Called *Plantas Medicinales de Filipinas* by Dr Trinidad H. Pardo de Tavera, the original edition was not illustrated. In 1996 I commissioned him to paint a palm and a few months later a splendidly informative and charming study arrived of the palm, *Areca catechu*. He painted a superb study of a staghorn fern in 2019, included in this publication.

DE REZENDE, Maria Alice (born Paracambi, Rio de Janeiro, Brazil 1961) 6
I met Alice during her stay at Kew as a Margaret Mee scholar in 2004. She had painted the Washington Palm in the Palm House there during her period of tuition from Christabel King. Since then I have seen her in Rio, where she showed me a range of paintings and her outstanding technical pen and ink illustrations. She has taught a number of courses in watercolour, gouache and black and white techniques in Rio and has worked for the Botanical Gardens of Rio de Janeiro and New York. She has received awards in Rio and Marinha do Brasil. She is an enthusiastic professional and an example of how the Margaret Mee Foundation encourages the development of Brazilian artists.

DE VILLIERS, Margaret (born South Africa 1939) 4
Margaret first exhibited paintings at the Kirstenbosch Biennale in 2008. At the 2010 Biennale she was awarded a silver medal and at the 2013 exhibition a gold medal for her *Erica* paintings. She exhibited at the RHS Botanical Art Show in London in 2013 and 2016, and was awarded gold medals on both occasions. In 2013 she also gained Best Painting in Show with her *Erica bodkinii*. This piece was purchased by the RHS Lindley Library. Margaret's paintings have been published and acquired by international and local botanical art collectors. She has participated in a number of botanical art exhibitions including Botanical Art Worldwide (2018) in Johannesburg. In 2019 she held a solo show of her botanical watercolours in her hometown, Hermanus, which I visited. She has an interesting style reminiscent of the works of Francis Bauer, showing finer details under her main image.

DE VRIES GOHLKE, Monika (born Germany 1940) 9
Monika de Vries Gohlke lives and works in Brooklyn, New York. After coming to the US from Germany, she attended a number of art schools and worked in the fabric and home design markets. For the last 30 years she has focused primarily on botanical art, painting and etching the plants she grows in her own garden as well as the Botanic Gardens in New York City. Her work has been widely exhibited from the US to Australia and the UK to Iceland over the last 10 years. She has been collected by the Met Cloisters, the National Museum of Women in the Arts, Washington, DC, the Metropolitan Museum of Art, Drawings and Print Collection, NY, the Library of Congress and many more. Her prints have won awards, including the Helen Gray Garber Award for Outstanding Botanical Artwork in 2017.

DE WET, Lynda (born South Africa 1951) 2
Lynda de Wet holds a diploma in fine art from Michaelis School of Art, University of Cape Town. A self-trained botanical artist, her interest in flora began during the recording of Sandveld Fynbos on the West Coast. This collection of paintings, in excess of 900, was intended for identification not exhibition. However, as her expertise and knowledge grew, so did her passion for botanical painting. She was awarded bronze medals at the 2006 and 2008 Kirstenbosch Biennale, and a gold in 2010 and 2013. She exhibited at the RHS show in London in 2014 gaining a gold medal. In 2016 she took part in the Plant Exhibition at Kirstenbosch and exhibited in Botanical Art Worldwide (2018) in Johannesburg. She has had paintings accepted for the Grootbos Florilegium and her artworks are in various collections around the world including SANBI, Brenthurst Library and the RHS Lindley Library. She now resides and has a studio in the shadow of the Kogelberg Biosphere between Betty's Bay and Kleinmond, where the pristine fynbos of the area is a constant artistic stimulation. She often includes pollinating insects and butterflies in her compositions.

DEAN, Pauline (born Brighton, England 1943–2007) 4
Pauline Dean exhibited her meticulous watercolours of plants over a long period. She started in 1987 after training as a registered nurse but with no formal tuition in botanical art. She died after a long, courageous struggle with cancer. She was awarded 8 gold medals and 2 further joint ones by the RHS. She had a solo exhibition at the Botanical Gardens in Geneva (1999) and exhibited at the Linnean Society in London, the Hunt Institute, the Everard Read

Gallery, Johannesburg. She also illustrated books and received commissions from *The New Plantsman*. For 11 years until 2002 she taught botanical art at RHS Wisley. She designed a successful series of 'Winter Flower' ceramic plates for the RHS made by Royal Worcester. In 2004 she published a beautifully illustrated biography, *Pauline Dean – Portfolio of a Botanical Artist,* which shows many of her paintings, mostly of plants at Wisley. In 2006 she was invited to the International Exhibition and Conference on Botanical Illustration for Tropical Plants at the Queen Sirikit Botanic Garden in Chang Mai, Thailand where she showed her work and gave an illustrated talk on botanical painting.

DEMONTE, André (born Niteroi, Brazil 1957) **2**
André Demonte was a member of the Atelier Demonte created by his father, Etienne, in Petrópolis on the edge of the Atlantic rainforest above Rio de Janeiro. He started exhibiting his work in Brazil in the late 1980s and showed in the US and England throughout the 1990s, notably at Nature in Art in Gloucester and in the Chris Beetles Gallery in St James, London. In 1998 he exhibited at the Tryon and Swann Gallery, London and at Art Expo, New York. As a trained, practising geologist he tries to connect field work to his art on trips to wild, remote regions of South America. André Demonte painted an attractive study of a ginger *Costus spiralis* and Black Jacobin hummingbirds *Florisuga fuscus* in 1998. Influenced by his father, André frequently has used hummingbirds in his compositions.

DEMONTE, Etienne (born Niteroi, Brazil 1931–2004) **3**
Etienne Demonte achieved a great deal for botanical art in Brazil during his lifetime, as well as being a famous painter of birds. He lived in Petrópolis, a city above Rio in the cooler Atlantic rainforest, as part of a large family of wildlife painters who were passionate about saving the unique environments of Brazil and triggering conservation through their artistic output and records. He was an influential teacher. From the 1960s onwards he had over two dozen shows in Brazil and exhibited widely internationally in Greece, Spain, the UK, at the Smithsonian, and the Hunt Institute. He featured with his sisters in a National Geographic film for an 'Explorer' programme, showing his research and painting in the Bahia region, in the bay of the San Francisco river.

DEMONTE, Rosália (born Niteroi, Brazil 1932–2009) **2**
Rosália Demonte lived in Petrópolis, sharing a studio with her sister, Yvonne, next to a house shared with her daughter Ludmyla and nearby to her brother, Etienne Demonte, who painted alongside his two sons. None of them had extensive formal training and their styles of painting are sometimes very similar. Rosália exhibited in London, Madrid and New York, as well as being part of a large show at the Hunt Institute, with an emphasis on Brazilian ecology. I first heard about the family through *Flora and Fauna of Brazil*, a mixture of essays and plates showing a range of their work, written by Chrystiane Ferraz Blower, another of Rosália's daughters. To study their subjects in the wild, Rosália, Yvonne and Ludmyla took off into the jungle in a big camper driven by Richard Blower, Rosália's husband. It was on one of those trips near the town of Caitité in Bahia that Rosália found the rare *Langsdorffia hypogea*, a curious root-parasite. She painted this for me from her notes using a large sheet of vellum that had originally belonged to Rory McEwen, which she was given by the Hunt Institute. Another painting of hers is an extraordinary vine, *Aristolochia gigantea*. The specimen she painted for this dramatic picture, with its striking maroon and white flower, was given to her by Roberto Burle Marx, the famous landscape designer who was such a great friend of Margaret Mee.

DEMUS, Jakob (born Vienna, Austria 1959) **3**
Jakob Demus trained at the Vienna Academy where he studied sculpture, anatomy and drawing in master classes under Joannis Avramidis. His passion for nature eventually made him decide to concentrate on painting and the graphic arts. An artist who is much influenced by the past he has not only studied the work of Pieter Breughel the Elder, Claude and the Dutch paintings of the 17th century, but he also uses their techniques, grinding and mixing his own colours and making extracts of wood smoke to create the warm tones of his bistre. As well as flowers Demus also draws detailed studies of rocks and stones and delicate landscapes. His work has been exhibited widely, in Tokyo, Vienna, Munich and New York and is held in the British Museum, the V&A in London, the Metropolitan Museum of Art, New York and the Rijksmuseum, Amsterdam. I acquired 3 diamond point etchings from Demus, the latest being drawn in 2005.

DIETZSCH, Johann Christoph (born Nürnberg, Germany,1710–1769) **3**
The Dietzsch family, in common with several others in Nürnberg at that period, boasted a number of artistic members, many of whom who continued to paint in the tradition of van Kessel and Maria Sibylla Merian in which flowers and insects were illustrated together. Johann Israel Dietzsch (1681–1754) was an artist, whose daughters Barbara Regina (1706–1783), Margaretha Barbara (1716–95) and son Johann Christoph were all talented painters. Johann, worked with his father and sisters at the court in Nürnberg, and was particularly known for his landscape paintings, although he also produced a number of flower paintings, and was also an etcher and engraver. Both he and his sister Barbara Regina who often worked in gouache, painted flowers on a very dark brown background. Thistles with butterflies were among their favoured subjects, so it is difficult to be certain who painted these pictures.

DOWDEN, Anne Ophelia (born Denver, Colorado, US 1907–2007) **3**
Anne Ophelia Dowden can be considered the 'grandmother' of America's contemporary botanical artists in much the same way that Mary Grierson fills that role in the UK. Both have produced many books and patiently instructed aspiring artists, continuing to paint in later years. I met her in July 1998 in her apartment in Boulder, Colorado. She was very organised, with her drawings and notebooks arranged meticulously. She used these repeatedly as source material over the years when she was writing, illustrating and publishing her books. She was worried about her failing eyesight which made it impossible for her to continue painting in the detail that botanical subjects demand. But she could see the huge banner of her vastly enlarged Autumn Foliage painting outside the Denver Art Museum at a major show I organised there in 2002. She was not forgotten in her later years. The ASBA gave her its annual award for her achievements as an illustrator and author in 1996 and she had another award from the Garden Club of American Zone XII in the same year. In January 1999 she received the Gertrude B. Foster Award for Excellence in Herbal Literature from the Herb Society of America.

DOWLE, Elisabeth (born London, England 1951) **7**
Elisabeth works in watercolour on paper and vellum, in a detailed and botanically accurate

style. She specialises in painting crops, particularly fruit. She has illustrated 15 books, including *The Book of Apples*, *The Book of Pears* and *Collins Field Guide to Crops*. Her work has been selected for the Highgrove and Sydney Botanic Garden Florilegia, and has been exhibited in many collections and institutions worldwide. Elisabeth has been awarded 7 gold medals by the RHS. Her art has featured on packaging, calendars, seed packets and porcelain. In 2014 she appeared on BBC Countryfile in a feature about her paintings of pears from the National Collection. In May 2019 her paintings of fruit formed a major exhibition at Cannon Hall Museum, Barnsley, UK.

EDEN, Margaret Ann (born London, England 1939) **2**
Lady Margaret Ann Eden studied at the English Gardening School, Chelsea Physic Garden taught by Elizabeth Jane Lloyd and later by Anne-Marie Evans. These impressive courses have been responsible for fine-tuning some of today's best British botanical artists. She spent most of her childhood in Canada and Hong Kong. She started painting early and in 1959 she went to the Byam Shaw School of Art, later studying portrait, life and still-life painting with Bernard Adams. She began painting flowers in watercolours at the end of the 1960s. She has an unerring eye for an interesting subject. Her study of *Medinilla magnifica* is from the island of Luzon in the Philippines. The watercolour shows each stage of the opening bud and the cascade of flowers. It has been chosen for a special series of ceramic plates by Wedgwood, commemorating the SSC.

EDWARDS, Brigid (born London, England 1940) **15**
Inspired by the works of the Bauer brothers and Ehret, Brigid Edwards started painting plants in the mid-1980s. She has been a trailblazer and has exhibited her work widely; a beautiful study in the SSC of two magnolia leaves, the mature one separated from an old leaf by a fruit placed between them, was in the 1990 summer show of the Royal Academy, a regrettably rare honour for botanical artists today. In 1994 she was part of a group show at Kew and she has had major exhibitions at the Thomas Gibson Gallery, London (1995 and 1997), and the William Beadleston Gallery, New York (2000). In 2006 she surprised everyone in the botanical art world by showing a series of much enlarged insects at the Gibson Gallery. More recently she had another show with Thomas Gibson in 2016, this time returning to plant portraits where I acquired an interesting sunflower study.

EMMONS, Jean (born Huntsville, Alabama, US 1953) **4**
Formally trained in colour and abstraction, Emmons feels plants provide the perfect subject for studying light on form. Their reflective and iridescent qualities always present a challenge. She enjoys underpainting in unusual colours and then knitting it all back together. Among many awards, Emmons has won 2 gold medals and Best Botanical Painting of Show from the RHS and the ASBA Founder's Award for Excellence. In 2018, she won Best in Show at the ASBA's 21st Annual International.

ESPARZA, Elvia (born Mexico City, Mexico 1944) **2**
Elvia Esparza has been scientific illustrator at the Institute of Biology and professor at Universidad Nacional Autónoma de México (UNAM), Mexico City. She was founder president of the Mexican Academy of Scientific Illustration from 1991 to 1998 and has had her work reproduced in books and journals; she is especially well known for her paintings in *Flora de Veracruz*. She has had over a dozen solo exhibitions, mostly in Mexico and in England, at the Linnean Society, RHS Wisley, Kew and the Natural History Museum, London. Her work is held at Kew and in the Hunt Institute as well as at UNAM. She was awarded a gold medal by the RHS in 1999 for paintings of dramatic Mexican cacti and desert plants. She has taught a variety of courses and workshops internationally, and the Museo de las Ciencias (UNIVERSUM) celebrated its first 10 years with an exhibition including 50 of her paintings (2000). She paints animals and insects as well as plants in a lively and yet accurate way; she was awarded Best Botanical Artist and another gold medal at the RHS exhibition in Birmingham in 2004.

FARRER, Annie (born Melbourne, Australia 1950) **15**
Annie Farrer studied English and history of art at Manchester University. In 1977 she was awarded a Churchill travelling scholarship which took her to Kashmir and Ladakh to draw the illustrations for *Flowers of the Himalaya* by Polunin and Stainton (1984). She often travels to the Himalaya having led treks there for 15 years. She may have inherited this passion for far-away places from her famous relative, botanical explorer, Reginald Farrer (1880–1920) who travelled widely in China and Burma and introduced many plants into Western gardens. Annie Farrer has been awarded 6 gold medals by the RHS and was the first recipient of the Jill Smythies Award by the Linnean Society in London (1988). She has illustrated many books and painted plates for *Curtis's Botanical Magazine*, *The Plantsman*, and the *New Plantsman*. Her work has been exhibited at Kew, the Peter Scott Gallery at Lancaster University, at Hortus and at the Hunt Institute's International Exhibition. She was an active member of RHS Picture Committee for many years. More recently an art foundation course followed by an MA (Fine Art) has enabled her to step outside the confines of botanical illustration and explore many different techniques.

FENG, Jinyong (born Yixing, Jiangsu Province, China 1925) **5**
Jinyong Feng has taught many botanical illustrators in China during the course of a long career, and has won major prizes in his own country as well as exhibiting at the Hunt Institute and Missouri Botanical Garden in the US, in Sydney, Japan and at the Everard Read Gallery, Johannesburg. He is now retired. I met Professor Feng in Beijing in 1994 and found his work exceptionally fine, particularly his older pieces. He showed me line drawings of great beauty, executed with a brush made of just 3 hairs from a wolf's tail; even under a powerful magnifying glass they were breathtaking.. I wanted to buy some older paintings of camellias but he was very reluctant and offered to copy them for me. This is a very alien approach for a Westerner, but within the Chinese tradition. Eventually we agreed that I would buy one older painting, a small treasure of *Camellia chekiangolesa* and a recent painting of the newly discovered *Camellia chrysantha* executed on Winsor & Newton paper brought back from a visit to Canada. As a charming gesture he gave me a flowing brush-painting of iris mounted on a silk surround, called Butterflies before the Wind, which is slightly reminiscent of Elizabeth Blackadder's work. At the end of our meeting I agreed, rather uncertainly, that he would copy a white *Camelia vietnamensis* for me. It is a success and, happily, has the quality of the original which he painted when he was younger.

FINNAN, Ingrid (born Leczyca, Poland 1944) 3
After a long career designing for the decorative textile market, Ingrid Finnan turned to botanical art. Inspired by the Dutch floral painters of the 17th and 18th centuries, and by the work of Raymond Booth, the British botanical artist who painted in oils on paper, it followed as a natural choice for her to explore this medium. For the last 13 years she has painted on gessoed paper in oil. She enjoys the flexibility and depth of colour that the medium allows. She has showed widely since 2006 in many juried exhibitions.

FOMICHEVA, Dasha (born Moscow, Russia 1968) 2
Dasha Formicheva earned an honours degree in stage design from Moscow Art College, an MA in painting from Surikoff State Academy, Moscow and studied watercolours with Sergey Andriaka, People's Artist of Russia. For 10 years she divided her time between Jordan and Russia, working primarily for the Jordanian Royal Family. She painted watercolour interiors of the Kremlin Cathedrals for the Kremlin State Museums and landscapes of Petra for the Jordanian Royal Family in 1993 and 1994, and 160 military illustrations of the history of the Hashemite Kingdom for HRH Prince Abdullah; she also paints portraits and lectures in fine art theory. Since 1993 she has exhibited in Moscow, Amman and London, participating in *Botanical Artists of the World* (Tryon Gallery, London, 2001). One project supported by HRH Queen Rania resulted in the publication of *Jordan in Bloom: Wildflowers of the Holy Land* which contains 53 beautiful watercolours executed with a fluent, luminous technique. I asked her to paint the extraordinary, sinister purple-black arum found in Jordan, *Biarum angustatum*. She sent me 3 dramatic studies which I arranged as a triptych.

FRANCIS, Mally (born Leeds, England 1946 – 2019) 1
Mally trained in 1988 under Anne-Marie Evans, becoming a Fellow of the Chelsea Physic Gardens in 2001. Moving to Cornwall in 1997, she lived in a private area of the Lost Gardens of Heligan where she held regular botanical painting classes in a wonderful studio, the Saw Pit at Heligan Farm. Mally was the first tutor of botanical painting at the Eden Project in 2001 becoming the founder chairman of their Florilegium and also a Fellow. She retired as chairman in 2012 and was created a Fellow of the Linnean Society. She died in 2019; her husband Charles hopes to continue her work with other tutors. Her beautiful study of the Babington leek was on the cover of the ABBA's Botanical Art Worldwide brochure and is now part of the SSC.

FRASER, Liz (born Newcastle Upon Tyne, England 1959) 28
Liz Fraser gained a BA (Hons) in illustration and printmaking from Duncan of Jordanstone College of Art, Dundee before moving to Cape Town in 1984. Over the next 12 years she painted the flora and fauna of the Cape, illustrating and co-authoring two books. Her third book, *The Smallest Kingdom*, was published by Kew in 2011. After a decade of teaching back in Scotland, Liz returned to full-time painting and now runs her own publishing and painting venture in East Lothian.

GRAHAM, Sarah (born Edinburgh, Scotland 1973) 2
Sarah Graham completed two MA's at Edinburgh University, in History of Art and Fine Art. She then spent 10 years travelling and painting across the world from Australia to Tajikistan, made a film *Beyond the Mountains of Heaven* and co-wrote a book *Silk Road, Troubled Dreams*. She has exhibited annually in London, New York or Aspen since 2006. I first saw her work in Sims Reed Gallery in 2008, where I acquired her Big Fir, a large study of a cone of *Leucadendron strobilinum*, collected on Table Mountain, Cape Town. She showed me the small cone which she had magnified so enormously into a striking painting in crayon. Recently she has been concentrating on one plant subject, *Medinilla magnifica*, studying aspects of this dramatic tropical plant, from its leathery leaves to shocking pink flowers, always enlarged and now executed in graphite or using coloured ink on paper.

GRIERSON, Mary (born Bangor, North Wales 1912–2012) 6
Mary Grierson honed her observational skills as a Women's Auxiliary Air Force flight officer interpreting aerial photographs during World War II, and later worked as a cartographer. In 1960, when she was nearing 50, she began a new career as the official botanical illustrator at Kew, encouraged by John Nash RA whom she encountered at a series of courses on botanical painting at Flatford Mill, Essex. I met her at Kew and later as a judge on the RHS Flower Painting Panel. The first of her paintings that I bought was from an exhibition at Spink, London, where she showed for many years. She was awarded 5 RHS gold medals, also their Veitch Memorial Medal in 1984. In 1986 she received an honorary doctorate from Reading University. She produced designs for postage stamps and for the Franklin Mint's commemorative china. Her work is in the British Museum, Natural History Museum, London and at Kew. She illustrated a plethora of books as well as contributing to *Curtis's Botanical Magazine*. She painted the plates for the huge *Orchidaceae* by P. F. Hunt, and in the 1970s was invited to Hawaii to record its native flora, published in *A Hawai'ian Florilegium*. Mary Grierson died in 2012, aged 99.

GUEST, Coral (born London, England 1955) 20
Coral Guest's work has redefined the traditional practice of the observational flower painter. Much influenced by early training at the Chelsea School of Art, London, and in Japan, she has been an established artist and teacher since the 1990s. She has taught at Kew, the Nature in Art Gallery, Gloucestershire, Monet's garden at Giverny and at Harewood House, Leeds. In 1997 she was tutor for one of the first botanical classes held in Orient-Express Hotels around the world. Her work includes landscape as well as outstanding plant portraits and is held in the Fitzwilliam Museum, Cambridge and the RHS Lindley Library. She painted me a magnificent dark purple iris over 1.8 m tall when framed, with a velvety flower, perfectly delineated leaves and a tangle of roots emerging from the rhizome. Her *Lilium longiflorum* 'Ice Queen' is a remarkable composition, subtly painted, comparable with the work of Redouté, Merian or with early medieval religious art. She was commissioned by my family to portray the pocket handkerchief tree, *Davidia involucrata,* as the 1000th work in the SSC.

GURJAR, Damodar (born Nahira, Rajastan, India 1958) 1
Damodar Lal Gurjar, is influenced by the traditional school of painting from the desert state of Rajasthan, but his technique is a blend of the traditional and contemporary. He is one of India's leading natural history artists, a master at super-realism and depicting textures in his subjects. Educated at the Rajasthan School of Art, Gurjar he has made his career as an artist painting numerous private commissions in watercolour, gouache and tempera. Much inspiration for his paintings comes from native gardens and crop fields. He

is particularly drawn to botanical specimens that are rich in colour with intricate texture and structure. Following early botanical artists, he lays emphasis on keen observation of actual specimens. In the final composition, careful consideration is given to the colour balance of the plant components. He uses watercolours, sable brushes, smooth hot-press and cold-press paper, working with a mix of colours consistent with the specimen, and a range of techniques such as tempera, to carefully describe the unique beauty of the subject as well as its scientific botanical structure.

HAGEDORN, Regine (born Göttingen, Germany 1952) 13
Regine Hagedorn was educated in Switzerland and France and studied at the Ecole des Arts Décoratifs in Geneva. She designed jewellery and established a graphic design studio, but also painted botanical watercolours and created a private garden near Geneva. She was awarded 3 RHS gold medals between 1998 and 2005. Her tight, meticulous studies of thorns, stems, rose hips and tree buds are laid out almost like a child's exercise in neat rows, so exquisitely painted that they can be best appreciated under a magnifying glass. Each is labelled in minute, delicate pencil script, an element in her composition which gives an added dimension to her work. Her watercolours have an intense, introspective quality, hard to convey in reproduction. Some of her rose paintings are lush yet detailed, exquisite and romantic. Her work is represented at Kew, the Hunt Institute, the RHS, London as well as the Isaac and Alisa Sutton Collection. Although she 'retired' in 2018, she is still designing and painting.

HAGUE, Josephine (born Liverpool, England 1928) 7
Josephine Hague studied textile design at Liverpool College of Art, from 1979 to 1985 and then embarked on a freelance career in textile design and illustration. Between 1984 and 1988, she was awarded 4 RHS gold medals and in 1993 was invited to become artist in residence at the Liverpool Museum of Natural History. She has exhibited in many galleries including Kew, the National Theatre and the Tryon Gallery in London, at the Hunt Institute (1997) and the National Botanical Gardens of Wales (2002). She has designed a series of British wildflower ceramic plates for the Conservation Foundation and painted a *Meconopsis* for the RHS Lindley Library in 2000. She completed two paintings for the *Highgrove Florilegium*; one was reproduced as a print for Prince Charles to give as gifts. Ness Gardens, attached to the University of Liverpool, provides many of her subjects.

HAMILTON, Gertrude (born Ghent, Belgium 1968) 1
Gertrude Hamilton was born in Belgium where she trained in graphic design. She continued her education in the arts in Paris at Atelier Lettelier. Work took her to New York where she continued drawing classes at The Art Students League. Evelyn Kraus, curator for the Ursus print department, came across her portfolio and offered her a solo show. It was the beginning of a whole new career. She began to apply herself solely to botanical and natural history illustration. Using antiqued paper, she combines a variety of historical inspirations with a keen modern sensibility resulting in a unique and refreshing interpretation of the classic genre. In the last few years her art has morphed into a more liberal interpretation of botanical illustration. She has held several solo shows at Ursus Galleries, New York, and her work may be found in numerous private collections in the US and abroad.

HEGEDÜS, Celia (born London, England 1949) 5
Celia Hegedüs was taught painting by her mother, a stage set Designer. She trained at the Hammersmith School of Art and the City and Guilds, London. She continued to paint while bringing up her family and showed at the Royal Academy Summer Exhibition in 1993, 1995 and 1997. Meanwhile she exhibited her work at the RHS where she has gained 6 gold medals. One of her iris watercolours has been acquired by the RHS Lindley Library. She has had 4 solo exhibitions at Waterman Fine Art, London and was invited to show at the Tryon & Swann's International Exhibition in November 1998. Among her best works are 3 iris paintings on vellum acquired for the SSC in 1996, *Iris foetidissima, I. pseudacorus* and *I. sibirica*. Recently she has been painting outsize tulips, magnified to show the striped and patterned petals. In each case she has caught the character and essence of the different plants and has created a wonderful translucence with the light penetrating the vellum.

HERBERT, Sue (born Darwen, England 1954) 3
Sue Herbert trained at Blackpool College of Art and Technology and Sunderland College of Art. She has shown in a number of group exhibitions in London, including the Tryon & Swann Gallery in 1998. I was first introduced to her work at the Hunt Institute's 7th International Exhibition (1992), where I saw one of her huge leaf paintings. It was an exciting, arresting watercolour and I asked her to show me more when I returned to London. Since then I have showed her work in exhibitions all over the world. I commissioned her to paint a *Gunnera* leaf and photographed the picture's development at several stages. This plant has the most enormous leaves, measuring up to 1.8 m across, and I have grown them near water for many years. Her leaves complement Ruskin's quotation 'If you can paint one leaf you can paint the world', although he certainly did not contemplate painting such massive subjects.

HISHIKI, Asuka (born Kyoto, Japan 1972) 1
Having grown up with nature books and frequent visits to the parks and gardens in her hometown, Asuka Hishiki's curiosity towards nature grew tremendously. After completing her MA in fine art painting at Kyoto City University of Arts in 1997, she spent ten years in New York. She was awarded the Diane Bouchier Award in 2018 and has shown her work around the world in China, Tokyo, Kew, London, New York, Italy and Hawaii to great acclaim. She now lives and works in Hyogo, Japan.

HISLOP, Helga (born London, England 1941) 3
There are 3 of Helga's paintings in my collection, each of them treasured. One is an exquisite circlet of wild spring flowers so delicate it seems ephemeral; another is of most beautifully painted rosehips on vellum, reminiscent of an ancient herbal. The third, a recent acquisition, is a tiny work of autumnal objects with echoes of Hoefnagel and van Kessel, with scraps of leaves, mistletoe and a snail scattered on the vellum. She has also done an exquisite book of tiny, seasonal studies. She has a great gift for recording the small and inconspicuous, the 'found' objects in our gardens. Her paintings, especially on vellum, have a quiet and reflective quality which will endure.

HORIKOSHI, Hideo (born Gunma Prefecture, Japan 1936) 2
After a career of 40 years with the National Federation of Agricultural Co-operative Associations Hideo Horikoshi, became a freelance artist in 1997. He has studied botanical painting with Valerie Oxley, Yoko

Kakuta and Mieko Ishikawa. He has participated in many group exhibitions and I saw his work in shows at the RHS in 2015 and 2018 where he was awarded two gold medals. I acquired two of his paintings of vegetables which are exquisitely drawn and were awarded Best in Botanical Painting in 2015. His work also featured in *Flora Japonica* in the SSG and Tokyo.

HOVE, Waiwai (born Malaysia 1974) 2
Waiwai Hove graduated with distinction in the distance learning diploma on botanical Illustration by the Society of Botanical Artists, UK, gaining the highest marks on the course ever given, in 2011–13. She started illustrating 30 Heritage Trees in Singapore Botanic Gardens for their library and painted an orchid named for Angela Merkel for her state visit to Singapore, in 2015. She was commissioned to paint 15 gingers for the Gardens' records most of which were used in their 2019 calendar and exhibited in the CDL gallery in Singapore Botanic Gardens. During the exhibition *Tropical Splendour*, the first show in the CDL gallery, she demonstrated painting a study of *Dipterocarpus* fruits which is now in the SSC as well as a painting of *Globba sherwoodiana* named after Shirley Sherwood by the NMNH, Smithsonian.

HUGHES, Annie (born Santiago, Chile 1948) 2
Born in 1948 in Santiago, Chile, Annie Hughes moved to Australia in 1966. From 1972 she spent 12 years in UK, where she obtained a diploma in art & design, before returning to Australia and earning a BA with first class honours in 1990. Having worked as a textile designer for 15 years, she turned to botanical art in 2005. She has won many awards, including gold medals in RHS botanical art shows, London in 2011, 2012, 2013 and 2017, and gold at BISCOT, Edinburgh (2014). She continues to live and work in Australia exhibiting her paintings and occasionally teaching. Her art is held in many collections, including the Hunt Institute, RHS Lindley Library, the Florilegium Sydney and in private collections in Australia, the UK and Japan. A new interest is glass work.

HYDE-JOHNSON, Jenny (born Johannesburg, South Africa 1955) 3
Jenny lives in a beautiful World Heritage Site 'The Cradle of Humankind' 30 miles NE of Johannesburg. These wonderful natural surroundings inspire many subjects for her paintings. She trained and worked as a graphic designer but has been painting full time since 2006. Her bird paintings have exhibited and toured yearly in the prestigious Leigh Yawkey Woodson Art Museum's (LYWAM) *Birds in Art* exhibitions in Wasau, Wisconsin US, 2008–2018. Her animal paintings have hung in the Mall Galleries, London, with the David Shepherd Foundation's Wildlife Artist Exhibitions, 2009–2014 where she was highly commended in 2010. Her botanical work has appeared in calendars, garden guides and other publications including the *Flowering Plants of Africa*, *The Botanical Artist* journal of the ASBA and the newsletter of the Botanical Artists Association of South Africa (BAASA). She was honoured to receive gold medals in all 3 Kirstenbosch Biennales which she entered (2006, 2008 and 2013) as well as a gold in the 21st International Orchid Congress in 2014. Her work is in the public collections of South African National Biodiversity Institute Yellowoods/Spier SA, LYWAM, the Hunt Institute as well as in many private collections worldwide.

IKEDA, Mariko (born Chiba Prefecture, Japan 1981) 1
Mariko Ikeda trained in Art and Design at the University of Tsukuba, Ibaraki and has been a botanical art instructor at Gakushuin University, Sakura Academy, Tokyo since 2006. She was an overseas trainee of the programme of the Agency for Cultural Affairs, Japanese government in 2018. Her work has been exhibited in Japan, Europe and the US, including Kew, the Forum Botanische Kunst, Thungers-heim, and the Hunt Institute. In 2017 she was awarded Best Botanical Art Exhibit at the RHS Botanical Art Show, London and the ASBA's 20th Annual International Exhibition, New York.

IKEDA, Zuigetsu (born Kanazawa, Japan 1877–1944) 1
Zuigetsu Ikeda was a passionate fancier of plants, who devoted his life to sketching them all over Japan. His work has not been known in detail until recently, as he did not seek a brilliant success in art circles and focused his work in sketching plants against vanishing nature. His main works are 14 scrolls of plant sketches, compiled over 30 years, and original paintings for *Rankafu*, an orchid florilegium. Original *Rankafu* woodblock prints were shown in the SSG in 2018, loaned from Prof. Stephen Kirby's collection and a book published by Kew *Rankafu: Orchid Print Album* to act as a catalogue.

IMAI, Mariko (born Kanagawa, Japan 1942) 12
Mariko Imai is undoubtedly one of the world's most important botanical artists; she works for long, sustained periods on a particular plant family to produce a series of definitive portraits. She has had many exhibitions in Japan and Canada, produced illustrations for several books and has executed superb covers for the Japanese version of the RHS magazine. In 1996 25 of her paintings were shown at the 5th Exhibition of *The World's Precious Plants* at Tobu Department Store in Tokyo; later 10 of these were awarded a gold medal at the RHS in London and donated to the Lindley Library. One of her major contributions is her superb plates in an important multi-lingual book *Masdevallia and Dracula* by Y. Udagawa (1994). She teaches botanical painting at Mito Botanical Gardens and has painted plants for the *Endangered Plants of Japan: a Florilegium* (2004) issued by the Japan Botanical Art Association. In 2006 she illustrated a book for children called *The Climbing Plant – Towards the Sunlight* published by Fukuinkanshoten Japan. She has been concentrating on painting *Asarum* and recently gave me 4 studies remarkable for their intricate rooting systems and beautifully painted leaves.

ISHIKAWA, Mieko (born Tokyo, Japan 1950) 7
Mieko Ishikawa trained at Musashino Art University and has since taught in the Agahi Cultural Centre and other institutions in Tokyo, including the Tokyo Metropolitan Jindai Botanical Park, Chofu, Tokyo. Her work is held in the Hunt Institute, Tokyo Metropolitan Jindai Botanical Park, and the Flower Museum, Chiba-city, Chiba. Since 1980 she has illustrated a large number of books and had several solo exhibitions at the Tama Forest Science Garden, Hachiojie, Tokyo. Recently Mieko Ishikawa has focused on painting cherry blossom, conifers and rainforest plants. Her watercolours are immensely delicate with the blossom petals faintly outlined with pencil or colour, very characteristic of Japanese artists. The works deserve the closest examination for their meticulous detail. Two spectacular drawings of *Prunus pendula* 'Pendula-rosea' were awarded a gold medal in the RHS show in 2006. She must be one of the best artists today to portray this fleeting blossom which is her passion and has such significance in Japan. Recently she has been working in Borneo on *Nepenthes* and *Rafflesia* and has visited there 12 times.

ISOGAI, Noboru (born Gunma, Japan 1935) 1
Noboru Isogai graduated as a mechanical engineer from the University of Tokyo in 1959 and worked at Seiko Instruments, Tokyo until 1998. Then he became a teacher in botanical art at the cultural centre at Chiba, where he lives. He is a member of the Seiko Art Association, Japan and the Society of Botanical Artists, UK. He started showing his work in 1995 in Tokyo and since 1999 has exhibited every year at the SBA in London and the Agape Gallery, Tokyo. His *Pandanus tectorius* is a large, beautifully painted watercolour of swirling leaves, notable for its energy and exquisite design.

IVANCHENKO, Yuri (born Sverdlovsk, Russia 1961) 1
Yuri Ivanchenko studied at the Repin Institute of Painting, Sculpture and Architecture in the Graphic Faculty from 1985 to 1991 in Leningrad (now St Petersburg). He exhibited at Colnaghi, London in 1994, at M.ARS, Moscow, St Petersburg and Geneva. His work is held in the collection of the Museum of Modern Art, Moscow. His solo exhibition at Colnaghi, London in 2003 included a series of 12 paintings celebrating the seasons by month.

JEPPE, Barbara (South Africa (1921–1999) 3
The first book Barbara Jeppe illustrated was *Trees and Shrubs of the Witwaterstrand*. She spent time in the Cape writing and painting bulbs for *Spring and Winter Flowering Bulbs of the Western Cape* and prepared the superb illustrations for *The Amaryllidaceae* some of which were completed by her daughter, the artist Leigh Voigt. Sadly, I never met her but was able to buy 3 of her preparatory sketches of Amaryllidaceae from Everard Read Gallery, Cape Town in 2017. The book was finally published in 2017, written by Graham Duncan and is an important and beautifully presented publication. She received awards including The Start Woman of the Year (1977), Cynthia Letty Gold Medal (1990), gold medal from the South African Nurserymen's Association (1990), and a silver medal from the Transvaal Horticultural Society (1991).

JOHN, Rebecca (born London, England 1947) 4
Rebecca John was drawn to illustrating plants thanks to her research for 3 books by Elizabeth David, a collaboration that inspired her to pursue botanical subjects. She began in 1984, later attending a course taught by Anne-Marie Evans at the English Gardening School (1994). In 1996 she curated a magnificent touring exhibition of her grandfather Augustus John's drawings and also wrote a biography of her father, Admiral Sir Caspar John (1987). Rebecca John lives in London and also in a cottage in mid-Wales. There she found the subject matter for her recent paintings; twigs and branches of ancient gorse, encrusted with lichen and mosses. In a masterly introduction to her first solo exhibition at the Lefevre Gallery, London, Grey Gowrie compared her work with that of Rory McEwen. I find parallels with Richard Carroll's still-life studies and Kate Nessler's work on vellum: these artists have an intense, tightly focused viewpoint, all are conscious of the space around their work. Her most recent exhibition was in 2019 at the Tristan Hoare Gallery.

JONES, Paul (born Sydney, Australia 1921–1997) 17
Paul Jones was one of Australia's foremost flower painters; in a country with a strong re-emergence of excellent botanical artists. He produced wonderful material for a series of books, becoming an expert on camellias, one of which is named after him. He created a series of drawings in the romantic style of Thornton's *Temple of Flora*, published as *Flora Magnifica* by the Tryon Gallery in 1976. He started by painting his subject in watercolour on plain white paper, then prepared a coloured background of acrylic and painted a second version on top of the acrylic background. One of the works in my collection is the original watercolour painting for the sunflower in the Tryon book, strong and vigorous and so striking it was chosen for the poster of my exhibition at Millesgarden Museum, Stockholm (1999). He gave me an essay just before he died entitled *Thoughts on Flower Painting* which ends 'Sureness of touch comes with unrelenting practice. A blank sheet of paper is very intimidating. There must be perfect coordination between the eye which observes, the hand which is directed by the eye, and the brain which makes the decisions. All must work in perfect unison. But the real worth and true quality of a memorable drawing can only come from the heart. Every part of one's being is involved and it is total. Talent raises the drawing from ordinary documentation. Flawless technique can astonish only, but fails to capture that particular "something" which can only be described as "magic".'

JOUBERT, Elbe (born Standerton, South Africa 1951) 1
Elbe Joubert studied at the Pretoria Art Centre, taught art at Rustenburg High School, fine arts at the Technical College and then established her own art school (1990). Today she presents short courses to keen students, both beginners and advanced. Her works are widely represented in South African and overseas collections. She has exhibited at the Everard Read Gallery, Johannesburg including Botanical Art Worldwide (2018), Kirstenbosch and London. She was awarded 3 RHS gold medals in London and one at Kirstenbosch. Since 1997 she has been commissioned to prepare book illustrations for Stellenbosch University, Kew and the University of the Western Cape. These include paintings of *Agapanthus* and *Nerine* species of South Africa.

KAKUTA, Yoko (born Talien, China 1939) 2
Japanese artist Yoko Kakuta followed a career in teaching after studying at Ochanomizu University, Tokyo. She then became a student of the botanical artist Ohta Yoai and began to exhibit her work in the 1980s, when she also became an instructor at the Asahi Cultural Centre and the Sogei Cultural Centre, Tokyo. She has illustrated several books. In 1992 her work was included in the Hunt Institute's 7th International Exhibition. She went to Vietnam 12 times from 1995–2016 researching yellow camellias and *Polysporas* (*Gordonia*) to paint, including some new species. She has been awarded 4 RHS silver gilt medals, Best Botanical Artist by the BBC (2003) and has exhibited at the Hunt Institute.

KING, Christabel (born London, England 1950) 4
Christabel King has an honours degree in botany from University College London and studied scientific illustration for 2 years at Middlesex Polytechnic, now Middlesex University. Since 1975 she has produced an extraordinary number of illustrations for *Curtis's Botanical Magazine*. She illustrated several books in the 1980s and has painted plates for 8 Kew monographs, the most recent being *The Genus Roscoea* by Jill Cowley (2007). Her illustration in *All Good Things Around Us* by Pamela Mitchell re-appeared in a new book *Edible Wild Plants and Herbs*, (2007). She received the prestigious Jill Smythies Award from the Linnean Society (1989). Her highly professional work is characterised by

meticulous handling and subtle colours. She is particularly good at cacti, where she achieves a wonderful contrast between their fleshy, succulent, spiny stems and their delicate flowers. Like Pandora Sellars, her work is always immediately recognisable. Since 1990, Christabel King has been an inspiring and memorable tutor to many Brazilian students who come to Kew under the Margaret Mee Fellowship scheme. In 1994 she visited Brazil and taught courses in Rio de Janeiro, Sao Paulo and Caxiuanã, in Pará province, running further courses in 2003 which Brazilian artists still talk about. Since 2002 she has been training botanical artists in Turkey, as well as teaching in London.

KING TAM, Geraldine (born Toronto, Canada, 1920–2015) **2**
Gerry King Tam lived on Kauai, Hawaii. She took her first degree in English and French at McMaster University, Hamilton, Ontario, and an MA in art education at Columbia University, New York. Like many other botanical artists she had a period as a textile designer, as well as teaching jewellery design, but her main occupation from 1955 to 1976 was teaching art at the Dalton School, New York. During this period she married the celebrated Kauai-born poet and artist Reuben Tam who greatly influenced her later work in Hawaii. While in New York they spent their summers at an artists' colony on Monhegan, an island off the coast of Maine, where she started drawing native plants. She had a solo exhibition of 50 of these at Syracuse University (1968). In 1980 she and her husband moved to Kauai. Reuben wanted to grow the flowers and fruit trees he had known as a child and he encouraged Gerry to paint them. Her style changed as she was challenged and exhilarated by the exotic tropical flora, and her plant portraits became striking with flowing lines, true colours and beautiful designs. Her graceful paintings capture the spirit and essence of her subjects. She worked from fresh plants, growing many in her own garden. This was wrecked by Hurricane Iniki in 1992 and she herself was knocked unconscious;her studio flooded, but miraculously, none of her work was destroyed. After this, in 1994, she met James White and decided to give 31 of her paintings to the Hunt Institute so they would be preserved in a museum environment She produced a lovely book, with text by David J. Mabberley, aptly entitled *Paradisus*. It contains 60 superb plates of flowering and fruiting tropical plants that grow in the Hawaiian Islands, some native, but many introduced as food plants by Polynesian settlers, others by Chinese and European immigrants. She was designated as a Living Treasure by the Kauai Museum in Lihue and honoured by McMaster University.

MACKAY, David (born Hornsby, New South Wales, Australia 1958) **2**
David Mackay began his professional career in the 1970s by preparing botanical illustrations for the Papua New Guinea National Botanic Gardens in his school holidays. Since then he has worked at botanic gardens and universities in Australia and overseas, including over 10 years at the Royal Botanic Garden Sydney as a botanical illustrator. During that period he took a BSc (Hons) at the University of Sydney. He honed his skills under a family friend, the well-known Australian wildlife artist William T. Cooper. He now works freelance from his home and studio in Armidale, New South Wales. His work has received much acclaim and is in public and private collections in Australia, the UK and US. He began exhibiting in 1989 and has made major contributions to numerous group shows in Sydney, Adelaide, elsewhere in New South Wales and northern Queensland. His drawings and paintings have been published in over a hundred books and scientific papers as well as calendars, magazines, greeting cards and other media. His *Eucalyptus macrocarpa*, or mottlecah, is a spreading glaucous scrub eucalyptus which can grow as tall as 5 m. It is restricted to southern Western Australia, where it grows on undulating heathland south from Enneabba and in remnant vegetation in the Wheatbelt near inland Corrigin.

MAKRUSHENKO, Olga (born Moscow, Russia 1956) **5**
Olga Makrushenko trained at the Moscow Institute of Engineering and Physics and was employed as a mathematical engineer for 10 years from 1979 at the Kurchatov Institute of Atomic Energy. She studied painting at the Moscow State Pedagogical Institute and took various courses on colour techniques. After Russians were allowed to travel more freely she established a connection with Broadland Art Centre, Norfolk, and Nature in Art, Gloucester, England where she demonstrated her elaborate technique, combining watercolour, pencil and air brush. She has exhibited widely in Moscow, at the Hunt Institute (2006) and in Focus on Nature (2006). She visited Chang-Mai, Thailand for the first South East Asian Conference on Botanical Art (2006). She is particularly fond of irises, lilies and magnolias which are good subjects for her lush and flowing technique. In 2017 she had a solo show in Mytistchinskyi Art and History Museum, Moscow.

MANISCO, Katherine (born London, England 1935) **7**
A graduate of the Slade School of Fine Art, London, Katherine Manisco studied painting at the Accademia dell'Arte in Florence. She is a member of the ASBA and the Chelsea Physic Garden Florilegium Society. She has contributed work to the Brooklyn Florilegium Society. Her art is included in the permanent collections of the V&A, Fitzwilliam Museum, Cambridge and the Hunt Institute. She has exhibited in New York and elsewhere, including a strong show at Colnaghi, London (2003) and a delightful display of lemons in the renovated Limonaia in the Boboli Gardens, Florence (2004). She had a most successful solo exhibition at the W. M. Brady Gallery, New York (2006). She was elected a Fellow of the Linnean Society in 2004. She divides her time between New York City and Rome.

MARIGO, Gustavo (born Rio de Janeiro, Brazil 1981) **2**
Gustavo Banhara Marigo graduated in design. He started illustrating wildlife at a very young age; one of his works in the SSC was painted when he was 16 years old. He won first prize in the Botanical Painting Contest of the Margaret Mee Botanical Foundation in 2000, becoming a specialist in scientific botanical illustration through the Margaret Mee Fellowship Programme in 2015. He has worked for biologists and editors to illustrate scientific articles and books, and has also shown in international exhibitions such as *Brazil – A Powerhouse of Plants* at the SSG (2016). He won the second prize in the Margaret Flockton Award for Scientific Botanical Illustration in 2016, and his work featured in Botanical Art Worldwide, Curitiba, Brazil (2018). Currently he runs workshops at the Botanical Garden of Rio de Janeiro, teaches classes and private lessons.

MARUYAMA, Kimiyo (born Hyogo, Japan 1936) **3**
Kimiyo Maruyama took a correspondence course in botanical art run by the Japan Gardening Society, Tokyo (1992–1993), watercolour classes with Hiroki Sato (1993–

1998), followed by a correspondence course with Musashino Art University, College of Art and Design (2002–2004). She is now a freelance artist and a member of the Japanese Association of Botanical Illustration, the Kobe Association of Botanical Illustration and the Botanical Artists' Association of the Gardening Society. Her awards include the Award of Excellence at Japan Grand Prix International Orchid Festival (1999), the Minister of Education Award at the 16th Botanical Art Competition in the National Museum of Nature and Science of Japan (2000) and gold medals at RHS shows in 2001, 2003, 2005, 2010 2015, with Best Exhibit in 2010. Her work is held in the SSC, RHS Lindley Library, Kew and the Hunt Institute. Her illustrations have been published in *Curtis's Botanical Magazine*. Kimiyo has had 12 solo exhibitions in Japan. She participated in the Japanese Association of Botanical Illustration project, posted 4 works in *Endangered Plants of Japan: a Florilegium* (2004), and 2 works in *Drawings of Alien Plants of Japan: A Collection* (2009). She is particularly gifted in painting conifers and there are two outstanding ones in the SSC.

McEWEN, Rory (born Berwickshire, Scotland 1932–1982) **10**
Rory McEwen's work influenced the development of a number of artists in my collection; Brigid Edwards, Jenny Brasier, Susannah Blaxill and Lindsay Megarrity are examples. I regret I never met him and missed the memorial exhibition of his work shown in Scotland and at the Serpentine Gallery, London (1988). He painted flowers from the age of 8 and was encouraged by Wilfrid Blunt, his art teacher at Eton, to look at the works of Redouté and Ehret. Blunt described him as, 'perhaps the most gifted artist to pass through my hands'. He had no formal training in art, but by the time he left Cambridge University his illustrations had been published in *Old Carnations and Pinks* by Charles Oscar Moreton (1955). He illustrated *The Auricula* (1964), and painted many of the plates for a revision of Wilfrid Blunt's *Tulips and Tulipomania* (1977). He travelled widely, especially in the Far East, showed his work in Japan and also in modern art galleries including MOMA, New York. His exhibition *True Facts of Nature* at the Redfern Gallery, London (1974) attracted a great deal of attention. Plants and vegetables were sometimes painted in the same frame, always with the space between them being as important as the objects themselves. He was much influenced by the past and his studies of the botanical masters like Robert, Redouté, Ehret and Aubriet are reflected in his work. When I was looking at Ehret's drawings of tulips in the V&A I had an immediate, uncanny sense of recognition (I have a tulip painted by McEwen). His work on vellum is particularly noteworthy and he encouraged many recent artists to try this medium. There was a memorable exhibition of McEwen's work and of artists he influenced held in the SSC in 2013, with a book *Rory McEwen The Colours of Reality* published by Kew, celebrating his life.

McGANN, Joan (born Kansas, US 1950) **1**
Joan McGann received her BA in fine arts from Wichita State University and a certificate of excellence from the Arizona-Sonora Desert Museum Art Institute, Nature Illustration Program. Her current botanical illustrations focus on plants native to the Sonoran Desert, several being protected and endangered species. Joan works on paper with graphite pencil, coloured pencil, watercolour, and ink. Her work is in the permanent collections of the Hunt Institute and the Arizona-Sonora Desert Museum.

McNEILL, Robert (born Falkirk, Scotland 1954) **1**
Robert is a graduate of Edinburgh College of Art, where he studied drawing and painting, and was awarded a year of postgraduate study. Although following a teaching career, retiring early in 2011, he has never ceased painting. In 2013 the SBA awarded him a certificate of botanical merit, the Suzanne Lucas Memorial Award and the People's Choice Award. He has work in the Hunt Institute and he is represented by the OA Gallery, Kirkwood, Missouri, US.

MEE, Margaret (born Chesham, Buckinghamshire, England 1909–1988) **15**
Margaret Mee's influence has grown steadily among botanical artists, environmentalists and ecologists in recent years. Hers was one of the first voices raised to alert the world about the exploitation of the Amazonian rainforest. The 58 plates that she painted for her second book *Flores do Amazons – Flowers of the Amazon* were shown at Kew in 1988, shortly before her death in a car accident. These paintings of Brazilian rainforest plants were acquired by Kew in 1995 and became the core of an important travelling exhibition shown in venues in the US, seen by thousands of people, raising interest in the Amazon as well as Kew's work. Margaret Mee trained as an artist at St Martin's School of Art, the Central Art School and Camberwell Art School, London. She moved to Brazil in the early 1950s, became fascinated with the exotic flora and undertook solo journeys into the rainforest, searching for exciting plants to paint. This seemingly frail, petite woman went on 15 challenging collecting trips with only Indian guides to accompany her. She would sketch specimens *in situ* and then try to get them back to Rio so they could be cultivated. She brought back hundreds of valuable plants and 4 previously unknown species were named after her. She has inspired many Brazilian artists such as the Demonte family, Marlena Barretto, Patricia Villela and Álvaro Nunes. The Margaret Mee Foundation has raised money to finance the exchange of dozens of artist scholars between Kew and Brazil. It also organises exhibitions and competitions in Brazil which have a steadily increasing standard. She has become an icon in South America; her life was even chosen as the theme for a Samba School for the Rio Carnival with 3,000 eco-friendly dancers parading to a Margaret Mee theme song – there is no greater accolade than that! I attended a ceremony naming a tree-lined avenue for her in the Rio de Janeiro Botanical Gardens, celebrated by some of her old friends and several young botanical artists. We put on a big Brazilian exhibition in the SSG in 2016, showing both her works from Kew and some in my collection.

MIRRO, Angela (born New York, US 1953) **1**
After graduating from Parsons School of Design, Angela developed a career as a textile designer, working for Ralph Lauren's Home Collection, but she has focused on botanical watercolour paintings of orchids for more than 30 years. Illustrating orchids has consistently been her passion and pursuit, this has led to many wonderful travels and experiences. Her work has been exhibited widely. She prefers painting orchid species *in situ*, and when possible, tries to convey something of their natural habitats, as much of it is disappearing. She was the first artist to illustrate the newly discovered *Phragmipedium kovachii* in the Peruvian Andes near its source in 2003. This painting is in the SSC.

NESSLER, Kate (born St Louis, Missouri, US 1950) **14**
With exhibitions in Jonathan Cooper's Park Walk Gallery, London, Kate Nessler has confirmed her position as one of today's most important botanical artists. She has had 8 solo shows there since 1995. I have 14 Nessler paintings, collected since our first meeting at the RHS where she was awarded 3 gold medals in the early 1990s. Her recent works are all on vellum which has impacted on her style, making her more introspective and detailed. By 1999 she seemed to be moving to more intense studies of plants in their natural surroundings, with snowdrops breaking through a covering of dried, dead leaves, a clump of bird's foot violet nestling on sticks and stones, and a brilliant study of rose hips, oak leaves and an acorn withered at the onset of winter. The last few years have been packed with achievements.She has been involved with the ASBA from its onset, becoming its president and receiving its most important accolade, the ASBA Award of Excellence (1997). She has paintings in the Hunt Institute and RHS Lindley Library, and her exhibition *The Baker Prairie Wild Flower Collection* has travelled in Arkansas in co-operation with the Arkansas Natural Heritage Commission, helping educate children about their local plants. Her work is collected in the Morton Arboretum, Lisle, Illinois, Highgrove Florilegium, Brooklyn Botanical Garden Florilegium, and the US National Museum of Women in the Arts, Washington, DC.

NETTLETON, Julie (born Sydney, Australia 1954) **1**
Julie's career was in interior design before she became a botanical artist. Her work focuses on Australian native species that are classified as significant, rare or endangered in the Sydney region, and in particular plants growing in an almost extinct bushland called Easter Suburbs Banksia Scrub (ESBS) at North Head Sanctuary in Manly. It is classified as an endangered ecological community so the recording and preservation of what survives is important. The beautiful *Styphelia triflora*, known as pink five-corners, with its elegant dissections of bud, flower and fruit, was acquired for the SSC in 2014. Julie's work is held in private and public collections, including the Hunt Institute, Florilegium Society at the Royal Botanic Garden Sydney and the Botanic Collection at the Royal Botanic Gardens Victoria, Melbourne. Julie was awarded a gold medal and Best Botanical Painting at the RHS Botanical Art Show, London (2016).

NICHOLSON, Catharine (born London, England 1958–2011) **5**
Catharine Nicholson was a specialist in very fine pen and ink drawing, focussing in minute detail on such subjects as leaf litter, mosses and fungi. All her work was completed in the space of her last 12 years, when she lived in a village in south-west England. Her huge and immensely ambitious late pictures have been seen as autobiographical accounts of her fight against cancer, expressing a visionary sense of nature's dynamic power in relation to decay and ageing. She was a 3 times RHS gold medal winner and Fellow of Chelsea Physic Garden's Florilegium Society. Her solo retrospective exhibition, Some Get More Eaten Up Than Others at St John's College, Oxford (2012) was remarkable.

NUNES, Álvaro Evando Xavier (born Anápolis, Goiás, Brazil 1945) **35**
Álvaro Nunes is based in his birthplace, but spends long periods away, working in remote areas of Brazil. He is particularly interested in the Brazilian savannah and has painted many of the fruits of native trees from the savannah, Amazonia and the Pantanal. Finding the specimens involves long journeys of up to 8 months to these isolated parts of the country. He qualified as an architect at the Federal University of Brasilia (1971), then worked for the government of Brazil on urban projects until 1981. His botanical studies started with a 6-month internship in the botanical department of Brasilia Federal University (1989), where he focused on the flora of the Brazilian savannah. He also attended a painting course taught by Christabel King at São Paulo Botanical Institute (1993). He participated in botanical drawing workshops in the Federal Universities of Brasilia, Juiz de Fora, Minas Gerais, Goiás; and at the 'Swamp-land campus' of the University of Matto Groso do Sul. His drawings have been published in a number of books including *Fruiteras da Amazonia, Peixes do Pantanal* and a series of books *Plantar* and *Frutex* all published by Embrapa, the Brazilian Institute for Rural Research. He was well represented in the show of Brazilian artists in the SSG in 2016 celebrating his importance in Brazilian art.

OGILVY, Susan (born Kent, England 1948) **8**
Susan Ogilvy qualified as an occupational therapist and completed a foundation course at Luton School of Art (1970). She went to work at a mental hospital just north of London and found it both fascinating and rewarding. Her marriage led to travel abroad, and she returned to painting, including portraying the exotic flowers in the gardens around the British Embassy at Muscat. She exhibited at the RHS where she was awarded a gold medal (1997) and has had several successful solo exhibitions at Jonathan Cooper's Park Walk Gallery, London. She has shown an arresting collection of grass and fern studies interspersed with wildflowers, viewed from above, painted from locations around her home. Inevitably one thinks of Dürer and his *A Large Piece of Turf*. Her exhibitions also have included architectural uses of plants in house decorations. Her book *Overleaf* (2013), is a delightful study of both sides of leaves. She has paintings in the Highgrove and Transylvanian Florilegia.

OOZEERALLY, Barbara (born Poland 1953) **8**
Barbara Oozerally lives and works in London, England. An architect by profession, she became a botanical artist in 1996. She has since taken part in many exhibitions in England, Australia, South Africa and the US. Barbara's paintings have won her many awards, including 2 RHS gold medals and certificates of botanical merit from both the SBA in London and the ASBA. Other achievements include the prestigious Diane Bouchier Award for Excellence in Botanical Art, a silver medal from the Kirstenbosch Biennale Exhibition of Botanical Art and winning the Channel 4 Watercolour Challenge at the RHS Chelsea Flower Show (1999). Barbara's works are in many private and public collections, including the Hunt Institute, Kew, the RHS Lindley Library and the SSC. Her book, *Magnolias in Art and Cultivation* (2014) has over 150 illustrations painted by Barbara over 9 years. She is now working on a further book on other species of magnolia. A *Nerine* and a new hybrid of *Magnolia* have been named after her.

PARKER, Hillary (born Lakewood, New Jersey, US 1964) **1**
Hillary Parker is a naturalist and international award-winning botanical watercolour artist with paintings exhibited, published, and sold worldwide. She enjoys a dual career of painting and teaching spanning 30 years. Her teaching includes workshops, ongoing classes, private art instruction and online courses throughout the US and Australia. Highlights of her painting career include juried international exhibitions, solo exhibits, and private commissions, with paintings that hang in prominent collections in 12 countries.

PETER, Sylvia (born Kaufbeuren, Germany 1970) 1
Sylvia Peter studied painting at the Academy of Fine Arts Burg Giebichenstein, Halle with Prof. Christine Triebsch. In 2009 Sylvia Peter founded the Gallery Forum Botanische Kunst, which shows works of distinguished botanical artists from Europe, the US and Japan. Her work is held in the SSC and the Hunt Institute. She is a member of La Sociêté Francaise d'Illustration Botanique and the ASBA, and she worked on the steering committee for Botanical Art Worldwide (2018). In 2018 she celebrated Botanical Art Worldwide Day for Germany in her gallery.

PETRINI, Angela (born Novara, Piedmont, Italy 1958) 2
After completing a secondary education in art Angela Petrini graduated in law from the University of Turin. She started painting watercolours in 2004, soon after focusing on botanical illustration. In 2010, she earned a distinction in the SBA distance learning diploma and joined Floraviva, the Italian Association of Botanical Artists, of which she is currently president. She was awarded an RHS silver gilt medal in 2014 followed by a gold medal (2018) for a detailed study of rice. The history of plants and their use by man has always fascinated her. This has led to a commission by the Italian National Trust, to portray several Mediterranean species both cultivated and wild, to be found in the Kolymbethra Garden, an archaeological site in the Valley of the Temples, Sicily.

PETTERS, Yanny (born Dublin, Ireland 1961) 3
Yanny Petters paints Irish wild plants in Verre Eglomisé (reverse painting on glass). Through her work she raises awareness of the wonders of wild habitats, particularly Irish bogs. Collections which hold her work include the Office of Public Works, National Botanic Gardens, Dublin and the Watercolour Society of Ireland. She has won a number of medals and awards in recent times and is represented by the Olivier Cornet Gallery in Dublin where she has held numerous shows. She has been very influential in the founding of the Irish Society of Botanical Artists and in the publication *Abítir: The Irish Alphabet in Botanical Art* (2014).

PHARAOH, Jenny (born Port Elizabeth, South Africa 1953) 2
Jenny Pharaoh studied art at the Ruth Prowse School of Art and the University of South Africa. She became involved in botanical art in 2008 after seeing the first touring Shirley Sherwood exhibition, which brought her love of the rich diversity of indigenous South Africa plants together with that of art. She has done short courses with many South African and overseas artists and participated in several exhibitions including Botanical Art Worldwide. She is currently documenting the plants of the upper Breede River Valley, located within a couple of hours of Cape Town.

PHILLIPS, Jenny (born Boort, Victoria, Australia 1949) 9
Jenny Phillips started painting plants in 1971. I first met her at the RHS in 1993, when she was visiting from Melbourne. She showed 8 euphorbias there and was awarded a gold medal. Shortly after this she established her Botanical Art School of Melbourne, creating a purpose-built studio where she has taught hundreds of devoted pupils. When I initiated botanical painting classes in Orient-Express Hotels in 1997 I asked Jenny to become one of the teachers. From 1998 she gave master classes in hotels in Sydney, the Blue Mountains, Cape Town, Johannesburg, Venice, and Charleston. She has taught at the Getty, LA and has become one of the most sought-after teachers of botanic art in the world. Her paintings are in the Highgrove and Transylvania Florilegia and many other collections. She had a splendid show in the Arader Galleries, NY and a memorable retrospective in Mornington Peninsular Art Gallery, Victoria, Australia in 2009. She won the Celia Rosser prize in 2008. Her beautifully painted *Strelitzia* can be compared to superb studies by Franz Bauer (1758–1840) of the same plant. These works, held by Kew, are some of its greatest treasures and yet the Jenny Phillips portraits can bear the closest comparison.

PIKE, Barbara (born Johannesburg, South Africa 1933) 2
Barbara Pike obtained a BSc majoring in botany and zoology from the University of Witwatersrand where she later worked as a botanical artist. She has contributed to numerous scientific papers and botanical books including Shirley Sherwood's *A Passion for Plants*. She has exhibited at the Kirstenbosch Biennale since its inauguration in 2000 and has been awarded 2 gold 2 silver and a bronze medal.

PISTOIA, Marilena (born Milan, Italy 1933–2017) 1
There are more botanical artists in Italy now, but when Marilena Pistoia started she was an exception. A large body of her work is published in big books produced by Mondadori (Milan) and Calderini (Bologna). Her flowers are always most beautifully arranged upon the page, often curved in soft swathes around the centre, and painted in a sensitive and yet decisive way. When I visited her austere studio near Modena, she retrieved her original flower paintings from the bank to show me. Then she said, 'I stopped painting flowers, it was a different period of my life and it is completely finished. I only did it to make a living'. After that time she only drew futuristic globes delineated with a fine compass-operated pen. The rest of her time was taken as professor at the Accademia di Belle Arte di Bologna where she taught etching. I tried to persuade her to draw something for me or to let me buy one of her flower paintings. She refused, kindly, but firmly, but she gave me a delicate painting of a dandelion as a consolation.

POOLE, Bryan (born New Zealand, 1953) 8
Bryan Poole is a botanical and natural history artist who has lived and worked in the UK since the early 1980s. He trained as a botanical artist at Kew, under the counsel of botanist Dr Christopher Grey-Wilson. Bryan is a RHS gold medal winner and a member of the Royal Society of Painter-Printmakers (RE). His work is true to the 17th century intaglio etching technique. He is a 'modern classicist' who combines traditional methods of illustration and reproduction with a contemporary approach to botanical art and design. Over the last few years he has painted botanical subjects in watercolour on vellum. His work is held in collections including Kew, the Natural History Museum, London, the National Museum of Natural History, RHS Lindley Library, the Smithsonian, Museum of New Zealand and the New Zealand Parliament building. He has exhibited widely, including the Chelsea Flower Show for 18 consecutive years and Botanical Art Worldwide (2018) in New Zealand. He had a full retrospective show at the London Sketch Club in 2019.

PURVES, Rodella (born Paisley, Renfrewshire, Scotland 1945–2008) 1
Educated in Edinburgh, Rodella Purves took a diploma in agricultural botany followed by another in seed testing. She went briefly to New Zealand before returning to Scotland to work on exhibitions at the Royal Botanic Garden, Edinburgh. She made her first attempt at portraying plants when helping to put up a large introductory panel for an exhibition,

featuring a pansy. Other displays followed and eventually she was introduced to the refinements of botanical painting in 1971 with courses at Flatford Mill with John Nash RA and at Edinburgh College of Art. From 1976 she became a freelance artist producing work for both private and public collections. She published work in *Curtis's Botanical Magazine* and *The Plantsman*. Her work has appeared in *The Orchid Book* by James Cullen (1992), *The Rhododendron Species* by H. H. Davidian and *The New RHS Dictionary of Gardening*. She exhibited regularly after 1975 including the Hunt Institute's 4th International Exhibition (1976). Her most important show was a retrospective of 20 years work at the City Art Centre, Edinburgh (1996) comprising an impressive display of 69 watercolours. I had to wait several years before Rodella Purves could fulfil my commission. We decided on a blue *Meconopsis*, a wonderful azure poppy that blooms briefly in May and flourishes in the Royal Botanic Garden, Edinburgh.

QUINTELLA, Rosane (born Sao Paulo, Brazil 1959) 1
Rosane Quintella graduated in art from the School of Music and Fine Arts of Paraná (1981) and in biology at Pontifical Catholic University of Paraná (1992). She began her career as a botanical illustrator in 2002 after attending a 2-year course in botanical illustration at the Botanical Illustration Center of Paraná, and was awarded a fellowship in the Margaret Mee Fellowship Programme to study at the Royal Botanic Gardens Kew. After returning to Brazil, she became an active member of the Botanical Illustration Center of Paraná. She also belongs to the National Union of Scientific Illustrators. Since 2006 has taught courses in botanical illustration. Her work includes both watercolour illustrations and pen-and-ink scientific drawings. She has participated in many exhibitions, the most important being a show which took place at Kew at the end of her Mee fellowship programme (2005) and Botanical Art Worldwide, Curitiba, Brazil (2018).

RAMSAY, Denise (born Auckland, New Zealand 1971) 7
Growing up in New Zealand, surrounded by green hills and native forest, Denise fell in love with flowers and their rich colours. When she started painting in 2012, she discovered she had a passion for translating nature's beauty onto paper. Based in both tropical Hong Kong and rural France, Denise is not short of inspiration. The large scale and vibrancy of her works are modern and detailed, and her work has been exhibited around the world and featured in many books and magazines. She gained a distinction in the distance learning diploma from the SBA in 2013. The following year she was awarded a RHS gold medal. Her work has appeared in exhibitions at the RHS, London, Hunt Institute and Filoli, California, US.

RAUH, Dick (born US 1925) 1
Dick Rauh came to botanical painting in retirement, after a career in motion picture special effects. In addition to earning a certificate in botanical illustration from the New York Botanical Garden, he received a doctorate in plant sciences from the City University of New York (2001). Rauh's work won a gold medal and Best in Show at the 2006 RHS show in London. He is a fellow of the Brooklyn Botanic Garden Florilegium Society, and past president of both the ASBA and the Guild of Natural Science Illustrators. His work is in permanent collections of the RHS Lindley Library, New York State Museum in Albany, and the Hunt Institute. He has exhibited widely throughout the US and has shown recently at the Kerschner Gallery in Fairfield, CT, the Wilton Library and the Highstead Arboretum. In 2014 he had a solo show in the Steinhardt Gallery of the Brooklyn Botanic Garden. He has been an instructor on the botanical illustration certificate programme at the New York Botanical Garden since 1994 and was named Teacher of the Year (2010). He teaches drawing classes at the Fairfield and Westport Senior Centers and at Lifetime Learners Institute at Norwalk Community College.

REDDICK, Carol (born UK, 1974) 1
Carol has lived in Cape Town, South Africa for the last 35 years. She studied fashion and textile design at Portsmouth College of Art in the UK, has worked as a costume designer for London theatres, TV shows, as a fashion buyer and as a designer for kitchen and shop layouts. She began botanical painting in 2001 in South Africa, taught by Vicki Thomas at a weekly class in Kirstenbosch Botanical Gardens, Cape Town. She first exhibited in the Kirstenbosch Biennale in 2002 and has shown in each of the subsequent Biennales. She won silver medals in 2008, 2010, 2013 and another at the Bothalia Exhibition in Lucca, Italy (2010). Her works have been included in Botanical Society of South Africa calendars. A painting of the *Welwitschia mirabilis* was included in the book *Uncrowned Monarch of the Namib* by van Jaarsveld and Pond (2013). Her painting of *Chlorophytum cremnophilum*, a new and rare plant discovered by Ernst van Jaarsveld, it appeared in *Bradleya*, the yearbook published by the British Cactus and Succulent Society. In 2018 Shirley Sherwood bought her painting of *Psychotria capensis,* black bird-berry, from the Botanical Art Worldwide Exhibition in Johannesburg South Africa, to add to her collection.

ROSSER, Celia (born Melbourne, Australia 1930) 2
Celia Rosser can certainly claim her place in history through her remarkable work on the Australian genus *Banksia*. These paintings have been reproduced in 3 volumes by Monash University, published between 1981 and 2000. She became Science Faculty Artist at Monash University, Melbourne, Australia in 1970, starting her monumental work on banksias there in 1971. She has been painting them ever since. Every time the end was in sight another new species was found; the last volume contains portraits and descriptions of 4 extra species, bringing the total in all 3 volumes to 76. Alex George, known throughout Australia as the 'banksia man', wrote the text. George and Rosser travelled all over the country for rare specimens and George's unrivalled knowledge meant that they could collect specimens at the right time of flowering or fruiting. I consider *The Banksias* one of the very best publications in any field produced in the twentieth century, or indeed in any century, and it represents a truly colossal achievement. Celia Rosser has received a number of accolades for this mighty work, including the Jill Smythies Award for Botanical Illustration from the Linnean Society of London (1997) and an Honorary MSc and PhD from Monash University. Her *Banksia serrata* in my collection has been shown all over the world from Kew to Tokyo and from Sydney to Stockholm, including the Museum of Modern Art in Edinburgh. Celia came to the opening in Edinburgh, which happily coincided with her Linnean Society award. In 2003 a new species was discovered and named *Banksia rosserae*; Celia sent me a charming print of her 'name' plant.

RUST, Graham (born Hertfordshire, England 1942) 6
Graham Rust trained in art schools in London and New York. He is best known for his murals and ceiling paintings which adorn houses all over the world. Perhaps the most remarkable is 'The Temptation', his spectacular mural at

Ragley Hall, Warwickshire which took him over 10 years to complete. Besides his skills as a muralist he is a wonderfully accomplished painter of flowers and a prolific illustrator of books. He put many of his mural designs together to produce *The Painted House*, a bestselling book now published in 4 languages. His sequel, *Revisiting the Painted House*, was published in 2005. I well remember my delight in finding, by chance, his *The Secret Garden* which became a treasured Christmas present for one of my grandchildren. His flower paintings were used to illustrate a very successful edition of Vita Sackville-West's essays, *Some Flowers* in 1996. He has had an amazing 32 solo exhibitions ranging from Panama to Chicago, New York, San Francisco and London, including 4 in aid of the Royal Commonwealth Society for the Blind.

SAITO, Manabu (born Tokyo, Japan 1929–2018) 3

Although Manabu Saito was born in Japan, he spent most of his life in the US, becoming an American citizen in 1968. Near the end of his life he lived in Tucson where he painted the Sonoran Desert Flora, mostly cacti. However, I met him when he was living in Stillwater, New Jersey. He was very prolific, illustrating many books and plates for *Audubon* and *National Geographic* magazines. He went to school in Tokyo and studied English literature at St Paul's University there. Between 1953 and 1957 he took a degree in industrial design at the Pratt Institute, Brooklyn, New York where he was awarded two scholarships, one by the Pratt Institute Art School and the other by General Motors. For 10 years he worked as an industrial designer in New York, then became a freelance botanical artist in 1971. His work on book titles is impressive and includes all 127 plates showing 1563 species for *Wildflowers of North America* by Frank D. Venning (1984). In 1989 he did the cover and 27 plates for *How to Know Wildflowers* by Mrs William Starr Dana, a book originally published in 1893, a project which gave him particular pleasure. His first solo exhibition was in 1968 and had an annual show at the Zyt Gallery, Los Altos, California ever since 1980. He exhibited in the Hunt Institute 4th International Exhibition (1977). Saito also visited Zimbabwe for the Malilangwe Conservation Trust to record some of the local flora. He did a certain amount of teaching, at annual workshops at Brooklyn Botanic Gardens, New York, instructing on watercolour techniques. He was introduced to me by Elizabeth Scholtz, a former director of the gardens who was a great enthusiast of Saito's work.

SANDERS, Lizzie (born London, England 1950) 6

Lizzie Sanders has been producing botanical paintings for some 25 years. Her work is botanically accurate, painted meticulously in watercolour, using a dry brush technique. She aims to produce contemporary 'graphic' images where neither art nor science is compromised and is particularly interested in the tension created by presenting an image which reads as truly 3-dimensional against a stark, flat, white background. Lizzie is fortunate to live close to the Royal Botanic Garden, Edinburgh (RBGE) where she obtains many of her specimens. Her favourites are always bold, structural plants which make a grand statement and lead to careful, sometimes unconventional, composition. She tutors the diploma course in botanical illustration there, as well as teaching master classes in the UK and the US. She has exhibited work at the RHS show in London 3 times and on each occasion was awarded a gold medal; in 2000 for a series of plant portraits entitled Rare and Endangered Species from Socotra, in 2002 for 8 paintings of climbing plants from the glasshouses at RBGE, and in 2004 for 8 portraits of *Vanilla imperialis*. *Passiflora helleri*, from the Climbing Plants series was purchased in 2002 by the Hunt Institute. The RHS Lindley Library purchased one piece from the *Vanilla imperialis* show. In 2004 Lizzie was honoured by the ASBA who awarded her the Diane Bouchier Award for Excellence. Two paintings, *Acer palmatum* 'Hessei' and *Rhododendron basilicum* have been accepted for inclusion in the Highgrove Florilegium. In 2006 she was awarded the Mary Mendum Medal by the Royal Caledonian Horticultural Society. In 2007 Lizzie won a judges' Award of Excellence at *Blossom – the Art of Flowers*, a competitive exhibition sponsored by the Susan K. Black Foundation in Houston, Texas. She was awarded Best on Show at the Horticultural Society of New York annual exhibition in 2003, 2011 and again in 2016. Her work has appeared in many of my books and exhibitions and I acquired 3 of her *Vanilla imperialis* series in 2009.

SANDERS, Rosie (born Stoke Poges, Buckinghamshire, England 1944) 12

Rosie Sanders was known initially for her superlative studies of fruit, apples in particular. She lives in Devon, in cider country, and has devoted much of her time to painting old varieties, culminating in her book *The English Apple* (1988). I bought two apple paintings from her in 1992 which have been widely exhibited since. She went to High Wycombe College of Art and became a freelance botanical artist in 1974. She has received 5 RHS gold medals and the Royal Academy Miniature Award (1985). Her work has been exhibited in Britain, and in the Hunt Institute 7th International Exhibition (1992). Her commissions include paintings for HM Queen Elizabeth II, HM the Queen Mother, the RHS, the Royal National Rose Society and the design for a set of wild plant stamps for Barbados. She is not only interested in plant studies but has been involved in a number of crafts, particularly print making. She was made a member of the Devon Guild of Craftsmen in 1997 and in the same year was involved in the compilation of *A Printmakers Flora*. In 1999 I bought a study of a striking string of garlic which she said she could not resist painting when she hung it in her kitchen. Since then she has changed her subject matter and the way she paints dramatically. In 2004 she had an extraordinary innovative show at Jonathan Cooper's Park Walk Gallery of huge carnivorous plants, vastly magnified yet still in watercolour. Her spectacular *Sarracenia* hybrid is at the extreme edge of botanical art, as is the remarkable, huge study of *Arisaema*. Her enlarged, flowing paintings of roses and orchids have become immensely popular and successful, she is a most inventive and distinctive artist.

SATO, Hiroki (born in Marugame, Kagawa Prefecture, Japan (1925–1998) 1

Hiroko Sato graduated from Kagawa Prefectural Art College of Architecture. He moved to Tokyo in 1950 as an illustrator for numerous encyclopaedias, newspapers, magazines, and certified textbooks. He was a founding member of the Japan Botanical Arts Association (1970), which hosts exhibitions every year in Tokyo. In 1986 he became the chief professor of the Plant Painting Course, a correspondence course hosted by the Japan Horticultural Society. He has taught many botanical art courses throughout Japan. In 1994 he received the International Arts and Culture Award from the Japan Society for the Promotion of Culture for contributing to the establishment, improvement and development of botanical art. I met him briefly just before he died and he gave me some copies of his beautifully drawn calendars.

SAUL, Margaret (born Brisbane, Australia 1951) **5**
Margaret Saul was born into a family of artists with a keen interest in the Australian native plants that grew around their home in Brisbane, Australia. She had 4 years of traditional art school education followed by staff positions as a natural science illustrator at various institutions in Australia. She produced artwork for numerous botanical publications as the Queensland Herbarium's first staff illustrator. During a stay in the US (2000–2007) she was instrumental in establishing the Brookside Gardens School of Botanical Art and Illustration, Maryland which attracts students from Washington DC and surrounding states. She developed the school's policy and the curriculum for a certificate programme based on criteria that she views as essential for botanical art and which has been adopted by the ASBA in their guidelines for jurors. In 2007 Margaret Saul moved to live in Italy. She continued to direct her school in Maryland until 2015 and extended the school's programme to Siena. She has been painting since 1976 and is represented internationally in numerous public and private collections including the Hunt Institute, where 2 of her paintings were exhibited in their 12th International Exhibition (2007). Her botanical portraits are published in 3 books that specifically document botanical art. Her favoured media are watercolour with dry-colour pencils. She initiated the establishment of the ever-growing Botanical Artists' Society of Queensland (2004), and the Botanical Art Society of the National Capital Region, US. She has been a member of the Guild of Natural Science Illustrators since 1968, is an ASBA member and has honorary life membership of the Botanical Art Society of Australia.

SCHWEIZER, Ann (born Cape Town, South Africa 1930–2014) **20**
Ann Schweizer enjoyed a wide range of academic interests. Her first degree was in art and languages from Rhodes University, Grahamstown and she studied fine art under Maurice van Essche. Later she took another degree in archaeology at the University of Cape Town followed by further courses in botany and geography. She became a scene painter at the Hofmeyr Theatre, Cape Town for a year and then was resident artist at the South African Museum. From 1963 she went freelance, undertaking botanical painting, archaeological and ethnological drawing, book illustration and posters, designs for silk-screen printing and, perhaps most unusual of all, drawing a cartoon strip travels of William Burchell for the Botanical Society of South Africa. She exhibited at the Everard Read Gallery, Johannesburg and in several others near Cape Town, mostly showing botanical subjects. She caused a sensation in the first Kirstenbosch Biennale Exhibition when she presented a dramatic branch of figs and a spectacular *Strelitzia*. She completed a remarkable series of bamboo studies in 2003 which now hang in the Bamboo Room in Westcliff Hotel, Johannesburg and she painted fruit with a sure touch and flowing use of watercolour.

SELLARS, Pandora (born Herefordshire, England 1936–2017) **12**
Trained initially as a designer, Pandora Sellars then studied at the Cheltenham School of Art and Manchester College of Art. She became a teacher and freelance botanical artist, exhibiting widely in Britain and abroad from 1972. Her work has been much reproduced and the RHS awarded her a gold medal (1977). She had a successful solo exhibition at Kew in 1990. Pandora Sellars completed a number of studies of *Arum* species and it became one of her favourite genera while she illustrated the monograph, *The Genus Arum* by P. Boyce (1993). She received the Jill Smythies Award from the Linnean Society (1999). Wedgwood selected her painting of the Gloriosa Lily for a ceramic plate celebrating the Shirley Sherwood Collection. I am not alone in considering Pandora Sellars one of the most important botanical artists of all time. It goes without saying that her work is scientifically accurate, but here is an artist who has transcended the pedantic plant study to paint true works of art. Hers is a subtle approach, restrained and yet surprising. Her paintings have an immediately recognisable stamp to them and probably her leaves are among the most beautiful yet accurate that have ever been painted. There was a most impressive retrospective exhibition of her works in the SSG in 2018 which attracted many artists to view her extraordinary work.

SHEPHERD, Jess (born Chichester, England 1984) **4**
Jess Rosemary Shepherd is a botanical artist, painter, publisher and botanist who practises under the alias of Inky Leaves. In 2014, she featured on the BBC4 documentary *In Search of Rory McEwen* where she demonstrated how to paint on vellum. In 2017, she held her first solo exhibition in London, published her first book, *Leafscape* and produced the *Leafscape* soundtrack in collaboration with Derek Thompson. She also set up Inky Leaves Publishing. In 2018, she launched a cross disciplinary botanical art publication called *INK Quarterly* and the Inky Leaves Podcasting channel which, via a series of talks and interviews, discusses and promotes botanical art. I first met her in the early days of the SSG when she was starting out on her botanical odyssey.

SHERLOCK, Siriol (born, Nantwich, England 1954) **8**
Siriol Sherlock studied textile design, specialising in printed furnishing designs before establishing her name as a botanical artist in the 1980s. She began exhibiting in 1986 and has continued ever since. She has shown with the Society of Botanical Artists annually since 1988 and had a solo show at Kew in 1992. She has painted detailed botanical studies for *Curtis's Botanical Magazine* and *The New Plantsman* and undertaken numerous other commissions. She was a member of the RHS Picture Committee for 8 years until 2006. I have known Siriol Sherlock since I first started collecting botanical art in 1990 and she has taught several of the master classes in Orient-Express Hotels initiated when I started exhibiting my collection around the world. I have a number of her beautiful, free watercolours, impressive for their design, translucent colour and fresh, crisp detail. She is renowned for the fluidity of her watercolours, going straight in with a brush and no pencil. She put her teaching experience to good use by producing a book *Exploring Flowers in Watercolour*. An excellent book for beginners and also experienced artists, it won the Art Instruction Book of the Year award in 1998.

SHOWELL, Billy (born Carshalton, England 1966) **1**
Billy Showell is a botanical artist based in Kent who originally trained in fashion design at St Martins School of Art. She is known for her fluid compositions and is the recipient of a number of awards from the RHS, SBA and a gold medal from the Royal Caledonian Horticultural Society. Billy's work is held at Kew, the Hunt Institute and in private collections. She is also a well-known teacher, across the UK and worldwide; she has produced 4 bestselling painting books and runs an online tutorial

website. Billy is the current President of the SBA. 'At the heart of my work is the love of plants, the love of watercolour and the desire to bring as many people to this art form as I possibly can ...over the 23 years I have been painting and teaching I have introduced this love to huge numbers of budding students, sharing what I do is my passion and loving what you do is my mantra. Botany brings enlightenment and painting helps spread the word.'

SIEGERMAN, Sheila (born Kamloops, BC, Canada 1931) 2
A women of many parts, Sheila Siegerman has been a musician, jewellery and theatre set designer and self-taught botanical artist. I first saw her botanical work at the Hunt Institute's 7th International Exhibition (1992), where she showed a blockbuster orchid, fleshy, voluptuous and slightly vulgar with its red-rimmed yellow flowers displayed with vigorous roots and strong leathery leaves. Its impact stayed with me and I eventually bought a second version of the same plant when I met her at the RHS the next year. She was awarded a gold medal for a strong series of 8 orchids, all grown in her own home and painted with great confidence.

SILANDER-HÖKERBERG, Annika (born Gothenberg, Sweden 1949) 1
Annika Silander-Hökerberg has only shown work at the RHS (where she was awarded a gold medal) and at the Hunt Institute's 8th International Exhibition (1995). Her paintings of tulips, lemons and irises demonstrate great confidence and quality of execution and design. She showed a wonderful painting of a euphorbia at the Hunt, which was greatly admired on the opening night with many fellow artists crowding round to look at it with their magnifying glasses. Her mastery of dry brush technique was honed at one of Kew's painting courses and she seems to catch the very essence of each subject she paints. She has a degree in political science and economics and, perhaps more relevantly, she studied graphic design at Konstfack, Stockholm.

SILBURN Laura (born Norfolk, England 1973) 3
Laura learned watercolour painting with Mally Francis at Heligan Gardens. She is a painter and tutor for the Eden Project Florilegium Society, near her home in Cornwall. She has received 3 RHS gold medals (2013, 2014 and 2018), Best Botanical Art Exhibit and Best Botanical Painting awards (2014, 2018). Laura has 7 paintings in the prestigious Transylvania Florilegium and work in the Hunt Institute, Royal Botanic Garden Sydney Florilegium, and RHS Lindley Library.

SINGH, Thakur Ganga, Rai Sahib (1895–1970) 1
Thakur Ganga Singh was made Rai Sahib for his contribution to the arts after about 30 years painting at Dehra Dun Forest Research Institute, India. During this time he and his colleague, P. N. Sharma, painted 188 watercolours and made many ink drawings which are still held there. In 1931 he was awarded a scholarship to the Slade in London. Ten years later Singh was commissioned by the Maharajah Yadhavindra Singh of Patiala to record the flowers of the Simla Hills for a book. This most beautiful part of the Himalayas has a spectacular flora and Singh completed over 400 watercolours. He died in 1970 and the Maharajah died 2 years later with his book unfinished, although the paintings were complete. Since then his son has taken on the task of preparing the work for publication.

STAGG, Pamela (born Nottingham, England 1949) 6
An RHS gold medal kick-started Pamela's painting career in 1991. Now living in Canada, she has taught a generation of Canadian botanical painters and illustrated magazines on both sides of the Atlantic. She illustrated *Roses: A Celebration*, edited by the late Wayne Winterrowd, and has designed a gold trillium coin for the Royal Canadian Mint. She has lectured internationally. Her work has been exhibited around the world and is held at the Hunt Institute.

STOCKTON, Peta (born South Africa 1973) 6
Having moved to London, Peta Stockton started painting full time in 2004 and went on that year to win a gold medal at the prestigious Kirstenbosch Biennale in Cape Town as well as being awarded a gold medal at the RHS. She had previously taken a foundation course in graphics at the Ruth Prowse School of Art and majored in English and history of art at the University of Cape Town. Growing up in Kirstenbosch Botanical Garden has heavily influenced her choice of subject; she remained firmly wedded to *Protea* even after moving to Vienna for several years where she could only paint dried specimens. She showed two *Protea* of great quality at the Hunt Institute in 2007. She became fascinated with the fearsome thorns of the acacia trees found in the African scrub and did several well-observed studies. Her detail is truly remarkable and her work rewards very close inspection.

STONES, Margaret (born Victoria, Australia 1920–2018) 2
Margaret Stones studied at the Swinburne and National Gallery Schools in Melbourne. During the Second World War she trained as a nurse, but contracted tuberculosis and in her convalescence took up painting the wildflowers which visitors brought to her bedside. She came to England in 1951 and her work soon came to the notice of botanists at the British Museum (Natural History) and Kew. In 1958 she became the chief artist of *Curtis's Botanical Magazine*. She also produced the paintings for important projects, such as the 250 plates for *The Endemic Flora of Tasmania* (1967–78), and lily paintings for the *Supplement to Elwes' Monograph of the Genus Lilium* (1934–40). In 1976 she started a project to paint some of the wildflowers of Louisiana for the bicentenary celebrations, this culminated in over 200 paintings published in *Flora of Louisiana* (1991), also exhibited that year at the Fitzwilliam Museum, Cambridge, in Edinburgh and Oxford. In many of these paintings, Margaret Stones drew the plant life-size and included details of flower or fruit, in the style of Ferdinand Bauer. Her work was always of the highest scientific standard, accurate and artistic, and she scrupulously annotated each painting with date and provenance of the specimen, and the magnification of any details. She retired to Australia and died in 2018.

STRICKLAND, Fiona (born Edinburgh, Scotland 1956) 2
World-renowned botanical artist Fiona Strickland's signature approach to botanical watercolour demonstrates a passion for intense colour and extraordinary attention to detail. A post-graduate of Edinburgh College of Art, she studied with Dame Elizabeth Blackadder. She is a recipient of an RHS gold medal, an ASBA Best in Show and multiple awards from the SBA. She has paintings in the collections of the RHS Lindley Library and the Hunt Institute. Represented by the Jonathan Cooper Gallery, London. I acquired her first botanical painting of sweet corn, seen at an SBA show in 2008 and another of an interesting rhododendron in 2016.

SUH, Jee-Yeun (born Seoul, Republic of Korea 1981) 1
Jee-Yeun Suh holds a BA from Chung-Ang University and earned the Koo, Jee-Yeon's botanical art and illustration certificate. She has worked as a botanical illustrator in the National Project of the Korea National Arboretum (KNA) since 2006. She won the Minister of Environment's award in the first Korean Wild Natural History Scientific Art & Illustration Competition of the National Institute of Biological Resources (2006), the Minister of Agriculture's prize in the 2017 *Flora of Korea* exhibition and the prize awarded by the Director General of KNA. Her work is in collection at the KNA, National Institute of Biological Resources, Korea and she has illustrations in many publications. Jee-Yeun has exhibited annually since 2007 and is a member of the Korean Society of Botanical Illustrators. She showed a spectacular *Euryale ferox*, (prickly water lily) in the Worldwide 2018 *Flora of Korea*, which I acquired for the SSC.

SURLO, Gustavo (born Itamaraju, Brazil 1996) 5
Gustavo Surlo took drawing classes from the age of 6, with Samuel Ribeiro as a teacher. In 2017 he graduated in biology from the University of Bahia and in 2018 was chosen as the student for the Margaret Mee artist scholarship at Kew. His first international award came at the age of 18, at the Latin American Congress of Botany, portraying an endangered orchid. The main objective of his work is to alert the need for preservation of the species he portrays. His painting is immaculate and he is very confident with white subjects.

TAKANO, Kumiko (born Changchun, China 1945) 1
Kumiko Takano was educated as a graphic designer and has worked in advertising and fashion in Japan. She became a freelance botanical artist in 2008, taught by Masako Sasaki. She was awarded a gold medal by the RHS in 2015 and her work was shown in *Flora Japonica* (2017) in the SSG.

TANGERINI, Alice (born Takoma Park, Maryland, US 1949) 2
Alice R. Tangerini began her career as a freelance contract illustrator for Dr Lyman Smith in the department of botany at the National Museum of Natural History, in 1969 while attending Montgomery Junior College in Rockville, Maryland. She continued her education at Virginia Commonwealth University, Richmond, Virginia, where she received a BFA (1972). Since graduating, she has been the staff illustrator for the Department of Botany at NMNH. In this capacity, she has illustrated at least 1,500 species of plants that have appeared in almost 50 scientific periodicals, a dozen or more floras, and several books. She has illustrated many species of grasses, especially bamboos, and composites; two families of plants whose diagnostic characters are difficult to visualise without the aid of technical illustrations. Typically, she works from pressed and dried herbarium specimens using pen and ink or graphite. Field assignments have taken her to California, Hawaii, and Guyana where she was able to draw from living material. Her responsibilities also include managing and curating an extensive collection of botanical illustrations. In addition to departmental obligations, Alice has shared her knowledge of botanical illustration with other organisations and conducted classes in botanical and natural history illustration.

TAZZA, Aurora (born Italy 1956) 1
Aurora Tazza gained a degree in architecture from the University of Rome La Sapienza in 1986 and specialised in botanical illustration at the Botanical Garden in Rome (1992–1995). From 2000 she became a botanical painting instructor in Rome. I acquired a lovely study of a bunch of grapes from her in 2004 and have seen her work in many Italian exhibitions.

TCHEREPNINE, Jessica (born London, England 1938–2018) 4
Jessica Tcherepnine lived and worked in New York although she visited England regularly and showed in London. She described herself as having 'no relevant education and no career' but she did start painting flowers from her family's garden in Sussex at an early age. Later, she studied drawing in Florence and learned that important facet of botanical art – intense observation. She had many solo exhibitions regularly from the early 1980s onwards, in London, New York, Paris and Palm Beach, Florida. One was at Harris Lindsay, London (2005) where I acquired her strong painting of a coconut. The RHS has twice awarded her gold medals. I first met her when I bought her *Fritillaria imperialis* from Shepherd's Gallery in New York in 1991. I had noticed a large banner floating from the gallery showing a vastly magnified drawing of the crown imperial fritillary. I saw the original painting which had been used as a poster for the New York Flower Show. Her work is held at the Hunt Institute, the Natural History Museum, London, RHS Lindley Library and the Benois Family Museum, St Petersburg, as well as in private hands. She contributed to the Highgrove Florilegium as well as being a founding member of the Brooklyn Florilegium Society. She was also a founding member of the ASBA and a director of the Horticultural Society of New York. She was a strong and consistently good painter, producing many excellent works over a long period and became a good friend.

THOMAS, Vicki (born South Africa 1951) 13
Vicki Thomas is an energetic botanical artist and teacher who lives in Betty's Bay in the Cape, South Africa. Her artwork is in collections around the world, including the Highgrove Florilegium, and has been exhibited in prestigious exhibitions in South Africa, Japan, the UK, and US. Her painting of *Brunsvigia orientalis* was on display in the Hunt Institute's 12th International Exhibition. A book *The Southern African Plectranthus and the Art of Turning Shade to Glade* (2007) contains over 60 of her exquisite paintings of *Plectranthus*. The Botanical Society of South Africa's calendar 2007 featured her paintings of indigenous flowers. She has worked on illustrations for a monograph on *Lobostemon* and has had scientific illustrations published in many botanical journals and in two books dedicated to botanical illustrat ion. She has gold and silver medals from Kirstenbosch Biennale Exhibitions. I was having lunch with her in Cape Town when she was called away to a bad fire in Betty's Bay. She raced home to find her house safe, and then drove on to the site of one of the Cape plants she was painting for me; she was waiting to complete the work with a ripe fruit capsule which was endangered by the fire. Vicki teaches a course in scientific illustration to Stellenbosch University students and has taught botanical illustration through the University of Cape Town's extra mural studies for several years. She regularly holds courses around South Africa. She is a founding member of the Botanical Artists' Association of Southern Africa and a past chairperson.

TOYOTA, Michiko (born Tokyo, Japan 1952) 2
Having started as a kimono designer in Yuzen, Michiko Toyota now works as a freelance botanical artist and instructor in painting at the Botanic Gardens of Toyama. She was given her

first art lessons by her artist grandfather. She studied botanical art under Yoshio Futakuchi and Yoai Ohta. She has won a variety of awards including the Superiority Prize at the International Orchid Festival, Tokyo, 1994. Since 1983 she has exhibited in galleries and botanical gardens from Tokyo to Nagoya, Mito, Yokohama and the Hunt Institute (1988). Her work has been used for posters and to illustrate several books and pamphlets. Fascinated by wild plants indigenous to Japan, Michiko closely observes their form and captures it on paper. Her unusual study of oak tree seedlings shows every stage of germination and has a big visual impact.

TRICKEY, Julia (born Birmingham, England 1964) 1
Julia has been painting botanical watercolours since 1998 when she joined an adult education class in South London. She now tutors classes in Bath and as far afield as Boston, New York and Moscow. Julia exhibits internationally, has work in collections worldwide and has received numerous awards for her paintings including 4 RHS gold medals. She has written books and produced other resources for students of botanical art. She has a particular fascination for botanical specimens that are less than perfect such as autumnal leaves, fading flowers and seed heads, often depicting them larger than life. In 2014 Julia's illustrations appeared on 16 Royal Mail Post and Go British Flora stamps. Her work has been selected for the Transylvania Florilegium, presently being created under the umbrella of the Prince of Wales's Foundation Romania, to record the flora of this region. She wrote and illustrated *Botanical Artistry: Plants, projects and processes* published by Two Rivers Press in 2019. It contains many interesting facets of botanical art and the pictures are excellent.

UCHIJO, Yoko (born Tokyo, Japan 1949) 3
Yoko Uchijo is a good botanical painter although she has had no formal education in this field. Immediately after leaving school she was employed by a company that produced animated films, but she has also worked at the Asahi Cultural Centre for Botanical Art, Tama, Tokyo. Currently she teaches botanical art at the Asahi Culture Center in Yokohama. She is a member of the prestigious Japanese Botanical Art Association and exhibits regularly in Japan. She has received several gold medals from the RHS for her paintings. She exhibited in the Hunt Institute's 7th International exhibition (1992) and I saw more of her work when I met her in Tokyo in 1994. Yoko Uchijo uses pencil to define her watercolour and places her images very well on the paper. She has illustrated a number of books for children. The Japan Plant Club published her *Illustrated Works of Yoko Uchijo: A Florilegium* in 2013. Since 1980, she has been interested in the suburban woodlands to the west of Tokyo, where she has been managing a grove of coppiced trees.

VAN DE GRAAFF, Bronwyn (born Sydney, Australia 1964) 2
Now living in Avoca Beach, New South Wales, Bronwyn practised as a criminal lawyer before becoming a full-time painter in 2012. In 2018 she spent the winter in Falls Creek, Victoria, drawing and painting snowgums. For many years she has painted botanical and natural history subjects from life. These are highly observed and detailed and aim to have a richness of depth, colour and luminosity created by applying many thin layers of glazing. They take many months to complete. She is currently exploring the natural world by painting feathers and bird wings found as roadkill. She also specialises in still-life oil paintings inspired by the Dutch Renaissance and highly detailed paintings and drawings of flora, fauna, in particular feathers, cacti and sea creatures. She is also painting the theme of the Garden of Eden with richly coloured oils and including exotic plants, birds, and still life with tropical fruits. Bronwyn was awarded a gold medal by the RHS in 2004.

VIAZMENSKY, Alexander (born Leningrad now St Petersburg, Russia 1946) 15
Alexander Viazmensky paints both fungi and landscapes. Each summer he ventures deep into the woods near St Petersburg for his specimens, visiting secret spots for his trophies. His fungi paintings were one of the great successes of the Tryon & Swann International Exhibition (1998) and the Denver Art Museum (2002). Since 1997 his style has become more detailed and clearly outlined, although he retains his customary clutter of leaves, pine needles and strands of grass. His work is held at the RHS Lindley Library. He produces excellent prints that can be seen in the Grand Hotel Europe, St Petersburg and has illustrations in the *Red Data Book of Nature of St Petersburg*. He had a solo show as part of the XV Congress of European Mycologists (2007). He has taught at the Minnesota School of Botanical Art, and now occasionally teaches master classes and leads fungi forays in the US, marshalling enthusiastic groups of fans.

VILLELA, Patricia Arroxellas (born Rio de Janeiro, Brazil 1952) 34
Patricia Arroxellas Villela trained at the School of Visual Arts, Rio in the 1970s and in the early 1990s at the Rio de Janeiro Botanical Institute. Later she was taught by Malena Barretto, Christabel King, Etienne Demonte and Jenevora Searight. She also attended a workshop by Katie Lee in Tuscon, Arizona. She has been awarded a number of prizes including first place in the Margaret Mee Foundation's Annual Contest (1996), the Brazilian Bromeliad Society (1997) and the Mexican Biological Institute (1998). She has shown at the Hunt Institute, also in Mexico and extensively in Rio. Her work is strong yet subtle. She has a good sense of design and obviously enjoys painting the exotic plants of Brazil. In 2017 she was invited to participate in a programme to teach the art of botanical illustration to Brazilian people of different ethnicities on the border of the Amazon Forest. Most paintings created were of local fruits and plants, using their own tools. The classes were an extraordinary opportunity to appreciate indigenous and scientific knowledge. She is currently illustrating two different books: *Leaf types* (Personal Collection, Brazil) and the *Rio de Janeiro Botanical Garden Seeds Collection*. She is a most impressive artist.

VIRDIS, Marina (born Cagliari, Sardinia, Italy 1950) 1
Marina Virdis grew up in Sardinia gaining a first degree in ceramics at the local School of Art (1967). She continued her studies in Rome at the Fine Arts Academy where she obtained a degree in art while also working freelance as a graphic designer in advertising. She has played many roles in the field of communications; as owner of a graphic design and advertising company, a public relations adviser, and a journalist contributing articles to different papers, among them the *Il Corriere della Sera*. She has also been involved in the women's movement in Italy. In 1989 she changed her lifestyle and went to live in Scotland for 2 years as a member of the Findhorn Foundation, an international spiritual community where she began to work on art and nature themes. Since then Marina has committed herself to botanical painting. She has had many solo exhibitions in Italy, showing two groups of paintings, the first described as

The Rose Garden, where the subjects were old roses. The second, *Gaia's Flowers*, were watercolours of wildflowers from the Sinis peninsula, near Oristano in Sardinia. Her exhibitions have been supported by FAI, an Italian organisation akin to the National Trust, the Great Italian Gardens Society and similar organisations. In 1999 she was awarded the first prize at the spring exhibition at Landriana, a beautiful garden near Rome, designed by Russell Page for Marchese Lavinia Taverna. She was awarded a silver gilt medal at her first showing at the RHS the same year. I saw her work at the RHS and acquired her *Erythrina crista-galli*. Also called the coral tree, it comes from South America, but she painted it in Sardinia where it grows very well. One of her other pictures was awarded an RHS gold medal and later bought for the RHS Lindley.

WARD–HILHORST, Ellaphie (born Pretoria, South Africa 1920–1994) 3
Ellaphie Ward-Hilhorst must certainly be placed among South Africa's greatest botanical artists and her work was recognised much further afield. She began her career as a botanical artist in 1973. She had always loved pelargoniums and decided to paint all the known species. She collaborated with botanists at Kirstenbosch, producing the illustrations for 3 remarkable volumes on the pelargonium, involving 314 watercolours and 160 habit sketches. Ellaphie Ward-Hilhorst was involved with many other distinguished publications, including the journal *Flowering Plants of Africa*. The book *Gasterias of South Africa* was published just after her death. She had a prodigious output; 800 plant portraits, mostly in watercolour, during her 24 years as an active botanical artist. She produced some larger plant portraits for commissions and showed at the Hunt Institute, the Everard Read Gallery, Johannesburg and in Art meets Science, a South African touring exhibition. She was awarded the Botanical Society of South Africa's Cythna Letty Gold Medal and an RHS gold medal for her *Haemanthus* paintings. Her accuracy with pelargoniums was such that one researcher told me she need not measure a living specimen; she could get all the information she required from Ellaphie's meticulously accurate and yet beautiful plates. Her work can be compared in quality with succulents painted by Ferdinand Bauer for the *Flora Graeca* (1786).

WATANABE, Noriko (born Hiroshima, Japan 1954) 1
Noriko Watanabe completed her BA at the Osaka University of Arts and worked as a kimono pattern designer in Kyoto. She began tuition in botanical art in 2001 at the University of Toronto. She was awarded an RHS gold medal in 2006. Noriko's work is found in the collections of the RHS Lindley Library, the Hunt Institute, and the Royal Botanic Garden Sydney Florilegium.

WICKISON, Sue (born Sierra Leone, West Africa 1958) 2
Sue Wickison worked as a botanical illustrator at Kew for a 9 years, recording different families of plants for publications, namely grasses, orchids and legumes. While there she was awarded a Winston Churchill Fellowship to travel to the Solomon Islands to collect and illustrate orchids. She had a solo show New Zealand House, London in 2006 and another solo show at the Savill Gardens, Windsor in 2007. She was awarded an RHS gold medal in 2008 and the New Zealand Plant Conservation Network commissioned a painting of the extinct Adam's Mistletoe *Trilepedia adamsii*. She has illustrated books for the Agricultural and Forestry departments in the Solomon Islands, Nepal and Vanuatu and designed over 50 natural history stamps for 7 countries. She drew 8 black and white plates of *Brachyscome* seeds for the *Flora of Australia*. Being born and brought up in Sierra Leone, West Africa, her passion for plants was nurtured by her father, an amateur botanist and artist who used to take her on expeditions locating, identifying and collecting botanical specimens. She has never lost the joy of plants and the excitement and satisfaction they bring to her work. She now lives in New Zealand.

WOODIN, Carol (born Salamanca, New York, US 1956) 6
In recent years Carol Woodin has become one of the most outstanding of the botanical artists working in the US. She became a full-time botanical artist in 1990 and has spent 30 years investigating colour, painting plants in watercolour on vellum. Her work has been exhibited and collected around the world; recent show venues include the SSG at Kew, Museo della Grafica, Pisa, Italy, Museum de Buitenplaats, Eelde, Netherlands, and Newhouse Galleries in New York. It is held at the Hunt Institute, Kew and the Niagara Parks Commission, Canada as well as in many private collections. Among the awards she has received are an RHS gold medal, the ASBA Diane Bouchier Founder's Award, and the Orchid Digest Medal of Honor. She has concentrated on orchids, working on vellum, a surface on which she achieves an astonishing translucency. I saw a painting of *Disa* and asked her to do the same subject for me. *Disa uniflora* is a dramatic orchid which lives under waterfalls on the Cape in South Africa. She made several trips to South America to prepare plates for the monograph *Slipper Orchids of the Tropical Americas* by Phillip Cribb and went to Peru to paint *Phragmipedium kovachii*. She has led two fascinated groups of painters to Machu Picchu to see the local orchids for botanical painting classes organised by me. She is the ASBA's Director of Exhibitions and masterminded the remarkable Botanical Art Worldwide day in 2018, coordinating paintings of native plants from 25 countries.

YAMADA, Michie (born Hiroshima, Japan 1965) 1
Michie Yamada is resident in Yokohama, Kanagawa prefecture. She has been interested in painting since she was a child. As an adult she has continued to study botanical art, which has included taking in Mieko Ishikawa's classes since 2013. She has provided paintings to a calendar company and a gardening magazine in Japan. She has taught botanical art in several classes, mainly in Tokyo and Kanagawa since 2007. She has held a solo exhibition in Tokyo every year since 2008 and has participated in several group exhibitions. She was awarded an RHS gold medal and Best Botanical Art Exhibit (2018) with works of wild roses in Japan.

ZAGONEL, M. Fatima (born Canoinhas, Brazil 1954) 5
Fatima Zagonel lives and works in Curitiba, Paraná in south Brazil, having graduated from the Pontificia Universidade Catolica do Paraná in 1976. She attended courses in art, design and watercolour in the late 1970s. In 1993 she gained a postgraduate degree in publicity and advertising. While working as a graphic designer she became interested in botanical illustration and in 1998 studied at Curitiba with Diana Carneiro, exhibiting in the same year in Mexico as part of a presentation by the Curitiba Botanical Gardens. In May 1999 she

was awarded a Margaret Mee Fellowship to study with Christabel King at Kew; this was followed by a small exhibition at Kew of the work she had completed there. She has had illustrations published in *Foresta Atlantica – Reserva da Biosphera* and *Arvores Historicas na Paisagem de Curitiba* and also in a calendar of plants from the Paraná. Her work is held in major collections including Kew, the Hunt Institute and the New York State Museum. She is a founder member of the Center of Botanical Illustration of Paraná.

ZHANG, Tai-Li (born Jin Zhou, China 1938) 4
Tai-Li Zhang has worked as a botanical painter all her life, training at the School of Botanical Painting, Institute of Botany, Academia Sinica, Beijing from 1958 to 1960 and then working for 35 years for the department of plant taxonomy in the Institute of Botany. Her work is in several publications that have won prizes. I met her in Bejing in 1994 and acquired 4 strong paintings for the SSC. I thought her work was outstanding.

Artists in the Shirley Sherwood Collection

The number following each artist's name denotes the total number of works by the artist held in the SSC. Names in *italic* denote artists featured in this book.

Allen, Beverly 6
Allen, Martin J 1
Allevato, Sergio 3
Amies, Katharine 1
Anderson, Fay 3
Anderson, Francesca 13
Andrews, Laurie 2
Angell, Bobbi 2
Ballard, Fay 1
Barlow, Gillian 7
Barlow, Jeni 1
Barretto, Malena 4
Bartholomew, Isobel 2
Batten, Helen J. 2
Bauer, Franz Andreas 5
Bean, Deirdre 1
Beckett, June 1
Berge, Leslie Carol 8
Berni, Stephanie 2
Besler, Basilius 1
Binns, Evelyn 2
Blackadder, Elizabeth 1
Blamey, Marjorie 3
Blaxill, Susannah 13
Blincoe, Anna 2
Blossfeldt, Karl 1
Booth, Raymond 4
Braithwaite, Victoria 2

Brasier, Jenny 6
Briggs, Norah 1
Brown, Andrew 3
Buytaert, Jean-Claude 1
Cameron, Elizabeth 2
Candido, Alessandro 1
Carroll, Richard 2
Cassels, Jean 1
Castillo, Juan Luis 3
Chakkaphak, Phansakdi 44
Chalmers, Olivia 1
Chambers, Anne M. 2
Chiliza, Sibonelo 1
Christopher-Coulson, Susan 2
Cody, John 2
Condy, Gillian 5
Coombs, Jill 1
Cooney, Roy J. L. 1
Cooper, Alison 1
Cordova, Emmanuel L. 2
Cox, Vicky 2
Cunha, Miguel 1
Dale, Patricia 1
Daniel, Brigitte E. M. 2
Davern, Moya 1
de Bassi, Carolina 4
de Chair, Patricia 1
de Jonquieres, Annette 2

de Meester, Angeline 2
de Rezende, Maria Alice 6
de Souza, Nunes Anelise 1
de Villiers, Margaret 4
de Vries, Gohlke Monika 9
de Wet, Lynda 2
Dean, Pauline 4
Dein, Rachel 3
Delvo, Pierino 2
Demonte, André 2
Demonte, Etienne 3
Demonte, Ludmyla 1
Demonte, Rodrigo 1
Demonte, Rosália 2
Demonte, Yvonne 1
Demus, Jakob 3
Dietzsch, Barbara Regina 1
Dietzsch, Johann Christoph 2
Dowden, Anne Ophelia 3
Dowle, Elisabeth 7
Duckworth, Barbara 1
Eden, Margaret Ann 2
Edwards, Brigid 15
Edwards, Yvonne 1
Eloff-Layden, Wilna 5
Emmons, Jean 4
Esparza, Elvia 2
Farr, Margaret 2

Farrer, Annie 15
Feng, Jinyong 5
Finnan, Ingrid 3
Fomicheva, Dasha 2
Francis, Linda 6
Francis, Mally 1
Fraser, Ann 1
Fraser, Liz 28
Funk, Linda 1
Futakuchi, Yoshio 1
Gentilini, Jeanitto 1
Gradidge, Daphne 3
Graham, Sarah 2
Greenwood, Lawrence 2
Grierson, Mary 6
Griffiths, Gillian 1
Grunwaldt, Noel 1
Guest, Coral 20
Güner, Işık 1
Gurjar, Damodar 1
Hagedorn, Regine 13
Hague, Josephine 7
Hamilton, Gertrude 1
Hammond, Yvonne G. 4
Hand, Wayne D. 1
Hart-Davies, Christina 3
Hayden, Toni 2
Haywood, Helen 4

Hegedüs, Celia 5
Herbert, Sue 3
Hickman, Ellen 1
Hinton, Betty 1
Hishiki, Asuka 1
Hislop, Helga 3
Holgate, Jeanne 1
Hoola van Nooten, Berthe 1
Horikoshi, Hideo 2
Hornby, Nicole 1
Hove, Waiwai 2
Hughes, Annie 2
Hyde-Johnson, Jenny 3
Ikeda, Mariko 1
Ikeda, Zuigetsu 1
Imai, Mariko 12
Irani, J. P. 2
ISBA Portfolio 1 portfolio
Ishikawa, Mieko 7
Isogai, Noboru 1
Ivanchenko, Yuri 1
Jeppe, Barbara 3
John, Rebecca 4
Jones, Marilyn 1
Jones, Paul 17
Joubert, Elbe 1
Jowett, Jenny 1
Kakuta, Yoko 2
Kamiti, Andrew 1
Keir, Sally 1
Kemp, Martha 2
Kessler, Patricia 1
Kijima, Seiko 2
Kincheloe, Sharron M. 1
King, Christabel 4
King Tam, Geraldine 2
Knox, Charlotte 1
Kodaka, Yasuko 1
Kojima, Mariko 2
Kunz Veit, Martin 2
Kuwajima, Asako 1
Lambkin, Deborah 1
Lane-Fox, Flappy 2
Langhorne, Joanna 2
Lawniczak, Diana 5
Lee, Katie 9
Lima e Silva, Isabel 2
Lincoln, Thalia 1
Liška, Petr 5

Lloyd, Elizabeth,Jane 1
Lober, Angela 1
Mackay, David 2
Makrushenko, Olga 5
Manisco, Katherine 7
Mannes-Abbott, Sheila 1
Marigo, Gustavo 2
Maruyama, Kimiyo 3
Mason, Anna 2
Mathews, Alister 2
Matyas, John M. 1
Maury, Anne Eldredge 1
McElwain, Dianne 1
McEwen, Rory 10
McGann, Joan 1
McNeill, Robert 1
Mee, Margaret 15
Megarrity, Lindsay 2
Mirro, Angela 1
Mishima, Mitsuharu 1
Miwa, Kazuko 1
Moir, Mali 1
Moraes, Renato 2
Morato, Parecis 2
Morley, Carol Ann 1
Murakami, Yasuko 1
Nessler, Kate 14
Nettleton, Julie 1
Nicholson, Catharine 5
Nunes, Álvaro Evando Xavier 35
O'Connor, Anne 2
Ogilvy, Susan 8
Okakura, Miyoko 1
Olson, George 3
Oozeerally, Barbara 8
Palermo, Luca 1
Pangella, Ronaldo 1
Parker, Hillary 1
Pedder-Smith, Rachel 3
Peter, Sylvia 1
Petrie, Anne 2
Petrini, Angela 2
Pestell, Jacqueline 1
Petters, Yanny 3
Pharaoh, Jenny 2
Phillip, Beth 1
Phillips, Jenny 9
Pickles, Kathy 2

Pike, Barbara 2
Pistoia, Marilena 1
Poole, Bryan 8
Prasad, Jaggu 1
Purves, Rodella 1
Quintella, Rosane 1
Raistrick, Reinhild 1
Ramsay, Denise 7
Rauh, Dick 1
Reddick, Carol 1
Reddish, Terrie 1
Rees-Davies, Kay 1
Rice, Elizabeth 1
Rosser, Celia 2
Rust, Graham 6
Sagara, Takeko 1
Saito, Manabu 3
Sanders, Lizzie 6
Sanders, Rosie 12
Sasaki, Masako 1
Sato, Hiroki 1
Saul, Margaret 5
Schofield, Sara-Anne 4
Schweizer, Ann 20
Scott, Gillian 1
Searight, Jenevora 1
Sellars, Pandora 12
Sellwood, Gael 1
Sharma, P. 1
Sharma, Vijay Kumar 1
Shepherd, Jess 4
Sherlock, Siriol 8
Sherras, Clark Elisabeth 1
Showell, Billy 1
Siegerman, Sheila 2
Silander-Hökerberg, Annika 1
Silburn, Laura 3
Singer, Alan 1
Singh, Thakur Ganga, Rai Sahib 1
Small, Julie 4
Spector, Sally 1
Speight, Camilla 5
Stagg, Pamela 6
Stenning, Penny 1
Stern, Miriam 1
Stockton, Peta 6
Stones, Margaret 2
Strickland, Fiona 2

Suh, Jee-Yeun 1
Surlo, Gustavo 5
Swan, Ann 2
Takahashi, Kazuto 1
Takano, Kumiko 1
Tangerini, Alice 2
Tarraway, Mary 1
Tazza, Aurora 1
Tcherepnine, Jessica 4
Tennant, Emma 1
Thomas, Vicki 13
Tingey, Sharon 1
Tingley, Alisa 1
Toyota, Michiko 2
Trickey, Julia 1
Tullett, Nicki 1
Turina, Maria 2
Uchijo, Yoko 3
Undery, Dawn 1
van de Graaff, Bronwyn 2
van de Kerckhove, Omer 1
van Raalte, Jeannetta 1
Vartak, Arundhati 2
Viazmensky, Alexander 15
Villela, Patricia Arroxellas 34
Virdis, Marina 1
Wall Armitage, Sandra 1
Ward-Hilhorst, Ellaphie 3
Ward, Veronica 2
Wastie, Sarah 1
Watanabe, Noriko 1
Watts, Brenda 1
Westmacott, Marion 1
Wickison, Sue 2
Wilkinson, Joan 2
Wilkinson, John 1
Williams, Sue 1
Willis, Heidi 1
Woodin, Carol 6
Wormell, Jane 1
Worthington, Susan 1
Wright Østern, Hedvig 1
Wunderlich, Eleanor 2
Yamada, Michie 1
Zagonel, M. Fatima 5
Zelenko, Harry 1
Zhang, Tai-li 4

The Shirley Sherwood Collection exhibitions and venues

1996
Kew Gardens Gallery, Royal Botanic Gardens, Kew, UK
The Hunt Institute for Botanical Documentation, Carnegie Mellon University, Pittsburgh, Pennsylvania, US

1997
Gibbes Museum of Art, Charleston, South Carolina, US
New Orleans Museum of Art, Louisiana, US
Wave Hill, at the National Arts Club, New York, US
Museum of Modern Art, National Galleries of Scotland, Edinburgh, UK

1998
S. H. Ervin Gallery, Sydney, Australia
Yasuda Kasai Museum of Art, Tokyo, Japan
Kirstenbosch National Botanical Gardens, Cape Town, South Africa

1999
Millesgården Museum, Stockholm, Sweden

2000
Dixon Gallery & Gardens, Memphis, Tennessee, US

2001
Marciana Library, Venice, Italy

2002
Denver Art Museum, Denver, Colorado, US

2003
National Museum of Natural History, Smithsonian Institution, Washington, D.C., US

2004
Royal Albert Memorial Museum, Exeter, UK

2005
Ashmolean Museum of Art and Archaeology, University of Oxford, UK

2006
Seiji Togo Memorial Sompo Japan Museum of Art, Tokyo, Japan

2008
Shirley Sherwood Gallery, Royal Botanic Gardens, Kew, UK
Treasures of Botanical Art: Icons from the Shirley Sherwood and Kew Collections
Down Under: Contemporary Botanical Art from Australia and New Zealand

2009
Shirley Sherwood Gallery, Royal Botanic Gardens, Kew, UK
Art of Plant Evolution

2010
Shirley Sherwood Gallery, Royal Botanic Gardens, Kew, UK
Old and New South American Botanical Art
Hidden Treasure: Bulbs
Real Jardin Botanico, Madrid, Spain
Old and New South American Botanical Art

2011
Shirley Sherwood Gallery, Royal Botanic Gardens, Kew, UK
Plants in Peril

2012
Stadt Paderborn, Paderborn, Germany
Plants in Peril
Shirley Sherwood Gallery, Royal Botanic Gardens, Kew, UK
Portraits of Leaves and Fungi

2013
Museo Della Grafica, Pisa, Italy
Botanical Art into the Third Millennium
Shirley Sherwood Gallery, Royal Botanic Gardens, Kew, UK
Rory McEwen: The Colours of Reality
The McEwen Legacy: Artists Influenced by Rory McEwen

2014
Shirley Sherwood Gallery, Royal Botanic Gardens, Kew, UK
Botanical Art in the 21st Century
Inspired by Kew

2015
Shirley Sherwood Gallery, Royal Botanic Gardens, Kew, UK
The Joy of Spring
Nature's Bounty: Fruit and Vegetable Portraits
Singapore Botanic Gardens, Singapore
Tropical Splendour

2016
Shirley Sherwood Gallery, Royal Botanic Gardens, Kew, UK
Brazil: A Powerhouse of Plants
Brazilian Artists in the Shirley Sherwood Collection
Japanese Artists in the Shirley Sherwood Collection
Strawberry Hill, Twickenham
A Collector's Collection: Dr Shirley Sherwood Selects Botanical Art

2017
Shirley Sherwood Gallery, Royal Botanic Gardens, Kew, UK
British Artists in the Shirley Sherwood Collection
Abundance: Dispersal of Seeds, Pods and Autumn Fruits

2018
Shirley Sherwood Gallery, Royal Botanic Gardens, Kew, UK
Down Under II
Botanical Art Worldwide Day (18 May)
Trees: Delight in the Detail

2019
Shirley Sherwood Gallery, Royal Botanic Gardens, Kew, UK
Exotica: Paintings of Plants from Distant Lands
Modern Masterpieces of Botanical Art: The Shirley Sherwood Collection

Selected bibliography

Kress, W. J. & Sherwood, S. 2009. *The Art of Plant Evolution*. Royal Botanic Gardens, Kew.

Morris, C. & Murray, L. 2018. *The Florilegium: Royal Botanic Gardens, Sydney Celebrating 200 Years*. Royal Botanic Gardens, Kew in association with the Royal Botanic Gardens, Sydney.

Rix, M. (ed.) 2015. *Rory McEwen The Colours of Reality*. Revised edition. Royal Botanic Gardens, Kew.

Sherwood, S. 1996. *Contemporary Botanical Artists: The Shirley Sherwood Collection.* Weidenfeld & Nicolson, London.

Sherwood, S. 2000. *A Passion for Plants*. Cassell & Co, London.

Sherwood, S. 2005. *A New Flowering: 1000 Years of Botanical Art*. Ashmolean Museum, Oxford

Sherwood, S. & Rix, M. 2019. *Treasures of Botanical Art*. Revised edition. Royal Botanic Gardens, Kew.

Acknowledgements

Covering such a long period of collecting has been a challenging task. The last decade has been dominated by the Shirley Sherwood Gallery in Kew where Laura Giuffrida and now Maria Devaney have hung more than fifty exhibitions.

This book would not have been completed without the mighty efforts of Sophie Cooper, while Andrew Donaldson has been the most cheerful of picture movers.
My special thanks go to my family who have been so supportive and even secretly commissioned the thousandth painting in my collection.

Finally, I am very grateful to the three hundred botanical artists with paintings in my collection who have made my life so rich and interesting over the last thirty years.

Index

Abrus precatorius 130
Aconitum 42
Acorns 82, 248
Adansonia za 174
Adonis 257
Adonis vernalis 257
African migrant 183
African monarch 183
Allen, Beverly 206–9, 286
Allium ampeloprasum var. *babingtonii* 24
Aloe ferox 170, 186, 187
Aloe peglerae 176
Amaryllis belladonna 172
Anderson, Fay 170–2, 286
Anderson, Francesca 102–3, 286
Angola white lady 183
Anisoptera megistocarpa 268–9
Annona crassiflora 155
Apium graveolens var. *rapaceum* 117
Apple 72
Apricot playboy 183
Areca catechu 272, 289
Areca palm 238, 272
Arisarum proboscideum 60
Aristolochia 13, 288, 290
Artichoke 5, 10
Arum 89, 302
Arum italicum 60
Arum maculatum 60
Asarum minamitanianum 247
'At the Edge' Concord Grapes 126
August (pea) 90
Australian tree fern 7
Autumn foliage & berries 101, 113
Babiana stricta 'Ixia' 26
Baboon Flower 26
Balantium antarcticum 7
Banded euproctis 183
Banksia rosserae 206, 224, 300
Banksia serrata 206, 225, 300
Baobab 174
Barlow, Gillian 5–6, 286
Barretto, Malena 141–2, 287, 297, 305
Bauer, Franz (Francis) Andreas 70, 74–5, 170, 222, 287, 289, 291, 299
Bee 78
Beech 41
Beetroot 206, 212, 287
Begonia coccinea 'Pink' 167
Belladonna Lily 172
Berge, Leslie Carol 102, 104–6, 287
Berni, Stephanie 7, 287
Besler, Basilius 70–1, 287
Beta vulgaris 212
Biarum angustatum 89, 292
Bilbergia sanderiana 146
Bird of Paradise Plant 235
Black bird-berry vi, 190, 300
Black Jacobin hummingbirds 145
Black morel 95
Black rice 84
Blaxill, Susannah 1, 210–3, 287, 297
Bluebell 53
Blue bird flower 62
Blue water lily 58
Booth, Raymond 8, 287, 292
Braithwaite, Victoria 9–10, 288
Brasier, Jenny 11, 288, 297

Briggs, Norah 13, 288
Brittlegills 93
Bromelia sp. 156–157
Brown, Andrew 12, 288
Bushman's melons 191
Bushman's River cycad 105
Butterfly 72, 73, 183
Cabralea canjerana 154
Caltha palustris 6
Camellia chekiangolesa 264, 291
Camellia chrysantha 264, 291
Camellia japonica 'Elegance champagne' 214
Camellia 'Star above Star' 211
Candido, Alessandro 143, 288
Cape Gooseberry 19
Cardiocrinum giganteum 43
Carica papaya 112
Carnegiea gigantea forma *cristata* 124
Carroll, Richard 107–8, 288, 295
Castillo, Juan Luis 98, 288
Catopsilia florella 183
Cattleya coccinea 151
Cattleya schilleriana 164
Cedar of Lebanon 21
Cedrus libani 21
Celeriac 117
Cereus pernambucensis 161
Chakkaphak, Phansakdi 240, 273–7, 288
Cherries, flowering 250
Chiliza, Sibonelo 170, 173, 288
Christopher-Coulson, Susan 14, 288
Cirsium eriophorum 72
Citrullus lanatus 191
Clematis 'Elsa Spath' 33
Clivia gardenii 186
Clover 41
Clusia grandiflora 152
Coccoloba uvifera 123
Coconut palm 129
Cocos nucifera 129, 133
Colocasia esculenta 'Dodear' 243
Colotis lais 183
Combretum platypetalum 183
Condy, Gillian 170, 174–6, 288–9
Coral pea 130
Cordova, Emmanuel 238, 271–2, 289
Corn 127
Corymbia ficifolia 221
Costus spiralis 145, 290
Courgette 22
Crassula coccinea 203
Crested saguaro 124
Crinum moorei 192
Crown imperial fritillary 40, 102, 304
Cucurbita pepo 22, 115
Cyathea dealbata 206, 229
Cycad 102, 104–5, 287
Cyclamen persicum 103
Cyclamen pseudibericum 11
Cynara cardunculus 5, 10
Cyrtanthus ventricosus 170, 199
Danaus chrysippus 183
Dandelion 53, 55, 86, 299
Dark Dahlia 'Rip City' 116
Davidia involucrata 281–5, 292
Dean, Pauline 15, 289–90
Demonte, André 145, 290

Demonte, Etienne 146, 290, 305
Demonte, Rosália 147, 290
Demus, Jakob 76–7, 290
Dendrobium victoria reginae 239
de Rezende, Maria Alice 144, 289
Deudorix dinochares 183
de Villiers, Margaret 170, 177–9, 289
de Vries Gohlke, Monika 102, 109–12, 289
de Wet, Lynda 170, 180–1, 289
Dietzsch, Barbara Regina 70, 73, 290
Dietzsch, Johann Christoph 72, 290
Diospyros kaki 256
Dipsacus fullonum 49
Dipterocarpus alatus 268–9
Dipterocarpus zeylanicus 268–9
Disocactus ackermanii 149
Douglas fir 19
Dove tree 281–5
Dowden, Anne Ophelia 101–2, 113–5, 290
Dowle, Elisabeth 16, 290
Dracaena draco subsp. *draco* 98
Dragon tree 98
Dryopteris affinis 'Cristata' 65
Durantia erecta 273
Echinocereus polycanthus 148
Echinocereus triglochidiatus var. *paucispinus* 38
Echinopsis ancistrophora 143
Eden, Margaret Ann 17, 291
Edwards, Brigid 4, 18–20, 291, 297
Elegia capensis 181
Emmons, Jean 102, 116–8, 291
Encephalartos trispinosus 105
Eragrostis 183
Erica blenna var. *grandiflora* 178
Erica fascicularis 74
Erica patersonii 179
Erica plukenetii 75
Erythrina crista-galli 88, 306
Esparza, Elvia 139–40, 148, 291
Eucalyptus macrocarpa subsp. *elachantha* 218
Eulampis jugularis 230
Euphorbia grandicornis 220
Euryale ferox 240, 278–9, 304
Eutremia japonicum 241
Evans, Anne-Marie 1, 287, 288, 291, 292, 295
Farrer, Annie 4, 21–3, 291
Feng, Jinyong 238, 264, 291,
Fern 7, 53, 128, 206, 229, 271, 298
Ferraria variabilis 188
Ficus carica 137
Figs 137, 302
Finnan, Ingrid 102, 119–121, 292
Fire lily 199
Florisuga fuscus 145, 290
Fomicheva, Dasha 89, 292
Francis, Mally 24, 292, 303
Fraser, Liz 25–26, 292
Fritillaria imperialis 40, 102, 304
Galanthus nivalis 46
Ginger, common 102, 120
Ginkgo 41, 131, 265
Globba sherwoodiana 132, 240, 270, 294
Globe artichoke 'Lindisfarne Castle' 10

Gloriosa superba 209
Goat bitter-apple 198
Gold arum lily bulbs 26
Golden dewdrop 273
Graham, Sarah 27, 292
Grape 107
Graphium angolanus 183
Grass and moss clump 23
Grass tree 228
Great Himalayan lily 43
Grierson, Mary 4, 28, 290, 292
Guest, Coral 4, 29–32, 282–5, 292
Gunnera manicata 35
Gurjar, Damodar 238, 267, 292
Gustavia augusta 142
Gypsy moth 183
Haemanthus coccineus 25
Haemanthus norteri 198
Hagedorn, Regine 79–82, 293
Hague, Josephine 4, 33, 293
Hamilton, Gertrude 78, 293
Hegedüs, Celia 34, 293
Helianthus annuus 20
Heliconia bihai 230
Heliconia chartacea 162
Heliconia solomonensis 216
Herbert, Sue 4, 35, 293
Hibiscus syriacus 62
Hippeastrum 59
Hishiki, Asuka 241, 293
Hislop, Helga 36, 293
Horikoshi, Hideo 242–3, 293
Horsetail restio 181
Hove, Waiwai 240, 268–70, 294
Hughes, Annie 214, 294
Hyde-Johnson, Jenny 170, 182–185, 294
Hylocharis cyanus 146
Ikeda, Mariko 244, 294
Ikeda, Zuigetsu 238–9, 294
Imai, Mariko 245–7, 294
Ipomoea batatas 'Beniaka' 242
Iris 31, 51, 77, 98, 171, 288, 291, 292, 293
Iris 'Spartan' 51
Iris 'Superstition' 31
Iris siberica 99
Ishikawa, Mieko 238, 248–51, 294
Isogai, Noboru 252, 295
Ivanchenko, Yuri 90, 295
Jade vine 15
Japanese black pine 254
Japanese horseradish 241
Japanese persimmon 256
Japanese pine cone 274
Japanese stewartia 260
Japanese wild orchid 246
Jeppe, Barbara 170, 186, 295
John, Rebecca 37, 295
Jones, Paul 1, 205, 215–6, 285, 295
Joubert, Elbe 170, 187, 295
Kakuta, Yoko 253, 295
Kalahari orange tip 183
Kalanchoe thyrsiflora 193
King, Christabel 38, 140, 287, 288, 289 295, 298, 305, 307
Kingcup 6
King Tam, Geraldine 122, 296
Knappetra fasciata 183
Lactarius repraesentaneus 92

Laelia tenebrosa 58
Laeliocattleya 136
Laminaria 210
Langsdorffia hypogaea 147
Latania loddegesii 109
Ledebouria marginata 184
Leucadendron strobilinum 27, 292
Leucospermum catherinae 200–1
Lichens 37
Lilium lancifolium 266
Lilium longiflorum 'Ice Queen' 29, 292
Lilium regale 31
Long leaf pine 255
Lymantria dispar 183
Mackay, David 217–8, 296
Magnolia 63, 70, 91, 96–7, 216, 291, 296, 298
Magnolia campbellii var. *mollicomata* 63
Magnolia grandiflora 205, 216
Magnolia soulangeana 'White Giant' 97
Magnolia x soulangeana 96
Mahango firebush 183
Maidenhair tree 41, 131, 265
Makrushenko, Olga 91, 296
Malvaviscus arboreus 166
Mangifera indica 110
Manisco, Katherine 1, 102, 123, 296
Marianne North Gallery 4
Marigo, Gustavo 149, 296
Maruyama, Kimiyo 254–6, 296
McEwen, Rory 4, 11, 34, 39–42, 290, 295, 297, 302
McGann, Joan 102, 124, 297
McNeill, Robert 43, 297
Meconopsis x sheldonii 50
Medinilla magnifica 17, 291, 292
Mee, Margaret 1, 4, 39, 140, 143, 144, 149, 150–3, 159, 160, 167, 287, 288, 289, 290, 296, 297, 300, 304, 305
Melocactus in tortus 71
Mermaid rose 80
Mirro, Angela 102, 125, 297
Mitrephora winitii 276
Monk's hood 42
Monstera deliciosa 30
Morchella elata 95
Morning glory 246
Moss 23, 48, 295, 298
Moustache wild ginger 247
Mystropetalon thomii 180
Nasturtium tropaeolum 267
Natal lily 192
Nelumbo nucifera 277
Neoglaziovia variegata 153
Neoregelia cruenta 165
Neoregelia magdalenae 141
Nepenthes truncata 245
Nepenthes villosa 238, 249, 251
Nessler, Kate 102, 126–8, 295, 298
Nettleton, Julie 219, 298
New Zealand flax 135
Nicholson, Catharine 44, 298
Nigella 81
Nigella damascene 81
Nivenia stokoei 171, 286
Nunes, Álvaro 140, 154–8, 297, 298
Nymphaea nouchali var. *caerulea* 58
Nymphaea thermarum 160
Oak 259, 298, 305
Ogilvy, Susan 46–7, 298
Onion wood 217
Oozeerally, Barbara 70, 96–7, 298

Otyza sativa subsp. *japonica* 'Gioiello' 84
Paeonia 9, 32
Paint brush lily 173, 288
Pandanus boninensis 244
Pandanus tectorius 252, 295
Papaver orientale 'Brilliant' 232–3
Papaya 112
Paperbark 196
Parker, Hillary 129, 298
Passiflora edulis 258
Passiflora laurifolia 122
Passiflora 'Lavender Lady' 231
Paulownia elongata 265
Peanut tree 226
Pear 16, 213, 291
Pear 'Conference' 16
Pelargonium tetragonum 202
Pelyecyphora aselliformis 139
Peony 9, 32
Peter, Sylvia 70, 83, 299
Petrini, Angela 84–5, 299
Petters, Yanny 48–9, 299
Pharaoh, Jenny 170, 188, 299
Phillips, Jenny 206, 220–3, 299
Philodendron 150
Phormium tenax 135
Phragmipedium kovachii 102, 134, 297, 306
Physalis peruviana 19
Physoplexis comosa 159
Picea abies 'Virgata' 119
Pike, Barbara 170, 299
Pillansia templemannii 197
Pink five-corners 219, 298
Pinus densiflora 274
Pinus palustris 255
Pinus thunbergii 254
Pistoia, Marilena 86, 299
Pisum sativum 90
Pitcher plants 54
Plantago lanceolata 83
Platycerium coronarium 271
Plums and custard 94
Polytrichum commune 48
Pomegranate 191, 209
Poole, Bryan 206, 229–30, 299
Poplar 61
Populus x canadensis 61
Populus tremula 79
Protea coronata 194
Protea holosericea 106
Protea neriifolia 195
Protea repens 180
Prunus cerasus 72
Prunus pendula 'Pendula-rosea' 250, 294
Pseudotsuga menziesii 19
Psychotria capensis 190, 300
Punica granatum 191
Purple currants 78
Purves, Rodella 50, 299
Pygmy Rwandan waterlily 160
Pyrus 213
Quercus robur 82
Quercus serrata 259
Quintella, Rosane 159, 300
Ramsay, Denise 206, 231–3, 300
Ranunculus asiaticus 76
Raspberries 78
Rat's tail 83
Rauh, Dick 102, 130, 300
Ravenala madagasceriensis 234
Red crassula 203

Redcurrant 18, 73, 78
Reddick, Carol 170, 190, 300
Rhododendron 'Horizon Monarch' 66
Ribes rubrum 18
Rice 84–85, 299
Rosa filipes 'Kiftsgate' 261
Rosa hirtula 253
Rosa microgosa 111
Rosa moyesii 8
Rosa rugerosa 262, 263
Rose 8, 36, 41, 56, 71, 79, 80, 111, 253, 261, 263, 275, 293, 301, 306
Rose hips 36, 293, 298
Rose of Jericho 71
Rose: Red Sensation 56
Rosser, Celia 206, 224–5, 300
Rowan 37
Russula 93
Rust, Graham 51, 300
Sacred lotus 277
Saito, Manabu 131, 301
Sanders, Lizzie 52, 301
Sanders, Rosie 53–6, 301
Sarracenia x whittarii 54
Sato, Hiroki 257, 296, 301
Satyrium coriifolium 177
Saul, Margaret Anne 226, 302
Sauromatum venosum 12
Saw Banksia 225
Scadoxus puniceus 173
Schweizer, Ann 170, 191–3, 302
Sea grapes 123
Seaweed 210, 287
Seed pod of great Himalayan lily 43
Selaginella lepidophylla 71
Sellars, Pandora 1, 4, 57–60, 296, 302
Shepherd, Jess 61–2, 302
Sherlock, Siriol 63, 302
Shirley Sherwood Gallery 1, 4, 71, 102, 140, 206, 239, 240, 285
Shorea sumatrana 268–9
Showell, Billy 64, 302
Siberian iris 99
Siegerman, Sheila 136, 303
Silander-Hökerberg, Annika 99, 303
Silburn, Laura 65, 303
Silver tree fern 229
Singh, Thakur Ganga (Rai Sahib) 238, 266, 303
Snail 78, 293
Snake branch spruce 102, 119
Snowdrops 46, 298
Solanum aculeastrum 198
Spinach 108
Squash 115
Squill, common 184
Stagg, Pamela 102, 137, 303
Staghorn fern 271, 289
Sterculia quadrifida 226
Stewartia pseudocamellia 260
Stockton, Peta 170, 194–6, 303
Stones, Margaret 1, 227, 303
Strelitzia 163, 189, 207, 222, 286, 287, 299, 302
Strelitzia 'Mandela's Gold' 222
Strelitzia nicolai 189, 207, 286
Strelitzia nicolai subsp. *augusta* 163
Strelizia reginae 234, 235
Strickland, Fiona 66, 303
Strongylodon macrobotrys 15
Styphelia triflora 219, 298
Suh, Jee-Yeun 240, 278, 279, 304

Sunflower 20, 102, 291, 295
Surlo, Gustavo 160–1, 304
Sweet potato 242
Syagrus 158
Syzygium alliiligneum 217
Tacca nivea 121
Tahitian screwpine 252
Takano, Kumiko 258, 304
Tangerini, Alice 132, 240, 304
Taraxacum officinale 86
Taro 243
Tazza, Aurora 87, 304
Tcherepnine, Jessica 1, 102, 133, 304
Teasel 49
Tecomanthe speciosa 229
Telopea speciosissima 175
The Babington's leek 24
The Phenology Cabinet of the Incandescent Petal 32
The Traveller's Palm 234
Thistle 72, 290
Thomas, Vicki 170, 197–201, 300, 304
Thorny giant 240, 278–9
Three Kings climber 206
Tiger lily 266
Toadstool 118
Toyota, Michiko 259, 304
Trichodesma scottii 52
Tricholomopsis rutilans 94
Trickey, Julia 67, 305
Tryon Galleries 1
Tulipa 34, 57, 67
Tulipa 'Orange Favourite' 67
Tulipa 'Rory McEwen' 34
Turk's cap aloe 176
Turk's cap cactus 71
Uchijo, Yoko 260, 305
Upper Club, Eton 39
Vachellia sieberiana 196
van de Graaff, Bronwyn 228, 305
Viazmensky, Alexander 70, 92–5, 305
Viburnum rhytidophyllum 227
Victoria cruziana 144
Villela, Patricia 162–5, 297, 305
Vine 87, 107, 288, 290
Violet 215, 289
Virdis, Marina 88, 305
Vitis labrusca 126
Vitis vinifera 87, 107
Voodoo lily 12
Waratah 175
Ward-Hilhorst, Ellaphie 170, 202–3, 306
Wasabi 241
Watanabe, Noriko 261, 306
White bat flower 121
White-chinned sapphire hummingbird 146
White lady 193
Wickison, Sue 206, 234–5, 306
Wild garlic 53
Wollemi pine 206, 208
Woodin, Carol 102, 134–5, 306
Xanthorrhoea johnsonii 228
Yamada, Michie 262–3, 306
Yellow archangel 53
Yellow bearded milkcap 92
Yellow water lily 28
Zagonel, Fátima 166–7, 306
Zea mays 127
Zhang, Tai-li 238, 265, 307
Zingiber officinale 120